THE PRE-RAPHAELITE TRAGEDY

THE PRE-RAPHAELITE
TRAGEDY

William Gaunt

JONATHAN CAPE
THIRTY BEDFORD SQUARE LONDON

FIRST PUBLISHED 1942
REPRINTED 1942
REVISED EDITION 1975

JONATHAN CAPE LTD, 30 BEDFORD SQUARE, LONDON WCI

ISBN 0 224 01106 5

PRINTED AND BOUND IN ENGLAND BY
HAZELL WATSON AND VINEY LTD
AYLESBURY, BUCKS

CONTENTS

LIST OF ILLUSTRATIONS

9

The Argument

This is the true story of what happens in mature life to a group of very remarkable people, united, when young, in the pursuit of an ideal. Estrangement springs up and their paths diverge, but they have generated, among them, a force which powerfully affects the life of each one in a different way. The main actors are Dante Gabriel Rossetti, poet and painter; William Holman Hunt and John Everett Millais, painters; William Morris, poet, craftsman and socialist.

Rossetti, Hunt and Millais meet as art students in London and form an alliance which they call the Pre-Raphaelite Brotherhood. Each interprets its aim after his own fashion. Rossetti sees its ideal in a woman. He falls in love with a beautiful model, discovered by a member of the group, and marries her: but she takes a fatal dose of laudanum, as he thinks through his treatment of her, and in remorse he buries his poems in her grave. Later he resurrects them, though this also helps to make him a haunted man. He becomes a recluse and his existence is clouded by despair and the use of a dreadful drug. Hunt sees the ideal in religion, and his fanatic belief in the aims of the Brotherhood, which he conceives to be his own creation entirely (though the world gives the brilliant Rossetti most of the credit), turns into a kind of religious obsession. Millais, less intellectual than the others but superbly gifted in skill, sees the ideal in worldly success and gradually yields to its lure.

Before the death of his wife, Rossetti, already parted from his earlier friends in spirit, attempts to revive the original enthusiasm with a new set of disciples, of whom William Morris is the chief. To Morris the ideal represents itself as a complete change of the social order. His failure to achieve this object completes a many-sided tragedy, complex and subtle as the dream from which it has arisen.

The action takes place between the middle of the nineteenth and the early years of the twentieth centuries; with many shifts of scene from one

part of London to another; to the Australian gold-diggings, Jerusalem, Iceland, a mediaeval stronghold in Scotland, a manor house in Oxfordshire, a bungalow at Birchington-on-Sea and elsewhere.

The cast includes lesser members of the Brotherhood and Pre-Raphaelite followers: and many of the most famous actors on the vast stage of the Victorian era: poets, prophets, artists, novelists, scholars, scientists, churchmen, politicians and women of beauty and fashion.

———————

The seven members of the original Pre-Raphaelite Brotherhood:

WILLIAM HOLMAN HUNT
JOHN EVERETT MILLAIS
DANTE GABRIEL ROSSETTI
WILLIAM MICHAEL ROSSETTI
JAMES COLLINSON
FREDERICK GEORGE STEPHENS
THOMAS WOOLNER

Friends and unofficial associates of the Brotherhood:

FORD MADOX BROWN, WALTER DEVERELL, ARTHUR HUGHES,
CHARLES ALSTON COLLINS

Associates in the second Pre-Raphaelite phase:

DANTE GABRIEL ROSSETTI, EDWARD BURNE-JONES, WILLIAM MORRIS,
FORD MADOX BROWN

I

Brotherhood

1 A Child Wonder

It was prizegiving day at the Royal Academy in 1843. The students were all assembled in the lecture-room. A flunkey in scarlet threw open the doors and in came the R.A.s, gravely acknowledging their pupils' applause.

The Royal Academy, the one organised centre of Art in England, was then housed at the National Gallery in Trafalgar Square. It was a creation of the time of George III and still retained its eighteenth-century character. There had been great changes in life and thought since its foundation. England had been industrialised, London had grown vast. The Romantics of literature and architecture had begun their protest against the formal and classic culture of which it was the offshoot: but it remained so far impervious to the new imaginative spirit of the age.

Englishmen became poets by dint of genius and originality. Englishmen became painters, as they became grocers, by Industry. Seventy-five years before the first President, Sir Joshua Reynolds, had laid down this principle: and Industry had come to excuse the lack of other qualities.

For aspirations soaring higher there was a prescribed formula – the classic 'Grand Manner' of Italian art, of Raphael and the School of Bologna, the Caraccis and Renis of the sixteenth and seventeenth centuries. To imitate their florid compositions, grandiose subjects and dusky tones was considered to be the supreme exercise of the imagination.

In 1843 the Academy was at a low ebb. The great innovator in landscape, John Constable, had died in 1837 and his inspiration was felt in France rather than in his own country. Sir David Wilkie, painter of the *Blind Fiddler* and the *Village Wedding*, had died in 1841. He left a decaying tradition of homely and domestic subjects. There was one giant remaining, Joseph Mallord William Turner, aged sixty-eight, a being apart. In this year, 1843, he exhibited the mistily glowing *Sun of Venice* and was held to be in his decline. The attacks made upon him had just

inspired a young Oxford man, John Ruskin, to produce a work in his defence, called *Modern Painters*.

The procession which entered the lecture-room was thus distinguished by its stateliness and respectability rather than by its genius. These worthy men were mostly purveyors of anecdotes in paint. Some drew their material from eighteenth-century novels. Some went in for the epic and historical line, making their pictures very large and very dark so that they should look like old masters. Many are now forgotten or vaguely remembered. In the forefront was Keeper Jones, who was very proud of being so often mistaken for the Duke of Wellington[1]; then the genial Charles Robert Leslie, who was well up in Addison, Goldsmith and Sterne and painted Sir Roger de Coverley and Uncle Toby and the Widow Wadman; the gently humorous Thomas Webster, noted for such works as *The Dame's School* and *The Truant*; Daniel Maclise, as handsome as Byron, who did huge battle pieces and never used a model; Charles Robert Cockerell, striking in appearance with white hair and black eyebrows, an architect member, who completed St George's Hall at Liverpool; stout little William Etty of the voluptuous nudes, with an odd and exceptional streak of genius; and finally, great triton among the minnows, Turner himself. Shabby, hooked-nosed, furtive, old, he shambled hurriedly to a chair with its back to the audience, peevishly refusing to deputise for the absent President, the Irish portrait-painter Sir Martin Archer Shee.

Such was the scene, such the artists who passed before the fascinated and attentive gaze of a young student, a solemn boy of sixteen. His name was William Holman Hunt. He was not yet admitted to the Academy Schools, but he attended the lectures and his card allowed him to be present on special occasions of this kind. His eye roamed over the copies on the walls and behind the dais, Leonardo's *Last Supper*, Rubens' *Descent from the Cross*, and the cartoons by Raphael: and became intent as the name of the gold-medallist in the Antique School was announced . . . JOHN EVERETT MILLAIS.

He it was whom Hunt had come especially to see: the famous child prodigy, who, a year or two earlier, at the age of ten, had been the youngest student ever to get in the Academy; whose miraculous talent was the talk of the whole art world.

Standing up was a quaint, angelic little creature – an Early Victorian angel. Long light curls fell over his goffered collar, his face was fresh-coloured and open, his eyes a candid blue. He wore a tunic with a cloth

belt, short trousers above white socks and patent leather shoes. They passed him from hand to hand over the seats, while the students laughed and clapped and the platform smiled approval. 'The Child' was the darling of the institution, destined, it would seem, by nature, for all its honours; but little did those approving academicians know that in a glance that had passed was the first spark of a mighty rebellion.

2 A Conspiracy of Two

A year later they met over their drawing-boards and it was not long before Millais had invited Hunt to his half-French, very English home at No. 83 Gower Street. The Millais family had come from Jersey. Johnny had been born at Southampton. In Gower Street he was the centre of an adoring circle – a pleasant sight to Hunt, who, in his own home at Wood Street, Cheapside, had to put up with a Puritan father's gloomy dislike for art. Johnny's mother was sure he would be one of the great painters. The colonel of the regiment at Dinan said so when Johnny, aged six, made a marvellous likeness of him, smoking a cigar. Mr Bessel, the best art master in St Helier's, said so: and had not President Shee, when she took the portfolio to show him, said first, 'Madam, you had better make him a chimney-sweep', but after he had looked at the contents, 'Madam, it is your duty to bring the boy up to art.' Mrs Millais fondly showed the extraordinary imitations of Hogarth, Stothard and Cattermole on each of which she had inscribed his name and years.

He had never been to school. She said he was delicate and taught him herself what she could. He was enclosed by adoration and his own precocious ability within the limits of art alone.

They groomed him like a young colt. His mother found subjects for him in books and looked up knotty points of history and dress in the British Museum. The father, a musician, sat for him for heads and hands, and by painting in different beards, Johnny made him into various types. His brother Bill, also, was kind and made a grand St John, the beloved apostle. 'Dear creatures', said Johnny, and rubbed his curly hair against mamma's forehead and patted 'old daddy' (who was forty-seven or so) on the back. Then the latter would twang *The Harmonious Blacksmith* on a guitar and Johnny would beat time to the tune while playing a game of chess with mamma, and their happiness was complete.

In the big room he used as a studio there were little statuettes of a cow and a calf under glass domes on the mantelpiece. A back window looking

out on a Bloomsbury yard had been painted with Gothic figures, to look like stained glass. A lady's worktable stood near a large canvas of Pizarro seizing the Inca of Peru. Here, as time went on and he and Hunt grew more intimate, Johnny talked of himself and what he would do. He was going to paint a huge thing, nine feet one way by sixteen the other, to be called *The Widow's Mite*.

Hunt, in turn, confided his enthusiasms. He had bought a little paper-backed copy of Keats for fourpence and started to read it aloud:

> 'The hare limp'd trembling through the frozen grass
> And silent was the flock in woolly fold:
> Numb were the Beadsman's fingers . . .'

but Millais, looking uneasy, stopped him, saying 'It's like a parson'. However, he did consent to try *The Eve of St Agnes* and *The Pot of Basil* for himself. So they studied, talked, painted together, each doing a little hackwork, too, because funds were not plentiful in either household, though the Millais were the better off: and Millais grew into a tall youth of eighteen, with sandy curls, very correctly dressed to show he was not a Bohemian 'genius', and Hunt a serious fellow of twenty, worrying much over the problems of art and somewhat prone to sermonise about them. They both agreed they must strike out a new line. Art was getting stale and empty. Raphael and the 'Grand Manner' were overdone. There was much to be altered, much that was lacking in the Academy whose pupils they were. Hunt had found a gospel in a new book called *Modern Painters* by 'A graduate of Oxford', the already famous defence of Turner. 'Go to nature in all singleness of heart, selecting nothing, rejecting nothing.' This was its creed for the young. It carried conviction with Hunt. He had by this time begun a picture of *Christ and the two Marys* which required an Eastern background, so he went in all singleness of heart to Kew Gardens and struggled home with a twelve-foot palm tree which the curator obligingly lopped down for him. Millais, in his eager impulsive way, took fire at the idea. Truth to nature, with a miraculous detail and finish, was the means of demonstrating to those sluggish old men of the Academy the power he felt himself to possess. So he and Hunt, the executant and the reformer, concocted a plot to develop this new way of painting and thus launch themselves on the way to fame.

It was at this point and in the year 1847 that a strange being crossed the
path of the two young artists. A fascinating, careless, wayward, capricious,
irreverent, dominating being. A London Italian. Not even a professional
painter – a sort of poet or a poet and something of a painter as well.
Spouting endless verses, some of them his own. A genius, perhaps, in a
way, but not a straightforward way like Millais'. Full of contempt for
authority. Cascading out words, beautiful words, grotesque and invented
words, slang words. Casually revealing a curious and wide knowledge. In-
clined to be masterful and to turn ugly and irritable if contradicted.
Juggling with ideas and making too free, Hunt thought, with the ideas of
others. Withal, one you could not resist. His name was Rossetti.

Hunt had seen him before at a distance; fitfully attending the Academy
schools; with a trail of the wilder students who were his devotees. Now
he was flattered by a direct approach. The strange youth said that Hunt's
Eve of St Agnes, with which he had just made his Academy début, was
the best thing there. They talked about Keats and in a few days' time they
had become friends.

Rossetti was poetic in looks, after a rich, southern fashion; with an
angular clean-shaven face, a dreamy gaze, full lips, hair waving to his
shoulders and small, olive-coloured hands with delicately tapering
fingers. Hunt noted, in precise anatomical detail, the grey eyes whose iris
did not reach the lower lid, the aquiline nose and the depression of the
frontal sinus shaping the bridge, the sloping shoulders, the wide hips and
the rolling, slouching gait; noted also, in his exact way, the splashes of
dried mud on the long-unbrushed brown overcoat whose pockets bulged
with manuscript. Then Rossetti began to talk and the other was held in
thrall by a voice of uncommon range, now deep, now soft and persuasive,
and the power of a cultured mind such as he had not previously known. It
was observable always in Rossetti that he flung out a net, with a sort of
random deliberateness, here, there and everywhere, catching acquain-
tances, experience and ideas. He was already equipped with a jumble of
learning which comprised both good things and odd, old and new. He
had spoken Italian from childhood and was as well acquainted with Dante
as with Shelley. His modern enthusiasms included Browning's *Paracelsus*,
Coventry Patmore's *Woodman's Daughter* and Sir Henry Taylor's poetic
drama, *Philip van Artevelde*. He had learnt some German and had a taste
for legend, pageantry and witchcraft as in Meinhold's romance *Sidonia*,

the Sorceress. He was the possessor of a priceless collection of William Blake's prose, verse and designs, bought (his brother supplying the cash) for ten and sixpence from Palmer, an attendant in the British Museum. He quoted Blake's lampoons on Sir Joshua Reynolds. He had discovered a book of nonsense verses by a man called Edward Lear and made comic rhymes on the same model (a habit which continued through life).

He seemed to be alive to everything that was going on in the arts. He sought out what he thought were new and vital things and freely expressed his admiration to everyone, including the producers of these things. At that moment a master in the new Government School of Design at Newcastle, William Bell Scott, was feeling rather flattered on learning that a Mr Gabriel Chas. Rossetti liked his poems *Rosabell* and a *Dream of Love* and that this Mr Rossetti had 'fallen like a vulture' on his *Year of the World* and read it at a sitting. He felt a thrill of excitement when, in the course of a post or two, his correspondent sent him for perusal some poems mysteriously described as *Songs of an Art Catholic*. He wondered what *Art Catholic* could mean – it savoured to him of popery; but in *The Blessed Damozel* and *My Sister's Sleep* he discovered a real, an extraordinary power. Poor Hunt, of course, with his fourpenny Keats, was quite overwhelmed and when the rich voice declaimed:

> 'From the fixed place of Heaven she saw
> Time like a pulse shake fierce
> Through all the worlds. Her gaze still strove
> Within the gulf to pierce
> Its path; and now she spoke as when
> The stars sang in their spheres'

Hunt recalled certain attempts at versification of his own and privately resolved to try no more.

But Rossetti was diffident about his painting. He announced that he would like to be Hunt's pupil. He laughed over a previous experience of tutelage with the painter, Ford Ma ox Brown (whom he called 'Bruno'). In Brown, aged twenty-six, train Belgium, France and Italy, recently settled in England, he recognised ng man. He had written an effusive request to be taken on as pupil ad called on him with a big stick and an appearance of indigna ole, in his modesty, to believe the letter was not a hoax. The ar t had been tried, however, but did not work. The master, it see ad objected to Rossetti's habit of cleaning his palette on sheets of notepaper which stuck to Brown's boots

when he came home in the dark: and the pupil had found copying old bottles and such still-life things dull; so here he was, ostensibly living with his family but free to rove, sampling life and art and staying with whom he liked. Before Hunt well realised it Rossetti was encamped on him in his new studio at Cleveland Street and Millais, who had been away when they first met, also, though with some reservations, came under the spell; and they were three instead of two.

It is doubtful if Hunt and Millais ever understood their newly acquired companion. Bent on an industrious and profitable career they were out of key with one who was simply as yet an experimenter in living, a sensitive instrument thrilling to the great forces that were moving in the world. They felt only in a vague way what he fully grasped with a sure instinct – the emotional and spiritual development of the age, in reaction against its own and the preceding century's materialism. His choice of books was a medley of the romantic and poetic literature of Europe. His choice of a title for his poems was influenced by the religious revival set on foot in England by the *Tracts for the Times* of Newman, Pusey and Keble. His choice of a master showed his sense of the purifying spirit at work in painting. Through Madox Brown he became aware of the austere Christian art of the Germans, Cornelius and Overbeck, whose sect lived like monks in Rome; and thus in several ways his casual habit of life and thought took on a design not at first obvious or even known to himself. Subtly he was to change, to confuse, to enlarge, the reform his friends proposed to themselves, though to the end of his life Holman Hunt was convinced that Rossetti was an amateur painter whom he, Hunt, had trained.

4 Three Become Seven

'Good evening, Mr Madox Brown', said old Gabriele Rossetti to Holman Hunt when the latter called at 50 Charlotte Street, Portland Place. So many of Gabriel's friends came and went that it was difficult to know who was who. Gabriele was Gabriel's father. With a black cap on his head, a shade over his failing eyes, a large snuff-box and manuscript book conveniently to hand, he had all the melancholy importance and industry of a refugee and a patriot. Exile of Vasto in the Abruzzi, one of the most noted *improvisatori* of Naples, former curator of Ancient Bronzes in its Museum, librettist to the operatic theatre of San Carlo and with a certain exquisite talent in pen-and-ink drawing, he was the worthy parent of an unusual

son. The ode with which he had greeted a new constitution, granted to Naples by the Bourbon tyrant, Ferdinand, beginning:

'*Sei pur bella cogli astri sul crine*'
'Beautiful indeed art thou with the stars in thine hair'

had been celebrated in his native land. But the constitution had been revoked and Gabriele, a member of the Carbonari, proscribed. One of his lyrics had given especial offence to the King:

'*Che i Sandi ed i Luvelli*
Non sono morti ancor'
'For Sands and Louvels are not yet dead'

an indiscreet reference to the possibility of assassination. He had escaped, with the connivance of Sir Graham Moore, in the dress of an English sailor; had been received with courtesy at Malta by Hookham Frere, the translator of Aristophanes; and now was Professor of Italian at King's College, London. His wife, a Polidori, was half-English, half-Tuscan. There were, besides Gabriel, three children, Maria Francesca the eldest, William Michael who was in the Civil Service, a year younger than his brother, and Christina Georgina, the youngest.

As Hunt sat gingerly down to a dish of macaroni, he observed the foreigners grouped round the fire. They went on talking through the meal. Occasionally one would burst into a passion of gesture and voluble speech in the Italian tongue, Gabriele would quit his plate, go over to the fire and join in. Amid the hubbub the names of Mazzini, Garibaldi, Pio Nono, Bomba could be heard, uttered with varying tones of rapture and denunciation.

Leaving this excitable assembly to its dominoes and chess the young visitors trooped upstairs to discuss the business of their own. And much business there was. The snug little plan of Millais and Hunt was getting out of hand. A crowd was tumbling into it and it was all Rossetti's doing. He seemed to think it was an Italian secret society – and moreover a secret society which everyone could join, wide open to the four winds of heaven.

They were now seven, instead of three.

The newcomers, with one exception, were introduced by Gabriel on slender grounds.

There was Thomas Woolner enlisted, primarily, because he lived next door to a man called Hancock on whom Gabriel had quartered himself. Woolner had been apprentice to the sculptor, Behnes, acquiring the nickname 'Behnes' tiger', and assistant to the portrait-medallion man,

Alexander Munro. He hailed from Suffolk and was a bold, decided youth who meditated enormous groups of statuary. He smoked caporal tobacco in a clay pipe, with the number 46 stamped on the bowl, which he had brought back in a handsome case from Paris. Waving this object he declared his admiration for a painter the others didn't care about, Ary Scheffer, and a picture by Mulready entitled *Train up a Child in the Way he should Go*. In his favour was his conviction that sculpture ought to be true to nature and a worship of Shelley. He paid special visits to a wood near Marlow because an old man had told him he once saw Shelley there, 'his hat surrounded by some sort of weed resembling ivy'.

Then there was James Collinson, whose somnolence was a great source of mirth to the group, like that of the Fat Boy in the *Pickwick Papers*. He was, according to Hunt, a 'meek little chap'; but Gabriel said he was 'a born stunner', and it was one of his amusements to wake him up and drag him out for a long walk late at night. Collinson was attested by a work called *The Charity Boy's Début*. He solemnly promised to be true to nature and go in for the severe style.

The next was William Michael Rossetti, Gabriel's brother, who was in the Inland Revenue and didn't paint at all, though he might one day. Finally, Hunt had produced Frederick George Stephens, to balance up the candidature. Stephens was the son of an official in the Tower, and might also learn to paint one day if he had the time and the ability. Efforts were made by Rossetti to rope in Madox Brown but, much to Hunt's relief, he would not join.

And what of the idea? It had seemed clear to begin with and now it was a dozen things. This was Rossetti's fault, of course. He had some cloudy vision of a great union of all the arts, except music, which bored him: of a whole population of painters, excepting only the young aristocrats and millionaires who would buy their work; of an ascetic community of 'art catholics' and 'early Christians', like the 'Nazarenes' who had impressed the 'Brownonian mind'. They would abjure bohemianism, swearing and drinking; rescue fallen women; and, perhaps with a dispensation in favour of Woolner, they would not smoke. Then he would shoot off at a tangent and draw up a memorandum on immortality: making out a list of immortals who would constitute 'the whole of our creed' and denoting the grade of each by one, two or three stars. Jesus Christ had four: the Author of *Job* three, Homer two, and the list included Joan of Arc and Mrs Browning, Kosciusko and Columbus, Tennyson (one star) and King Alfred (two).

Hunt patiently disentangled the revivalist and other heresies; eliminated the pranks and whims. A primitive purity of feeling, yes; but pruned of primitive faults. They must aim at something quite modern in accuracy and truth: to which Gabriel, who cared nothing for truth of any material kind, never looked at a landscape and questioned, being in mental date somewhat before Galileo, whether the earth really moved round the sun, remained indifferent. They must not, said Hunt, copy those monastic Germans who were cold and hard; or their English follower, William Dyce, who produced the effect of a daguerreotype; or Ford Madox Brown, who had a style of his own: to which Gabriel replied with a defensive paean of praise for 'Bruno'.

It was all difficult. Millais was quite angry. 'I can't understand what you're after,' he said, and 'Are we starting a regiment to take the Academy by storm?' The complications of the programme were beyond him. The Camorra so swiftly and carelessly organised was not at all to his taste. He pulled a long face and said it was a very serious undertaking. They ought to have some test of what these fellows could actually do. Hunt quailed a little before his admired hero's sensible indignation, but smoothed him down and at length it was agreed they should have a full meeting at Millais' house to clear up what it was all about.

5 Seven Become Brethren

The times were disturbed. The hungry forties had reached their crisis. Europe was menaced by Liberals, dangerous folk whose badge was a beard. England was bewildered by the first big slump in industry. There were riots in Berlin, in Munich, in Milan, in Madrid, in Glasgow, barricades in Paris. Louis Philippe and his wife came scuttling over to Newhaven as plain Mr and Mrs Smith. Mazzini left London to join in the Lombard revolt. On Bankside Bill Sykes prowled with his cudgel in angry mood. Special constables looked hard at a group of small boys squabbling over an orange. Thomas Carlyle, a mature prophet of fifty-three, who some years earlier had (in *Past and Present*) contrasted the new age to its disadvantage with the days of monastery and guild, asked for 'some scheme or counsel' in the 'abyss and imbroglio'. Holman Hunt and John Millais followed in the wake of the Chartists' monster petition from Russell Square to Kennington Common. They, too, felt the spirit of revolt. The boyish group began to regard the Academy as a despotism. Their numerous talks, prolonged far into the night, took on an aggressive

turn against its virtual monopoly, its dull and foolish productions. Down with Sir Sloshua Reynolds (a distortion of the first great President's name which they adopted with delight), down with Mr Sloshy-Slosh, RA. Down with 'Monkeyana', animals by Landseer, *Books of Beauty* and simpering choirboys. Down with Raphael, of course (though they knew next to nothing about him). Up with – well, what? What were they to call themselves? Early Christian, again suggested Rossetti, and again Hunt corrected him. They must convey their avoidance of Raphael and of the great evil he had done to art. Before Raphael. Pre-Raphael. *Pre-Raphaelite*. Gabriel had the last word. It must be a brotherhood; and the Pre-Raphaelite Brotherhood it was.

In August 1848 the pact was concluded at No. 83 in what Tennyson was to term 'that long, unlovely street'. On this famous occasion they were all there, Millais doing the honours, Hunt anxious, Rossetti playful, his brother puzzled but playing up, Woolner arrogantly smoking and Stephens dimly present. They looked over a folio of Lasinio's outline engravings (described by Ruskin as 'execrable') from the frescoes in the Campo Santo at Pisa, by Benozzo Gozzoli, Orcagna and other Italian artists of the fourteenth and fifteenth centuries. Where the folio came from is vague. It appears to have been lent to Millais: however, there it was in Gower Street and it served to inspire them. They admired the charm and invention of the frescoes, though there was some laughter at the absence of perspective, the incorrect drawing, the stilted backgrounds, in fact at qualities most distinctive in the originals they did not know and perceived faintly through the economical suggestions of the engraver. 'That's the sort of thing the Pre-Raphaelite clique should follow,' Millais later remembered himself to have said; and they all solemnly swore their adherence and promised in no circumstances to divulge the secret of the letters PRB: which letters Rossetti proceeded forthwith to design in a sternly simple and angular form.

In later life Rosetti was to declare, with one of his full-chested laughs, 'Pre-Raphaelites! A group of young fellows who couldn't draw'. He was tired, he said, of 'the visionary vanities of half a dozen boys'. 'We've all grown out of them, by now, I hope.' And, indeed, one might look on the Brotherhood itself as a boyish lark, were it not that something quite mysterious had happened.

The much bemuddled idea came to life.

The group had acted as the medium for the Romantic spirit of the century whose essence was a love of the past and of unsophisticated

nature. It was linked with Romantic Poetry, with the Gothic and religious Revival, with the reaction against the Industrial Revolution; with Wordsworth, Keats and Shelley, Pugin and Pusey, the anti-Victorian thinkers Ruskin and Carlyle, though with the Italian masters of the later Middle Ages, who provided its curious name, it had very little to do. It had also the realist, reforming spirit of 1848.

The very contradictions of the plan became important. There could be no such thing as absolute truth to nature. That is to say, they had embarked on a search for something that did not exist. They were quite ignorant of the fourteenth century, which was to be their starting-point. In other words, the starting-point was something which never had existed; but this tissue of absurdity began to palpitate like a grain of chemical substance, defying analysis, with its own inward energy, becoming more instead of less intense. Pre-Raphaelitism was a misunderstanding they all misunderstood. It was a reform and a dream. It was real and unreal. It was modern, it was in the Middle Ages. It was a reasonable conclusion on fanciful premises, a fantasy resulting from a practical proposal. It was an escape from the age and a means of converting it. It was a circle in which the future and the past chased each other round. It was a dimension, in which people and things were actual and yet phantom. It was to die and be born again, to shoot an uncanny ray through the material opacity of the times, to sparkle like radium in the leaden tube of Victoria's reign: through literature, art, religion, politics, even tables and chairs.

Within its luminous boundary human lives were to assume the transmuted vividness of *Alice in Wonderland* or Dante's *Inferno*; an inconsequent two-sidedness, on a plane or a series of planes which were now in this world and now in the world of make-believe and at intervals, with a mixture of the jolliest farce and the strangest agony, in both worlds at once; and drama was to be enacted with an unearthly enthusiasm, an incredible complication of character and scene and a more than natural intensity.

The strangely pregnant myth having come to birth, the Brotherhood set to work on the serious task of combining the real and the unreal, dream and actuality. They toiled like demons, and they produced beautiful, enchanting pictures. It is convenient and roughly correct to denote this phase of joint effort by the years 1848–53; though certain changes in the relations of the Brethren took place within these arbitrary limits and must, in due course, be remarked. And the method was this: they fitted real people and real backgrounds to imaginary scenes or vice versa, paint-

ing these imaginary scenes from nature with the most scrupulous fidelity of detail and pure and vivid colour. It was the rudimentary stage of the Pre-Raphaelite magic; it was practised domestically. Relatives, friends and fellow-students were pressed into service and converted into historical and legendary characters. Millais, now thoroughly habituated to Keats, chose for his first masterpiece the moment in *Lorenzo and Isabella* when the suspicion of the villainous brothers is aroused by the glances of love exchanged between the two who

> '. . . could not sit at meals but feel how well
> It soothèd each to be the other by.'

So William Michael Rossetti of the Inland Revenue became a 'young palmer in Love's eye'. In the picture he hands a lemon to mediaeval Mrs Hodgkinson (wife of Millais' half-brother). At the end of the table is Dante Gabriel Rossetti, a sinister guest, straight out of Boccaccio, draining a wineglass. Mr Millais, a stately old Florentine, beardless for the occasion, politely wipes his mouth with a napkin. A Mr Wright, an architect, launches a kick of quattrocentist savagery at a greyhound, while the serving-man, somewhat self-conscious in his tights, is an art student called Plass. In Rossetti's *Girlhood of Mary Virgin*, old Mrs Rossetti is St Anne and Christina, God's Virgin pre-elect. In his *Annunciation* Woolner is the angel. In Hunt's *Rienzi* Rossetti again appears, his hand uplifted, vowing vengeance to all the gods that be. The son of the Tower official, Frederick Stephens, is Millais' Ferdinand wandering in Prospero's isle, vexed by the tricksy spirits, about his feet a profusion of grasses and herbs whose minuteness is sheer wizardry: and Millais' *Christ in the House of His Parents* represents a collaboration of the whole Millais clan.

If you were a Pre-Raphaelite you would, perhaps, notice, as you took a walk, an old hollow tree with gnarled branches and lichenous crusts of bark. You would then see a Huguenot in the hollow who would turn out eventually to be your Academy friend, Arthur Hughes. Or you would sit side by side with a fellow enthusiast in Red Lion Square, convinced you were in the Forest of the Ardennes, slavishly copying its arboreal magnificence from a few dusty, London plane trees. There was no limit to the pains taken to ensure accuracy. At Ewell in Surrey, obliging countrymen shot water rats for Millais and held down sheep for Hunt to copy with the requisite care; and the strawberries in the young aristocrat's hand in Millais' *The Woodman's Daughter* cost five and sixpence at Covent Garden.

Then the movement, said Rossetti, must have its literary expression, and with the same inspired unity they all joined in the creation of an organ called *The Germ*; and just as everyone was to be a painter so now it seemed everyone was to be a poet. Gabriel wrote the prospectus with a most firm and correct insistence on truth to nature and William Michael contributed a sonnet on Pre-Raphaelite aims of a certain obscurity, while the sculptor Woolner bothered Gabriel for hints on metre and rhyme and produced at length the very creditable *My Beautiful Lady*. But this quasi-domestic unity was not to last. The new game with pictures was one at which others could play, being instructed in the rules. The young friends of the PRBs took it up with zest – Arthur Hughes who was to remain a most devoted adherent, Walter Howell Deverell, an enthusiast who died young, Charles, brother of the novelist, Wilkie Collins. Ford Madox Brown, having influenced these young men, was now influenced by them in turn; and became a sort of mainstay and benevolent guardian to them all. The circle began to spread, to impinge on other circles in the interlacing Victorian system. The Brotherhood disintegrated; but the force which it had produced remained as strong as ever, though varying in form.

[1] 'Strange,' said the Duke, when he heard of it. 'No one ever takes me for Mr Jones.'

II

Separation

1 The Dream-woman Appears

A woman came on the scene in 1850 who was profoundly to affect the
fate of Gabriel Rossetti. A beautiful young woman – a girl of eighteen. Her
name was Elizabeth Eleanor Siddal.

She was discovered, quite inevitably, by the group in its search for
models. Young men in their twenties could not eternally paint the
adaptable Mrs Millais senior, the admirable Polidori. In all logic a move-
ment of dreams must have its dream-woman. If Miss Siddal had not
existed it would have been necessary to invent her.

She worked in a milliner's shop in a picturesque court of such shops
called Cranbourne Alley. Young men would pause before its windows,
smitten by the casual glance of a pair of sparkling eyes, the turn of a
shapely arm, tantalisingly perceived through the glass, among the bonnets
and gowns. Strolling thuswise, in appraisal, William Allingham saw her
first.

Allingham, excise officer in Donegal, loved London. Eagerly he came
from far Ballyshannon, to read his Irish poems about fairies to his Pre-
Raphaelite friends, to explore the endless, romantic streets.

He told Walter Deverell about her – lively, ill-fated Deverell, so hand-
some with his straight nose and silky moustache that ladies, passing by,
used hurriedly to go round side streets in order to catch a second glimpse
of him. Deverell wanted a model for Viola in a picture of *Twelfth Night*.
He went, with his mother, to Cranbourne Alley. Mrs Deverell approved
the young woman in the shop as respectable and Walter came raving to the
group of the 'stunner' he had found.

For a brief while the group assimilated her with the same indifferent
enthusiasm as if she had been a sister, an aunt or the wife of a half-brother.
She sat for them all. She was the red-haired Celt in Hunt's *Christians
sheltering from the Persecution of the Druids*. She was Viola disguised as a
page in Deverell's *Twelfth Night* (in which Rossetti posed for the Jester).

She was Ophelia for Millais, lying, 'her clothes spread wide and mermaid-like' in the bath at Gower Street, so that the artist could depict the very nicety of drowning.

Then Rossetti claimed her for his own.

The attraction, in a way, was obvious. It was generally agreed that she was beautiful. 'Beautiful as the reflection of a golden mountain in a crystal lake,' said Ruskin, adding, with his sudden scratch of perception, 'which is what she is to him.' She was tall, for that time, and slender, with small regular features, a stately neck, blue eyes and a mass of reddish, coppery hair. Her complexion was clear, her colour a shade too high and ominously suggesting delicate health. A surviving daguerreotype shows a somewhat drawn and even acid expression which may have been due to physical pain. She was passive. Quietly and still the 'poor wretch' lay in that bath in her embroidered dress, without protest, while the lamp that had been put underneath went out and the water grew icily cold. Inertly she sat for long hours looking into the fire. This passivity helped to bring them together. She trailed slowly towards him, a melancholy doll, set in sluggish motion by the virile, expansive gestures of the warm Latin. His roar of laughter elicited from her a wan smile, his jests provoked a faint answering shade of humour, his ardour the ghost of passion. In the same contrary fashion he loved her because she was so little responsive. No one knew what she was thinking of or if she thought at all. She was that double enigma of Victorian England, a woman of the refined small middle class. She had, of this class, the habit of 'keeping herself to herself' which deepened into an unfathomable reserve on being introduced into a clever and freakish group of artists. Hers was the stoic dignity of those accustomed to scrape the last farthing together in order not to be a day behind with the rent; to economise words lest an unguarded expression should betray the refinement assiduously sought. The discipline of the Kent Road where she lived in prim, clean poverty with her mother and father (an 'optician and cutler' from Sheffield) gave her the inscrutability of a sphinx. It aroused in him a spirit, an inspiration of conjecture. In her mournful beauty, her natural silence, her frigid apathy, she was like a statue to be warmed into life, into which he could project, with that dangerous power of his, thought, emotion and even genius.

2 A Traitor and a Champion

About the same time a storm of wrath burst upon Pre-Raphaelitism. To old John Bull it was unpleasantly reminiscent of the subversive trends that

28

were giving him a political headache. Mrs Millais gazed one morning with incredulous eyes at the newspaper held in a trembling hand which stated Jack's picture to be 'revolting . . . disgusting'. In words that have been used so regularly about every new movement in art as now to have a most familiar ring, the *Athenaeum* condemned the 'eccentricities which have a sort of seduction for minds that are intellectual without belonging to the better orders of intellect'; the 'Art Idol set up with visible deformity as its attributes'; whose aim seemed to be 'to defy the principles of beauty'. *The Times* would give 'no quarter' to a 'morbid infatuation which sacrifices truth, beauty and genuine feeling to mere eccentricity'. Mr Podsnap could not have been more indignant than Charles Dickens in *Household Words*, with his celebrated piece of invective about the *Carpenter's Shop* which he declared to contain 'a kneeling woman so horrible in her ugliness that (supposing it were possible for any human creature to exist for a moment with that dislocated throat) she would stand out from the rest of the company as a monster in the vilest cabaret in France or the lowest gin shop in England'. Macaulay was glad to see Pre-Raphaelitism was spreading, 'because it is by spreading that such affectations perish'. 'That sly Italian,' said Mrs Millais, meaning Rossetti; 'I wish Jack had never met him.' What Gabriel had done to deserve this bitter comment was to give away the secret that was no secret. He told Munro the sculptor what the letters PRB stood for; and Munro told a journalist called Angus Reach who promptly wrote a gossip paragraph about it. It might reasonably be held useless to organise such a society if its purpose was not to be revealed; but Rossetti had certainly given it away before any effort could be made (if it ever would have been made) to present its objects in a favourable light; and therefore might be held responsible indirectly for the anger of the public and press. But his treachery, his gay irresponsible treachery, went farther than this. He stole a march. He got in first with *The Girlhood of Mary Virgin*, before the others were ready. He did not stand shoulder to shoulder with them at the Academy but went off on his own to some gallery or other near Hyde Park. He exhibited the *Annunciation* there also; and then, when the stones were hurled and the arrows began to whistle round Pre-Raphaelite heads, he ducked down out of sight and exhibited no more, being content with the prestige of mystery thus effectively created; while like true Britons Hunt and Millais stuck to their guns and valiantly fired off round after round in the face of continued abuse. This may be considered as the beginning of the estrangement, though in true Pre-Raphaelite fashion there are several preceding and

subsequent beginnings. Hunt was slow to take offence. Once his mind was made up he did not easily change; and he had taken a great liking to Rossetti – the stern fondness of the Puritan for the erring. To him Gabriel was still the spoilt child, to be indulged and reproved at the same time. He was saddened by his naughtiness but willing to make excuses; and he accepted the sneers and the scoffs as the unavoidable accompaniment of martyrdom. But Millais could not condone so easily the un-English and unsporting behaviour of their Brother. There was no sympathy between them. He called Rossetti 'a queer fellow, impossible as a boon companion'; just as Rossetti, once, with a monstrous paradox, called him 'The Prince of Sneaks'. The treachery rankled in Millais' mind, and he was influenced by his parents' uncompromising hostility to the 'queer fellow'. Moreover, he, Millais, was in a delicate position as regards the Academy of which he had been the hope and pride. The PRB pictures were hung, it is true, but the Academy did not like them, was becoming alarmed and hostile at the sensation these young upstarts were causing. It had given its prodigy rope: leave to sow his wild oats; but it seemed he was going altogether too far. Millais wondered to himself if he had not made a great mistake in getting mixed up with an affair so discreditable in public esteem, so fraught with prejudice to his ambition.

Then an eagle scream was heard, a mighty talon hovered over the correspondence columns of *The Times*. It was Ruskin to the rescue. The Pre-Raphaelites had found a champion.

Coventry Patmore was the instigator. That poet of domesticity and librarian in the British Museum had come to know the group through Woolner, who had got to know him in order to get to know the innumerable people that he knew. Patmore asked Ruskin if he could not do something about the persecution that was going on. Ruskin was doubtful at first; warmed to it; being in, made it an eloquent piece of defensive aggression. Than Millais' *Mariana* and *Dove Returning to the Ark* and Hunt's *Valentine* 'there had been nothing in art so earnest or so complete since the days of Albert Dürer'. This was a new, a magnificent red herring across the trail, seeing that Dürer was an acquaintance and admirer of this mysterious bugbear Raphael and paid him the compliment of imitating his style; but grandly Ruskin went on to perceive 'the foundations of a school of art nobler than the world had seen for three hundred years'.

The 'graduate of Oxford', in 1851, was thirty-two years of age, tall, side-whiskered, with light, crystalline blue eyes, a lip slightly deformed by an early accident. He was in process of completing his encyclopaedic

work *Modern Painters*, a defence of Turner so long sustained that by degrees everything had got into it; the Old Masters so that they could be downed and derided; sticks, rocks, alps, lakes, trees, geological strata and formations of cloud, the universe united in testimony to Turner's cosmic truth. Every stop in the organ of his prose was pulled in turn, though throughout boomed the mighty and fallacious note of 'Truth to Nature'.

He was a puzzling individual. He puzzled his contemporaries as he has puzzled many since. He inherited an oddly assorted mixture of the temperaments which had alternated in his forebears. The extravagance of his spendthrift grandfather Ruskin; the shrewdness of his father who made a fortune out of the sherry firm of Ruskin, Telford & Domecq; the rebelliousness of his grandmother Cox who made a runaway match at six-teen; the bigot, convenanting strain in his mother: all these voices spoke through him with a Babel-like variety of opinion: the priggish voice of an only, sternly-pampered son, the thundering intolerant voice of a Calvinist minister, the sane sceptic voice of a man of affairs, the gleeful puckish voice of a crazy imp.

He was full of 'if onlys'. If only Mr Maclise would copy a *single* lock by Correggio – just one – he would find that a girl's hair 'verily does not look like a piece of wood carved into scrolls and French-polished after-wards'. If only Mr Millais would paint Mariana at work in an unmoated grange instead of idle in a moated one. If only Mr Rossetti would not make landscape look like something out of a Noah's Ark. If only the designers of railway trains would shape them into dragons as designers would if there had been railway trains in the Middle Ages. In fact you never knew what he was going to say. You would read in one place that Architecture was Detail and not Mass, but you had only to turn to another volume in order to discover that Architecture was Mass and not Detail. In a letter from him you would receive a page of small, neat, regular handwriting; and then a postscript would suddenly break out and stream wildly round the mar-gin, and finish upside down at the head of the page, containing some freak-ish sentiment wildly at variance with the rest. Who but Ruskin could ask, as he was to ask Burne-Jones, for the following illustrations to a serious and practical work on political economy . . . 'I want a Ceres for it and a Proserpine and a Plutus and a Pluto and a Circe and an Helen and a Tisiphone and an Ἀνάγχη and a Prudentia and a Sapientia and a Tem-perantia and a Fortitudo and a JUSTITIA and a CHARITAS and a FIDES and a Charybdis and a Scylla and a Leucothea and a Portia and a Miranda and an Ἀρητή and an Ophelia and a Lady Poverty and ever so many people

more . . . I'll cut up my text into little bits and put it all about them, so that people must swallow all at once and it will do them so much good.'

He was, of course, Pre-Raphaelite to the bone. It was not merely that, in common with Chartism, Photography, the Middle Ages, the Anglo-Catholic Revival, Dürer and Ford Madox Brown he had a claim to be one of its founders. He was the thing, incarnate, fulfilling perfectly the true formula. He was a reformer; a dreamer; a mixer of past and present, real and unreal; a bundle of contradictions with somewhere a coherent scheme of life redhot in the gaseous nebula of his ideas. From Carlyle he had learned to take the economy of the Middle Ages seriously. From Words-worth he had imbibed nature-worship. From Pugin an interest in things Gothic. In his writings he had passed on his thoughts to the Pre-Raphaelites before he personally knew them.

But Pre-Raphaelites and artists in general did not care about him. He made Woolner boil with rage. Anyone who could praise that foreign fake Marochetti, as he did, evidently knew nothing about sculpture. Ford Madox Brown, smoking a pipe in his shirt-sleeves, would listen con-temptuously to 'divers nonsense about art' uttered 'hurriedly in shrill flippant tones'.

'Mr Brown, will you tell me why you chose such a very ugly subject for your last picture?'

'Because it lay out of a back window,' answered Brown.

Bell Scott couldn't get on with him at all: 'There are natures sym-pathetic to each other and there are others antipathetic,' he grimly re-marked on their first meeting. Ruskin affected surprise that Scott should have written poems: criticised Scott's brother David. Scott, in retaliation, told a funny story about the vulgar way in which Ruskin's divinity, Turner, spoke of 'introdoocin' a bit of sentiment' into a picture: at which Rossetti, who was there, was greatly amused, and 'the poisonous expression of (Ruskin's) face was a study'.

But Hunt and Millais were grateful for the letters on Pre-Raphaelitism, which became a pamphlet. It was true the pamphlet was mostly about Turner: the dangers of everyone wanting to be a gentleman; about J. F. Lewis, Samuel Prout and Mulready who were not personally concerned: and contained a stern warning against 'mediaevalism and romanism', that is, the period and the religion of the art the Pre-Raphaelites had elected to follow. The effect, however, was achieved – the minatory scream had silenced the public clamour – Hunt and Millais wrote to thank him, and

one day a carriage drew up at 83 Gower Street and the Oxford Graduate, with his wife on his arm, went in to pay his respects to Millais.

They both liked Millais. Euphemia Chalmers Ruskin liked him as well as her husband, who decided he was the great artist of the band. Her maiden name was Gray. She was a distant cousin of Ruskin's, one of a number of daughters at the Scots house of Bowerswell. His parents had decided he ought to marry and that this was a suitable match. He had consented dutifully, and quite indifferently, being otherwise occupied with Swiss waterfalls and Turner watercolours. Wistfully at the back of his mind was the memory of a romance that had gone wrong – a vintage romance with a faint bouquet of Amontillado – a past love for Adèle Domecq of the sherry firm, a strand of whose hair he kept.

Millais went with them to Camberwell for a week. The great art critic took him to a phrenologist who felt his bumps and arrived, disconcertingly, at the conclusion that he had business organs far beyond the average. The intimacy ripened and in 1853 they made a trip to Scotland which was to bring a new twist into the Pre-Raphaelite course.

3 An Impeccable Elopement

'It's a very saaft dee,' announced every morning, for five weeks, the land-lady at the New Trossachs Hotel, Callander. The rain was continuous. Only at rare intervals did the sun break through the wet, rolling mist, causing a myriad sparkles on the dripping birch leaves and changing the mountains from David Cox to Pre-Raphaelite. Excursions were a hurried, drenched affair and there was little to do indoors. The party comprised Mr and Mrs Ruskin, his Oxford friend the great Dr Acland, Millais and his brother William. They climbed Ben Ledi, did a little fishing, played a lot of battledore and shuttlecock at the hotel; and Millais and Euphemia fell in love.

It was, really, very natural. The Oxford Graduate was cold. He had little taste for marriage and little interest in his wife. He preferred things – dreary inanimate objects, pieces of minerals and botanical specimens. It was a sort of cruelty, unconscious, no doubt, but in effect worse than a premeditated insult or a fit of brutality. Then there had come on the scene this young Apollo, tall, slim, handsome, with a simple, charming, generous nature and the most wonderful abilities. And he, after a life till then exclusively occupied by oil paint and parental devotion, found himself at close quarters and under unusual circumstances with a young attractive

woman. And there was the rain. Boredom smoothed the path of romance and like the blooms of spring their love grew with the showers.

His sketch-book was an avowal. She was on every page, sitting by his side in the boat on Loch Achray, standing by him with her battledore, offering him 'wayside refreshment', even clipping his curly locks ('The Countess' as barber, he inscribed the drawing). In his work at that time she was always triumphantly present – as Virtue in *Virtue and Vice*, as the lassie handing the pardon to the turnkey in *The Order of Release*.

On her part, no doubt, with feminine realism she saw she had made a mistake: that life as an additional specimen among the fluorine spar and the views of Lucerne would not be tolerable: that with Millais she could make no mistake. It would be wrong to say she threw herself at his head; at the same time she was not unaware of the impression made by her learning in Scottish history and her little tales of the doughty deeds of Highland Chivalry; of the delightful figure she cut with palette in hand and brush held with a dainty awkwardness.

It was an impeccable elopement – if the word can be used. Euphemia went home to her parents and instituted proceedings for annulment of the marriage. Millais left unfinished his portrait of Ruskin standing on the Finlass stepping-stones and went back to town – to await the day when he could rightfully and lawfully claim his beloved; but the affair had in the public mind a 'running off', a dashing, Gretna Green flavour; and there was much tittering in the drawing-rooms and animated discussion in and out of the windows of cabs. Joyful in the flouting of its sex gestapo, society made the most of it; though feeling was on the side of the lovers. 'Good for Everett' said Thackeray. Ruskin incurred some odium as one who had neglected a pretty wife; but each of the main parties behaved almost absurdly well. Ruskin showed a gentlemanly indifference to the grounds of annulment, plainly declared to be 'impotence', and even offered to go on with the portrait sittings 'for the sake of art': continuing afterwards to praise and blame Millais' pictures, with a capricious fury in both respects, that was quite untinged with jealousy. He was rather relieved on the whole; and once the unpleasantness was over no one appeared any the worse. For Jack and Euphemia the decorous frolic – an unconventionality regulated by a strict regard for the conventions – was the prelude to forty-one years of married life in which the most censorious could find no flaw. Her matrimonial difficulties at an end, Euphemia turned to the efficient management of a home. She had the Scottish canni-

ness and she did it well: seeing callers, attending to matters of business, arranging sittings and entertainments, identifying herself with her husband's interests. Under her skilful guidance Millais began to pull away from the perilous shoals round the islands of dream towards the harbour of success.

Millais' love affair naturally caused a shift of Ruskin's allegiance. Disappointed in, or at any rate debarred from the company of Millais, he lavished his patronage on Rossetti instead. It was a wedge between Millais and Hunt and their uncertain partner; and still another declension in the Brotherhood must now also be noticed.

4 A Trip to Australia

It was a grey day in July 1852 at Gravesend. On the shore there was a crowd and the stir of departure. The sailing-ship *Windsor*, with a load of emigrants, was leaving for Australia.

Emigration was in the air. Hope in England of solving the industrial problem was at low ebb. Those hungry forties had left depression in their wake. The attempts at reform had produced no immediate result. The Great Exhibition of 1851 had not yet had time to exert its beneficent effect. The only recourse for large numbers of the twenty-seven million inhabitants of the tight little island (amiably described by Carlyle as 'mostly fools') seemed to be to leave it for ever. The Government itself advocated the plan; and there was an inducement to go. GOLD. In Australia there were enormous fortunes to be made. Ships were daily being outfitted, their sailings advertised. Special trains were run for the engineers, mechanics, farmers, artisans, not to speak of the writers and artists, who were bound for the land of promise. Among the crowd at Gravesend this grey day was a cluster of Pre-Raphaelites. There was Dante Gabriel Rossetti in a state of gleeful excitement, William Michael Rossetti and Holman Hunt. Ford Madox Brown, the 'dear old fellow', by now established as godfather to the movement, had come too. They were seeing off Woolner, who was bound for fortune in the Antipodes.

Woolner, like many another, was angry with civilisation. He had, as many another, the habit of closely associating his personal condition with the general state of society. His want of money clearly indicated a regrettable greed for filthy lucre in the world at large. He had had only one small commission in years and therefore civilisation was blind, crumbling, rotten. There were clear indications that of all the arts sculpture was in

the most parlous state; for his *Eleanor sucking the Poison from Prince Edward's Wound* had not fetched a single bid at the Academy: his life-size *Death of Boadicea* exhibited at the Colosseum in Regent's Park had been given away to save the trouble of breaking it up; and then there had been the affair of the Wordsworth monument for Westminster Abbey.

He had cultivated Wordsworth, as indeed a Pre-Raphaelite might be expected to cultivate the first great nature-worshipper. In 1851 he designed a medallion of the great poet for Grasmere Church and asked Tennyson himself (an acquaintance through Patmore) to suggest an epitaph. Tennyson, it is true, had been a little disappointing. He had proposed

To the Memory
of
WILLIAM WORDSWORTH
The Great Poet.

On second thoughts, Tennyson considered that even this (though noble in its simplicity) was too much, with masterly concision would eliminate further; proposed, in fact, nothing whatever. Early in 1852 Woolner had made his design for the monument: the poet seated, with a relief of Peter Bell and the Ass on the pedestal; on either side the Father admonishing his son and the Mother guiding her daughter to observe the beauties of Nature. And this design, admitted on all hands to be admirable, was set aside by the adjudicators in favour of a nonentity called Thrupp.

So in Woolner stirred the emigrant spirit of an Irish ancestor, pretty Mary Castlereagh, who had mated with the descendant of a Saxon *Ulnod*. His stick, which he called the *Antipleb*, for he was against people as well as government, was vigorously and rhetorically wielded; and he became an apostle of the wander-spirit; not only declaring his own intentions but trying to persuade the others to join him.

The very essence of their principles being an escape from present and prosaic reality, the Pre-Raphaelites were half persuaded. Hunt, resisting the invitation to go to Australia, was the more urged on with certain plans of his own to repair to the East. Ford Madox Brown had some confused but vaguely splendid thoughts of trying India; and Tennyson, even the mighty bard, were it not for 'Mrs T.', said *he* would go.

Woolner went to see him at Twickenham. There the 'royal Alfred', slow, heavy-shouldered, as yet clean-shaven, gravely pondered the matter. If the journey in prospect had been short, the object small, he might have shown concern. It was the small things he could not cope with. He had one day to visit William Michael Rossetti a few hundred yards away, overshot the mark by several miles and never found him at all. He entered the room once in the utmost distress saying, 'My watch has stopped'. Someone present, with ready wit, had stepped to his side, taken the key from his chain, wound the watch and handed it back to him, thus relieving a situation of unbearable tension and perplexity. The mighty mind could not grapple with such matters. But to roam to the other side of the earth, to find there an Aladdin's cave of wealth, by some means too trivial to deserve consideration: this was poetic, an idea at once comprehensible in its breadth and majesty. It is interesting that he never questioned the possibility of the wealth's not being there. His only anxiety was that Woolner should contain himself in its collection.

'Will you be content with twenty thousand pounds?' he asked, adding with philosophical resignation, 'But men are never contented about money, so I need not ask.'

Carlyle was not quite so encouraging – though Jane Welsh Carlyle, in an obsolete low-cut evening frock against which her thin arms seemed thinner than usual, listened with interest and approval to the schemes of the voluble youth. The sage discerned 'some savour of the mammon of unrighteousness' in the plan, but as he was good enough to explain to Bell Scott, whom Woolner took with him to No. 5 Cheyne Walk, in the voice that was like the rattling of pebbles and boulders in a stream in spate, 'Empty as other folk's kettles are, artists' kettles are emptier and good for nothing but tying to the tails of mad dogs'. The most crazy phenomena of this crazy world could not surprise him, least of all artists, of whom there was nothing to be made 'nor of their work either'.

Gabriel, with no intention of going anywhere (he never moved outside London if he could help it), was delighted with the determination of his 'Woolnerius'. He joked about his becoming 'a gold beetle' and building images in rivalry of Nebuchadnezzar. He had his comments to make on the bulky prospector's equipment, the corduroys, sou'westers, jerseys, firearms and the belts ringed with pouches to contain the golden nuggets. He promised himself much entertainment from the log Woolner was to write. While the *Windsor* strained at her moorings Ford Madox Brown cast a painter's eye on the scene: on the sculptor muffled up, with a sullen

dogged look, a little downcast now that the time of parting was near; the woman standing close by with sad eyes; the fluttering bonnet-strings, the flapping cordage, the barrier of the ship's rail on which they leaned; the excitement and the hint of disorder in the mixed crowd of English and Irish behind, who had already been drinking to success; and as the vessel slowly receded with its Pre-Raphaelite on board there was left on Brown's retina the image of his little masterpiece – *The Last of England*.

5 A 'Crib' in Dreamland

In the small hours, while Woolner was traversing empty parklands under a blazing sun, amid gum-trees oozing great drops of manna, where the white cockatoos flew with shrill cries, Gabriel sat writing him a letter, in altogether a different atmosphere.

He was in his new rooms at No. 14 Chatham Place, Blackfriars. It was dark and eerily quiet.

Outside, the feeble light of a gas lamp was repeated over and over in oily flickers that revealed a sort of horrible life in the river like a sluggishly coiling snake; creating at the same time an impenetrable depth. The silhouette of St Paul's, the rigging and masts of ships vaguely defined the scene. The black windows of the ghostly buildings on the bank glared and goggled with a skeleton idiocy. The barges bowed and nodded with a faint clank and plash, bumping against the festering timber of the piles, while the stream, its swift current attacking and piercing the heavy stagnance of its consistency, sucked and gurgled round the wharves. With the sickly mist that overhung the void there rose up a foul smell, that of the outpouring refuse of the capital, wafted in faint, nauseating puffs into the room.

Gabriel was describing the place to his friend.

'You cannot imagine what delightful rooms these are for a party, regularly built out into the river, and with windows on all sides – also a large balcony over the water, large enough to sit there with a model and paint – a feat which I actually accomplished the other day for several hours in the teeth of the elements.'

There was nowhere in London to live so romantic or so unhealthy as this double-faced dreamland. When the wind blew freshly, the tide was up, the sun was crisply shining, how wondrous it was indeed to be in the city's heart, to see the great artery pulse, the gilded dome glitter and the cheery sails belly; to sense, from one's look-out, like the leisured,

anonymous lord of a toiling host, the vast encirclement of human activity. But when the fog came down, the putrid mudbanks were left bare, and the threat of cholera and typhoid insinuated itself through every aperture, then indeed Chatham Place was weirdly transformed with a circle of Hell.

The choice had been made after a number of brisk and sudden moves. From Cleveland Street he had whisked away without reason or preparation. Hunt found to his surprise one day that his 'pupil' had flown, leaving as an only reminder a series of boisterous callers who banged on the door and enquired for him at all hours. Rossetti had gone to Newman Street 'over a hop shop', where the sounds of music and dancing came up from below. He had been in Red Lion Square with Walter Deverell, and it is typical of the remarkable man that he should write a single letter to Woolner at this time, early in 1853, from three different addresses – from Blackfriars, where it was begun; from the Hermitage, Highgate, where he dashed to see his Quaker friends, the Howitts, who permitted him to use a garden studio; from Arlington Street where he had been with his family. But in this deadly, fascinating 'crib', as he called it, 14 Chatham Place, he stayed nine years – for him, as for his great namesake Dante Alighieri, always a fatal and mystic number.

'I have been getting more domestic of late', he wrote in his free, stylish hand. It seems an odd kind of domestication. He was flitting restlessly from house to house. He had selected a 'crib' that was practically unfit to live in. Yet certainly now he had something of a permanent address, and here Miss Siddal was frequently to be found and his attachment for her grew apace.

Miss Siddal had now become Miss Sid, 'The Sid', was proceeding by stages to Lizzie, Liz and to the affectionate familiarity of 'Guggums', an invention which required the masculine counterpart of 'Gug'. It is necessary to consider their relations over a period, for only in this way can they be understood.

It is now 1853. They were married in 1860. She died in 1862. Theirs was 'a long engagement'.

The years between 1853 and 1862 were crowded years and yet nothing happened. There was feverish movement in them and yet a sort of fixity. These people lived, in fact, a dream, in a stagnant condition of anxiety, apprehension and exaltation. It is clear that Rossetti was, in the normal phrase, in love with Miss Siddal. It seems also that she was 'in love with' him; but their relations remained intangible, indefinite. Their love took

39

on a mysterious, idealistic, unearthly character. It was a sort of mediaeval love, as that was described in mediaeval books: a sorrowful, remote, unworldly, unphysical, mystical passion.

Like the Blessed Damozel, her hair riper than the ripe corn, Miss Siddal leaned from the bar of Heaven over Blackfriars. She sat passively for Gabriel, who made drawing after drawing after drawing of her – 'wonderful and lovely Guggums', said Madox Brown, 'each one a fresh charm, each one stamped with immortality'. The place, the poisonous place with its moments of exquisite and fictitious beauty and its vile and lulling miasma made her ill. It made them both ill. It used to give him an ulcerated throat. But she was already and continuously ill and it made her the worse. She was consumptive, though not seriously or vitally affected. At least such was the report of Dr Acland.

Ruskin got Acland to see her. Ruskin was as much interested in Rossetti's 'pupil' as in Rossetti himself. Through the graduate's oddity a real kindness and gentle concern struggled for expression. She might like to go to the Ruskin home at Denmark Hill and 'look at a missal or two' he thought. He offered help in money with a whimsical delicacy; just, he said, as he would try to save a beautiful tree from being cut down, or a bit of a Gothic cathedral. 'Be so good as to consider yourself as a piece of wood or Gothic for a few months.' He would send her books 'which you know are to be chosen from the most *un*interesting I can find'. With his help she went submissively to Nice. She did not care about it much, in which Ruskin agreed with her. 'I *hate* Nice myself as much as I can hate any place within sight of any sort of hill.' He recommended her not to go north into Dauphiné – 'a diabolical country, all pebbles and thunder'.

The constant illness set her apart as if already in another world. 'Everyone reveres and adores Lizzie', said Gabriel. It was the reverent fondness, the hushed respectful affection felt for those preoccupied without complaint by the lone combat of the body. The women liked her, beautiful as she was yet remote from their affairs; Brown's hardworking Emma, little Georgie Macdonald, the future Lady Burne-Jones; even stern old Mrs Ruskin was moved to become confidential and kind. Gabriel, in his own way, felt the necessity most of projecting a thought, a symbol, an aesthetic explanation into this remoteness of being. The artist in him was a force that could contemplate dispassionately, or even as a victim, the person closest to him. It sprang at her like a metaphysical beast of prey and fastened unrelenting fangs in the white column of her throat. She was to be Beatrice, beloved of the poet, Dante Alighieri, as well as Lizzie Siddal.

And he, of course, was Dante, the great Florentine, the author of the *Divine Comedy*.

The Rossettis carried Dante with them like a totem. He was to them what Shakespeare is to the Englishman, an ancestral god, an inheritance, a national glory. They absorbed him as a seventeenth-century Puritan absorbed the Bible, until he permeated their minds. Rossetti, when still in his teens, had translated the *Vita Nuova* or New Life, and the New Life written by the mediaeval poet was initiated in his affection. He and his Pre-Raphaelite brethren had gone back to the fourteenth century for inspiration in art. It seemed only natural to go back to that century for inspiration in love. The escape from reality was to be made not only through painting pictures but in the actual conduct of life.

The *Vita Nuova*, a sequence of sonnets, with an autobiographical thread of comment, teemed with doubtfulness as to the relation between fact and fancy, body and soul. Who and what was the heroine, Beatrice? No one quite knew – or whether she existed at all. Old Gabriele thought she was a symbolic personage and wrote a learned work (*La Beatrice di Dante*; 1842) to prove it, thus giving rise to much learned dispute. Dante Gabriel (it is no doubt of some significance that he now changed round the order of his Christian names) held that she was a real woman. When young, Dante Alighieri saw this ideal person, 'the glorious lady of my mind who is called Beatrice by those who know not how she is called', as he defines in an unfathomable phrase. Maybe she was Love itself, maybe the creation of the poet's emotion. At the sight of her Dante Alighieri was filled with longing and a woeful sense of the unattainable. She died and his grief continued, yet also a feeling that he was inseparably connected with her, that she was still present, while removed to a celestial sphere. From the enigmatic verse emerges a conception of Love, in the chastened mediaeval spirit, as grief, a mystery, something that is lost and sought and never found and never lost in a circle of predestined affinities.

Gabriel sloughed off the austere 'Early Christian' mood in which he had painted his first Pre-Raphaelite pictures. He referred disparagingly to the purity of these works. 'I have got rid of my white picture to an Irish maniac', he said, referring to *The Annunciation*, sold to Francis McCracken, the ship-broker of Belfast (otherwise known as *McCrack* and the *Kraken*). His letters had frequent references to his interest in the *Vita Nuova* and his efforts to represent the main influences of Dante's youth, Art, Friendship, Love. His paintings were all taken from Dante: and his Beatrice was taken from Guggums.

Thus he made a symbolic autobiography out of the middle ages. He and his lady love were each someone else; and she in particular was transposed into someone whose material existence was questionable, who might even be an abstract quality and not a human being at all, Love rather than the beloved, the poet's emotion rather than a cutler's daughter from the Kent Road. It was a stage farther than the Pre-Raphaelite make-believe which so pleasantly converted Mrs Hodgkinson into Isabella. It was, in very fact, their *life*; and it was a psychological nightmare.

She was, or was made, or appeared to be, unattainable. 'Why does he not marry her?' said Madox Brown, who liked and admired her as 'a stunner and no mistake'. Ruskin too approached the matter tactfully, asked Gabriel to tell him 'whether you have any plans or wishes regarding Miss S. which you are prevented from carrying out by want of a certain income'; and at last declared 'it would be best for you to marry, for the sake of giving Miss Siddal complete protection and care and putting an end to the peculiar sadness and want of you hardly know what, that there is in both of you'. The peculiar sadness was not so easily resolved. In observing this interior mental drama one can only proceed by interrogations, to which answers are possible but not certain. Did she want to marry? Was she not aloof in that other world of illusion, the world of physical pain? Was not marriage the petty contract of an existence from whose pleasures and responsibilities she was already freed in carrying a greater and mortal burden? And he? Could you marry Love itself? Was his reluctance a part of that detached and yet devouring artistic curiosity to observe a process conceived in the mind, hanging back to watch with a fearful interest the course of events to an end he instinctively apprehended from the beginning, dreaded and yet fated?

He did add another and morbid complexity to this already complex and morbid relation. He breathed genius into her. Under his influence she began to paint little pictures and write little poems. 'Thinner and more deathlike and more beautiful and more ragged than ever', Brown saw her, but 'a real artist, a woman without parallel for many a long year'. In the Kent Road she had shown an early taste for poetry. Tennyson had come to her on a discarded piece of print wrapped round a pound of butter, so the story went. Young women at that time did imitate the occupations of their artist admirers. They bedabbled themselves with pigment in the charming and pathetic belief that this would endear them the more to the men. They did not, however, become, or expect to become, geniuses. But in Lizzie there seemed to develop a creative spark that was not at first

there. Rossetti himself, almost tyrannically, insisted on her genius. In fact he was not only like a Pygmalion, warming into life the cold marble of a narrow existence, but a Svengali, eliciting, with mesmeric passes, an artistic performance from the animated statue. This genius was embryonic but real. Her verses were as simple and as moving as ancient ballads: her drawings were as genuine in their mediaeval spirit as much more highly finished and competent works of Pre-Raphaelite art. And this in turn begot in the strange pair that perverse struggle between the sexes – the struggle of artistic expression. He praised and encouraged the arts by which she strove unconsciously to emulate him, holding in his masterful grip a victim which, beaten, dominated and at the same time urged on to fight, valiantly, though wearily, fought back.

'Mental power long pent up and lately overtasked.' That was Dr Acland's own diagnosis of Lizzie Siddal's condition in 1855. Georgiana Burne-Jones could not understand how she suffered so much without developing any specific disease and she thought this must be the explanation: that Lizzie's powers had unfolded too quickly before the unrestricted blaze of his genius. She wished Lizzie could have had a rest-cure. But was there any escape from her fate in that? She did indeed float vaguely to Hastings, to Brighton and to Bath as well as to Nice, in search precisely of this relief, but her letter from Nice (one of the remaining scraps of her writing) after a forcedly humorous account of passport difficulties closed with this forlorn cry: 'First class, one can get to the end of the world; but one can never be let alone or left at rest.'

There was another phase of the *Vita Nuova* which shot the subtle pattern with a coarser thread. Dante Alighieri (in the sonnets) was turned aside for a while from his contemplative devotion by a certain *Donna della Finestra*, a lady at a window, who was ambiguous too. She might be anything, simply another woman or Philosophy even, personified. Dante Gabriel, in this respect also, followed the mystic poem; though for him the donna was no high-born Florentine at her casement but a lively Cockney encountered perhaps in the Strand, cracking nuts with her teeth and throwing the shells about; and the face was not that of serene and gracious Philosophy but of 'Jumbo', 'The Elephant', as he called her, the lady described on her professional model's card as Fanny Cornforth, whose real name was Sarah Cox, who later became Mrs Hughes and eventually Mrs Schott. Fanny, whom Rossetti got to know and first used as a model probably about 1854, was no passing fancy, though for a long time she makes no direct appearance in the story of his life. A brief

unfavourable comment of one of Rossetti's friends from time to time dimly reveals her. Nevertheless, she was in the background – an influence, an 'evil influence' as many thought, one of the causes of tension in the drama he had so artistically devised – an opposite to Lizzie, defining by contrast the spirituality of his passion for the latter. In Fanny, model and mistress, he found the satisfaction of a purely physical and material liking. Her nickname bore reference to her size. Her 'Finestra' was possibly located for a time in Wapping, though whether this was an actual address or merely symbolical of her far distance from the superior land of dreams is also doubtful. In some not very precise fashion Rossetti divided his time between two mistresses – the exalted mediaeval mistress on a metaphysical plane and the mistress, in a commonplace sense, of vulgar good looks and easy affections. He was, as it were, faithfully unfaithful to them poth: loyal, curiously, to the end, to Lizzie until the end of her life and to Fanny until the end of his own.

Exactly how far the remote Lizzie-Beatrice was affected by this poetically-sanctioned diversion of Gabriel-Alighieri cannot be known. An extra pang, it may be, in the twisted ligaments of her soul: a dart from which even her remoteness was not immune: a double pain, as the whole strange situation resolved in endless doubles, of jealousy added to phthisis.

But in this way, between them, Dante Gabriel Rossetti and Elizabeth Eleanor Siddal created the mysterious agony of Pre-Raphaelite love with its droop and heavy-lidded frustration, its unspeakable and unexplained sadness: 'which time' like the Ophelia for whom she had posed, the unfortunate object of this mediaeval enthusiasm chanted snatches of old tunes, 'Like one incapable of her own distress' – tunes with a little sob and moan that were old in spirit but about herself:

> 'Sweet, never weep for what cannot be
> For this God has not given:
> If the merest dream of love were true
> Then sweet we should be in heaven.'

6 The Brotherhood Vanishes

By 1854 the Pre-Raphaelite Brotherhood was at an end, which, it will presently be seen, is as good as to say it was about to begin. Christina Rossetti summed up in a sonnet concisely and with humour:

The P.R.B. is in its decadence
For Woolner in Australia cooks his chops,
And Hunt is yearning for the land of Cheops.
D. G. Rossetti shuns the vulgar optic:
While William M. Rossetti merely lops
 His B's in English disesteemed as coptic.

Calm Stephens in the twilight smokes his pipe
But long the dawning of his public day.
And he at last, the champion Great Millais,
Attaining Academic opulence,
Winds up his signature with A.R.A.

So rivers merge in the perpetual sea;
So luscious fruit must fall when over-ripe:
And so the consummated P.R.B.

The hope of making anyone and everyone into an artist dwindled away. William Michael, it was soon clear, was not to be a painter. 'It's only a sort of club,' he explained apologetically to Bell Scott at the beginning; 'it is only friendly . . . I, the youngest of the set, but no artist, am to be secretary.' When it ceased to be either friendly or a club he continued the secretarial function, never quite getting over his surprise at the importance of it. He became art critic on *The Spectator*, wrote modest little eulogies on Pre-Raphaelite works and was regarded with disfavour by Hunt and Millais as, for family reasons, a biased historian.

Calm Stephens remained in the twilight. He also became an art critic, on the *Athenaeum*. The sleepy Collinson painted one picture, *Saint Elizabeth of Hungary* from Kingsley's *Saint's Tragedy*. The young queen and saint was shown praying in church, the latter being copied with truth to nature from a Revivalist building in London, with brand-new Minton tiles. Then he retired into a Jesuit college where they set him to clean the boots 'as a lesson in humility and obedience'. He left it, married the sister of an R.A. after being refused by Christina Rossetti, hovered indecisively between the Anglican and Catholic faiths, painted a little more, and disappeared from public view. Of the unofficial P.R.B.s, Walter Deverell, suddenly overwhelmed with the difficulties of keeping a family after the death of his father and mother, died early in 1854: Millais, with his real kindness of heart, being constantly with him at the last and arranging with Hunt to buy one of his pictures, unknown to Deverell, through a third party. Charles Collins, suffering from a failure of the visual imagination,

drifted off into letters. One of the most poignant of early Pre-Raphaelite moments was when he had worked with infinite pains for many weeks on a background – an old shed with broken roof and sides through which sunlight streamed, with a glimpse of greenery outside – then simply did not know what it could be the background for. A French peasant, with his outcast and starving family, taking refuge in a ruined hut, tended by some holy man? Collins thought of that, but the effort was too much and he gave up in despair. When he died this unfinished canvas, a melancholy symbol of hope, was lying on his bed.

Only the gentle Arthur Hughes quietly (and very beautifully) worked on in the approved fashion. The stage was swiftly cleared, and when Gabriel heard of Millais' election as A.R.A. he remarked, 'So now the whole Round Table is dissolved'. The three great P.R.B.s were then twenty-six, twenty-five and twenty-four years of age. Millais, in these years, was like a man waking from a dream: with uneasy starts and shivers, and relapses into dreaming. He had worked like a titan; and there had been a hectic brilliance in his work, a strangeness which came, not from his own nature, but from the force evolved by the meeting of the Brethren; though there was in him, at the same time, a consistent and unchanging element with which this had little to do. Alongside the Pre-Raphaelite in Millais there was the Academy child still, with his frilled collar, and ingenuous delight in winning a prize: unswerving from the idea that all the talk of poetry and of the Middle Ages, all the intellectual privateering and swashbuckling was a sort of machinery brought to bear on the institution he admired and feared, to which he belonged almost from birth. The Academy, watching with mistrust the erratic performance, decided, similarly, to win him back; incidentally to break a prospect of unwelcome competition from a rival body by depriving it of its most able supporter. Thus he was strongly favoured as a candidate for Associateship. When the results were due in November 1853, he was in a fever. He and his brother, with Wilkie and Charles Collins, went off to Hendon for distraction. In a sandy lane where they stood aside to let a large three-horse wagon pass, Millais lost a jewelled pin. 'Now, Wilkie,' he said, 'this is an ominous sign I shall not get in.' They all searched desperately in the furrows left by the wagon – and at last, 'There it is, by Jove', shouted Millais, confident that it was a portent of success. They went straight back to the Academy, were greeted with an arch little joke by Charles Landseer: 'Well, Millais, you are in this time *in earnest*' (his name having been entered as John Ernest instead of John Everett).

Neither Hunt nor Rossetti was capable of feeling this excitement over an academic honour. Though it had provided the original basis of Pre-Raphaelite argument, the Academy was no longer much in their thoughts. To Millais it was important. He was prepared to make intellectual or spiritual sacrifices for it. His inconstancy, in this respect, that is to the intellectual or spiritual ideal, was as clearly marked as his loyalty to a person he liked or his belief in the world's opinion. He found (at some time in these still early days) Bell Scott examining, in his studio, an engraving by Agostino Lauro, in which every detail was exact and microscopic; and again the voice of the child spoke candidly and clearly, disclaiming the theories which its intellectual elders had tried to instil. 'That's P.R.B. enough, is it not? We haven't come up to that yet. But I, for one, won't try: it's all nonsense; of course nature's nature and art's art, isn't it? One could not live long doing that', and thus he replaced a deceptive confusion by a deceptive clarity.

Millais had a foreknowledge of greatness, a calm confidence in his powers, instilled at home from his earliest years, unshakable by the self-questioning or the nice distinction of more subtle or more humble friends. He was not much in Bell Scott's orbit but they met at Alexander Munro's in 1853, just before Millais set off on the fated holiday in Scotland with Ruskin and his wife. Scott and he were both sitting for portrait medallions, and as Millais mounted the sitter's chair Scott commented on the red mark on Millais' left eyelid. Millais said he had had it all his life, and, laughingly:

'There are spots on the sun, you know.'

Scott, the critical and carping 'Duns Scotus' as Rossetti called him, scenting pomposity and pretension, looked at him narrowly. No, it did not seem to be conceit, just high spirits and 'amusing chaff': yet, as plainly as could be, a revelation of Millais' certainty that he was, indeed, a Sun.

Holman Hunt, meanwhile, was dissatisfied. At some point, the movement in which he believed seemed to have taken the wrong turning. He could understand Millais' attachment to the Academy though he did not share it himself; but the curious flavour that was creeping into Rossetti's work and his obscure, erratic life, seemed to him a departure from the ideal. There must be a means of affirming the ideal beyond all question; of causing it to shine out resplendent above the mists, colourful as they might be, which hung round it; of making it, as *he* had intended, an instrument of reform. How?

To be a reformer with the help of small dabs of paint squeezed out

on a piece of wood and brushed on a canvas in certain shapes was by no means easy. He argued to himself that the solution lay in substituting great terms for small: in fact, the greatest that could be imagined. Of truth to nature there must be even more, so much as amounted to a mortification of the flesh. Instead of reforming simply a group of old-fashioned painters there was the world to reform; and the greatest means of reform was religion. Those dabs of paint must be so assembled as to preach purity of life and Christianity itself. Morality and Religion went together. He worked on a moral and a religious picture simul-taneously.

They all arrived at the notion of a picture on the question of morality and the relation of the sexes at the same moment. Millais thought it was the material of an Academy sensation. Hunt wished to show the operations of conscience. Whether Gabriel wished to demonstrate anything is not so clear. What he did was to extend the woe of Pre-Raphaelite love to Pre-Raphaelite morality. If love could be mediaeval so could sin: and if love could be spiritual so could vice. The history of these moral works was attended by more ill-feeling. This time Rossetti felt that his idea was stolen. He complained to Ruskin that he was the one who had first thought of painting a picture dealing with sin. 'I suppose that actually you were the first,' said Ruskin, 'but it would have been impossible for men of such eyes and hearts as Millais and Hunt to walk the streets of London or watch the things that pass each day and not to discover also what there was in them to be shown and painted . . .'

Rossetti himself had got the idea from Bell Scott. In the poem *Rosabell*, on which Rossetti had written to congratulate him, he had described in recitative story, interspersed with songs, the downfall of a young woman:

> 'Fates with scorpion-whips each side
> Ran thrusting her to hell.'

It contained a scene in which her rustic lover, Andrew, having seen the 'lost girl' in the town on market day, waited outside her parents' cottage-door, hesitating to knock, not knowing how to break his evil news. Gabriel decided to paint the moment of their meeting: as in the poem *Jenny* he had already adapted another phase of the story, Rosabell's fatal acquaintance with 'a handsome friend'. Ruskin was very uneasy about it, had, he said, 'naturally a great dread of subjects altogether painful'. For some reason he could be 'happy in thinking of Mary Magdalene' but 'was

merely in pain' while he thought of the other subject. In fact it was 'a *dreadfully* difficult one'. He had the same feeling about *Jenny*: he did not mean that 'an entirely right-minded person never keeps a mistress' – but the man that Rossetti had described 'reasons and feels like a wise and just man – yet is occasionally drunk and brutal – no affection for the girl shows itself – his throwing the money into her hair is disorderly – he is altogether a disorderly person'. He also pointed out (wrongly) that ' "Jenny" does not rhyme with "guinea".'

He had no original view to offer, but merely expressed the general repugnance to mention or think about the tabooed subject. The mystery of the Victorian taboo may be explained in various ways. Scott, speaking with authority as the writer of *Rosabell*, blamed the women.

> 'They shut their eyes to every form of the Social Evil and take it as an impertinence in any man, poet especially, who draws their attention to these matters; and I have never known the woman yet, however "strong-minded," who will allow any poem to lie on her table or within sight that has any allusion whatever to Cyprians or bastards. "Serve them right" is the verdict of the sweetest and gentlest of creatures.'

Gabriel did not attempt to explain the mystery. It was enough for him that it was a mystery – a 'great world to most men unknown'. He interpreted vice, like love, a grief, a morbid suffering beyond understanding. He devised a picture, *Found*, in which mediaeval Platonism thus merged into the Victorian conscience. In *Found*, the ingredients were a drover with a symbolic calf, netted in his cart, discovering in a London street his former and now fallen love, sunk on the pavement against a wall and turning her head aside in shame. He saw a suitable wall at Chiswick. Fanny Cornforth posed for the girl and Madox Brown found him a calf which he painted hair by hair. 'Very beautiful,' said Brown, 'but takes a long time.' It was painted mostly at Finchley, where Brown was living. He was in low water. His wife was expecting her second child and now Rossetti was upon them, exigent of food, clothes and materials. He was wearing Brown's great-coat ('which I need'), also a pair of his breeches, besides having to be fed and provided 'with an unlimited supply of turpentine' and help in laying a white ground on the canvas. 'I know you have told it me a hundred times, but I never can remember that sort of thing.' He was obsessed with his picture but did not advance with it, dragged Brown into long and fruitless discussions, wore everybody out. *Found*, in the end, was reminiscent of the *Vita Nuova* with a rustic Dante,

encountering a bedraggled Beatrice in Central London. That *Found* was never really finished and was lost to several would-be purchasers was an additional Dantesque irony.

Hunt does not seem to have felt any grievance at their choosing the same theme. He wrote to Gabriel from Jerusalem, 'I can't tell why you think people can suppose it [*Found*] to follow in the wake of my last year's picture. I could wish we were all employed about such subjects if there be any power in a simple representation by art of such terrible incidents.' If they were to be debarred from the same subjects he, Hunt, would never be able to paint another picture, 'for I believe', he said to Rossetti, with a still intense hero-worship, 'you have designed subjects bearing on every art, science, feeling and virtue that exist in our world'. Surely it was enough to illustrate a moral with a different incident from that of another. His own picture, *The Awakened Conscience*, depicted (in the words of a contemporary account) 'the interior of one of those *maisons damnées* which the wealth of a seducer has furnished for the luxury of a woman who has sold herself and her soul to him.' The man is 'a showy tiger of the human species, one of his patrician arms surrounding the victim of his passions, while with the hand at liberty he strikes the keys of a pianoforte, the music of which he is accompanying with his voice' (Moore's *Oft in the Stilly Night*). She stands, 'her wide eyes straining on vacancy as if seeing Hell open, the trinkets on her hands driven into the flesh and the fingers intertwined with a spasmodic power'. It is interesting, however, that in Hunt's picture so much of the moral resided in the furniture. The critic of the *Athenaeum* (who found the sentiment 'of the Ernest Maltravers school') suggested that 'innocent and unenlightened spectators' might 'suppose it to represent a quarrel between a brother and sister': but he overlooked the evidences of guilt that might be expressed by a piano, the wickedness of a blatant carpet, the cynicism of rosewood, 'hard, varnishy and new, unconsecrated to the domesticities by long use, the large mirrors utterly disproportionate to the size of the apartment, ornaments all in a flashy, splendid and showy taste'. It was the very point which Ruskin seized on in a letter to *The Times*. 'There is not a single object in all that room, common, modern, vulgar, but it becomes tragical if rightly read. That furniture so carefully painted ... is there nothing to be learnt from that terrible lustre of it, from its fatal newness; nothing there that has the old thoughts of home upon it, or that is ever to become a part of home?' Poor Holman's acquaintance with the human aspect of such scenes may have been limited, but none have raised the properties of interior decoration to a

pitch of detailed ugliness so formidable; and the puritan in him castigated the splendour as much as the vice.

But though in *Found* and *The Awakened Conscience* they at least circled round the same theme, Rossetti and Hunt were set on different courses. The latter was coming towards religion. For some years he had been working on a religious theme – *The Light of the World* – from the text in Revelation, 'Behold, I stand at the door and knock'. He explained it to Millais in 1851. It was to be night to show the times were dark; Christ was to hold a Lantern, giving Light to the Sinner; the door was to be choked with weeds, indicating that it had not been opened for a long time; and in the background there was to be an orchard (for which the Rectory Farm at Ewell would serve). Millais thought it was a splendid idea, and at once volunteered to make a companion piece with the door opened and the sinner revealed, falling at Christ's feet, but Hunt contrived to head him off this embarrassing proposal.

No Eastern ascetic could have contrived a more exacting discipline than that he followed in painting this celebrated picture. In the Ewell orchard working hours were between 9 p.m. and 5 a.m. the next morning. As the nights were cold he had a little sentry-box built of hurdles and sat with his feet in a sack of straw. Every full moon the process was repeated. So that the subtleties of moonlight should not be lost he strained his eyes by the flicker of a candle, blowing on his numbed fingers the while to restore circulation. He slept between five and ten in the morning, then went back to his hut to correct what he had done and prepare for the next night's work. What the village policeman on his late rounds thought is not recorded. Hunt asked him if he had seen any other artists painting landscape in the neighbourhood. 'I can't exactly say as I have at this time o' night,' he replied with constabulary discretion.

The struggle was renewed in London; with the further complication that there it was necessary to paint lamplight in daytime and render moonlight by artificial means. In the small drawing-room of his house near the old church in Chelsea, Hunt made a darkened recess with screens and curtains in which the lay figure weirdly stood, near a board on which ivy had been nailed, holding a lighted lantern in its lifeless hand while the artist peered into the gloom through a hole. The omnibus groom taking his horses home at one o'clock in the morning would see him working at an open window when real moonlight was to be had. Could Truth to Nature further go?

Yes, Hunt thought it could. Pursuing his own logic, it was clearly

necessary to paint the greatest of events where they actually had happened. The search for truth must be carried on in Palestine and Syria, in the steps of the Master. It was not a question of looking for a good subject but of a call to perform a religious duty.

His mind, as always, once made up was not to be altered. Augustus Egg, the R.A. who had always been kind to him, pointed out the material disadvantages. He would fall behind in the race for fame; fade from the fickle, short-lived memory of the public. Coventry Patmore said he could find as much beauty at home. Ruskin argued that his true function in life was to train and establish a New School of Art; and Carlyle, invited to see *The Light of the World*, was discouraging in criticism. He looked at it with his deep-sunk blue eyes and an expression of rickety joylessness, and burst into a shrill tirade while Hunt vainly tried to get in a word, and Mrs Carlyle frowned and made signs with her fingers to him not to interrupt the sage's flow of eloquence. It was 'a mere papistical fantasy' and 'empty make-believe'. 'It's a wilful blindness,' said Carlyle. There were no means of raising up the Jesus of heavenly omens to the sight. He said he was only a poor man, but he would give a third of all the little store of money saved for his wife and old age for a veritable contemporary representation of Jesus Christ showing Him as He walked about while He was trying with His ever-invincible soul to break down the obtuse stupidity of the cormorant-minded bloated gang who were doing their best to make the world go devilward with themselves. He had seen the representations of Him by the greatest artists and (here his voice rose high) '. . . when I look, I say, "Thank you, Mr da Vinci," "Thank you, Mr Michael Angelo," "Thank you, Mr Raphael," that may be your idea of Jesus Christ, but I've another of my own which I very much prefer' . . . no 'puir weak-faced nonentity' but One toiling along in the hot sun, His rough and patched clothes covered with dust, 'a missioner of Heaven sent with brave tongue to utter doom on the babbling world and its godless nonsense.' Dürer had some gleam of penetration, but even he had failed. As for Hunt the best thing he could do was to use his cunning hands and eyes on the things about him, the fields and trees, and not 'confuse his understanding with mysteries'.

Hunt listened and remained stubborn. Other friends, on a less exalted plane, spoke of the danger; but danger was not a thing one took into account, having heard the call to a noble mission. Even Edward Lear, who was frightened out of his life by dogs, or said he was, and would never carry a gun or lift a finger against anyone, had travelled through the wildest

regions, Calabria, Albania and Syria, without turning a hair or coming to the slightest harm. Hunt and Millais had stayed with him at Fairlight in Sussex, and the example of this mild and humorous man (who called Hunt *Daddy* though he was twenty years older) had impressed him too.

No doubt Rossetti regarded Hunt's journey in much the same way as Woolner's Australian exploit. In December 1853 he sent to Holman a daguerreotype of *The Girlhood of Mary Virgin* inscribed with a quotation from Taylor's Philip van Artevelde:

> 'There's that betwixt us been, which men remember
> Till they forget themselves, till all's forgot,
> Till the deep sleep falls on them in that bed
> From which no morrow's mischief knocks them up.'

It remained on Hunt's table always, a reminder of a friendship which was now approaching its end. But Rossetti did not come to see him off. Only the faithful Millais was there as he settled hurriedly in the mail train. He flung some sandwiches from the buffet into the moving carriage.

III

Illusion and Disillusion

1 On the Dead Sea Shore

It was a strange shore to which Hunt had been led by his desire for truth; desolate and sunbaked, rimmed by the fissured and purple mountains of Moab wherein was no life; a landscape of nightmare. Whitening bones lay on the beach, hideously caked with brine, and the pelvis of a camel was upreared like the remains of some monster long vanished from the earth. Trees had sunk in the salt and stood leafless and stark, while in the deeper waters of the Dead Sea the topmost twigs of a submarine forest could just be seen. The swimmer in this leaden element would roll over and over, feet above head, driven by the current against the dead arms of submerged trees: smarting from its salty bite. The caves of Oosdoom (the ancient Sodom) were hung with stalactites of curious form and if you shouted 'Remember Lot's wife' the rumour of sound hurtled round every silent crag and repeated with morbid accuracy, 'Remember Lot's wife'.

At a respectful distance, Soleiman, the Arab bodyguard, looked with astonishment and awe at the operations of the mad foreigner who sat from sunrise to sunset writing with coloured inks on a white sheet. Holman Hunt perched motionless and absorbed on his stool, protected from the blaze of sun by an umbrella, was painting the dismal scene as if his life depended on it. In the crook of his left arm was a double-barrelled rifle and under his coat a repeating pistol, these weapons being so disposed as not to hamper the use of palette and brush. Before him were a portable easel and canvas on which the mountains were beginning to emerge in a sunset glow. And tethered on the beach was a white goat, its hair falling in long matted ripples, its hooves cracking through the glittering crust to the black mud underneath and creating an uneasy patchwork of salt pebbles and map-like wrinkles around them.

The goat was the Scapegoat, the sacrificial animal, on which the burden of the community's sins was symbolically laid (Leviticus xvi. 21), cast out to perish in the wilderness, taking the sins with it. This was the

very place to which the ancient scapegoat might have staggered to die; and so conscientious was Hunt that he waited for the date of the Day of Atonement in order to begin work at the proper season.

To Soleiman it was a magic spell of some sort, evidently. This bearded Frank must be a holy man, a dervish; but, though some of his tribe were within call, he became anxious as the sun sank low and Hunt made no move to depart. There were *ghouls* and *afreets* to be feared: marauders also of flesh and blood. For it was wartime.

The Near East was in an uproar. A quarrel between the Greek and Latin Churches as to which was entitled to repair the roof of the Holy Sepulchre had, in a more or less mysterious fashion, embroiled Russia, France, Turkey and England. Lord Aberdeen had buckled on his armour, murmuring 'Peace, Peace', while Admiral Napier more practically gave out the order, 'Lads, sharpen your cutlasses'. Her Majesty, in 1854, decided to offer the Sultan 'active assistance against the unprovoked aggression of the Tsar'. Syria and Palestine muttered with discontent against the Turks and foreigners in general; and war made a good excuse for civil plunder.

There was, consequently, reason for Soleiman's unease: as indeed also to praise Holman's nerve. When the procession at length wended back to Jerusalem, a Pre-Raphaelite at the head of five picturesque Bedouin with a dying goat stretched out on his canvas (the poor animal did not survive the ordeal) and specimens of salt cake and Dead Sea mud for further scrutiny, they had exciting moments with armed parties on the way. No doubt the fantastic nature of the cavalcade secured it from harm.

But Hunt enjoyed it all. He liked Jerusalem with its numerous sects and nationalities; the intensity bred in its thin mountain air; the society of those who, like himself, had come to the Holy City under the impulsion of a dream, a private fanaticism, a fixed idea. He became a great friend of one of those characters, Henry Wentworth Monk, a Canadian fruit farmer with a plan for the abolition of war and the establishment of a united Christendom with a central government and police force. By this means energy was to be constructively employed, false diplomacy abolished, the increase of knowledge and wisdom fostered with the funds released from less worthy causes. Monk circulated his views among Emperors, Kings, Presidents, Ministers of State and Heads of Churches, editors and others. He was considered to be mad; but it was with such madness that Hunt felt himself in harmony, rather than the cold-douching common sense to which in 1856 he returned.

No one quite knew what to make of *The Scapegoat*. There was no immediately recognisable story or moral; and at the same time there was a strong effect of loneliness and horror. It was shown to the famous art dealer Gambart – a vain, irritable, uxorious little Frenchman with a house in St John's Wood and a profitable business on both sides of the Channel, described in one of Gabriel's most spirited limericks:

> There is an old he-wolf called Gambart,
> Beware of him if thou a lamb art
> Else thy tail and thy toes
> And thine innocent nose
> Will be ground by the grinders of Gambart.

The he-wolf said, 'What do you call that?'
'*The Scapegoat*,' replied Hunt.
'What is it doing?' asked Gambart.

It was, of course, impossible to say it was doing anything; it was just standing where it had been put, on the shores of the Dead Sea. The artist had to begin at the beginning and explain to the dealer that there was a book called The Bible which English people read a good deal – or were supposed to – and that they would all know about the sin-laden beast cast out into the wilderness; but Gambart, with that keen perception of universal ignorance which is one of the bulwarks of commerce, asserted that Hunt was quite mistaken, that no one would know anything about it at all and that if he bought the picture it would be left on his hands. He suggested they put it to the test. His wife, who was English, was outside waiting in her carriage, with a friend, an English girl. It would be interesting to see if they recognised the theme. Being ushered in they exclaimed, 'Oh! how pretty! What is it?' Told it was the 'scapegoat' one said, 'You can see it is a peculiar goat by the droop of its ears.' 'It is in the wilderness,' said Gambart; but the ladies only asked if Hunt were going to put in the rest of the flock, so it seemed after all that Gambart was right.

The Press, when the picture was exhibited (on the line, at the Academy), tended to be jocose. *The Times* said, 'The impression produced by this striking work, however complimentary to the skill of the painter, did not repress the wit of a very distinguished legislator who excited some merriment by his good-humoured *bon mot*, suggested by recollections of a recent parliamentary debate, that Mr Hunt's picture was an excellent portrait of Lord Stratford de Redcliffe'.

The *Athenaeum* could not get away from the fact that the goat 'was

but a goat'. As such it had no more interest for the *Athenaeum* than the sheep that furnished its yesterday's dinner, whatever quotations from The Talmud Mr Hunt might put in the catalogue. Of course the salt might be sin and the sea might be sorrow and the clouds eternal rebukings of pride, but these fancies might be spun from anything, from an old wall, a centaur's beard or a green duck pool (which was a more valuable remark than the *Athenaeum* meant it to be). The *Art Journal* thought the animal 'an extremely forbidding specimen of the capriformous race ... which might be hung in the Museum of the Zoological Gardens' but that 'the picture was useless for any good purpose, meaning nothing and therefore teaching nothing'. In this way they all made merry, according to their lights, about Hunt's inarticulate effort to express the deep earnestness of his belief. He exhibited a martyrdom, the result of much self-torture, mental and physical, of danger, hardship and privation; and he was martyred all over again for doing so. The effect was to strengthen his belief. He saw himself as a man of sorrow, an apostle persecuted as the apostles of old. He determined to go again to the East where all values were changed, where small material things shrivelled to their proper insignificance in the sun's glare and the pain of living was not felt in the soul's exaltation. Perhaps in some subconscious way this determination was also a rebuke to Rossetti, whom he adored as he reproved, a rebuke to all such frivolous and sensual men. The past was no coloured pageant of knights and ladies but the life of the Lord on earth. The future was His coming. Truth to nature was the hard road of the spirit's integrity. Reformation was not a question of some few painting better, but of all living more worthily. The Christian element in the Pre-Raphaelite dream, the same pious spirit as in the German Nazarenes, came uppermost in him.

2 At the Tail of the Hounds

Millais was also being converted. To fox-hunting. At the moment when Hunt was parleying with savage tribesmen his fellow Pre-Raphaelite was 'putting on steam' to clear a fence in Leicestershire, on one of those thin-necked, reptile-headed hunters which John Leech drew.

It was Leech who introduced him to the sport. He said that after the enervating influence of the studio, an artist could only do justice to himself at the tail of the hounds. He took Millais to the correct boot-maker in Oxford Street for his first 'tops'. 'Ah, sir,' said the shopman, 'what a fine leg for a boot ... same size all the way up' – an episode 'immortalised in

Punch'. Together they hunted in the shires and at Stobhall, near Perth, they shot deer, stalked grouse and fished for salmon. Leech drew their adventures in the humorous epic of 'Mr Briggs'. With him Millais discovered a taste for the life of the country gentry.

It was a distinct world among the many diverse Victorian worlds. By no means uncouth, for there was easy access by the railway to the clubs, the libraries, the theatres – the part of its social perimeter which Thackeray described. By no means idle – a world of professions, Politics, Church, Army, though professions subordinated to the prime need of behaving as a gentleman; which meant a deprecation of all extremes. It abhorred accents of dress, thought, emotion. It had no great passions and no great ideas. It knew of love-making, but little of love. It valued women according to their fortune, and fortune as representing leisure and ease. It tolerated the arts in so far as they conformed to its code of moderation, and to violent and unbalanced events remained indifferent altogether or reduced them to nonentity by its sceptic genius.

John Leech was its typical artist, the well-bred man of the world who handled a talent diffidently, kept it in its proper place and would rather talk about pike-fishing with Joliffe of the Light Dragoons than about the subtleties of draughtsmanship. His humour was a sort of excuse for practising an art. A nervous, melancholy man (who could not endure the noise of a barrel organ), his sensibility was kept in check by robust sports; and with his glossy top-hat, his well-rolled umbrella and the elegantly folding peg-top trousers, he was free from any stamp of occupation whatsoever.

Anthony Trollope was its typical writer: a man who got up at 5.30 in the morning and wrote his novels against time before breakfast, to leave the day clear for the Post Office or the hunting field. A gifted Philistine, as proud of his hunters *Banker* and *Buff* as of having invented the pillar-box or created *Barchester Towers*; suspicious of motives not clearly traceable to interest; frankly avowing that he spun words for money; punctual and exact in delivering any given number of them at a stated moment; abominating cant and including under that head poetry, art (as such); and all types of the imagination which had not had their wings clipped and learnt to walk quietly over trim, well-kept lawns instead of flying erratically about and becoming a nuisance or a danger. To Trollope, to speculate about the past and the future, and anything undefined in the present, was to be guilty of nonsense and to be guilty of nonsense was to be capable of any iniquity.

He, also, became a close friend of Millais. They met at a dinner given to the contributors to the *Cornhill Magazine* and the *Pall Mall Gazette* by the owner, George Murray Smith. 'From that day', Trollope said, 'my affection for the man has increased. To see him has always been a pleasure. His voice has been a sweet sound in my ears.' Millais was to illustrate *Framley Parsonage*, *Orley Farm*, *The Small House at Allington*, *Rachel Ray*, *Phineas Finn*, and to spend many a long sunny day at the novelist's house at Waltham Cross.

The effect of the new friendships on the young artist was considerable. He was removed from slovenly, slipshod Bloomsbury, erratic, treacherous, steeped in vain imaginings of a place and time that never was; at the same time dodging duns and dreaming of knightly deeds; into the placid, well-ordered, comfortable, reasonable existence of people who were kind, loyal, modest, plain of manners and speech, yet unmistakably possessed of power.

He appreciated the freemasonry of this country-house life – the understanding, hard to put into words but all the stronger for that, that arose out of a shared excitement in chasing a fox or shooting grouse – the sort of understanding that enabled a Prime Minister at breakfast to inform a rising politician and guest that he was to be Chancellor of the Exchequer simply by the intonation with which he made a casual remark about the weather. The impressionable Millais was quickly familiar with this phlegmatic, cultivated, immensely strong corporation; and that rival power, never natural to him, the imaginative force of the Brotherhood, which made him ill at ease though he had yielded to it, began to fade from his mind.

It faded by gentle degrees. In 1856, the year of Hunt's *Scapegoat*, he exhibited one of his most lovely pictures, *Autumn Leaves*; and until the beginning of the 1860s, when he came to a turning-point in his life, his work continued to have an autumnal note. It was, with him, the autumn of an idea; the autumn of poetry and truth, the fall of the Pre-Raphaelite leaf. With the detail he had so mastered there was a deepening of colour, a loosening of style; but each in their own way, the apple-cheeked maidens before a heap of withering foliage, the battered Sir Isumbras (1857) arriving at the ford at sunset, the nuns in the Vale of Rest (1859) digging a grave, have a sadness and presage an end.

The Academy had admitted him, but had its own means of indicating the works it approved and those it disapproved. He had to fight to get his pictures hung properly – 'I almost dropped down in a fit of rage in a row

I had with the three hangers, in which I forgot all restraint and shook my fist in their faces, calling them every conceivable name of abuse.' They wanted to lift one picture up after he had got permission to have it lowered three inches. They were 'felons – no better than many a tethered convict'. 'Art wants you home', he wrote to Hunt in 1855. 'It is impossible to fight single-handed, and the R.A. is too great a consideration to lose sight of, with all its position, with the public wealth and ability to help good art.'

It was necessary to exhibit rage, to shake one's fist and insist on those three inches, in order to keep one's place, not only on the Academy walls but in this other world whose delights opened out before him and whose enjoyment depended upon success.

3 At School with the 'Great Prohibited'

'Take all the pure green out of the flesh in the *Nativity* I send and try to make it a little less like worsted-work by Wednesday.'

This is not a quotation from Lewis Carroll. It was not the White Knight or the Red Queen who made the remark, but John Ruskin telling Dante Gabriel Rossetti what to do with a picture.

We are back in the mad world, contemporaneous with Millais' world of sober common sense. Rossetti in the toils of his mystic love, living at Blackfriars and painting pictures from Dante, had a patron with a mind as fantastic and intricate as his own. There was an antagonism between them, perhaps for this reason. They circled round each other like two wary duellists, disliking each other's fantasy but respectful of each other's power.

Rossetti had no belief in Ruskin as a critic – said with cheerful cynicism, 'As he is only half-informed about Art, anything he says in favour of one's work is sure to be invaluable in a professional way.' Hunt and Millais had been the enthusiasts for *Modern Painters*. But Rossetti was alive to the golden possibilities of mystification. 'Oh, Woolner!' he exclaimed in a letter to Australia, 'If one could only find the "supreme" Carlylian ignoramus, him who knew positively the least about Art of any living creature – and get *him* to write a pamphlet about one – what a fortune one might make.' He called Ruskin *The Great Prohibited*; and Ruskin called him the 'great Italian lost in the Inferno of London'. The 'great Italian' sometimes behaved like a character of Italian comedy – a clown mischievously piling up difficulties and inventing stratagems for the

discomfiture of Pantaloon. Various places were discussed as suitable for Lizzie to visit and where she might recover her health – Devonshire, Wales, Jersey, Switzerland. In some fashion not quite to be explained this became a reason for Gabriel's going to Paris; to which Ruskin remarked, 'You are a very odd creature and that's a fact'. He had no intention of supporting such a pleasure jaunt. 'Paris will kill her or ruin her like Sir J. Paul's bank'.

Ruskin, instead, tried to get him to 'run into Wales' and 'make me a sketch of some rocks in the bed of a stream with trees above, mountain ashes and so on, scarlet in autumn tints', adding, with that curious fairy-tale urgency, 'If you are later than Wednesday you will be too late'. Gabriel had not the slightest intention of going into Wales. On no account would he sit out to paint from the Nature to which he had promised to be true.

Then there was the ever-present need of 'tin'. 'If it is really a question of sheriff's officers', said Ruskin, reluctantly parting with £35, not so much ungenerously but with an inability to understand the grotesque economy of his protégé; for in spite of the Prohibited's buying so many pictures, completed and in prospect, in spite of the fact that he was also selling to Colonel Gillum, the 'wondrous Plint' and others, 'tin' was always lacking, made necessary 'avuncularism' (that is, visits to the pawn-broker), was even extorted from the poverty-stricken Brown. Having seen Lizzie off to Nice he appeared at Brown's, 'such a swell as I never saw before . . . everything about him in perfect taste except his *shoes*'. They found him 'making himself useful' by raking out the live coals all over the room, and burning large holes in Emma's new claret-coloured Kidder-minster with the chocolate *fleurs-de-lys*. He talked 'of buying a "ticker",' but not, said Brown, 'of paying me back my £15, alas'. Ruskin, in return, 'stuck pins' into Rossetti. He withheld the 'tin' provokingly: 'I could not send money to-day, it was so wet'. He made peremptory demands of the kind that were exactly calculated to annoy. 'Pack up your drawing, finished or not, in the following manner:—

1. Sheet of *smoothest* possible drawing paper laid over the face and folded sharply at the edges over to the back, to keep drawing from possibility of friction.
2. Two sheets of pasteboard, same size as drawing, one on face, the other behind.
3. Sheet of not too coarse brown paper, entirely and firmly enclosing drawing and pasteboards.

4. Wooden board, a quarter of an inch thick, exact size of drawing, to be applied to the parcel – drawing to have its face to board.
5. Thickest possible brown paper firmly enclosing board, parcel and all, lightly corded, sealed and addressed to me:

> Calverley Hotel,
> Tunbridge Wells
> *Paid per fast train.*

Take it to London Bridge station yourself and be sure to say it is to go by fast train. And there is no fear.' Possibly Rossetti echoed 'no fear'. It was all wrong for a much-rubbed water-colour, grubby from the creative process, to be treated in this way, at least by the producer of it. Then there were other demands: 'Can you dine with us on Thursday at 6? (and not be *too* P.R.B. as Stanfield is coming too!).' 'I expect Kingsley, the *Alton Locke*, to come out here on Monday in order to be converted to Pre-Raphaelitism. . . . Could you lend me that end of Blackfriars Bridge – the black drawing, I mean – till Tuesday.' Charles Kingsley had, it may be noted, described the Pre-Raphaelites as 'petrified Cyclops painting their petrified brothers'. Ruskin dictated subjects indicating briefly scenes from Dante as if they were part of an examination paper: 'Piccarda and Costanza in the moon'. 'Buoncontre of Montefeltro and Pia of Siena waiting behind him. Buoncontre uttering the line "Giovanna o altri" with any possible suggestion of lines 102–105 in the distance!' He had no scruples about criticising in the most drastic and despotic fashion. He complained of Rossetti's 'careless way of using colours'. He remarked derisively of a much-scrubbed face in a water-colour that looked as if it had 'a white respirator before the mouth'. 'What horses' legs!' Ruskin would say. 'Are *they* in armour too or only rheumatic?' Why were there 'black spots in the high lights . . .' and so on. When Rossetti turned crusty and irritable over these jibes he said, 'You are a conceited monkey,' that is for thinking he knew more about art than Ruskin. Ruskin also wished to regulate his life: 'Keep your room clean and go to bed early', he said. 'If you do right I shall like it – if wrong, I shall not.'

At the mercy of these whims Gabriel saw himself as a toady with tongue in cheek, as he explained in his own style to Ford Madox Brown.

'Ruskin was a sneak who loved him, Rossetti, because he was a sneak too, and half liked Hunt because Hunt was half a sneak, and hated Woolner and Brown because they were manly and straightforward. He adored Millais because Millais was the prince of sneaks, but too much so, for he sneaked away his

(Ruskin's) wife, and so he was obliged to hate him for having too much of his favourite quality.'

There is a grotesque humour in all this: yet Ruskin and Rossetti were not utterly divorced from reality. Indeed they were closer to what was going on in the age than that other world of serious politicians and able professional men among whom Millais now moved. They came into direct contact with that neglected and despised phenomenon, the 'working man'. Through Ruskin, Rossetti became a teacher at the Working Men's College and the dream advanced into a new phase.

Frederick Denison Maurice, the founder, was a man of ideas. His ideas on a future life appeared dangerous to King's College, London, and in 1853 he lost his position as Professor of English Literature and Modern History. He then took up in earnest the development of the 'Christian-Socialist' theory that every man was a spiritual being and expanded the night school he founded in Little Ormond Yard in 1848 into a real mechanic's university. Work now became the Pre-Raphaelite enthusiasm. It was of course Work on the mediaeval model. Work as it was in the ideal past. Ruskin expressed (to Lady Trevelyan) his desire to 'explode printing and gunpowder, the two great curses of the age, to teach illumination to the sign painters and the younger ladies; to write (prophetic words) a great work on politics founded on the thirteenth century'. At the College he instructed the beginners in black and white, setting them, much to the orthodox art-master horror of Bell Scott, to make minutely stippled pen-and-ink studies of twigs and ivy leaves. He would draw a little in the style of those sketches, with which he illustrated his books and always, through humility or dilettantism, left tantalisingly half-finished as though he said triumphantly – 'There, you see how impossible it is'. Rossetti, who taught the figure, was willing but prone to look on the amusing side of this humanitarian effort: 'You should see my class . . . the British mind brought to bear on the British *mug*: with results that would astonish you'.

A session under the purring gas lamps of Red Lion Square or Great Ormond Street had plenty of robust Pre-Raphaelite fun. Rossetti would hide all the Prussian blue, disapproving of Ruskin's setting the workmen to paint monochrome studies in this strong dye: at which Ruskin 'burst into one of his boisterous laughs'. 'Can you teach me how to draw a cart wheel?' Ruskin was asked by a horny-handed student. He explained that he did not teach anything special or technical but drawing in general, so that the learner would gain the power of drawing any object before him. 'Yes, but that isn't what I want. I don't care about drawing. I'm a wheel-

wright and I want to be able to draw a wheel.' A sign of Rossetti's fascinating personality is that among these men of narrow and starved minds he was tremendously popular. Devoid of any personal concern with the general good or social improvement, he gave his best to each one. Ruskin said he was like Cimabue because he taught all he knew. It did not seem in the least abnormal to him that an artisan should want to be an artist, as he considered it the natural state of all men; and when a member of the class went in for algebra Gabriel urged him to give it up, for what use was algebra in painting?

Arthur Hughes and Ford Madox Brown joined in. Indeed Brown had previously started a similar scheme of his own. His picture *Work* was one of the offshoots and it was one of the characteristic but quite unconscious humours of Pre-Raphaelitism that Carlyle and Frederick Denison Maurice, carefully portrayed in it, have the appearance of idle lookers-on. A further offshoot was no less than a completely new start of the amazing movement whose original founders had now drifted far away from one another. It sparkled afresh with its uncanny inward power.

4 The Magic Ray Sparkles

Proof of its independent existence as an idea is the effect of Pre-Raphaelitism after the original band had split up. The mysterious ray shone in the provinces. Into many dark lives it brought a glimpse of unknown splendour. It touched commonplace men and made them, momentarily, into geniuses. It released some hidden mental spring and set Liverpool and Manchester a-dreaming. There was quite a succession of small masterpieces wrenched from, or projected into, those who, once the ray had passed on its course, would never be heard of again; but for it, would never have been heard of at all. Everyone who goes to the Tate Gallery in London has seen *The Death of Chatterton*, the beautiful little picture in which the young poet lies pallid and outstretched in his attic, through whose window the dome of St Paul's shines in exquisite distance. 'Faultless and wonderful,' said Ruskin: yet who knows or thinks of its author, Henry Wallis? Or of the Liverpudlian William Lindsay Windus, who painted the superb *Too Late* (1858) and *Burd Helen* (1856) and then left off painting and was heard of no more? Or of W. S. Burton, who painted the miraculously detailed *Wounded Cavalier*, which hung next to *The Scapegoat* at the Academy in 1856, even then a mystery, for it was catalogued without title or artist's name? Or John Brett, who painted *The*

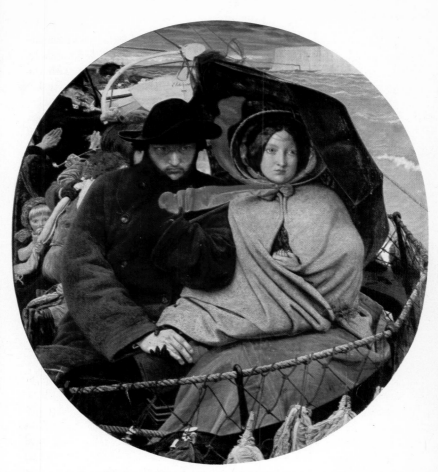

1 *The Last of England* by Ford Madox Brown, 1855

2 *Work* by Ford Madox Brown, 1852-65

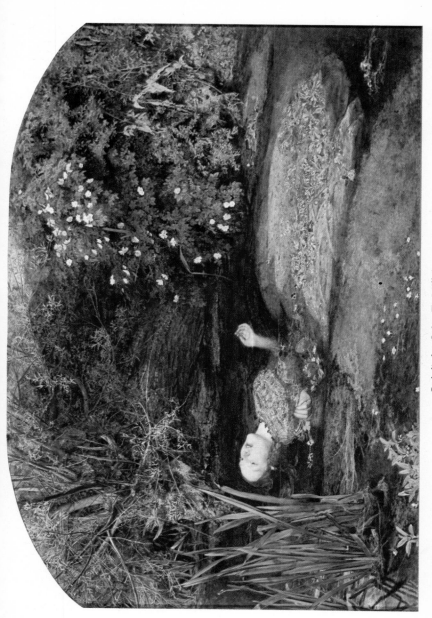

3 *Ophelia* by John E. Millais, 1852

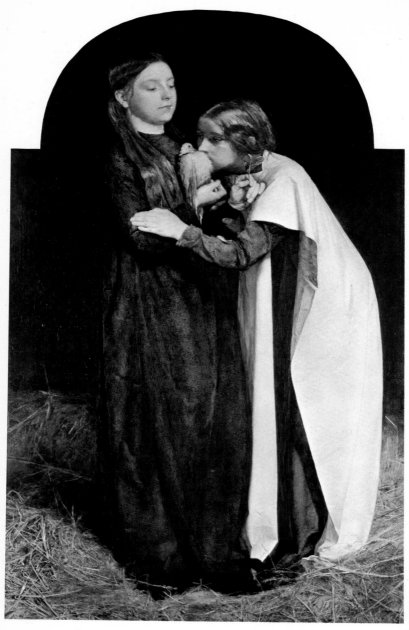

4 *Return of the Dove to the Ark* by John E. Millais, 1851

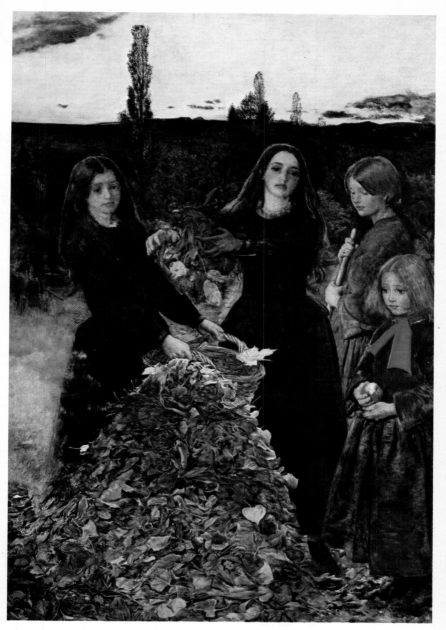

5 *Autumn Leaves* by Millais, 1856

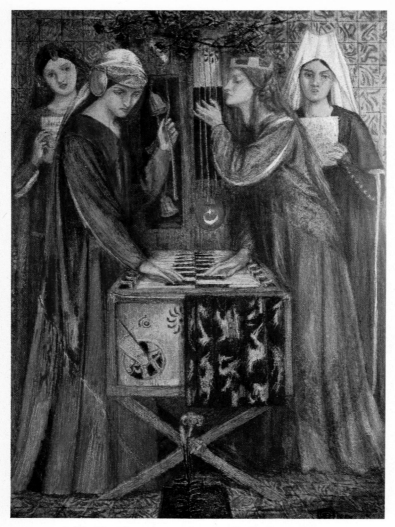

6 *The Blue Closet,* watercolour by D. G. Rossetti, 1857

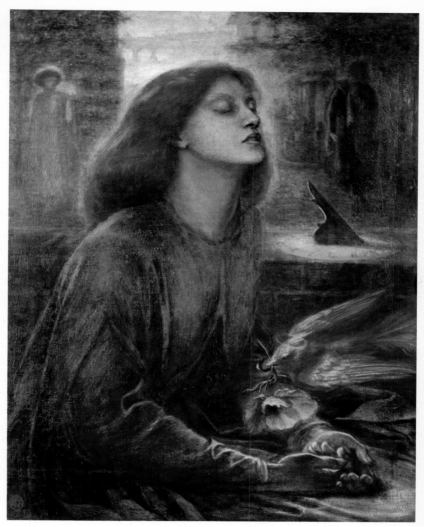

7 *Beata Beatrix* by D. G. Rossetti, 1864

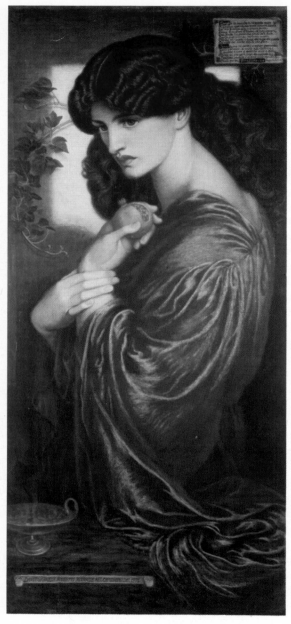

8 *Proserpine* by D. G. Rossetti, 1874

Stone Breaker which, said Ruskin, 'may be examined inch by inch with delight'. Or Robert Martineau, Hunt's pupil, who devoted ten years to *The Last Day in the Old Home*, a novel in itself of life in the 1860s?

There was a complete minor tragedy in this blossoming of fugitive inspiration. Either the ideal they followed was too exacting and they relapsed into mediocre ways; or, like Martineau, they died young; or they became discouraged like Windus by adverse criticism and personal misfortune: yet each having risen in a magical moment beyond the scope of his natural powers.

On men of business, on the cities devoted to commerce, the vision of an alternative, an imaginative existence acted with equal power. The annual Liverpool prize was one of the mainstays of the movement. Peter Millar of Liverpool, James Leathart of Newcastle, George Rae of Birkenhead, F. R. Leyland of the shipping line, T. E. Plint, the Leeds stockbroker, were among the sagacious men of affairs who were buyers not merely of pictures but of romance. Here and there in the new industrial masses, condemned to sordid gloom, it aroused a hope, of something – they scarcely knew what. 'Like a golden dim dream', said James Smetham, the mystical Methodist, of Rossetti's *Marriage of St George*. The masses as well as the few craved for refuge from industry, from the machine. It was a relief to escape with the Pre-Raphaelites into 'quaint chambers in quaint palaces where angels creep in through sliding panel doors, and stand behind rows of flowers, drumming on golden bells, with wings crimson and green'. 'Why is it,' said Thomas Dixon, the 'working cork-cutter of Sunderland', writing to William Michael Rossetti about the *Germ*, 'these pictures and essays being so realistic, yet produce on the mind such a vague and dreamy sensation, approaching as it were the Mystic Land of a Bygone Age? ... There is in them the life which I long for, and which to me never seems realizable in this life.' That this cork-cutter, who achieved a kind of passive fame as the 'Working Man' addressed in Ruskin's letters published as *Time and Tide by Wear and Tyne*, should be the first Englishman to appreciate Walt Whitman, having come across *Leaves of Grass* in the stock of a book-pedlar who had been in the American Civil War at the same time as the poet; that he should report his discovery to William Bell Scott; that Bell Scott should send a copy to William Rossetti; that William Rossetti should be instrumental in producing the first English edition (even though Gabriel termed Whitman 'sublimated Tupper'): all this is typical of the system of Pre-Raphaelite intelligence and literary espionage and the distance to which it reached.

Though the Brotherhood was finished, Pre-Raphaelitism remained a society – a very large society of friends, mutually communicative of enthusiasms and useful projects. Its 'members' were distributed in every branch of society and in a few years it had become a force in Victorian life, not only as a style of painting but as a focus of every kind of idealism. So strong an advocacy of culture could not pass unnoticed at the Universities. Oxford indeed had connections with the movement from the beginning. Wyatt, the picture dealer there, and Thomas Combe of the Clarendon Press were among the earliest friends and helpers of Millais and Hunt. Through the Combes Hunt became the guest of several high tables where he preached his gospel, and the friend of Acland and John Hungerford Pollen, a don of artistic leanings who had already decorated the ceiling of Merton College Chapel.

Oxford was a university with Pre-Raphaelite possibilities. Its architecture, its leaning, even its sense of humour, mediaeval and Victorian (a combination of buffoonery and transcendentalism), were a product of the Middle Ages. Its spires dreamed. At the same time it was full of ardent youth, in whom the dreams of the past fermented to some future purpose of active effort. In so defining it you practically defined the Pre-Raphaelite idea.

In the 1850s it was rousing from the gross and lethargic state which Gibbon described with a mixture of relish and reproof. It was turning Gothic again, austere, clerical. And at Exeter College were two undergraduates, Edward Burne-Jones and William Morris, who were fated to be the instruments of Pre-Raphaelitism reborn.

The connection of Morris and Burne-Jones with Rossetti and their activities at Oxford is one of the most well-known episodes of Pre-Raphaelite history. It was a second beginning of Pre-Raphaelitism, not to be confused with the first; though it should not be considered as something quite different from the original Pre-Raphaelitism because it was a fresh start. In accordance with its peculiar genius, the future of the idea was its own past and Morris and Burne-Jones fit inevitably into its circular destiny. They were the same people as before, whilst being, with that interchangeability which will be readily understood by this time as part of the dream, different; and the more the idea changed the more it was the same thing.

They were Pre-Raphaelite before they met Rossetti. The strange lambency which had invaded the smoke pall of the industrial cities penetrated the grey stone of an ancient college, crept into 'tumbly old

rooms, gable-roofed and pebble-dashed, with a couple of steps up to a seat in the window and a couple of steps down into the bedroom – the which was bliss'. The spirit of the Middle Ages, modified by Denmark Hill, Gower Street and Chatham Place came back to one of its starting-points.

5 Gay Knights and Ladies at the River Bank

'I have just come in from my terminal pilgrimage to Godstowe ruins and the burial place of Fair Rosamond. The day has gone down magnificently all by the river's side. I came back in a delirium of joy . . . in my mind pictures of the old days, the abbey and long processions of the faithful, banners of the cross, copes and crosiers, gay knights and ladies by the river bank – and all the pageantry of the golden age – it made me so wild and mad I had to throw stones into the water to break the dream.'

Edward Coley Burne-Jones, a lank, pale, delicate, fair-haired under-graduate, was writing home in 1854. He had entered the university in the previous year. He was already the friend of William Morris, the son of a bill-broker who lived at Walthamstow, a sturdy young man with a mop of crisply curling black hair and the face of a mediaeval king sculptured on a tomb. Morris was nicknamed 'Topsy' in reference to his dark curls. They told each other their discoveries; and Ruskin was their prophet. Morris ran into Jones' rooms one morning with a book which had to be read right through aloud on the spot. It was Ruskin's Edinburgh Lectures. There they found mention of the Pre-Raphaelites, and first heard of Rossetti; and when Millais' *Return of the Dove to the Ark* came to Mr Wyatt's shop in the High Street, 'then,' said Burne-Jones, 'we knew'.

There was the makings of a Brotherhood. A number of Burne-Jones' Birmingham friends were up with him. They formed a 'Birmingham Group'. Cormell ('Crom') Price, of Brasenose (later the headmaster to whom Kipling dedicated *Stalky & Co.*), the brilliant Faulkner of Pem-broke, Dixon and Fulford: meeting for abstruse conversation and horse-play. In 1855 Burne-Jones and Morris on a visit to London spent a happy day in Tottenham at the house of Mr Windus, the picture collector, looking at Ford Madox Brown's *Last of England* and some things by Millais. At the end of the summer term Mr Combe let them see his treasures at the Clarendon Press – Hunt's *Christian Missionary* and a Rossetti water-colour of Dante drawing the head of Beatrice which they voted the best of the lot.

Morris had begun to write poetry, in a queer way, without pause, without effort. 'Well, if this is poetry,' he remarked, 'it is very easy to write.'

They went to France in the vacation. 'Topsy' Morris was fidgety in Paris, but in 'a state of calm joy' over the mediaeval towns, Amiens, Chartres, Rouen. Walking on the quay at Havre, on the way back, they resolved to begin a life of art instead, as they first thought, of founding a monastery. Ned Burne-Jones introduced Morris to Southey's reprint of Malory's *Morte d'Arthur*. Morris promptly bought a copy and at Birmingham they devoured it together.

They had already got hold of an issue of the *Germ* containing the *Blessed Damozel*. They decided to have a magazine of their own to be called the *Oxford and Cambridge Magazine*, because another Birmingham friend and possible contributor, Heeley, was at the latter university. He co-opted Vernon Lushington of Trinity, 'one of the jolliest men I know'. Morris was to take the financial risk, which he was well able to do, as his father, the City bill-broker, had made a lucky investment in copper. The first number was somewhat random in its appreciations; but Burne-Jones' essay on the Newcomes contained a glowing passage on Rossetti's illustration to the *Maids of Elfenmere* in Allingham's *Day and Night Songs*. He bestowed his undergraduate praise also on the *Blessed Damozel* and the *Story of Chiaro* by Rossetti, to the satisfaction of the latter. 'The most gratifying thing by far that ever happened to me,' said their author, '– being unmistakably genuine.'

Thus Oxford approached Pre-Raphaelitism, much in the same way as Millais and Hunt approached the idea before meeting Gabriel. Shortly to manifest itself was a reforming zeal in Morris as intense as that of Hunt, an impressionable mind and executant ability in Jones as in Millais. They also revered Ruskin, now piling *The Stones of Venice* upon *Modern Painters*. They had found for themselves Tennyson and Malory as their predecessors found Keats. They lacked only as the others did the third ingredient – the spark that would light their tinder.

Pre-Raphaelitism in the person of Rossetti was approaching Oxford; through a complication, typical, yet perfectly logical and reasonable. Rossetti admired the Fire Office in Chatham Place designed by Woodward, 'a thorough thirteenth-century Gothic man', otherwise described as 'the stillest creature that ever breathed outside an oyster'. Woodward was adding to the already considerable variety of Oxford architecture with the Venetian Gothic of the Union debating hall and the Museum. This made it natural that Rossetti should interest himself in the statues that were to

be among the Museum's features. 'I expect myself to have to do in some way with the decorations as the building goes on.' Woolner was to do a statue of Bacon, Munro of Galileo. It would be a pity if he, Rossetti, could not contrive to adorn a wall with paint.

Woolner had come back from the gold-fields. The Pre-Raphaelite habit of sudden goings and comings makes needful a bracket of explanation. The log-book of his outward journey, containing the careful description of many sunsets which made Rossetti laugh a great deal, sent home for the circle to read with solemn injunctions that great care be taken of it, was quickly lost; but his numerous letters showed a gradual disillusionment.

Socially the new world seemed to Woolner disappointingly like the old, save that the men looked rather less law-abiding and were in the habit of carrying guns. At the same time it was depressing to find, in the country you came to for riches, that everything was monstrously dear, that a cauliflower cost 3s. 6d. and the storekeeper at the diggings would charge you any figure that came into his head. 'The man of labour only buys the luxuries of life and servants rule their masters who bow down and flatter them. Such is the power of Gold', Woolner solemnly remarked. Some months spent in fossicking and prospecting, digging holes, felling trees, washing and rocking the ore-laden gravel, convinced him that gold-hunting was the hardest work in the world. The amount discovered did not come up to Tennyson's expectation and to get £50 worth of gold and pay out £60 in expenses was, in short, the 'poorest occupation going'. Moreover the Ovens Diggings and the Devil's River were the scene of violence. 'A man was murdered in his tent last night, three hundred yards away.'

The alarming thought occurred to him that he might lose not only his place in society but his hold on the evolutionary ladder; that the sculptor and contributor of verses to the *Germ* containing the most excellent, if melancholy, sentiments, might descend to the level of a bushranger, even of an aborigine. England appeared more attractive than before. If there were now, he added, one thing in nature that could send him suddenly mad, it would be a clear and settled conviction that he would never see England again.

He went back to his own business 'like all sensible people'. The latter part of this stay in Australia was occupied in digging modelling clay from the ground instead of nuggets and making portrait medallions in Sydney and Melbourne. In 1854 he returned, his homeward log containing

markedly little description and some reflections on wasted time. He saw 'the dear pale cliffs as comfort to my eyes, ease to my soul, as food to the hungry man', and straightway went back to work in London as if nothing whatever had happened. 'This has been indeed a strange experience for you,' Rossetti had written to him, 'and I have full trust that your genius will profit by it in the end'.

In 1856 Oxford and Pre-Raphaelitism met – in Vernon Lushington's rooms. Morris had taken a pass degree and made arrangements to study architecture with the Gothic Revivalist, Street. Burne-Jones was up and down between Oxford and London in some doubt as to what to do with himself. He was proud at that moment of being 'the man who wrote to Ruskin and got an answer by return'. The wild, the daring thought came into his mind that he might even encounter Rossetti. He nerved himself to enquire at the Working Men's College in Great Ormond Street, and paid a small sum to take tea and thick bread and butter, listen to the addresses and perchance see the very face of the demigod. It seemed, however, that the demigod was usually absent on the night of addresses and speeches, but the kindly Lushington invited him to his chambers in Doctors' Commons where, a few nights later, Rossetti was definitely promised. And sure enough there he was, rending to pieces someone who spoke disrespectfully of Browning's *Men and Women*, dealing firmly with someone else who expressed an interest in metaphysics, and, incredible to relate, bidding the undergraduate to come to his studio the next day.

'My first introduction to Gabriel was your doing – and big results it brought into my life', Burne-Jones wrote many years later to his Honour Judge Lushington. The thoughtful act for which he returned thanks was typical. Vernon Lushington was one of the Victorian intelligentsia, tolerant of the most advanced ideas, not religious in the conventional sense but with a sincere conviction of duty and the necessity of helpfulness to his fellows. His father, a famous judge, who lived to be ninety-seven, counsel for Queen Caroline, and the friend of Brougham and Jowett, was a man of liberal and rationalist principles, an opponent of capital punishment and the slave trade. Vernon inherited his passion for justice. Beginning life as a midshipman he was incensed at the bullying then practised; and finding one of the officers engaged in roasting a midshipman (over a fire, as in *Tom Brown's Schooldays*), knocked him down. This piece of insubordination deserved and received praise, but also a nominal reprimand; the upshot was that he left the navy and went to Cambridge to study law. Influenced

by the rationalist ideas of his father and the social theory of Ruskin and Carlyle, he became as time went on a follower of Auguste Comte's Positivism, which made a species of religion out of social improvement and the efforts made to promote it. He had volunteered his services to Carlyle as unpaid secretary, helping him with *Frederick the Great* and gaining unstinted praise from its author. The same need for a constructive participation in the social crusade brought him to the Working Men's College. He fell under Gabriel's spell and remained always a close friend and helper of the Pre-Raphaelite circle of Rossetti, Hunt, Hughes, Bell Scott, Jones and Morris. In a playful description of the Lushington family's 'Principles and Practice in Furnishing', his brother William applied to Vernon these epithets: 'High Art. Blue greens. Japanese Cabinets. Expense unworthy of consideration'.

'Big results' the introduction brought indeed.

The boy from Birmingham went to the miasma-laden rooms in Chatham Place. He found the great artist at work on a water-colour of a monk copying a mouse in an illumination. There were drawings tossed about everywhere, piled up on the floor. But no books on the shelves. Rossetti then had a theory that books were no use to a painter except to prop up a model. It is said that for this reason he threw his library out of the window, though the volumes were uncovered at low tide and brought back to him in muddy heaps by characters of the foreshore, scenting possible reward.

And in a twinkling all difficulties were solved. Of course Burne-Jones must not think of going back to Oxford. He must be a painter. His friend Morris too – as to whose poetry the master asked many questions. Gabriel's curious faculty of divining talent, or making it or both, was aroused. There was here a useful connection with Oxford, a connection he had wanted; and it is clear that he saw in his mind's eye a revised edition of the PRB. He mentioned to Allingham his meeting 'a certain youthful Jones . . . one of the nicest young fellows in Dreamland . . . For there most of the writers in that miraculous piece of literature (the *Oxford and Cambridge Magazine*) seem to be. Surely this cometh in some wise of the *Germ* with which it might bind up.' As was his habit, he expressed the same idea in a different form to his friend Jack Tupper, referring to 'one Jones of Exeter, Oxon . . . on the Oxford and Cambridge *Germ*', in which 'all contributors write for love or spooniness' and 'tin is out of the question'. Carelessly, facetiously, the magician spoke of the matter, but his magic was exerted with none the less irresistible effect.

The discrepancy between them in age was not great. In 1856, the Wonderful Year of Burne-Jones' later memory, Rossetti was twenty-eight, Jones twenty-three, Morris twenty-two. But for how much that difference of age counted in experience! Rossetti was a man of the world, a man indeed of half a dozen worlds, whom it was difficult to think of as young: the master among poets and painters, successful and important; at the same time the Bohemian of Blackfriars laying out clothes to sell to an old Jew for immediate cash; the enthusiastic teacher of artisans and the mournful idler whom Brown called 'poor Gabriello'; the explorer of London's amusements of low life and the spiritual kinsman of Dante; the debonair joker, the anguished lover, the heartless intriguer, and Ruskin's sneak.

Through the romantic haze that floated before young Oxford's eyes the subtle and unhappy character was simplified into a high-spirited nobility. The Bohemianism was picturesque, the idling a superb annihilation of time, the genius one that never doubted or faltered. He transformed London itself, by the magic of an attitude, into a place of high endeavour and blue summer 'in which I think it never rained nor clouded . . . and it was always morning and the air sweet and full of bells'. Together they wandered about the streets; to the theatre, which they obediently left as soon as Gabriel got tired of it, which he frequently did; to the 'Beast Gardens' in Regent's Park; to see the Madox Browns in Fortess Terrace, Kentish Town, the Brownings in Devonshire Place, to Holland House where there was the man who 'paints queer pictures of God and Creation' (G. F. Watts); to the *Judge and Jury*, which was like the Cave of Harmony at the beginning of the Newcomes and Gabriel said was better than a play: to some place in Cheapside with a board up to say 'Dinners for 4d', where Gabriel would stand at the counter eating a sausage and drinking a glass of beer and reading between times aloud from the *Morte d'Arthur*. One glorious day, while Burne-Jones and Morris were drawing at Chatham Place, there entered 'the greatest genius that is on earth alive, William Holman Hunt . . . a splendour of a man with a great wiry golden beard and faithful violet eyes.' And Gabriel, treating him like an ordinary friend, passed his paint brush playfully through the golden beard, talking – 'such talk', said Burne-Jones, 'as I do not believe any man could talk beside him'. He had become an out-and-out worshipper. 'I never wanted to think but as he thought . . . In the miserable ending years I never forgot the image of him in his prime and upbraided any fate that could change him.'

Rossetti threw himself into what they did. He called them familiarly Topsy and Ned. He praised lavishly. They were 'wonders after their

kind', and he took a deal of trouble to start Burne-Jones off in a successful way, knowing that he was poor. About Morris he did not worry so much because he was rich; though he preached to him that he should take up painting as the course of poetry was almost run and the next Keats ought to use a brush. Morris bought a picture, *April Love*, one of Arthur Hughes' best – 'nobble it as soon as possible', he instructed Burne-Jones. He painted a tree in the garden of their friend MacLaren of the Fencing Academy in Oxford, with such energy that it was long before the grass grew where his chair had been. Rossetti found them rooms, 17 Red Lion Square, the same rooms where he and Walter Deverell had painted the Forest of the Ardennes.

In 1857 Rossetti and Morris went to Oxford and came back full of a scheme. In Woodward's debating room for the University Union Society there were large bays above the gallery 'hungry to be filled with pictures – Gabriel equally hungry to fill them, and the pictures were to be from the *Morte d'Arthur*, so willed our master'. Thus wrote Burne-Jones and thus was the plan which Rossetti had conceived put into operation.

As Dante had presided over the first phase of the movements so now it was Malory. The *Morte d'Arthur*, substituted for the *Vita Nuova*, fulfilled the same Pre-Raphaelite conditions, albeit in a cruder way. It was a dream-like evocation of the past, not of thirteenth-century Florence, but of a middle age in which even more conveniently there was scarcely trace of a date at all. It had unhappy love for a theme – the adulterous attraction of Queen Guinevere for Sir Lancelot. It contained also a mystical search – for the Holy Grail – the dish in which Joseph of Arimathea received the blood from the wounds of Jesus – a symbol towards which knights struggled through the toils of a spell. There were emotions in it, sex and conflict, but overlaid by the archaic forms of language; real places like Winchester and St Albans that were concealed realities in a welter of fabulous history and geography. Through this wood of legend, dense and vague, the Knights of the Round Table flaunted with their sounding names and sharp heraldic colour.

Tennyson, of course, had already begun the Victorianisation of Malory. He had simplified and reconstructed him as Sir Gilbert Scott reconstructed churches. Madox Brown in 1855 was reading Tennyson's *Morte d'Arthur* and thought how well it would illustrate. No doubt this influenced the enthusiasm of Rossetti and his young friends for Malory. The Pre-Raphaelites looked on Tennyson as one of their lode-stars. They dedicated some of their best work to him. Eighteen hundred and fifty-seven was the

year of the famous illustrated Moxon edition of Tennyson's Poems, where incongruously side by side with Creswick, Mulready, Horsley, Stanfield and Maclise were illustrations of great beauty by Hunt, Millais and Rossetti.

The wall paintings were to be inflicted on Oxford as the illustrations had been inflicted on Tennyson, whose indifference to the visual arts was entire. (He liked the pictures in Florence very much but he could not get English tobacco, so he came away.) Tennyson did not care about being illustrated. He disliked Rossetti's St Cecilia, on the back of whose neck an angel appeared not merely to be 'looking' but bestowing a passionate kiss; and he asked Holman Hunt why he had made the Lady of Shalott's hair blown about like a tornado and the web wound round her like the threads of a cocoon. But Oxford did not object to being decorated: it appeared on the whole to enjoy it. It accepted the offer made to paint frescoes for the debating-chamber. The artists required no fee, the sole charge being the cost of lodging and materials. This, however, was considerably higher than expected. The participants were Dante Gabriel Rossetti, Edward Burne-Jones, William Morris, Arther Hughes, John Hungerford Pollen, Valentine Cameron Prinsep and Spencer Stanhope.

The enterprise was carried out in a state of wild hilarity. 'What fun we had in that Union! What jokes! What roars of laughter' said Val Prinsep ('Taffy' in Du Maurier's *Trilby*) then nineteen, six-feet-one, fifteen stone. G. F. Watts had 'plunged him into the Pre-Raphaelite Styx'. Prinsep, of course, was a Rossetti enthusiast, though Ruskin was anxious about Rossetti's influence on him. 'The worst of it is,' said Ruskin, 'that all the fun of these fellows goes straight into their work; one can't get them to be quiet at it, or resist a fancy: if it strikes them so little a stroke on the bells of their soul, away they go to jingle, jingle, without ever caring what o'clock it is.' Gabriel jingled at their lodgings in 'the High' like a burlesque freshman with a beard and a plum-coloured frock-coat. He added the university to his collection of worlds with aplomb; rejoiced in the polite invitations to dinner that were given to the celebrated visiting artist; while his serious conviction that everyone should be a painter won instant success as a witty absurdity.

It is interesting to look into their 'digs' through Val Prinsep's eyes, to see Rossetti, humming to himself after dinner, curled up on a sofa. 'Top', he would say to the short square man with spectacles and the mop of hair, 'read us one of your grinds.'

'No, Gabriel, you have heard them all.'

74

'Never mind, here's Prinsep who has never heard them and, besides, they're devilish good.'

'Very well, old chap', growled Morris, beginning to read in a sing-song chant, while twiddling his watch-chain. Rossetti lay with his eyes, that Prinsep observed to be melancholy, fixed on the poet, and Burne-Jones in a corner went industriously on with a pen-and-ink drawing.

Morris read, without the graces of elocution as if he were throwing a bone to a dog, breaking off abruptly – 'there, that's it.'

> 'Swerve to the left, son Roger, he said,
> When you catch his eyes through the helmet slit
> Swerve to the left then out at his head
> And the Lord God give you joy of it.'

It was slightly weird to hear him. His poetry was not simply an imitation of an old model. It was not (as one commonly understands the word) inspiration; but as if an ancient voice spoke through him – a voice from a previous life, jerking from a body with which it had nothing to do.

The humour which Rossetti thought proper to the occasion was broad comedy. It had always been a Pre-Raphaelite principle to offset their reverence and idealism by a deliberate jollity and slanginess of expression. So they described both male and female excellence by the epithet of 'stunner'. Rossetti was the leader in this species of obverse reverence. The noble ambition of the new group was sublimated in the comic.

The windows between the paintings, whitened over to tone the light, were covered over with wombats, 'a delightful creature', said Gabriel, 'the most comical little beast.' The old slang was revived and, to an enlarging undergraduate circle which included 'Swinburne of Balliol', every woman was a 'stunner'. When a bore said he would call for them in a few minutes and take them out to dine, Rossetti instantly ordered a cab and took the train for London. They stayed the night at the Euston Hotel, returning to work in Oxford the next day. Burne-Jones thought a man like that 'could lead armies and destroy empires if he liked'.

The cream of the jest, which had also something of nightmare, was what happened to the paintings. The distemper, as everyone knows, flew off the thinly whitewashed brick surface like smoke. The vision of an age that never was disappeared almost at once. This was artistically consistent with the rest of the episode. The spectacle of the Fellow of a college and four untrained youths (Pollen, Prinsep, Stanhope, Jones and Morris) with two professional artists (Rossetti and Hughes), one of the latter having an

outrageous indifference to the material he worked in: laughing like madmen; varying the representation of the Belle Iseult with that of an Australian badger, and putting in the dark angles of the roof little figures of Morris with his legs straddling out like the portraits of Henry VIII; painting on a wall too dark to allow of anything's being seen, with touches that faded as soon as they were applied: has a strong likeness to the clowning of the Marx Brothers.

The mystic 'rag' has remained an object of amusement and veneration. The ghost of extremely expensive colours lingered ethereally in the whitewash. In 1906 an attempt was made to record the phantom masterpieces by means of a sensitive photographic plate and by reflecting light on them with large mirrors. From the reproductions then made, and published in book form, it became possible faintly to perceive Sir Tristram and Iseult 'that was the loveliest maiden in the world' among Morris' sunflowers, the traces of Gabriel's Sir Lancelot prevented by his sin from entering the Chapel of the Holy Grail. In 1936, through the skill in restoration of Professor Tristram, the paintings themselves were brought back, almost as if by a spiritualist *tour de force*. The remnants of their material existence, however, had ceased to be of much concern. More important in consequence, the *Morte d'Arthur* was absorbed into the fibre of Burne-Jones' and Morris' being.

The atmosphere of burlesque delight pervaded also the rooms at Red Lion Square. There were 'victuals and squalor at all hours' – a stunner or two 'to make melody' – a slavey 'Red Lion Mary', who entered into the spirit of the establishment, made up beds for stray guests out of books and portmanteaux and got into a Rossetti water-colour of the Meeting of Dante and Beatrice in Florence. Rossetti had now taken possession of this ménage, stayed there constantly, ate prodigious late breakfasts, seemingly enjoyed the fun as much as any. But all this time there was a very different matter, a burden of anxiety on his mind. 'Lizzie is very ill at Matlock.' It was such a message that withdrew him from Oxford. 'I am most wretched about her. What to do I know not.' (To Madox Brown in 1857.) The thought was a gnawing care that tempered, if it did not actually produce, the flights of fancy – a dull constant pain against which he looked for counter-irritants.

The inglorious conclusion of the Union exploit was quickly followed by a new assortment of relationships.

In a dreamlike fashion the ingenuous bachelor rapture of which every

minute was a glorious hour dissolved swiftly: a new excitement brought with it a faint cold sadness of change. The pattern was reassembled domestically. By 1860 they were all married.

6 The Carpentry of a Round Table

Morris saw Jane Burden, the daughter of an Oxford livery-stable keeper, in the long vacation of 1857, when the Union pictures were in full swing. He, Rossetti, Burne-Jones and Arthur Hughes were at the little Oxford theatre. In a box above them was a girl of wonderful beauty, with eyes set wide apart, a rich full-curving mouth under the upper lip's short curve, a stately neck and hair almost black but with a gleam of light in it. A Stunner indeed. They gained her consent to sit for them. With the impulsive energy that was typical of him, Morris fell in love. It is related that after looking at her intensely he turned to her his canvas on which he had scribbled 'I cannot paint you but I love you'. The canvas was possibly that portrait of her which is now in the Tate Gallery. When Val Prinsep made a teasing remark about her at dinner Morris bit his fork in rage until it bent double. In April 1859 they were married at the Church of St Michael's in Oxford.

On the recommendation of Madox Brown (he was godfather to these as to the earlier Pre-Raphaelites), Burne-Jones and little Georgiana Macdonald got married in June, the same year, setting up house with a small deal table and some £30 from commissions for Mr Plint. She was one of the five daughters of a Nonconformist minister, good girls who took marriage very seriously as the only proper career for a woman. One of her sisters was to become the mother of Stanley Baldwin, another of Rudyard Kipling. She had known Burne-Jones in Birmingham, and in London when her father moved to Chelsea; followed his enthusiasms with a personal keenness; anxiously brooded over his delicateness. In the drawer of the small deal table was a set of wood-engraving tools. She wished to make herself helpful by practising his own art.

And in May 1860 'All hail' to Madox Brown 'from Lizzie and myself just back from church'. She and Dante Gabriel Rossetti were married at Hastings.

The prelude to the last event, the immediate prelude, was not bliss but woe.

'She has seemed ready to die daily and more than once a day. It has needed all my own strength to nurse her through this dreadful attack . . . it makes me

feel as if I had been dug up out of a vault, so many times lately has it seemed to me she could never lift her head again . . . I assure you it has been almost too much for me . . . indeed, it hardly seems as if I should ever work again.'

Marriage, to both, was a desperate remedy for an illness physical and mental: a *change*, like going to Bath or Nice; a medicine that was reported to do good; with, also, a sad likeness to the extreme unction.

In a pretence of gaiety, not without pathos, they went to Paris for the honeymoon, where Gabriel found time to paint in water-colour Dr Johnson and the pretty Methodists at the Mitre; and *How They Met Themselves* – a version of that legend of double personality which was to him, to her too, more than legend.

This domestic aspect of Pre-Raphaelitism led to various results, one of which was the formation of a business – a 'shop'. The newly-weds had no furniture. They required some. They found they could buy nothing that did not appear, to a taste in full reaction against normal Victorianism (if it can be so called), as hideous and impossible. They must therefore make their own. They must surround themselves with an outer shell in harmony with the dream that consumed them inwardly – that is furnishing in accordance with the spirit of the *Morte d'Arthur*. The imaginary Round Table was to be a solid presence made with a scrupulous exactitude from what they dreamed it might have looked like. According to the Pre-Raphaelite process of reasoning it was an obvious and inevitable step. The first attempts began at Red Lion Square. What Rossetti termed 'intensely mediaeval furniture, like incubi and succubi' was made by a local carpenter from Morris' drawings. There was a large round table 'as firm, and as heavy as a rock', some chairs 'such as Barbarossa might have sat in', the famous settle with a long seat below and, above, three great cupboards with swing doors. 'The night when the settle came home', the staircase was choked with vast blocks of timber. Some slight error in measurement had resulted in its growing to huge and unexpected size. The master 'laughed but approved'. The giant piece of furniture had much admirable painting surface which they started to cover industriously with *Love between the Sun and Moon* and Dante and Beatrice, of course; and going on to the chairs, they covered them with scenes from Morris' own poems, Gwendolen in the witch tower, and the arming of a knight from the Christmas Mystery of *Sir Galahad*.

After the rooms at Red Lion Square were let to what Red Lion Mary described as 'a gentleman out of Byron', the further problem presented itself, to Morris at least, of finding a house fit for a family of the Middle

Ages to live in. He decided to build one as he had built the settle. Bexley Heath in Kent was the place chosen, perhaps because Kent was associated with the Canterbury pilgrims. It is of interest to note that Pre-Raphaelites in the execution of any design always took whatever human material was at hand, counting on the splendour of their schemes to blow into whomever it might be an ability to carry them out; therefore Morris gave no prolonged consideration to the choice of an architect. Philip Webb was the chief clerk in Street's office where he, Morris, had worked. Philip Webb would do, as well as another, for the realisation of Morris' dream; and, as so often happened with these casual Pre-Raphaelite associations, they were to work together for many years.

The Red House, which was ready for occupation in 1860, was like no other house. It still exists, a strange thought, among the miserable huddle of subsequent building – a two-storied L-shaped anomaly with a high-pitched roof of red tile and an inner court with a most elaborate well-house of oak and brick. Swiftly completed, it raised the question of decoration in an acute form. A house like no other house required, even on grounds of consistency, decoration like no other. Tables, chairs, beds, tiles, curtains, candlesticks, jugs, glasses, fire-dogs, everything had to be made afresh. Who could make them?

Manufacturers were obstinate and stupid; with exceptions like Powell of Whitefriars who were eager and able to produce beautiful glass. All Morris' immense energy quickened at the blissful thought of making them all himself; and not merely for himself and Janey but for others too. The monastery, the brotherhood, the dream became in 1861 by inevitable steps – a limited company.

The idea, it is true, had been in the air. The Government Schools of Design, the Great Exhibition itself under Prince Albert's direction, had been much concerned with a possible, though still mysterious, connection of arts and manufactures. Hunt had made one or two Egyptian-looking chairs. Ford Madox Brown, who had made a certain number of things in order to copy them in his paintings, talked a good deal in the circle of the artist's usefulness in this respect. The magician, Rossetti, was the one who set things going. 'Let's have a shop, like Giotto.' His ancestry made it natural. The *bottega* in which Italian artists produced fine pieces of jewellery and gold and silver-smith work – pictures, too, when they felt like it and when pictures were wanted – was practical and sensible. You made something, then you sold it. It was business, but it was also art because you made what pleased you. Rossetti had, by nature, the interest in

exquisite and even trifling workmanship which balances the abstract ideas of an artistic people as the Italians or Chinese. Vernon Lushington asked him to choose a jewel to be given to Vernon's fiancée. The choice was characteristic – a barbaric ornament for the hair, such a thing as the princess of an Oriental fairy-tale might wear – a humming bird's breast coated with copper and enamel of dull blue-green, with a slender nodding metal head and quivering wings chased with enamel and copper – very different from the solid Victorian jewellery which a young lady, in the 1860s, would expect to receive from her betrothed. What artificer fashioned it is not on record. It has no period, no style save that of fairyland, quivering still with a faint dream-life and oddly imbued with Rossetti's genius.

But to Morris the matter was neither so simple nor, as he would have regarded it, so trivial. Not so simple as making and selling; nor so trivial as producing trinkets, however ingenious in fancy. As serious and conscientious as Hunt, art to Morris was essentially a matter of reform. The shop was a moral gymnasium – no catchpenny Latin trick but the expression of a faith, a boon to humanity, an example to the so-called civilisation in which they lived – a hope for the future which might be and a longing for what had once been, a code of ethics, morals and philosophy, a social system. It was a faith that assumed tangible form through common domestic objects as faith had become manifest to Hunt in the Dead Sea salt.

Rossetti wrote the prospectus. He had a persuasive touch, a talent for manifesto.

'The growth of Decorative Art in this Country, owing to the efforts of English Architects, has now reached a point at which it seems desirable that Artists of reputation should devote their time to it.' . . . 'The Artists, whose names appear above . . . deeply attached to the study of the Decorative Art of all times and countries, have felt more than most people the want of some one place where they could obtain or get produced works of a genuine and beautiful character . . . all work will be estimated for and produced in a business-like manner . . . it is believed that good decoration, involving rather the luxury of taste than the luxury of costliness, will be found to be much less expensive than is generally supposed.' (An ill-founded pious hope this last.)

The list of partners seemed to Bell Scott, somewhat piqued perhaps at being left out, 'a tremendous lark'. It had elements of the unexpected. The title 'Morris, Marshall, Faulkner & Co.', gave a surprising prominence to a sanitary engineer from Tottenham. All Pre-Raphaelite ideas had

many originators. Mr Marshall appears (along with all the others) to have suggested this firm. It is also possible that simply as a friend and being present when the scheme was discussed, he was promptly whirled into it. Faulkner, the double first and brilliant mathematician, was, according to Pre-Raphaelite calculation, just the man to keep the books. Philip Webb was the architect member – and the others were old friends. Ford Madox Brown, Dante Gabriel Rossetti, Edward Burne-Jones and Arthur Hughes (who, however, though he appeared on the prospectus, never took any active part). Some day, no doubt, someone will write an account of the most minor of the hordes of Pre-Raphaelite friends who have, for no particular reason, the brief vividness of the clergyman who, in Boswell's *Life*, made one remark and was instantly crushed by Dr Johnson. Max Beerbohm wrote an essay on him. He might have written in similar vein on the 'young inductive parson', a school-friend of William Michael's, whose presence in the circle is tantalisingly mentioned by Brown; or on the sanitary engineer from Tottenham.

7 Sugaring a Pill

At the same time domesticity, for Millais, had produced, or at least accentuated, a state of crisis. Expenses, in the state of life in which he had elected to live, were considerable. There were such things as his *pied-à-terre* in Langham Chambers, as the manse at Brig o'Turk in Glenfinlas, and you could not hunt and shoot for nothing. In addition, there were new responsibilities: 'the little miniature Millais by Millais', one of which Thackeray, in 1857, hoped and was sure, was a charming little work by that painter. But in 1859 the parent thought that ruin stared him, his wife and his family in the face.

Sir Isumbras at the Ford, a picture which had cost him endless pains, caused a howl of disapproval. Satires and skits were many, the most notable being Fred Sandys' pen-drawing in which Millais was represented as the knight, mounted on an ass with the letters *J. R., Oxon.*, branded on the crupper; and Rossetti and Hunt were the wood-cutter's children being carried over the ford. But this was comparatively harmless. What was really serious was the enmity of the great critic himself. Savage Ruskin 'stuck his tusk in' indeed. 'Not a fiasco but a catastrophe' were his words. He told young Prinsep that Millais had quite gone to the dogs. It seemed to Millais they were all trying to drive him to the dogs. The dealers were against him because he put on high prices and so shut them out.

'Gambart was there [at a private view] and several dealers but *none spoke to me.* They are not anxious to *look into my eyes just now*.' The academicians were against him. There was 'the wicked clique, who, of course, do their best to run me down'. 'I can scarcely regard a professional man as my friend.' The papers 'poured forth such abuse as was never equalled in the annals of criticism'. And a rival star had appeared on the horizon. A young man called Leighton (later Lord Leighton), trained in Germany and on classic models, with no Pre-Raphaelite nonsense about him but on the contrary a plainly expressed opposition to it, was making a great hit and showing a brilliance equal to Millais' own.

'Nobody seems to understand really good work, and even the best judges surprise me with their extraordinary remarks.' It was dispiriting in the extreme. He had done his sincere and genuine best. He knew that the pictures he had painted were very good indeed. The malice and hatred they aroused, in spite of their merits, sickened him while leaving him at a loss to account for it; and an awful conclusion stood out, engraved itself on his mind:

'You see, nobody knows anything about art.'

There were some few who were loyal or befriended him in this time of trial; John Leech, Holman Hunt and even 'the Rossettis and their clique'. One consistent merit in Dante Gabriel Rossetti was his unswerving loyalty to good work or an honest intention behind a work of art; and the gulf now otherwise existing between him and Millais made no difference to this integrity of thought. He stuck up boldly for him.

One day in London a shabby grey-haired man came to the Millais' door. Euphemia thought he was a tramp and told him to go away; but the tramp said, 'Oh, beautiful dragon! I am Charles Reade who wrote *Never Too Late to Mend* and I must have *The Knight Crossing the Ford.* I would write a whole three-volume novel on it and then have sentiment enough to spare'. Thackeray said, 'Never mind, my boy, go on painting such pictures – ' spreading out his great arms and embracing him. And things looked up a bit. Gambart did not behave so badly after all: Mr Windus bought 'the Nuns' and the crisis was averted by degrees – but – Millais had come to certain conclusions.

It was essential to be a success in the world. Years before he had told Madox Brown, Seddon and Collins that 'no good man is ever unsuccessful in life'. He cited two examples of 'irreligious men going to the dogs'. ('Rossetti off early' was a pendant in Brown's diary to the report of this edifying conversation.) It was easy to reverse the proposition. Unsuccess

meant you were not a good man. 'Going to the dogs' was a proof of irreligion. Further, if unsuccess was the result of painting without other care than that of expressing your deepest feelings, it seemed to follow that this also was wrong; that the expression of these deep feelings was not proper to the good or religious man. Could it be that a higher aim for the artist was to *help* these people who knew nothing about art by providing for them what was within the capacity of their minds to grasp – that indeed by less of personal sincerity the artist might positively be more worthy. 'I have, up to now, generally painted in the hope of converting them to something better,' he said to Hunt, 'but I see they won't be taught.' Pre-Raphaelitism had dogged his steps with ill-luck, therefore it was necessary to try other means.

'A physician sugars the pill and I must do the same.'

In 1859 a picture called the *Black Brunswicker* was in his mind. A good subject, a little like that of his earlier *Huguenot Lovers*, but with contemporary point – tuning with the prevalent anti-French sentiment. For, alas, in 1859 our allies of the Crimea were not our friends. There was some fear that they meditated an invasion: the scare having led to the formation of a home guard, the Volunteers. The Artists' Rifles was a constellation of talent, including Leighton, Millais, Hunt, Morris, Watts, Swinburne, Rossetti and Burne-Jones, while Ruskin was an honorary member. It was true that Morris invariably turned to the right when the order 'Left' was given, that Rossetti said 'Why?' on the command to form fours and that Holman Hunt, at lock drill with an old-fashioned Brown Bess, always lost the screws; but with a company of artists (and especially Pre-Raphaelites) such things were bound to happen.

A handsome young Teutonic warrior in the striking uniform with death's head and cross-bones going off to fight against a Napoleon was just the thing.

'*I feel confident it will be a prodigious success* . . . Russell (*The Times* correspondent) was quite struck with it and he is the best man for knowing the public taste.'

Everything was calculated to please.

The young woman who posed for the soldier's sweetheart, reluctant to let him go, was Miss Kate Dickens, daughter of the novelist (Millais was by this time reconciled to that former opponent).

He painted her with a particularly sweet expression, like one of the figures in a Book of Beauty, in a glossy satin dress. Several great ladies of the day were not displeased to be taken for the model.

83

As for the Brunswicker, the whole of the 1st Life Guards paraded at the Albany Street Barracks in order that the artist might choose the most handsome. Six distinguished officers were said to have sat; though the actual choice was a private, who died in the following year of consumption.

The inclusion of a poodle sitting up and watching the lovers was an endearing touch. It was painted as well as Landseer could have done it. Millais was a great friend of Landseer also, another object of Pre-Raphaelite dislike to whom he was reconciled. They hobnobbed over brandy and water after official dinners.

The deliberate effort to please went down well. The public thought it the gem of the 1860 Academy. Tom Taylor, the capricious art critic of *The Times* whom Whistler so cursorily 'killed', said he had heard nothing but 'dead good' of it. Gambart bought it for a thousand guineas.

The tone of Millais' comments sensibly altered. 'The fact is the Royal Academy is the only place for a man to find his real level. All the defects come out so clearly that no private puffing is worth a farthing. You cannot thrust pictures down people's throats.'

So popular was the *Black Brunswicker* that he had to make seven or eight replicas in water-colour. This and other 'beastly copying', together with illustrations (*Framley Parsonage* belongs to 1860), kept him profitably busy; but they dined out, he and his wife, a great deal. His society was courted by such notables as Sir Coutts Lindsay, Lady Somers, Lord Lansdowne, the beautiful Lady Waterford, Lord and Lady Delamere, and if, indeed, success were the criterion he could now say that he was a better man than before.

Something drove him to have a last fling at the poem Hunt had introduced him to so many years ago – *The Eve of St Agnes* –

'Full on this casement shone the wintry moon
And threw warm gules on Madeline's fair breast.'

Perhaps he wished to show that he could be as Pre-Raphaelite as ever if he chose. He carried out the original exacting formula, sitting by moonlight in the depth of winter in an ancient, eerie room at Knole, his fingers numb with cold, while his wife stood shivering with unlaced bodice, as model. The bed represented was that in which James I slept. It was covered with gold thread and silver appliqué. It was, like the room itself, of genuine ancientry. And nothing availed. The enchantment was gone;

the magic would no longer work; the Pre-Raphaelite spirit was no longer in him.

The public did not like it either. 'I cannot bear that woman with the gridiron', said Frank Grant (Sir Francis Grant, P.R.A.) referring to the barred shadows on the floor. 'Where on earth did you get that scraggy model, Millais?' asked Tom Taylor, breezily offensive.

It was a mistake, clearly, to go back. Even the moonlight was discouraging. It was not strong enough, at its strongest, to throw any colour through stained glass at all. Warm gules, alas, was purely verbal magic. Keats and Truth to Nature did not in this respect agree.

So Millais next painted two works well coated with sugar: two delightful pictures of English childhood, *My First Sermon* and *My Second Sermon*. His daughter Effie posed, bolt upright in the first with innocent solemnity, in the second a little cherub fallen asleep in her pew, her hands tucked in her muff. There at least there was nothing to offend. Each was a picture everyone could understand. *My First Sermon* supplied the cue for the Archbishop of Canterbury at the Academy Banquet.

'Still,' he said, 'Art has, and ever will have, a high and noble mission to fulfil. That man, I think, is little to be envied who can pass through these rooms and go forth without being in some sense a better and a happier man: if at least it be so (as I do believe it to be) that we feel ourselves the better and the happier when our hearts are enlarged as we sympathise with the joys and the sorrows of our fellow-men, faithfully delineated on the canvas; when our spirits are touched by the playfulness, the innocence, the purity, and may I not add (he waved towards *My First*) the piety of childhood.'

And how perfectly he, the same Archbishop, appreciated, a few years later (in 1865), *My Second*.

'I see a little lady there' (the archi-episcopal finger pointed) 'who, though all unconscious whom she has been addressing, and the homily she has been reading to us during the last three hours, has in truth by the eloquence of her silent slumber given us *a warning of the evil of lengthy sermons and drowsy discourses*. Sorry indeed should I be to disturb that sweet and peaceful slumber, but I beg that when she does awake she may be informed who they are who have pointed the moral of her story, have drawn the true inference from the change that has passed over her since she heard her "first sermon" and have resolved to profit by the lecture she has thus delivered to them.'

It was an after-dinner benediction such as the *Scapegoat* had not received: but so queer and disturbing a thing as that was best left alone. If it came to discussing aesthetics in public there was no knowing what

85

sort of a mess you might land in: but the delightful innocence of child-hood was safe ground and surely one who painted innocence so well must be an artist beyond reproach.

8 A Lonely Bachelor

A series of invisible fences separated these ring-like worlds. Moving from one to another was like a parlour game. Your circle impinged on another circle at some point. You could, if you chose, travel round it, meeting, by an introduction to one, a hundred new friends. Where this circle touched another, the process might be repeated. In a short while acquaintance was very large indeed. Yet the fences, invisible as they were, were quite real. You could know the same people in a different way according as to which side of the fence you were on.

There was, for example, only two miles from Hyde Park Corner, Little Holland House, a house of rambling passages, many stairs and ancient rooms, with a garden of fine trees, a paddock and a farm, its win-dows overlooking a field where once, grim-visaged, Cromwell and Ireton had paced discussing secret business. At the centre of this, the circle of Henry Thoby Prinsep of the East India Company, was George Frederick Watts, the man who painted the 'queer sort of pictures of God and Creation'. He had come to stay for three days and remained for thirty years. He knew all the Pre-Raphaelites who came there, yet never quite as an intimate, always from the other side of the impalpable barrier.

Hunt, the only Pre-Raphaelite bachelor left (he did not marry until 1865), wandered, a little disconsolately, in this and other circles. Under the murmuring elms, where snowy tea-tables were spread, and the click of croquet mallet against ball could be heard, mingling with the music provided by Joachim and Hallé, all the great and famous people, Thackeray, Tennyson, Browning, politicians, generals, East India Company nabobs, Lady Somers, Mrs Cameron taking her photographs and swathing guests in suitable draperies for the ordeal, Mrs Prinsep her sister, the hostess, distributing generally a warm kindliness and charm. Holman Hunt would meet Thackeray again, perhaps at one of Arthur Lewis' smoking evenings in Jermyn Street, where members of many circles found their way, in passing, into a more sportive and Bohemian ring; and here there might be his friend Millais, Trollope, Leighton, Lord Houghton, the biographer of Keats, John Leech and Dicky Doyle, the *Punch* draughtsmen, Arthur Sullivan the composer, the redoubtable Tom

Taylor, dramatist and critic, Tattersall, the horse-dealer, and the tailor of Savile Row, Poole, whose £10,000 loan to Louis Napoleon helped to create the Second Empire.

And at Mrs Cameron's own house he would meet Tennyson again with Woolner and be transported thence to the Tennysonian circle at Farringford in the Isle of Wight. Woolner had settled himself in the Tennysonian circle and was making 'meds' as he called them, medallions in low relief, of all the literary and learned. Dr Jenner, the apostle of vaccination, who was entranced with Woolner's bust of The Bard and thought *In Memoriam* the 'highest revelation we have had for guidance'; Froude, the historian, a 'clever, quiet-looking man with a musical voice'; Matthew Arnold, 'a regular swell in brilliant white kid gloves, glittering boots and costume cut in the most perfect fashion'; and Francis Turner Palgrave, who awed the sculptor as a man who had read the whole of Plato in Greek, for whom he made the drawing of a piping shepherd which still appears on the title-page of Palgrave's classic anthology – *The Golden Treasury*.

To Hunt it seemed that none of these worlds was his. But which was his? The almost fourth-dimensional Pre-Raphaelite sphere which superimposed itself on all these others was broken. He felt excluded from the doings of the young men Rossetti had got together. He had a real quarrel with Rossetti in 1857 in some not very precisely revealed matter, concerning a woman – a Miss Annie Miller, it would seem, who turned professional model – in which William Michael candidly but nevertheless vaguely admitted his brother was (though not gravely) to blame. Ford Madox Brown had also elected to quarrel with Hunt – Hunt had taken Mr and Mrs Combe to see him and they looked at *Work* while the painter was out. 'No one', wrote Brown angrily, 'is ever allowed in my studio while I am out – which were it not explained to you as part of a general plan, might on some future occasion take you by surprise or appear unfriendly.' Some misunderstanding about Hunt's offer of help in getting Carlyle to sit for the same picture produced further acrimony. 'I should have doubts of the success of the mediation', said Brown 'and, indeed, from the steps you have taken you must be aware that the chances of my ever getting him to sit . . . are smaller than ever (if only from the mere disgust of being so frequently requested as a subject for an art he despises) . . . your practice has been a *leetle too sharp* in this case.'

In this atmosphere the Hogarth Club, whose circulars Carlyle described as 'in their great frequency and miscellaneous complexion an afflictive phenomenon more or less', formed with a lukewarm idea of reshaping the

original Brotherhood, did not flourish, while Millais and Woolner were intent on careers in which Hunt could not share. He must go to the East again. He felt its pull strongly. 'I could never tell you,' he had written to Rossetti from Jerusalem in 1852, 'what a full equivalent the beauty of this country is to any bothers I suffer from'. 'Even with all the hideous domes and minarets the city is the most purely poetic sight on earth I am convinced.' In London he was merely a spectator of an idle show – there he would actively resume his mission which renewed acquaintance with society made to appear more than ever worth while. What was it they said in America when his replica of the *Light of the World* was shown there? 'Never mind the gas, that picture will light us all up.' He came out of Vanity Fair, comforted by the thought of such remarks from simple working people, determined to light them up further.

It was necessary, however, to live. He spent so much time on his religious works that his output was extremely small, his income correspondingly so. Whatever he did was highly finished, absorbed him wholly while in process. A letter to Combe from Ockham Park, Ripley, Surrey, where in October 1862 he was painting Vernon Lushington's father, gives detail of his laborious concentration on a portrait.

'My time for writing is immediately before bell. I rise at 8, go into my painting room for half an hour or more before breakfast. Come back again at ¼ to 10 and then remain at work till about 5. The Doctor, of course, sits but a short time of all this. At 5 I mount and ride for about an hour in the dusk. I have now just come in from my ride and have an hour to spare. I may as well go on with my narrative and state that I pass the evening in the drawing-room till eleven and then descend with the sons to smoke over politics, theology and philosophy for an hour – so you see if my leisure hour before dinner is shortened by the dinner being at 7 instead of 7½ I have a difficulty in writing at all.

'The good old Doctor has not the virtue of being a steady or patient sitter – he in fact does not sit at all, and I could not wish him to do so for once or twice when I have for a minute kept him in one position his whole expression has become so different that I have not been able to go on, the only chance there is is the most perfect perseverance.'

'. . . He tells me wonderful tales [the Judge, then seventy-one, had among other things kept a mob at bay with his stirrup from the coffin of Queen Caroline] but sometimes when at work I am too absorbed to listen attentively and at others I cannot find leisure to put them down.'

The main thing was to complete his picture of *The Finding of Christ in*

the Temple, started on his first journey when he had experienced difficulty both in getting Jews to pose and inspecting the area where the Temple used to be. How was he to be recompensed for this toil of years sufficiently to start off again? Wilkie Collins supplied the answer: by asking more for it than had ever been asked for a picture before; and Collins insisted that he should take Dickens' advice.

If you knew Wilkie Collins you had to know Dickens. It was still another Victorian circle. It happened ironically that a Pre-Raphaelite should go to consult one of the most violent of their early critics but Millais had made it up with him and so did Hunt. The great novelist received Hunt in Tavistock Square one day in 1860. He was forty-eight, bony, dignified, business-like, already worn with lecturing but at the height of his powers and writing *Great Expectations*. He asked how much the picture might reasonably be expected to bring in. The answer was illuminating. The sources of revenue were: a shilling a head for visitors to the gallery exhibition, say £20 or £30 a day; subscriptions for an engraving of the work at £3, £5 and £8 each; and of course the sale of the picture itself: Hunt explained that Mr Gambart had told him he could not, of course, expect payment adequate to the time he had taken; that he should be satisfied with the prestige he would gain. Dickens appeared to be familiar with this argument – 'We inspired workers for the public entertainment', he said ironically 'ought to think of nothing so much as the duty of putting money into publishers' pockets but we are a low-minded set'.

He gave it as his verdict that Hunt ought to have the 5,500 guineas he required, but that the business man should be given time; that he should pay £1,500 down, another £1,000 in six months and the remainder at intervals over two or three years.

Hunt thanked him profusely. He forgot only one thing: to ask Dickens to see the picture; and Dickens never asked to see it.

Gambart said it was quite impossible to pay that price; but he did pay it in the end, and 'God bless my living soul,' said Thackeray meeting Hunt, when the news was known, 'here we are in the presence of the happiest man of the day'.

IV

Climax and Catastrophe

1 An Overdose of Laudanum

The 1860s were a prosperous time: somewhat sinister too, at least as far
as the huge, unhygienic capital was concerned. Fashion itself was un-
hygienic. Beards had come in, in the later 1850s. 'You must imagine me',
wrote Woolner, 'with a coco-nut mat tied under my chin.' Mrs Tennyson
sighed for an Act of Parliament that would deprive Alfred of his. Female
bodies were burdened and stifled with the crinoline, which came in at the
same time. Everything was concealed. Through heavy curtains one per-
ceives the lurid glow of feverish unhealthy pleasure in a London still a
victim to cholera and typhoid. The gutters ran with chloride of lime and
Mr Gladstone in 1860 announced a fifty per cent cut in the duty on
brandy, which considerably increased the consumption of that spirit.
'Acrid putrescence', Carlyle is reported to have said to Tennyson, at
some time during this period, when they were walking together across
Eaton Square. It is not quite clear whether he referred to Eaton Square
itself, to London as a whole, to the period they were living in or to life in
general: though it fitted the period with some aptness.

The death of poor Lizzie in 1862, early in the flashy and morbid
decade, was a tragic climax in the Pre-Raphaelite sense. That is to say it
was the last term in an ascending scale of events; but it was also the first.
It was a tragedy of the past. It was also a tragedy of the future. It was an
event midway in a love story, if it could be called a love story, as the death
of Beatrice was an event midway in the mystic passion of the *New Life*.

> 'With sighs my bosom always laboureth
> On thinking as I do continually
> Of her for whom my heart now breaks apace.'

She had been a dying, almost a dead, woman for years. Marriage made
no alteration in that. At the Red House where she stayed, with and with-
out Gabriel, she seemed, so it was described to Charles Ricketts 'a ghost

in the house of the living' – a delicate wraith which appeared without a word at dinner; 'rising – gliding away silent and unobserved as she had come'. Perhaps in her detachment she too found those about her like ghosts: even solid little Georgiana Burne-Jones, fixing her with adoring eyes, prepared like her husband to adore every Rossettian thing, as Lizzie wearily took off her bonnet in the little upstairs bedroom with its lattice window and let fall her loosely fastened deep-red hair in soft heavy wings. The Morris' were 'those people', almost as if they were strangers, though she saw few other people save the Burne-Jones' and the Madox Browns. She wrote to Gabriel in 1861 from the Red House, asking him to send her 'the money for those knives, as I do not wish those people to think I am unable to pay for them'. On this, a question of the respectable middle-class front, she showed a slight animation as on all others a complete apathy. 'I am most sorry to think of your picture going at that low price but of course there was nothing else to be done.'

The state of her lungs grew no better in these last years at Chatham Place. Even Rossetti admitted it was scarcely suitable for her delicate health and found an alternative at Highgate. To the inroads of phthisis was added an acute neuralgia. After the birth of a stillborn child she became fretful and nervous. She began to take laudanum, and in considerable quantities, to dull pain and get sleep. It was an overdose of laudanum that killed her, at the age of twenty-nine.

The verdict at the inquest was one of 'Accidental Death'.

What the immediate events were that may have caused her to take the overdose, assuming she meant it to be fatal, are not certain enough to be definitely stated. They went out together, Gabriel and Swinburne (who was now living in Grafton Street, Fitzroy Square, and was greatly attached to them both) to dine at the new Hotel Sablonière in Leicester Square. They left early and came home about eight o'clock. About nine Gabriel went out again with the purpose of visiting the Working Men's College, leaving her going to bed. When he came back at about eleven-thirty she was unconscious, and the empty phial was on the table at her side. The times are those stated at the inquest.

An oral tradition would have it that the evening was one of scenes and bickering; that at nine Gabriel did not go to the College but spent the time with some other woman; that Lizzie, left alone, suspected this and, being in an abnormal condition, committed suicide through jealousy. Jealousy of Fanny, the obscure yet definitely existing 'other woman' has been held to account for some of the petulant crises of her ill-health. It

91

was possible that on this occasion he had sought relief from the nervous strain of a miserable evening in 'Wapping' – or wherever it was; that Lizzie's intuition or knowledge of this mode of escape caused the final crisis of all.

Another version is that he did, in fact, go to the College; but that Lizzie imagined he had gone to the other woman, the effect on her mind being the same. The tradition also refers to a farewell note, pinned to Lizzie's nightgown and found by Ford Madox Brown, which was not disclosed at the inquest nor its exact terms revealed, its purport being 'My life is so miserable I wish for no more of it'. The phrase might be purely self-regarding. It might not imply more than a feeling of physical futility, a short cry of despair as she had despairingly cried before in her few and otherwise dull and flat letters, in her little tragic verses. 'All people who are at all happy or useful seem to be taken away.' Thus she had written to 'Gug' in the previous year among some commonplace remarks about the death of Mrs Wells (wife of the author of *Joseph and his Brethren*). Yet it might also be taken to mean that Rossetti had made her life so miserable that she wished for no more of it; not that she wished him away but that his being away, and away under circumstances in which she detected faithlessness, was unendurable to her.

A great deal of conjecture must necessarily go into the adjustment of that most exquisite of balances – of the motives of self-destruction. It would be fruitless, perhaps, did it not bear on the tragedy to come, on the question: Was it simply grief that Gabriel subsequently felt or remorse? – or both together?

He had, no doubt, in a way, behaved badly; he had lived a careless life, leaving her for long intervals, neglecting her in many material respects. On the other hand he had certainly given her affection. She was, certainly also, a responsibility for a young artist. John Henry Middleton, the Cambridge don and friend both of Morris and Rossetti, told Wilfrid Blunt that 'Rossetti was addicted to loves of the most material kind both before and after his marriage, with women, generally models, without other soul than beauty. It was remorse at the contrast between his ideal and his real loves that preyed on him and destroyed his mind.' Middleton, it will be seen, makes the matter plural instead of singular. There is, however, no doubt that the contrast of ideal and real emphasised by Pre-Raphaelitism itself, had become a morbid element in the man's over-subtle and ingenious mind; the same subtlety preventing him from arriving at a termination of the confusion thus produced. Remorse did not lead him

to renounce 'Fanny Cornforth', with whom there was no recorded break in his relations but some indication of closer proximity. He did not confuse the liking he had for this lady, compounded of amusement and wonder, as it seemed, before a vulgar and avaricious specimen of human organism, with the spiritual love he felt for that other; at the same time he made, or could make, no conscious effort to control the fate of his affections. Hall Caine, who was to know Rossetti in his later years, had a different explanation from Middleton's. He reconstructed

'the figure of a man who, after engaging himself to one woman in all honour and good faith, had fallen in love with another and then gone on to marry the first out of a mistaken sense of loyalty and a fear of giving pain, instead of stopping, as he must have done if his will had been stronger and his heart sterner, at the door of the church itself. It would be the figure of a man who realised that the good woman he had married was reading his secret in spite of his efforts to conceal it and thereby losing all joy and interest in life. It would be the figure of a man who, coming home late at night to find his wife dying, probably by her own hand, was overwhelmed with remorse not perhaps for any unkindness, still less any act of infidelity on his part, but for the far deeper wrong of failure of affection for the one being to whom affection was most due.'

In other words Rossetti fell out of love with Lizzie, but married her all the same like a gentleman. To whom did he transfer his affections? Caine is not very explicit. Did he mean Jane Morris? An oral tradition would have it that Rossetti loved her. . . . It is a pity he was not more definite. It is not easy to imagine from the 'reconstruction' what the overwrought, drug-ridden painter told him in a dark, swaying railway carriage somewhere between Cumberland and Euston. Nor, if one did know, would one accept, without caution and allowance, the rambling phrases of delirium. There may be truth in wine but not in drugs. Assuming, however, a love for Jane Morris, reciprocated by a quite irreproachable and innocent friendship on her side, and ideal and platonic in Rossetti – the amorous complication in the time preceding Elizabeth Eleanor Rossetti's death becomes even more formidable. There would then have to be reckoned with the possibility of rival ideal women – a jealousy between spiritualities as well as a jealousy between ideal and material. It is just conceivable that the austere Lizzie could bear, though not with entire equanimity, the suspected fact of a vulgar and commonplace amour. But to be supplanted, not as simply a physical toy, but as a spiritual ideal, to realise also that these mutually compensating forms of love were

distributed between two other women – that would indeed be a torture. The 'eternal triangle' is usually regarded as an adequate symbol for the complexity of sexual relations; but by what geometrical figure this indecisive play of forces between three women and a man should be rendered – almost defies representation. Even Dante Alighieri did not conceive the possibility of two Beatrices. The possibility of a loyalty maintaining in position this unique parallelogram of two different kinds of forces under the necessary appearance of treachery to each is at least interesting.

But grief Rossetti certainly felt, and remorse no doubt of a kind – perhaps even for having known Lizzie at all and drawn her into the vortex of his unnatural life. There is a throb of sincerity in the letter he wrote to Mrs Gilchrist, with whom not long before he had sympathised on the death of her husband, cut off suddenly while preparing the Life of Blake in which both Dante Gabriel and William Michael Rossetti had taken much interest. 'I thank you most sincerely for the words of sorrow and sympathy which coming from you seem more terribly real than any I have yet received. ... Of my wife I do not dare to speak now, nor to attempt any vain conjecture whether it may be possible for me, or I may be found worthy, to meet her again.' That the idea of meeting her again was in his mind is sufficiently evident from this; and for days before the funeral he gazed on her face, more beautiful than ever in the calm of death, until he became convinced she was not really dead, that she was in a trance due to the slumberous drug, and he insisted on recalling the doctor and asking if it were not so.

Impossible not to think of the *Vita Nuova*; of the state of trance resembling death in which

'Beatrice is gone up into high heaven
The kingdom where the angels are at peace':

that his mystical mind, ever snatching at analogies, finding the only true reality in the spirit, connected the tragedy with the poem in which he had steeped their lives, whose sequence was so strangely paralleled by what did, in fact, happen.

It was something beyond 'romantic love' – a union of spirit, inasmuch as he had created or projected his own spirit into her: and as formerly she had been the victim of his artistic imaginings, goaded into reflecting his genius, agitated, even fatally, by the expansion of her life in the heat of his mind, so now, perhaps, he was her victim, simply because of the fusion of spiritual being between them. It was in this sense that the death

of Lizzie was a point midway in their love story. Not to be separated from the fabric of his mind, in spite of the other rival elements interwoven in it, she remained, immortal to him as Beatrice to Dante, and her sufferings were now prolonged in him. That he did think of her like this may be guessed from the famous *Beata Beatrix* which he painted in 1863, the year after she died. Beatrice sits on a balcony overlooking the bridged river and city of Florence, misty and dim like London. Her head is thrown back, her expression is sad and sweet. There are many symbols. The bird that is the messenger of death is red, because red is the colour of love; her robe is green, colour of spring and hope; over a ground of Pre-Raphaelite purple – the colour of suffering. The face is that of Rossetti's wife, 'portraiture so faithfully reminiscent that one might almost say she sat in spirit and to the mind's eye', said William Michael.

Intensely personal as he was in all things, Rossetti felt the horror of separation as keenly as any human being could. To fasten some material bond between them still, to make some final sacrifice of what he valued, he strode unseeing past the friends in the outer room at Chatham Place, spoke to Lizzie as if she could hear and placed his little green- or grey-covered book of manuscript poems in the open coffin, between her cheek and hair.

The book was buried with her in Highgate Cemetery; and this was the first act of a tragedy as it was also the last.

2 The Whims of a Caliph

Dante Gabriel Rossetti was now thirty-four – and considerably changed from the poetic youth of the PRB days. The upper part of his face, the brow in particular, was fine, the eyes with their magnetic glint and changing lights remarkable though dark ringed; but the mouth was now inclined to looseness, the wide nostrils were coarse, the show of teeth when he laughed gave him a satirical look. Thin dark curls ringed his head while he wore a beard of curious square cut like the Winged Bull of Nineveh on which he wrote one of his best poems. His coat, fastened by a single button at the neck, was old (they wore clothes an unconscionable time in those days), his braided waistcoat bulged with an awkward and increasing fatness.

To outward appearances the shock steadied him, positively stabilised his existence. He slept no more in Chatham Place, which was taken over by his friend G. P. Boyce, the water-colour painter and a fellow-collector of china; but after a brief interval with the family in Albany Street, where Lizzie's bullfinch sang its cheerful song as if nothing had happened, and

in rooms in Lincoln's Inn, he took the lease of a pleasant house in Chelsea, No. 16 Cheyne Walk, which he occupied for the rest of his life.

It was a Queen Anne house whose site had some Tudor history. Bow windows had been added to the plain brick front. It had nearly an acre of garden which he permitted to become a complete wilderness. Nothing was ever done to the exterior and when Hall Caine saw it in 1880 a wild tangle of ivy was smothering the brick, the flags of its courtyard were grown over with weeds, and there hung about it an atmosphere of dirt and decay. The interior arrangement was confusing but the room space ample. Three doors led out of the hall, one at each side and one in front. Alterations had done away with a main staircase leading to the upper rooms, though a series of columns and arches on one side of the large studio room (thirty feet by twenty) suggested its position. Corridors led from the hall, lit only by the fanlight of the door and alteration had produced a bewildering plenty of nooks and corners, pleasing to the architect of so many intricate pen-and-ink palaces. The drawing-room, also used as a dining-room, ran across the front of the house and overlooked the river, and the picturesque and irregular shore, broken by jetties and beached sailing boats which existed there before the Chelsea Embankment was made. The rent was £110 a year: a good deal for those days; though the accommodation was much beyond his personal needs, enough to provide separate sitting-rooms for three guests as well as sleeping quarters; to provide also for domestic staff and painting assistants with the casual amplitude of an Italian palazzo. He himself slept at the back, in the dead quiet of a room overlooking the garden. The contrast between this and the noisy bustle to be seen and heard from the front was marked.

Having disposed of the dream lodgings he got rid of the dream patron. He would not see Ruskin any more. The latter's final effective act of patronage was to finance the publication, in 1861, of Gabriel's youthful translations of the *Early Italian Poets*. A suggestion that he might live at Cheyne Walk was vetoed. That fantastic friendship did not survive in the hard, the even vindictive atmosphere of grief.

He had renounced poetry. Having given up the poems he had already written, he did not for eleven years choose to write any more. He largely renounced – that is, as an emotional experiment – dream pictures; neither the *Vita Nuova* nor the *Morte d'Arthur* had its old spell; though one large picture of *Dante's Dream* was to occupy him technically a great deal. Instead he began to paint women or woman as woman. Before Lizzie died he had given evidence in his art of the treachery of idealism possibly

in his mind. Jane Morris had become and was to remain the ideal type in his paintings; though he made a drawing of the much-worshipped Miss Herbert, the actress, inscribed, with overwhelming tribute, BEATRICE, HELEN, GUENEVERE HERBERT. Fanny Cornforth, who was now Mrs Hughes, was his alternative type, more flamboyant and sensuous. She was installed in Chelsea, near at hand. He had models besides, but these two provided sufficiently opposite poles, a contrasting range of feminine qualities. Darkly beautiful, contemplative, mysterious, Janey was his *Proserpine*, while Fanny appears as a flaming 'stunner', rich in barbarous splendour of gown, ornament and countenance. A material, a surface luxury came uppermost, of colour, patterned stuffs, feathers and jewels. For several years Fanny predominated and it is fairly easy to trace the likeness of the 'pre-eminently fine woman with regular and sweet features and a mass of the most lovely blonde hair – light golden or harvest-yellow' so William Michael himself admitted 'Mrs H——' to be. In the same way it is easy to trace the likeness of Jane Morris, though the likeness was not his main purpose.

For the portrait, the specific image, Gabriel had some, perhaps even a superstitious, aversion. A letter to Vernon Lushington, dated 30 July 1865, gives one reason for this reluctance – an excellent water-colour, nevertheless, being the outcome.

'MY DEAR VERNON',

'I am heartily ashamed of not answering your letter before this but have been so busy with some work that there was no prospect of making an appointment to begin anything else. I must say, frankly, that whenever I have undertaken a portrait *as such*, I have always felt myself so encumbered with anxiety as to getting a good likeness (without which it is of no value whatever to friends) that I have generally failed in this more than in any other kind of work.

'I am so full now of many things to do for some time to come that I fear all I could undertake with the prospect of bringing it to a conclusion within a reasonable date would be a "head and shoulders" portrait. This I should like to attempt if first drawings (which I always make) come at all promising as to likeness. I fear from what you say, however, that there is no time to get the portrait done now before you leave town. But if you would like me to make the first step now by doing a drawing of Mrs Lushington could she kindly give an hour or two's sitting any day most suitable to herself after Wednesday next at 12 noon.

'With kind remembrances to her, I am ever,

'Yours affectionately,

'D. G. ROSSETTI.'

Georgiana Burne-Jones observed that his own image in the glass seemed as if it filled him with a sick melancholy as he drew it. In 1875 he conceived a great dislike for a portrait G. F. Watts had made of him and wheedled it out of Watts in exchange for a chalk drawing. The hated portrait found its way into the hands of Fanny.

Another curious thing was that now, quite suddenly, he discovered how to paint. There was no more of the fiddling, rubbing and scraping out, the fretful fumbling with his materials of the Ruskin days. With competence and certainty he carried out large pictures and handled difficult problems in a workmanlike way that was quite surprising. 'I paint by a set of unwritten but clearly defined rules which I could teach to any man as systematically as you could teach arithmetic,' he told Hall Caine, later.

'Still,' said the latter, all his romantic ideas tottering, 'there's a good deal in a picture like this besides what you can do by rule – eh?'

'Conception, no doubt; but beyond that, not much. Painting is the craft of a superior carpenter. The part of a picture that is not mechanical is often trivial enough.' Gabriel evidently enjoyed this.

The superior carpentry sold well. Like one of the old Italian masters he not only worked hard and continually himself, he employed assistants on details and on the many replicas which, like an Old Master, he turned out. Between 1863 and 1867 there was W. J. Knewstub who lived on the premises. He helped Madox Brown later at Manchester and continued to do odd jobs for Rossetti. From 1867 a Cornishman, H. Treffry Dunn, took his place at Cheyne Walk.

Money troubles, if not at an end, were at least kept down by the large income resulting from his steady industry. He had no accounts but he seems to have made anything between two and four thousand pounds a year. He would keep large sums in a drawer, bring out a handful of coins when required, giving them, uncounted, with the gesture of a prince bestowing 'a purse of gold'.

He upheld a princely state: untidy, inexact, yet spacious and free. He began to indulge a taste for collecting all kinds of old, curious and ornamental things, but mostly china. He had all the old charm and abundant humour; still showed himself in society and for a while received old friends. One moonlight night in 1865 there was a party in Cheyne Walk. There were many familiar faces. Georgiana and Edward Burne-Jones, William Morris and Janey, Munro the sculptor and his wife, Arthur Hughes and his wife, Bell Scott, the Warrington Taylors (Warrington

Taylor was the business manager of the Company), an artist called Legros whom Gabriel had met in Paris, who was settling in England. Christina Rossetti and Mrs Bell Scott would have been there but it was Passion Week. The Madox Browns and their two daughters arrived late, having come from Kentish Town to Chelsea by some roundabout and expensive train journey in order to save the cab-fare (Madox Brown, Georgiana noticed, was turning grey). William Michael and Swinburne, who were staying at Cheyne Walk, also appeared It was gay enough, though affecting to see Lizzie's water-colours framed and hung in the long drawing-room. They all met again one night at the Madox Browns'. There were Morris and Janey once more and Georgiana and Ned. Christina, this time, 'gently caustic of tongue', Legros and an American Gabriel liked, James Whistler, with thick black hair curling to his eyebrows, and an angry eyeglass; Swinburne in evening dress and Charles Faulkner who was pestered for 'stories' by little Nolly Brown, aged ten. 'And on this day of the union and reunion of friends there was one who had come amongst us in friend's clothing, but inwardly he was a stranger to all that our life meant', says Georgiana with about as near an approach to anger as she ever achieved. The stranger was called Charles Augustus Howell.

This new, and to the gentle and respectable devotees, alien presence, was that of a remarkable man. It has become possible to piece together from numerous scattered references the picturesque outline, in place, here, because of his influence on Gabriel. He has been represented as a villain; he was certainly a romancer.

> There's a Portuguese person named Howell
> Who lays on his lies with a trowel:
> Should he give over lying
> 'Twill be when he's done dying
> For living is lying with Howell.

It seems he was the son of an English drawing master living in Lisbon and married to a Portuguese. He claimed descent from Boabdil el Chico, rendered by the Pre-Raphaelites as 'the Cheeky'. His youth, he used to say, was spent in diving for gold in the sunken wrecks of Spanish galleons. He invested his presence in England with the vague importance of a secret mission and wore a broad red ribbon across his shirtfront which was alleged to be some Portuguese decoration. William Morris supposed he had stolen it from somebody. In 1857 he left Oporto where there was trouble over cards, and even 'card-sharping' was mentioned, and was sent

to an uncle in Darlington. He was only seventeen, but made his way to London and then met Rossetti for the first time. He was in Portugal from 1858 to 1864 and returned to London where he became, as Brown called him, the 'Munchausen of the Pre-Raphaelite circle'. About the time of the party referred to (1865) he was engaged by Ruskin as secretary. Both Ruskin and Rossetti were fascinated by him. The former, when asked why he employed such a man, explained that he could not give Howell a character, neither could he let his wife and family starve. Old Mrs Ruskin wondered 'how *can* you two men sit there and listen to such a pack of lies'. 'A Niagara of lies', as Gabriel delightedly styled his talk. But the author of *Modern Painters* continued to employ him, on his various charities and benevolences mainly, though Howell related that he was sent to Ireland in 1868 entrusted with the delicate mission of overcoming the difficulties of one of Ruskin's hopeless passions: that, disguised as a tramp, he obtained an interview but 'without effecting the desired change of sentiment'. In that year also Burne-Jones moved to the Grange. Northend, and Ruskin gave Howell £200 to live in the same region and keep Burne-Jones company. For a while the latter was fascinated by him, then something turned the painter into his enemy, and he made strong representations both to Ruskin and Rossetti to have nothing more to do with him. Howell's charm of manner and fund of amusing stories made him a general favourite. But of course those against whom the amusing stories were directed found reason to change their view and were loud afterwards in abuse.

In Watts-Dunton's novel with a key, *Aylwin*, Howell is *De Castro* and the most vivid and life-like scene in the book describes a conversation between him and the painter *D'Arcy* (Rossetti) in Scott's oyster-rooms. *De Castro* is broad-backed, yellow-green in complexion, 'something like a vegetable-marrow', smoking cigarettes in 'that kind of furious, sucking way which is characteristic of great smokers'. Clean-shaven, with a receding forehead, high cheekbones, a prize-fighter's jaw, he wore a smart velvet coat, and looked 'as if he might somehow be a gentleman'. (According to Hall Caine, in whom he produced the most disagreeable feelings, Howell had 'the face of a whipped cab-horse'.)

De Castro-Howell, in the oyster-rooms, was telling anecdotes with great gusto and humour – 'in which the names of Millais, Ruskin, Watts, Leighton and others came up in quick succession'. He was a story-teller 'reckless and without conscience . . . inventing anecdotes to amuse his companion whose manifest enjoyment of them rather weakened the impression that his own personality had made' on – Aylwin.

You might take such a man seriously and regard him as a smooth and plausible villain in whom there were alarming possibilities, a dangerous companion who might pull you into the depths if you were not careful. 'The pole-cat Howell; the vilest wretch I ever came across.' This was Swinburne's remark to William Michael in 1898. It summarised a queer story. Poor Algernon was in the habit of writing silly and improper letters to his acquaintances. Some such letters, written to Howell, came into the possession of an obscure publisher who threatened to issue them. It caused the poet much distress. He saw Howell at the bottom of it; and Howell, never able to resist being amusing at others' expense, did him harm also by his gossip.

On the other hand you might regard him as a supremely amusing type, almost a character of fiction. This was Whistler's view. He described him as 'the wonderful man, the genius, the Gil-Blas-Robinson Crusoe hero out of his proper time, the creature of top-boots and plumes, splendidly flamboyant'. It was Rossetti's view. A Pre-Raphaelite 'villain', and no doubt such an all-embracing movement had to have a villain, must necessarily be out of his proper time. He had to have a flavour of the past when even villainy was romantic and not the sordid material matter of modern times. It may be objected that Howell was not really Gothic enough, that his impudence savoured rather of the Baroque than the Mediaeval period – but romantic it was and his lies served in their own way the purpose of divesting facts of commonplace dreariness and indicating magnificent possibilities of imaginative life.

There was one thing about which there was no doubt and that was his commercial ability. By 1866 he had become Swinburne's man of business, the partner of his amusements and his literary agent. At the same time he began to interest himself in the sale of Rossetti's pictures. He had an amazing gift that way. He could deal conveniently with the output of poet and painter as they were both living at Cheyne Walk, and the artist found that he was selling more work than he had ever done before. Algernon Charles Swinburne, as the most recent worshipper of Gabriel and Lizzie, was an obvious candidate for one of the three sitting-rooms. Off and on, William Michael occupied another. George Meredith was to have had the third; but Meredith did not come to stay. There is some doubt as to whether he ever stayed a night. The novelist was a widower. Gabriel had written to him in 1860, expressing approval of *Evan Harrington*, and trying to induce him, as literary adviser of Chapman & Hall, to recommend a new edition of Charles Jeremiah Wells' Biblical drama, *Joseph and His*

Brethren. This poetic curiosity had been originally published in 1824 and was the belated discovery of Rossetti and Swinburne, both showing an extraordinary enthusiasm for it. The project had not come to anything. 'But a poem on a scriptural theme, you know how little chance it has with the British Public, be it never so good', said Meredith . . . '*sales* as well as merit, is what we shall have to look to.' A polite, but not cordial, friendship existed between Rossetti and Meredith. Hunt also desired the friendship of Meredith, whom he thought the perfect type of well-bred Englishman; but when he heard he was going to live at Cheyne Walk he dropped the idea. What Meredith was pleased to call his *lumen purpureum*, however, was scarcely in Rossetti's line. He observed later to Dr Thomas Gordon Hake that Meredith's novels were 'irritating to the nervous system'. Irritation of some kind appeared at once. It may have been the sight of the numbers of poached eggs, like so many bilious eyes, which habitually served for Gabriel's late breakfast, that offended the fastidious author of *The Ordeal of Richard Feverel*. Rossetti told Wilfrid Meynell, the author and editor, that they sat down to a meal, and Meredith said something annoying. 'If you say that again,' said Gabriel, 'I will throw this cup of tea in your face.' Meredith said it again, Rossetti threw the tea and 'the perfect type of well-bred Englishman' left the house at once and sent for his effects during the course of the day.

This impatience with a polite and formal person may have had to do with Gabriel's grief in an odd way; as if now a friendship of a merely amusing kind, with an element of caricature or excess, leaving untouched his still wounded feelings, alone would satisfy him. There was this element of caricature in his friendship not only for Howell but for Swinburne.

With Swinburne he could not be in perfect sympathy. There was something masculine about Rossetti even in his errors, in the wild flights of his subtle imagination. The 'demoniac youth', as Ruskin called Swinburne. doubting 'whether he will ever be clothed and in his right mind' was abnormal in a different fashion. He insisted on physical rather than mental sensation. He had that so often fatal combination of endowments, aristocratic birth and genius. Personal vanity, dauntless courage, physical weakness, a craving for what was sensational and exotic, with a delicate nurture that prevented his getting breadth of experience or a sense of proportion, coloured and clogged his gifts. With his huge frail brow and flaming red hair, his weak receding chin, the son of the admiral, the grandson of Sir John Swinburne of Capheaton, was a little like one of those odd noblemen the French delighted to put in their books – the Des Esseintes of Huysmans'

A Rebours who spent his life in devising exquisite sensations of smell, sound and sight; or the M. de Charlus of Proust. He rejoiced in having a head like Galeazzo Malatesta in Uccello's picture of *The Battle of Sant' Egidio*. He proclaimed at a party that it was his ambition to build seven towers and in each of them to enact one of the seven deadly sins. It was pathetic also because the twittering, restless little fellow, unable to keep still and constantly jerking his wrists and strumming with his fingers, could not stand debauchery and a small amount of liquor made him very ill indeed.

These three, Gabriel, Howell and Swinburne, the melancholy artist, the suave soldier of fortune and the freakish fragile aristocrat, now explored the 'acrid putrescence' of the London of the 1860s.

One imagines them at Cremorne in the *Hermit's Cave* and *Fairy Bower* amid the polka-dancing mob. One hears the pop of champagne corks and the gurgle of the brandy bottle in some blazing resort near the Haymarket. One sees Swinburne subsiding in the midst of a wreck of glasses, repeatedly comparing himself with Shelley and Dante, asserting that he was a great man only because he had been properly flogged at Eton; that two glasses of green Chartreuse were a perfect antidote to one of yellow or two of yellow to one of green. One sees them venturing into the slum quarters which were then infernal in their wildness and riot. Or at Astley's theatre, applauding Adah Menken in the rôle of Mazeppa. Rossetti, it is said, urged on Swinburne to make love to the celebrated equestrienne and poetess. When she began to talk of their common interest, Swinburne said, 'Darling, a woman who has such beautiful legs need not discuss poetry.' He was photographed with her, looking meek and dwarfed by her buxom contours.

'You see before you,' says De Castro in *Aylwin*, indicating his painter friend with a theatrical gesture, 'the famous painter Haroun-al-Raschid who has never been known to perambulate the streets of London except by night and in me you see his faithful vizier.' In all probability this is what Howell did say. There was now something of the Caliph in Gabriel. His famous menagerie with its varied assortment of animals was a caliph's whim.

He collected peculiar creatures as he collected peculiar people. It was another alternative world. Detached from it as he was detached, in fact, from Howell and Swinburne, he took pleasure in the imaginative fancy of creation. He understood animals, their antics and their humour though he did not make pets of them; and he found in them, with a sort of irony, the

equivalents of human beings. His purchases were made principally at Jamrach's in the Ratcliffe Highway, now a dreary little row of empty houses and shops, marked down for demolition and renamed St George's Street (subsequently *The Highway*); then a lurid quarter of sing-song caves, opium dens, sailors' orgies and savage misery.

It was not a phase that outlasted the 1860s, but during these years he possessed kangaroos, a wallaby, a chameleon, some salamanders, wombats, an armadillo, a marmot, a woodchuck, a deer, a jackass, a racoon and smaller animals galore. The birds included peacocks, parakeets, Chinese horned owls and a raven. There was a marquee and cages in the desolate garden to house them. He bought a Brahmin bull because he said it had eyes like Janey Morris. He would have bought a lion only this would have entailed a special arrangement of hot-water pipes. He wanted to buy an elephant. Browning, it is said, asked him what he wanted an elephant for. He replied that he meant to teach it to clean the windows so that people, seeing it, would ask who lived there and then come and buy his pictures.

As he collected curious people and animals so he collected curious things, blue and white Nankin, Japanese prints and screens, old carving and musical instruments. The taste for Oriental art had begun in Paris with the brothers de Goncourt who were among the first to appreciate in it a standard of beauty – a restraint, order and rhythm which the art of Europe had not consciously developed. Whistler picked up the idea and brought it to London. He imparted the craze for collecting Oriental things to Rossetti, though not the aesthetic motive: Pre-Raphaelitism was never so exact in its definition of beauty. It had nothing to do with 'art for art's sake', the discovery of the Second Empire in France and the imported creed of England in the 1890s; and Gabriel was unaffected by the 'Gallo-mania', literary with Swinburne, pictorial with Whistler, which heralded that epoch. A confusion arose at the time which has persisted since. The satires on the new mode, representing it as a 'precious' and affected craze, by du Maurier in *Punch*, were based on Rossetti. Millais, du Maurier's friend, may have contributed not a little to form this distorted picture of a funny foreigner out of the man who had been his fellow Pre-Raphaelite.

Rossetti's collecting was a sport in which Howell joined with a will. There is a description by Treffry Dunn of the pantomime which resulted from their each trying to steal a march upon the other. Howell discovered some rare piece of 'Blue' and invited a number of friends to see it. Rossetti made off with it under his Inverness cape and concealed it at Cheyne Walk, meaning to produce it at a return party. Howell guessed what had hap-

pened and quietly made a search at Cheyne Walk, finding the piece and substituting an old cracked piece of Delft in the cloths which Rossetti had wrapped round the treasure – returning quietly to his 'Irish cold' and the 'inevitable cigarette' in the studio. He then challenged Rossetti to produce the so-called rival piece to his: and when the cloths were unwrapped Rossetti was dumbfounded. 'Confound it!' he said, 'see what the spirits have done.' There was general laughter and he soon 'laughed as heartily as any of his guests at Howell's ingenious revenge'. Perhaps the most significant feature of this harlequinade is Howell's sleight-of-hand. One evening a pile of eleven etchings had been pulled by Whistler. The next morning there were only five. 'It's very strange,' said Howell. 'We must have a search. No one could have taken them but me, and that you know is impossible.'

When he died in 1890, under strange circumstances – he was found in the gutter outside a public house in Chelsea with his throat cut and a ten-shilling piece between his clenched teeth (expiring a few days later at the Home Hospital in Fitzroy Square) – many lost objects of art reappeared. Ellen Terry wrote to W. Graham Robertson, 'Howell is *really* dead *this* time – do go to Christie's and see what turns up'. He had previously shammed being dead and arranged a sale of this sort himself. Robertson gave a list of the items to Whistler who was able to recognise many of them. 'That was Rossetti's – that's mine – that's Swinburne's . . . You couldn't keep anything from him and you did exactly as he told you. He was really wonderful.'

With the wonderful man Rossetti went in for a more dangerous game than collecting. Some of the mistrust with which the 'wonderful man' was regarded came from his ability to play on the weak point to find the spot in the mind that was most tender and least protected. For all the front that Rossetti put on of the ironic, the detached artist, he had that tender place. It was the memory of his wife. She had disappeared from his art; was replaced in his life by diversions of the sort that have been described; but the thought of her was still before him. The idea not of a poet's conception of another world but of an actually existing other world now possessed him. He had never made any distinction between external reality and mental impression. Encouraged by Howell, he went in for the occult.

Occultism as a systematic performance had begun about the same time as the Pre-Raphaelite Brotherhood. William and Mary Howitt, Rossetti's friends, had been much interested in it, and became diverted from the Quaker faith to the notion of a universal religion to be found in Spiritualism.

Howitt's *History of the Supernatural* appeared in 1863. There had been quite a spiritualistic vogue among artists. Some of Gabriel's friends pooh-poohed it. William Bell Scott was scathingly unbelieving. In 1866 he went at Gabriel's invitation to a séance but insisted on seeing the medium's feet all the time, as well as those of the table. Rossetti protested at this sceptical attitude and the meeting broke up. Scott lamented his implicitly believing in a creature so abject as the medium.

But Howell, as capable of spinning plausible yarns about spirits as about living friends, at least pretended to believe and made it seem convincing.

In the garden at Cheyne Walk Gabriel received the mesmerist Bergheim. George Augustus Sala, the famous journalist, F. R. Leyland and Howell were there. Bergheim mesmerised two women assistants he had brought and suggested to them various acts which they carried out in a way only possible in a trance. One, to whom it was suggested that she was in charge of a small child about to be run over, picked up a heavy man (who was asked to represent the child) and moved him with ease. Rossetti was seriously impressed. He went further into it; and it is possible that with the magnetic power he had always had, which made the impression he created on most people he knew into a kind of mesmerism or supernatural force, he could actually transfer his thought to a sensitive object and receive it back again as if it were a supernatural message. In the end it filled him with dread. 'You must not go', he said to Hall Caine who intended to patronise a séance. The latter asked if he thought it was a fraud. 'No, but they're evil spirits – devils – and they're allowed to torment and deceive people.' He was by then liable to delusions and suspicions; but the vehemence of his objection testified at any rate to his belief.

Whatever the exact circumstances of his occult experience and whether or not the phenomena he saw were genuine, painful thoughts rankling in his mind were roused afresh; and this agitation was increased by a duality in himself which he had tried to subdue but which now rose up again, the duality of his gifts as poet and painter. It has been noticed that he had a certain contempt for the material and technical side of painting, before and after he had mastered it. After a prolonged bout of painting, during which his only poetical works were sonnets for pictures, the poet rose up in him with renewed vigour. 'My own belief', he explained to Dr Hake in 1870, 'is that I am a poet (within the limits of my powers) primarily and that it is my poetic tendencies that chiefly give value to my pictures; only painting being – what poetry is not – a livelihood – I have put my poetry chiefly in that form. On the other hand, the bread and cheese question has led to a

good deal of my painting being pot-boiling and no more – whereas my verse, being unprofitable, has remained (as much as I have found time for) unprostituted . . .'

He thought of coming before the world again as a poet, now that the bread-and-cheese question was less urgent. Moreover, he had begun to feel a strain on his eyes which was causing him alarm and inclined him to turn from painting to an occupation less exacting to the sight. To make an effective re-entry as a poet he must include with any fresh verses those he had already written; and they were in Highgate Cemetery under the ground. Swinburne and other friends could quote some from memory. He had made some manuscript copies and given them away. He could no doubt recall some himself; yet all this did not seem the same thing as the actual words and the precise order of words inscribed in that little manuscript book; and he began to think of recovering it, of bringing his poems back from the tomb.

No doubt Howell laughed away his scruples; appealed to the vanity of the artist; put forward common-sense arguments. He was certainly the executor of the plan. The arguments were these: that it was wrong to withhold from the world what was due to it as the best work of one of its great men. It could make no difference to Lizzie now. It had been a gesture of his own making, and seven years afterwards surely he might as reasonably give up this attitude of renunciation as one would give up a suit of mourning.

There was a certain reason in this. Ford Madox Brown had objected to Rossetti's burying the poems, and he was a sensible, honourable fellow. If Rossetti had been wrong then, was he not now persisting in his error? On the other hand – it was a desecration. However misguided he had been formerly, to recover the poems now meant rifling a grave – the grave of his wife. However acceptable they might be to the living, their recovery was an insult to the dead. Out of a petty vanity he was to undo an act of homage and atonement – to wriggle out of a sacrifice he had voluntarily made – to be false to the dead. All this must inevitably have passed through his mind, causing him to waver this way and that until finally the day was won by the 'person out of another world altogether' who was, in Hall Caine's opinion, 'totally destitute of delicate feeling and almost without the moral sense' – Howell.

'Your letter about the poems was very kind, but it's a ghastly business,' Gabriel wrote to Howell in the summer of 1869.

He was despatching notes hither and thither to see if he could collect

manuscript copies from friends, but without much success. This note, to his friend Lushington, dated 7 August 1869, is an example.

'MY DEAR VERNON,

'Did I, years ago, give you a M.S. copy of a poem of mine called "Jenny"? I want a copy, not having one in a perfect state. To someone I gave and have a faint notion it may have been to you.

'Write me a line,

'Ever yours,

'D. G. ROSSETTI.'

The results were not satisfactory and by 16 August 1869 he had decided. 'I feel disposed,' he wrote to Howell, 'if practicable, by your friendly aid, to go in for the recovery of my poems, if possible, as you proposed some time ago. Only I should have to beg *absolute* secrecy to *everyone* as the matter ought really not to be talked about.' He did not wish the family to know because of their religious principles, and he was like Macbeth in thinking "twere well it were done quickly'. 'If you think it can be done now, so much the better. It is a matter on which – having lately been taking up my old M.S.S. – I begin to feel some real anxiety.' The postscript to this letter shows eagerness. 'If I recover the book I will give you the swellest drawing conceivable or, if you like, paint the portrait of Kitty' (Howell's wife).

He instructed Howell to write to him in Scotland, whither he was just on the point of going – to Penkill Castle, Girvan, Ayrshire.

3 Hypochondria in a Castle

Penkill was an old, grey castle with battlements, a drawbridge and port-cullis, grim stone walls and mullioned windows. It had a square peel tower of five stories with corner turrets pierced with loopholes for defence. The lowest floor was the stable, above this was the living-room, above this the 'Ladies' Bower', the top room leading out on the roof. George Street, the Gothic expert, said the original part could not be later than 1450. In the seventeenth century more rooms and an outside stone stair-case had been added. A high stone wall enclosed this impressive demesne, and near at hand was a lovely glen through which the Penwhapple went rushing. It was the place for a baron of the late Middle Ages or a Pre-Raphaelite to live in.

And a Pre-Raphaelite did live in it. That is if William Bell Scott can

so be called; and indeed what else could he be called, having been drawn into the vortex so often and even in the provinces keeping his contact with them – with Rossetti above all. He also was a poet and a painter – the author of *Poems of a Painter* – which Carlyle, mis-reading, took to be *Poems of a Printer* and severely criticised, recommending to the supposed printer the habit of *doing* instead of *saying*. Essentially *null*, Carlyle declared him to be – though not so entirely as Carlyle, maybe with some personal dislike of the shrewd fellow-Scot, would make out. Two water-colours, at least, of Penkill and a Caledonian seashore, elect Bell Scott to Pre-Raphaelite merit. He was a sceptic both about religion and humanity, a pedagogue, candid, malicious, limited. His memoirs were considered to detract from Rossetti because they were outspoken – but they breathe an occasionally wistful affection for him, and he was in his own spiteful way one of Gabriel's slaves. He was now fifty-eight, had tufted eyebrows that went up at the corners like those of Mephistopheles, had lost his hair and wore a wig about which he was sensitive, and had a genial partiality for the wine of his native land.

When the Government Schools of Design were reorganised, he retired with a pension in 1864, devoted himself comfortably to painting for his friends, Lady Trevelyan and Miss Alice Boyd, was quite happily recon-ciled to the fact he would never set the Thames on fire. He had saved something, which he invested in Egyptian bonds and Berlin Water Works (the latter perhaps influencing his strong anti-French sentiment in 1870) and bought an attractive Adam house in Chelsea near the old wooden Battersea Bridge and not far from Rossetti. On Miss Boyd's suggestion he painted a series of subjects from the poem written by James 1 of Scotland at the end of his imprisonment in Windsor, the *King's Quair*, round the great circular staircase built by Spencer Boyd, the owner of Penkill. Spencer Boyd died in 1865 and Scott's visits to Spencer's sister Alice, who had come into the property, were indefinitely lengthening. Between him and Æ as he wrote her initials, there was a delicate, a spiritual relationship. There was a Mrs Scott, but she, Letitia, through an attack of typhoid, became simple after a fashion, disinclined to travel from London and un-able to share in her husband's artistic and intellectual interests, while remaining on perfectly amicable terms with him. In communion of mind, Æ did share those interests.

The art-master-baron, desirous of showing the King's Quair, and Miss Boyd thinking a change would cure his depression, induced Gabriel to visit Penkill in the autumn of 1868. This visit may have prepared him to

lend a ready ear to Howell, for they talked much of Rossetti's poetry and tried to 'change the bias' of the years during which he had been successful as a painter. There were four of them: Miss Boyd, Scott, Gabriel and Miss Losh of Ravenside, also a visitor, cousin of Miss Boyd's, aged seventy. Miss Losh hated Scott. She suspected his influence over Alice. She looked forward to playing off Gabriel against him, 'without', says Scott, 'in the least knowing anything of the fearful skeletons in his closet', skeletons that danced and rattled when the ladies had gone to bed and when the two men took long walks in the mountains.

The talk often turned that autumn on Gabriel's fear of blindness. What should he do if he lost his sight? 'Live for your poetry', said Scott. The ladies said the same. Rossetti was encouraged to recite to them *The Song of the Bower*:

> 'Shall I not one day remember thy bower
> One day when all days are one day to me?
> Thinking "I stirred not and yet had the power!"
> Yearning "Ah God, if again it might be!"
>
> Peace, Peace! such a small lamp illumes, on this highway
> So dimly, so few steps in front of my feet –
> Yet shows me that her way is parted from my way
> Out of sight, beyond light, at what goal may we meet?'

Æ was deeply moved. Scott vowed that the lines were those of one by birthright a poet, not a painter: and he gained the impression that Gabriel, thus strenuously recalled to his early artistic love, was like a dying man with new life transfused into his veins.

Miss Losh, whether she divined the presence of the skeletons or not, was captivated by Gabriel. She offered him the loan of a large sum so that he would be free of the necessity of painting or indeed doing anything whatever. When he came down late, somewhat the worse for all the whisky toddy he had drunk with Scott the night before, smashing on his plate the eggs which composed his huge late breakfast and making brown circles on the damask tablecloth with his teacup, she would say, 'You see, Alice dear, he is not like one of us, he is a great man and can't attend to trifles; he is always occupied with great ideas'.

Gabriel told Scott he would not think of availing himself of her kindness. Nevertheless, unknown to Scott, he did. In the winter of 1868 they corresponded, Gabriel exerting all his epistolary charm. In November he reported that his eyes were about the same and made joking references to

the 'Forbidden Fruit' which Scott had 'snatched in the Eden of Leicester Square'. The latter apparently had succumbed to the temptation of carrying off a coveted book from Puttick & Simpsons – 'an act that has doubtless been photographed by the Recording Angel'. This dig at Scott would not displease the old lady. In December Rossetti announced that his eyes were better, that Mr Bowman, the oculist, 'had no apprehension as to his sight; but he did not wish to overdo exertion and so run the risk of a relapse into total inertia'. He was induced, therefore, to avail himself 'still further than I have already done of your kind offer – that is to the extent of an additional sum of £400, making in all £500 received'. It would enable him, 'with the many present claims on my purse' which had resulted from his enforced inaction to 'refrain from overworking myself to meet them'. Undoubtedly, to Miss Losh, the unknown and invisible Fanny was one of these claims. What the final amount owing to Miss Losh was when she died in 1872 is not known. An I.O.U. for an unspecified amount was destroyed. She did not press for its return and seems to have enjoyed being able to give it: while he had no scruples in taking and was in no hurry to repay. It was partly to see his benefactress again that he went to Scotland in 1869, staying two nights at her home near Carlisle on the way to Penkill. The letter to his mother in which he mentioned the fact contained also an airy reference to his poems: 'I am printing some old and new poems – chiefly old – for private circulation . . . I thought it necessary to print them, as I found blundered transcripts of some of my old things were flying about and would at some time have got into print perhaps – a thing afflictive to one's bogie'.

On this visit 'he was more hypochondriacal than ever' says Scott. There were two strange episodes. One day they went to the Lady's Glen, a ravine in which the water fell into a black pool. The circular basin worn out of the rock was called the Devil's Punchbowl. They stood at its edge and Gabriel peered over. There came a peculiar expression on his face: an expression which seemed to mean 'One step forward and I am free'. He had been talking of suicide every day, and they thought he was going to commit suicide then; but he stepped back from the slippery wet lichen round the drop and they breathed again. All three were acutely conscious of what had nearly happened.

The following day when Rossetti and Scott were out walking, they found a small bird, a chaffinch, in the path. It did not fly away but remained still and quiet even when he picked it up. 'What is the meaning of this?' muttered Rossetti, his hand shaking with emotion. Scott

suggested it was a tame bird escaped from its cage. 'Nonsense,' was his reply, still in a mutter, 'I can tell you what it is, it is my wife, the spirit of my wife, the soul of her has taken this shape. Something is going to happen to me.' When they returned to the house Miss Boyd told them the great bell at the door, which needed a strong pull to ring, had been rung – and by nobody. Rossetti asked when it had rung and, finding it must have been just about the time they saw the bird, he turned a ferocious look on Scott as much as to say this confirmed the matter. The two episodes were disturbing in their revelation of a morbid state of mind, though at the same time he was working hard on revision and on new poems, *Eden Bower*, *Troy Town* and *The Stream's Secret*. Before he left Penkill he had a volume in print, but thin and meagre. Said Scott, 'He suddenly determined to reclaim the MS. book buried with his wife. . . . In a few days he was gone'. Scott assumed it was a sudden decision. He did not know that Rossetti had determined to reclaim the book long before – and was writing to Howell about the details from Penkill itself. On 26 August, 'Will you write me in answer to what I wrote before leaving town? The matter occupies my mind.' On 3 September it occurred to him that the Home Secretary was a man he knew, Henry A. Bruce, the Welsh M.P. who had interested himself in the paintings he had done for Llandaff Cathedral. He enclosed a letter for Mr Bruce to be sent on if Howell thought fit.

Howell did think fit. He evidently described himself as a Portuguese gentleman of distinction and a friend of Ruskin, for Mr Bruce addressed him in reply as 'My Dear Signor,' and hoped, rather absentmindedly, that 'Mr and Mrs Ruskin are tolerably well'. The grave could be opened with the consent of the owner. To Rossetti himself Mr Bruce agreed to waive this condition. 'I think that the circumstances you mention justify a departure from the strict rule.' Gabriel forwarded this letter to Howell from Penkill on 16 September. He gave him a further recommendation to Bruce and instructions about the book. 'The book in question is bound in rough grey calf and has, I am almost sure, red edges to the leaves. This will distinguish it from the Bible, also there as I told you.'

The difficulties were not, after all, very great. Rossetti came back from Penkill on 20 September. On 5 October the deed was done.

A fire was built near the family grave in Highgate Cemetery, the coffin raised to the surface and the book removed. The body looked quite perfect by the glow of the fire. When the book was lifted there came away with it a strand of red-gold hair.

It had to be saturated with disinfectants. Dr Llewellyn Williams of Kennington looked after this and dried it carefully leaf by leaf.

A lawyer had to be on hand to speak to the real nature of the manuscripts as difficulties were raised to the last by the Cemetery Authorities regarding the removal of papers. Henry Virtue Tebbs, a proctor at Doctor's Commons, acted in this capacity. Howell looked generally after the arrangements; Rossetti himself was not there; he stayed away in a state of agitation and torturing suspense.

The Penkill visit first openly reveals a change that was taking place in Rossetti. The humorous indifference, the philosophic irony with which he had invested himself was yielding to physical ill-health. From 1866 onwards he suffered from an affection of the kidneys, uraemia; and his refusal to take exercise must have contributed to the insomnia which began about the same time, together with the melancholy that was thrust down but unconquered. His trouble with his eyes may have been nervous, the result of auto-suggestion, for old Gabriele had lost his sight; or of stomachic disturbance or both mental and physical factors together. Given even slight symptoms of illness he was a man who could imagine himself into any condition. There was nothing actually wrong with his eyes, and the oculists Bowman and Critchett laughed at his fears. The incident of the Devil's Punchbowl is a clue to a general state of mind. The incident of the bird and the bell, trivial enough in themselves, might be expected from his previous dabblings in the supernatural association of signs and portents. The beginnings of that suspicion which poisoned his relations with his friends and alienated them from him lurks in this proneness to read ominous meanings into what had no obvious meaning at all, though no explanation can be offered for what happened at Penkill shortly after he left. He had been in the habit of going after dinner to the room above the drawing-room to read aloud to himself as he sat alone. In the drawing-room below they could hear him very distinctly. After he had gone they heard his voice reading as usual.

Scott at this time was writing a book on Dürer (described by Rossetti to Miss Losh as a bore). The priest who was helping Scott with the proofs of his Dürer heard the sounds in the room above and was the first to comment on them. Scott and Æ went up to the room but there was, of course, nobody there. The next night it was the same, and all that season they continued to hear the voice. It is not likely the rationalist Scott would have invented the story. There were two other witnesses, what is more. It was almost as if the late guest were playing a practical joke, as if

with his power of projecting himself into the life of others Rossetti had animated even the stone walls of Penkill.

Unintentionally Scott may have made Gabriel physically worse. It was on this visit he acquired the habit of drinking whisky. Previously he had the pious horror of the Latin for this strong and barbarous spirit. He drank with the Latin moderation some, but not a great deal of wine. William Michael blamed whisky as much as chloral for his breakdown.

As always, his mind and behaviour were complicated. At Penkill he was working really hard at his poems (he wrote the *Farewell to the Glen* the day before he left). He was writing lightly and humorously to Miss Losh. He was writing urgently to Howell about the exhumation. It has been assumed that Scott exaggerated his gloom and depression. With Rossetti and that capacity of his for living in half a dozen worlds at once, it does not follow. His lively imagination anticipated horror before the poems were exhumed. What fresh access of guilty remorse, what pangs of conscience he felt afterwards when filling in the gaps made in the writing by the encroachments of decay, remained in his mind alone. It is easy to imagine the reproach he would heap on himself. He was a traitor to a vow that reached beyond the grave – a thief who had wrenched his booty from the grasp of a poor, helpless creature lying still and for ever in the tomb – too cowardly even to perform the act himself – using a knave as his resurrection-man. He was oppressed by the eternal sad reproach of a woman moving dimly in an allegorical limbo which the cruel imagination of shameful genius had devised, taxed by the weight of a moral embargo, a strange dread, a strange curse. 'I am afraid all the symptoms from which I suffer could not possibly be referred to increasing fat.' Thus he wrote to Dr T. Gordon Hake in December 1869. Dr Hake was not his professional adviser, but Rossetti had long known him as a poet, had admired his *Vates or the Philosophy of Madness* and had come into contact again, after a lapse of time and through their common interest in poetry. Hake was then sixty.

'Nor have I increased to any appreciable extent simultaneously with these symptoms – indeed at this moment I am wearing a waistcoat made some years ago without the least inconvenience. Certainly there *is* a constant gradual increase in this respect, which occasionally becomes evident in me, but then seems to subside or to become unperceived. However, some months ago I commenced following to some extent a diet suggested by reading Banting's pamphlet; but although I was pretty strict (except a *little* milk and toast at breakfast) for a week or perhaps a fortnight, I failed to experience the remark-

able change promised even within the first 48 hours. I have continued ever since to restrict myself a good deal in several things and to banish sugar almost entirely, quite so except in the *very* occasional form of pastry.'

But Banting's pamphlet provided no cure for the soul.

4 Poems from a Grave

The exhumation of the poems is one of the most famous events in literary history. Rossetti meant it to remain a secret. 'I have begged Howell to hold his tongue for the future,' he wrote to William Michael when breaking the news, 'but if he does not I cannot help it', he added. He was scarcely hopeful. Knowing Howell, how could anyone expect it to remain a secret for long? That gentleman pasted all the documents in a scrapbook (they might be useful one day). The report got about at once and greatly increased the interest with which the volume of Poems was awaited.

It appeared in April 1870. The romantic circumstances, half-known, predisposed the public and the press favourably. The praise was general. The enormous number of Pre-Raphaelite allies, the Pre-Raphaelite system of mutual aid, was fully exploited. Even Morris, who hated puffing friends, was induced to write an appreciation in the *Academy*. Swinburne wrote enthusiastically in the *Fortnightly Review*. William Michael worked the *Athenaeum*. The bouquets were showered upon the renascent poet.

Rossetti took a holiday. He went down to Sussex, to Scalands at Robertsbridge, to stay at the cottage of Mme Bodichon – Miss Barbara Leigh-Smith, friend of the old days, feminist and amateur painter. He relaxed in the tonic spring air and derived some satisfaction from the achievement of authorship. Dr Hake wrote to congratulate him. He indicated in reply at the end of April that he was going to do more. There was no falling off in his work, evidently. 'The three poems to which you give the preference – viz. *Eden Bower, Troy Town* and *The Stream's Secret* are the only 3 new ones in the first section. . . . If leisure serves from painting – of which I fear there is only too much prospect on account of my poor health – I may perhaps be in the thick of another poetic venture before long.' He discussed *Lady Lilith* – 'a *modern* Lady Lilith combing out her abundant golden hair and gazing on herself in the glass with that self-absorption by whose strange fascination such natures

draw others within their own circle. The idea which you indicate (viz. of the perilous principle in the world being female from the first) is about the most essential notion of the sonnet. . . .'

Jenny, A Last Confession and the *House of Life* were the things he would wish to be known by: and as a true, not a pictorial poet.

'I should particularly hope it might be thought (if so it be) that my poems are in no way the result of painter's tendencies – and indeed no poetry could be freer than mine from the trick of what is called "word-painting".' As with re-created forms in painting, so I should wish to deal in poetry chiefly with personified emotions; and in carrying out my scheme of the "House of Life" (if ever I do so) I shall try to put in action a complete dramatis personae of the soul.'

On 7 May 1870 he remarked with pleasure, 'The book has sold unexpectedly well and my publisher has now gone to press with the 2nd thousand'.

The few adverse criticisms he treated lightly. An unfavourable notice appeared in *Blackwood's Magazine* soon after publication. He told Frederick Shields, a young artist who had become his friend, that he was surprised to find how fleeting was the momentary impression of unpleasantness – he might almost say none at all. In December 1870 he mentioned the *Daily Telegraph*'s criticism of *Jenny* as 'maudlin and maundering', in a joking postscript to a letter to Hake. 'I thought I was shaky and galvanic enough, heaven knows; but am astounded to find that my wires cannot quite be set in motion by *The Telegraph* for all that.' He had always been sensitive to personal criticism and had never been able to take it in very good part. He disliked the whole idea of critical writing about the work of artists. It was partly why he never showed his pictures. At the same time he had always expressed scorn of reviewers and wondered at Tennyson's obsession with 'literary cabals' under which he believed himself destined to sink one day. Now he seemed to be deliberately examining his own reactions, putting himself to the test and delighted to find that he survived it with ease.

Back at Cheyne Walk he wrote to Miss Losh (11 January 1871), 'Assuredly I have nothing to complain of'. There was blame as well as praise of the book, but the praise predominated and was, he thought, in the right direction. The 'Poems' had now reached a fifth edition, and though Emerson asserted that the Rossetti poetry was too exotic for America the book was doing well there.

To add to Rossetti's satisfaction, the trouble with his eyes seemed to be at an end. He had taken to spectacles, which remedied the evil. He could paint again, had been working for months at a big picture, ten feet by seven, with five lifesize figures in it, for Mr Graham, M.P. for Glasgow. He even contemplated an exhibition. The picture occupied him greatly. In September of 1870 he had declined to visit Vernon Lushington at Ockham Park because of it; 'just now I am a slave to a big picture which blocks up all my studio. It is not yet in a state to show (nor do I mean to show it till done, which will be about the end of the year) and everything else has to be turned into holes and corners out of the studio, where there is no light to see anything. So I am obliged to put off all visits for the present.' It was stupid, he must have thought, to take notice of omens. There had been no curse at all. All was going well.

And then the dreadful thing happened.

There appeared, not an adverse criticism simply, but a smashing, destructive, brutal onslaught on his work, his morals, his motives.

The reviving hopes of pleasant and worthy fame, the light-hearted indifference crumbled – revealed the truth that he was in a condition entirely abnormal.

He was felled like an ox with the blow of a butcher's mallet.

5 A Fateful Controversy

The notorious article called 'The Fleshly School of Poetry' appeared in the *Contemporary Review* for October 1871 over the pseudonym of Thomas Maitland. It was the sort of attack that might be expected in a Pre-Raphaelite history. It started before it began. It went on after it was finished. And it was about the wrong thing.

Swinburne and Swinburne's ideas were really the subject of the controversy. He, like all revolting aristocrats and not Rossetti, had extolled 'fleshliness'. The tocsin had sounded against Algernon years before. On the publication of his *Poems and Ballads* an unsigned article (by John Morley) in the *Saturday Review* had blared, 'The bottomless pit encompasses us on one side and stews and bagnios on the other'; declared the poet to be the 'libidinous laureate of a pack of satyrs'. The hue and cry had been generally taken up. 'Thomas Maitland', that is to say Robert Buchanan, had joined in. He was a young journalist, a Glasgow Scot, who had shared a struggling literary life in London with another young man, David Gray, who died before making a name. Swinburne made some

contemptuous reference to Gray. The excitement over *Poems and Ballads* gave an opening to Buchanan to avenge his friend. In the *Spectator* for 15 September 1866 he published *The Session of the Poets* – verses jibing not ill-naturedly and very amusingly at Swinburne. Friendship brought William Michael Rossetti into the fray. He opened his 'criticism' of Swinburne with a reference to the 'poor and pretentious poetaster, Buchanan'. Thus the Rossetti clan became an object of attack. In January 1870 Buchanan turned his fire on William Michael in the *Athenaeum*, while other attacks on Swinburne, like Mortimer Collins' *Two Plunges for a Pearl*, which Dante Gabriel called 'an elaborately spiteful outrage', kept the moral issue before the public.

In this novel 'a little man built like a grasshopper', Reginald Swynfen, whose poems dealt with 'effeminate heroes and somewhat masculine heroines', was clearly Swinburne. Collins was a friend of Buchanan.

Thus by 1871 the controversy was five years old. Dante Gabriel had not so far come into it at all; but he was a Rossetti, a friend and actual house-mate of Swinburne. Therefore he must be tarred with the same brush. The publication of Rossetti's poems was an excuse for a thorough-going diatribe against the whole gang, both as poets and painters, on the ever-safe and popular ground of immorality. How little discrimination there was in *The Fleshly School* may be judged from the fact that Morris was included; but Rossetti was the principal object of attack, as the only one who was both poet and painter of pictures and as the most recent author of a book of poems.

A piece of thoroughgoing journalistic humbug, the argument scarcely deserves serious consideration. The charge was that Rossetti, Swinburne and Morris had 'bound themselves into a solemn league and covenant to extol fleshliness as the distinct and supreme end of poetic and pictorial art, to aver that poetic expression is better than poetic thought and by inference that the body is greater than the soul and sound superior to sense.'

It was the precise opposite of all Gabriel's artistic aims, as he temperately pointed out in a letter to the *Athenaeum* in December 1871, *The Stealthly School of Criticism*; but Buchanan contrived to mix up Swinburne's latter-day Byronism, his interest in Baudelaire's *Fleurs du Mal* and the Marquis de Sade's *Justine* with Rossetti's interest in Dante and Malory. He spoke with horror of 'the fantastic figures with their droll mediaeval garments, their funny archaic speech and the fatal marks of literary consumption in every pale and delicate visage': implying that mysticism and

the Middle Ages were an offence against morals. There was also the specific charge that in one sonnet in the *House of Life*, called *Nuptial Sleep*, Rossetti had written appreciatively of physical passion. Puerile and confused as Buchanan's argument was, it found an echo of assent. Even poets, in 'Victoria's formal middle-time', thought it was wrong to dream. 'Yes,' said Robert Browning to Miss Isabella Blagden in 1870, 'I have read Rossetti's poems – and poetical they are – scented with poetry, as it were – like trifles you take out of a cedar or sandalwood box: you know I hate the effeminacy of his school – the men that dress up like women – that use obsolete forms too and archaic accentuations to seem soft.' This is as curiously and falsely mixed an accusation as Buchanan's own. And even poets thought it was wrong to go into details about the passion that was their stock-in-trade. Tennyson disapproved of *Nuptial Sleep*.

It seemed to Rossetti as if the whole power of society had descended on him in retribution, in punishment for bringing his poems back.

'I see by advertisements that I figure as the first victim in a series (I presume) under the title of the Fleshly School of Poetry in the *Contemporary Review* for October.' Apprehensive already, playing whist with Hueffer, a new German friend of the circle, and Bell Scott at the latter's Chelsea House, Bellevue, his mind would wander from the game and he would throw down his cards in despair. Scott vividly described, though in some rather muddled fashion as to date, a later occasion when he had seen the article: the frantic knocking at the door, the rush of steps on the stairs, the entry of Rossetti shouting wildly 'Robert Buchanan' and his reiteration of the words at intervals – 'Robert Buchanan' throughout a painful evening.

The wounded poet took great pains to compose a suitable answer, and composed several different drafts. He still tried to keep up the appearance of taking it lightly. He wrote to Hake,

'I fear my writing in that way to the *Athenaeum* has given my friends quite a false impression of the effect adverse criticism has on me. This in the *Quarterly* (a further attack) has none whatever, I assure you. I laughed on reading it and laugh on thinking of it. . . . You will remember the first form in which I had put my reply was one of pure banter and satire, having for its central part only a serious reference to the critic's misstatements. However, my friends seemed scandalized at the satirical side of the reply and this induced me to give up the idea of printing it as a pamphlet which a sense of fun chiefly had suggested.'

He referred to 'some slight misapprehension as to the importance I attach to such things'.

The 'sense of fun', still bravely maintained, led him on 17 February 1872 to write to Hake again. 'My last censor in the *Spectator* this week – and his indignation carries him into verse. This charge against Swinburne and myself is that we do not write about the Battle of Waterloo.'

It was no good, though. He was mortally wounded.

The tide of battle rolled on. Swinburne was delighted. It was a triumph to have shocked the public, as the French poet Baudelaire, whom he so much admired, had done. He loved the wordy dispute, the squibs, the lampoons, the cutting phrases. In 1872 Buchanan enlarged his article as a pamphlet, *The Fleshly School and other Phenomena of the Day*. Swinburne replied with *Under the Microscope*. Buchanan retorted with *The Monkey and the Microscope*. In 1875 there was published anonymously *Jonas Fisher: A Poem in Brown and White*, in which figured a 'prurient paganist' hymning 'the sensuous charms of morbid immorality'. Swinburne thought the author must be Buchanan and wrote an *Epitaph on a Slanderer* in the *Examiner*. In 1876 Buchanan brought a suit for libel against the *Examiner* and it appeared the author was really the Earl of Southesk, Buchanan receiving £150 damages. Watts-Dunton produced a sonnet called *The Octopus of the Golden Isles*, the golden isles being those of Romance where Rossetti was to be found and the octopus Buchanan. Thus the controversy went on for five years after it had done its work as far as Rossetti was concerned.

One morning in 1872 William Michael called at Bellevue and asked Scott to come at once to 16 Cheyne Walk. The latter hastily swallowed his breakfast tea and went with him. They found Dr Marshall and Dr Hake, looking very serious, and Dante Gabriel a complete wreck.

He was taken off to Dr Hake's house at Roehampton, complaining fretfully that a bell was being rung in the roof of the cab. He lay there for three days like one dead. At Roehampton the full seriousness of his condition became clear.

6 An Excess of Chloral

Chloral, a limpid, colourless, oily liquid, was discovered by Liebig in 1831, and was for some time regarded as a valuable agent in inducing a sound and refreshing sleep and quietening states of excitement. The Victorians, not knowing much about it, hailed it as a wonder-working

cure. As such it was recommended to Rossetti about 1870 by the American W. J. Stillman, who had first become entangled with the Pre-Raphaelites as London correspondent of an American art paper, *The Crayon*, and as an acquaintance of Ruskin. Well-intentioned as Stillman no doubt was, it was a fatal suggestion. Chloral was a harmful drug. Taken regularly it caused profound melancholy and enfeeblement of the will, muscular lassitude and an inability to secure the sleep it promised, thus making necessary a progressive increase in the dose. This was the final factor in Rossetti's collapse. He had had before him the example of Lizzie's shillings-worths' of laudanum. By a queer revenge his remorse led him to repeat the addiction under another form.

He took chloral to gain unconsciousness, not, as Coleridge and de Quincey had taken opium, to sail off into dreamland. Nevertheless it produced a state of mind curiously transforming reality; fitting into the sequence of illusions of which the *New Life*, the *Morte d'Arthur* and spiritualism were part.

He took enormous doses, followed by glasses of neat whisky. They followed considerable experimentation with sleeping draughts, and their effect was hastened by the already morbid state of his mind. His melancholy was intense, and the association of signs, symbols and portents which he had always made out of trivial or unrelated happenings now became a suspicious dread of everyone and everything.

Artists are, generally, liable to this sensitive mania. Some of the letters of Millais about the reception of his pictures read like the ravings of a maniac. Ford Madox Brown was suspicious in the same irrational way. 'Men of intelligence in England', remarked Rossetti once to Shields, 'are ever as a persecuted sect.' When there was no persecution they imagined it.

Rossetti thought Browning's *Fifine at the Fair* was full of insults directed against him; that Lewis Carroll's *Hunting of the Snark* made fun of him; the birds twittered derision, the streets were full of anonymous enemies. 'There is a dead set being made at me (I do not say this by any means solely on account of the Buchanan attack)', he informed Hake in September 1872, shortly after his arrival at Kelmscott; 'any connection with my name is sure to arouse a swarm of malignity against your book.'

The imagined malignity was in contrast with the tender kindness of his friends. Brown, Bell Scott, Dr Hake and, of course, William Michael fussed over him, and William Graham, who bought so many of his pictures, put his house, Stobhall in Perthshire, at his disposal. Thither he went

from Roehampton with Scott and the Doctor's son, young George Hake, fresh from Oxford, thus finding a somewhat peculiar introduction to the world of letters.

Stobhall was another house fit for a Pre-Raphaelite to live in. A seat of the ancient Drummond family, it had a tower and a chapel and Irish yews and hollies trained in straight columns twenty-five feet high and roses of almost the same height. Here Rossetti recovered somewhat and limped about in a dumb shattered way, for a paralysis of one side had afflicted him when he lay in stupor at Roehampton. He could not bear to read. He could not walk far. He moved with pain and stared wildly as one in a nightmare. It seemed to Scott that the unique man had a unique illness, as original as his art, that even his morbid symptoms had a touch of personal genius.

In the meantime the staunch Madox Brown looked after his affairs in London. One can only speculate as to the disorder of Cheyne Walk under the ministrations of Fanny Hughes, Howell and the careless undisciplined servants. Brown decided the pictures at least should be put out of harm's way. As Scott's house was near they were moved there, among them the large, unfinished *Dante's Dream*. The remaining animals presumably were disposed of. The collection of blue china was sold.

And then the amazing man got swiftly better. From Stobhall he moved to a farmhouse at Trowan near Crieff, where he made two excellent drawings of the Doctor and his son, as if to demonstrate that his faculties were unimpaired. Here he got through the *Arabian Nights* and finished Merivale's *Roman Empire* which William Michael had begun reading to him at Roehampton – 'an excellent book in all but a certain parsonic tinge that pervades it'. 'I am trying to reduce both stimulants and narcotics gradually,' he wrote to Hake from Trowan, on 12 September 1872, 'as a panic might result at Kelmscott of my late habits.' Kelmscott, Morris' house, was now his objective. At the end of September he was installed there.

2

1 A Dream Shop

In the intervening years Morris had been happy, prosperous, successful in all he undertook; had grown into a mature man of powerful and distinct character.

For him they were 'jolly years of invention and lustre plates'.

The Co. caught on. It was the kind of unbusinesslike improvisation for which an early failure might well have been predicted. Its finance was Utopian. There was a call of £1 per share, and an unsecured loan of £100 from Mrs Morris of Leyton, on which the first year's trading was done. In 1862 a further call of £19 a share was made, and the capital raised to £140. The business premises were a first and a third floor in Red Lion Square, a few doors away from the original bohemian lodgings. A small kiln was installed in the basement for firing glass and tiles. The staff was recruited on the Pre-Raphaelite principle of taking whoever came to hand. There were boys from the Boys' Home in the Euston Road, who made the high-backed chairs with rush seats for Georgiana and Edward Burne-Jones when they got married. The foreman was a glass-painter who had been to the evening classes at the Working Men's College. The company meetings retained the youthful mixture of farce and idealism, 'like a meeting of the "Jolly Masons" or the jolly something-or-others', said Faulkner. They met at 8 for 9 p.m. and began by telling the latest anecdotes. Topsy and Ned would then seriously discuss the art of the fourteenth century. Actual business was polished off somewhere about 11. But Morris had a commercial instinct. He saw the possibilities in church decoration and directed his efforts that way. Muscular Christianity, as the Master of Balliol, Mr Jowett, observed, was going out. The Anglo-Catholic revival was coming in, bringing with it a demand for wall-painting, embroidery, altar-cloths, stained-glass windows and floor tiles.

The most significant entry in the list of the firm's early purchases is that of a Clergy List and a Vulgate Bible. Rossetti's prospectus was sent to Morris' old tutor with a request for a list of clergymen.

Almost at once orders for stained glass were the result. A new church by Bodley at Scarborough had Rossetti windows; in the glass of St Paul's at Brighton shimmers Morris as a king and Swinburne as a shepherd. The roof of St Michael's at Brighton was painted by Morris, Webb and Faulkner with their own hands.

A further sensible and successful move was to take two stalls at the Exhibition of 1862. One was of stained glass, the other of furniture and embroidery. £150 worth of goods was sold from them. The exhibit attracted much attention and gave the firm standing.

In a general way, the new interest in the church interior created a similar interest in the domestic; but from the early days the wide Pre-Raphaelite acquaintance was used to the full in the latter respect. Val Prinsep dragged Mrs Richmond Ritchie, one foggy morning in 1862, 'to

some square miles away'. She bought two tumblers. Morris, who appeared in answer to a loud shout of 'Topsy', advanced it in their favour that they would stand firm on the table, as if no tumbler had ever stood firm on the table before.

The development of a staple product, a speciality or bread-and-butter line, was another factor in success. Over a period, indeed until 1941, the Morris wallpapers and chintzes have been a classic example. As covering materials for any area, large or small, their utility was obvious. To the Victorians they had also a refreshing novelty in their colour. The parallel with the early Pre-Raphaelite pictures was in this respect close. The brown, gold and crimson favoured by the Philistines was replaced by pure hues, blue, yellow, green, bright, not dirty, red. The wealth of detail, the new candour of colour, was transferred from the pictures to the walls and the chairs.

A good business manager was a real asset. By luck or shrewdness, Morris picked the man. Possibly no one else would have selected a penniless Old Etonian with an enthusiasm for Wagner and an entire incapacity to manage his own affairs, who was then a check-taker at the Opera House in the Haymarket. But Warrington Taylor, until his death in 1870, turned out surprisingly well.

There was a lucidity, a directness, displayed in the launching and development of the company which had the stamp of Morris' mind. The common sense with which he went straight to the heart of the matter, the ease with which he grasped the commercial principle, was that of a practical man.

A practical ability in the use of his own hands had appeared before the Co. was started, even when he was so far under the Rossetti spell as to try to paint pictures. His Union ceiling, a decorative pattern simply, was the first part of the work to be finished, the most permanent of any. From the record of the old Red Lion Square days one vivid detail stands out, the crucifixion of his white dress tie, nailed to the wall to make a rack for his wood-carving tools. 'Top has taken to worsted work,' grinned Rossetti, when he heard that Morris was doing embroidery himself. It was an upside-down version of the jibe Ruskin had levelled at Rossetti's watercolours. Morris did not mind. What was wrong with making things yourself? 'That talk of inspiration,' he said, 'is sheer nonsense. I may tell you flat – there is no such thing: it is a mere matter of craftsmanship.'

He was, then, a simple man, with a simple purpose in life and a simple method of obtaining what he wanted that any man of business could under-

stand and appreciate. So, on the surface, it looked. Were his character and his work actually so simple?

Behind the operations of the Co., in the brain of Morris himself, the dream, the Pre-Raphaelite dream, was shining with its strange effulgence. It made for complication.

Why and how the tables, the chairs, the papers, the tapestries assumed the forms and patterns they did was a quite mystical process. Nothing, it is said, comes from nothing. A decorative style is usually a modification of the decorative style which precedes it. The decorative style of Morris was not. It came from the dream – a vision of a past already lost and reconstructed by the past – so intangible that it might, in a way, be considered as the next thing to nothing.

It was firmly based on what had never existed.

The Red House was the immediate source of supply and inspiration to Red Lion Square. Until 1865, when he moved to Queen Square, Bloomsbury, it was the core of Morris' ideal. Here he was in a state of absolute contentment. Here his two daughters were born. He was happy in the companionship of his wife; and he kept open house for his friends, Rossetti, the Burne-Jones', the Browns, the Marshalls, Swinburne and the rest. The gradual ornamentation of its interior was his joy.

This ornamentation derived from the imaginary Middle Ages into which the *Morte d'Arthur* had been an introduction. The walls of the staircase were to be covered with paintings in tempera by Burne-Jones of scenes from the Trojan War. In the hall was to be a great ship carrying the Greek heroes. The ship, however, was to be a warship of the fourteenth century, with the shields of knights hung over the bulwarks. In other words, an idea of an idea of the past. Round the drawing-room was to be a continuous frieze, some part of which was executed by Jones, of scenes from the fifteenth-century romance of *Sir Degrevaunt* (doomed, alas, to fade like the Union frescoes).

Coming from a house which was like no other house that ever was, this decoration was like none other. 'If one had been told it was the South Sea Island sort of thing one could have easily believed such to be the case', Bell Scott ignorantly remarked.

As Lizzy and Rossetti had lived the dream of Dante, so Morris began to live the dream of Malory. Georgie and Janey spun their coloured webs like mediaeval ladies. Morris had a carriage built for himself with leather curtains and 'a decided flavour of the Middle Ages about it'. For music in the evening only the old English songs published by Chappell would

suffice. The fun that went on had a mediaeval heartiness. Faulkner would jump down from the Minstrels' Gallery, the top of the gigantic settle which had been moved from Red Lion Square, landing with a smack in the middle of the floor. They had battles with apples. In one Morris got a black eye. His own fun had an antique miming turn. At Red Lion Square he had imitated an eagle, climbing on to a chair and after a sullen pause coming down with a soft heavy flop. His imitation of a seasick passenger on a Channel steamer, in the course of which he balanced a coal-scuttle between his teeth and swayed perilously from side to side, actually terrified his audience.

At the same time the original doctrine of Truth to Nature was not lost sight of by Morris; but he gave it his own interpretation. Nature was a sort of homeliness, a rough and unaffected sincerity of substance – not the polish of porcelain but the genial coarseness of earthenware; not the cultivated bloom with a Latin title but the simple, unpretentious flower of the wayside with a sweet-sounding Old English name. Nature, so to speak, was Old English; and poetry, in being true to Nature, must be Old English too – its ecstasies never fused into a new and artificial unity – but piling the old simple words one on another in ecstatic compounds.

As the material products of the company were fabricated out of an illusion, it is the less surprising that the illusion was more important than they were. The Pre-Raphaelite values were maintained – the triumph of imagination over matter upheld. This explains a puzzling circumstance – that Morris would go to endless pains to make a practical thing– and, when it was finished, entirely ceased to care whether it was practical or not. The Red House, 'the small Palace of Art of my own', was a prime example. 'Divinely uncomfortable', 'gloriously uncomfortable', were the terms of praise given to it by those who stayed there. A similar trifling miscalculation to that which made the settle so uncommonly large had resulted in the house being uncommonly cold. It was planned in the hot dry summer of 1859. Recking naught of the winter, Morris and Webb made it face north, towards an exposed plateau. The windows, moreover, gave a mediaeval but small amount of light. Cold, dark and for the ordinary purposes of life inconvenient as it was, none of these drawbacks affected Morris in the slightest degree. The Red House to him was in every respect perfect.

Perhaps Jane, in the long run, had something to say about it. There were the children to be thought of. Other factors induced the move of 1865. Money was not quite so plentiful. The shares in the copper-mine

were yielding less. The firm had still to be nursed along; and travelling to and from London was exhausting. To keep two establishments going was more than Morris felt he could do.

He would have preferred to remove the whole thing to Upton and live communally with the Jones'; but the delicate health of these two was against it, as also a scantiness of means which tied them to town. So the Morris' transferred both themselves and the business to an old house in Queen Square, Bloomsbury. The Red House was sold; and now, finding more leisure, Morris began to write again.

And the dream advanced a stage further; or receded, drawing him in pursuit. He was so matter-of-fact about it that this made the process seem less abnormal than it really was. 'If a chap can't compose an epic poem while he's weaving tapestry,' he said, 'he'll never do any good at all.' He turned from one occupation to the other without difficulty and worked quickly and competently at both, though there was an abnormality in it, nevertheless. The mere smooth flow of words from his pen was astonishing; still more their character. They were short, hard words, none of which might not have been used hundreds of years ago: the words in which legends then old would be cast by a poet of the fourteenth century. In *The Life and Death of Jason* and *The Earthly Paradise*, the main works of the Queen Square years, he turned himself into a man of the past looking back into a still further past – a Chaucer rewriting such imperfect accounts as he might acquire of Greek and Norse and Persian story – of Theseus, Gyges and Ogier the Dane. Either Morris was an actual throwback to a dim and distant time, like the clerk in Kipling's *Greatest Story in the World*, or Pre-Raphaelitism had produced in him exactly the same effect.

In Rossetti's humour there was always a sense of the ludicrous in the point of contact between spirit and matter which Morris was quite without. Writing to Professor Charles Eliot Norton, Professor of the History of Art at Harvard, Dante scholar and old friend of Ruskin, Rossetti, on his best behaviour, said that the Red House was 'more a poem than a house'. At the same time he was delighted to find that the locality went by the name of Hog's Hole; and at no one did he more often direct his playful sarcasm than at Morris. It was he, at 'the Towers of Topsy', who inscribed in one of the scrolls left for Van Eyck's motto 'If I can' the alternative 'As I can't'. The harmless physical violence in which Morris indulged was always good for a laugh. The references to it and to *The Earthly Paradise* are frequent in Gabriel's letters to Miss Losh between

1868 and 1871. 'I called on Topsy who was howling and threatening to throw a new piano of his wife's out of the window. Unfortunately it arrived at dinner time . . .'

'Morris has at last finished his *Earthly Paradise* with the most triumphant success, the first 1,000 of vol. 4 having been bespoke before publication – he is becoming so well known as Morris that one is almost liable to forget his being Topsy until his presence brings the fact vividly into prominence. He still shows healthy signs, however, in the latter character. Lately he was known to hang on the bell-pull at dinner-time for at least 10 minutes; and when one calls on him one is occasionally informed by the servant from the area that it is no good knocking at the front door, as that will not open since Master last banged it. . . .'

In such references there is a persistent effort to regard Morris as the boisterous undergraduate Rossetti had first known, with an uneasy consciousness that he was no longer that; that he had grown in dignity and even majesty of mind; that he was, in certain essential particulars, a stranger.

Morris was still funny; with his comic temper, his inoffensive shouting and swearing, the dynamic habit of body which enabled him, so Burne-Jones used to say, to break the rungs of a chair by the spasmodic contraction of the muscles of his back. Now he was also inscrutable. Behind the broad, benevolent face with its dark encircling curls, the serenity that came of hard but untroubled and congenial work, the hooded eyes that were observant yet seemed not to look; in the mature Morris that Watts painted and idealised, some mysterious process of thought was going on in which Gabriel could not share.

Point by point, in character and in life they were different. You could say they were both lost in the age their bodies inhabited; that they looked for some essential part of themselves, elsewhere; but there the resemblance ceased. Their atavisms were opposite and rival. A 'man of the North', so Morris described himself. He loved to hear the rain beating on the windows, perhaps with some stirring memory of war-songs whirled to arctic gales. And as evidently Rossetti was a 'man of the South', indolent and sensuous. The 'man of the North' had the northern coldness, which made him inhuman even in his humaneness. It was said of him there was one thing he did not know, much as he had written about it, the love of a woman, and *that* he never cared to discuss; while to the 'man of the South', woman was the very centre, the essence of that life of the emotions which made art possible as it made all living tolerable. In the society of

Janey, Morris found contentment, but even she was outside and incidental to the labour in which he was absorbed: a *princesse lointaine*, said Watts-Dunton, who perhaps got a little tired at times of being so. In the society of Lizzie, Rossetti had found pain, yet she had been the innermost of his inspirations. The difference was present even in their choice of theme. With all its faint evocation of Florentine beauty in dress and buildings, the work of Dante was psychological in the main; it was concerned with states of mind even in their most subtle phases; while the legends of King Arthur, about which Rossetti obviously cared little, as Morris and Burne-Jones cared much, were crude and stilted in so far as any quality of mind might be said to come into them at all. They were full as any boy's book of a monotonous thumping of swords on armour; childish in their love scenes and naïve in magic. It was the armour and the heraldry, the pattern of the tale rather than the mystic element that had appealed to the two young disciples and continued to appeal.

Morris had the paganism of the north as Rossetti had the superstition of the south. He did not believe in God, the creator of the world, or any providence or future life; but in mankind as the crown of things. He looked therefore to first causes that his intelligence could take hold of, while Rossetti confessed 'to an even unusual indifference as to the first causes of all phenomena whatever', not irreligiously but in the conviction that such matters were outside his scope. Thus Morris liked what grew out of and into material form, while Rossetti saw the world as a curious show that passed and was gone; that you, also fleeting, could not make one with yourself. The one thus instinctively turned to the permanence of the country and life in the country, the other to the transient spectacle of the town.

So consistent was each that the comparison could greatly be extended, but the suggestion of the difference between them goes some way to explain the drama in their joint discovery of Kelmscott in 1871. Two great poets proposed to live in the same house, sharing the rent of £60 a year. One, healthy, 'in a state of ferocious and offensive health', he said, impersonal, serene; the other a nervous insomniac, uneasy, craving mental stimulus rather than rural peace.

2 The Co-tenancy of an Earthly Paradise

Kelmscott, on the upper Thames, thirty miles from Oxford by water and three miles from Lechlade, was discovered in a London house agent's list in the spring. They went down together to see it.

To Morris it was like coming to a place he had always known. He knew it in advance as they came in sight of a bank of elm-trees and the gables of a house by the river-lock. He saw with pleasure through the hawthorn spray and shoots of wild rose the flat meadow-land spreading far to a soft rim of blue hills. The road was familiar to him though he had never trod it before, and the cluster of little grey houses that was the village. His hand went straight to the latch of a door in the wall, and as they walked up the stone path the blackbirds were singing, the doves cooed on the roof-ridge, the swifts wheeled about the gables, the rooks cawed in the elms and the scent of June roses was strong and sweet.

'O me! O me! How I love the earth and the seasons and weather, and all things that deal with it and all that grows out of it as this has done.'

He thought this as he stood there in his blue serge suit and blue cotton shirt, Janey, beautiful as Juno, by his side, and with them, quite out of place, flippant and mocking, Rossetti, not in the least loving the earth, or the grey house that grew out of it, and rather less able to breathe in the clean, calm air than he was in Chelsea. He was deliberately, maliciously Cockney about it. He wrote his usual variations on the same theme to his friends. To Miss Losh, whom he took so much trouble to amuse, he sent a long description in October 1871, the admission of its beauty being amply seasoned with criticism. Lechlade was 'a "one-eyed" town, as the Yankees say'. Kelmscott was as quiet as Penkill; he only wished it were equally interesting. The country was 'deadly flat', the river walks pretty 'if somewhat monotonous'. (This was the flatness which Morris, the man of Essex, especially loved.) The village was 'the doziest clump of grey old beehives to look at that you could find anywhere'. The house and its belongings were an 'Earthly Paradise', appropriate you will say to our old friend 'Tops', 'my joint-tenant': but he managed to find plenty of faults in what to Morris were the virtues of the place.

For the first time Rossetti saw the real England, and it was an entirely foreign country. The 'great Italian' could be comfortably 'lost in London' because it was a city made to lose yourself in. At Kelmscott he was a solitary interloper in a place he could not understand, whose fat purring hedges and peace and quietude were the expression of an attitude to life in which it was impossible for him to share.

Morris, having found the corner of the past that suited him perfectly, went off almost immediately into a country still less up to date, a past still more remote. He went to Iceland, leaving behind a Rossetti at once meddling and critical, jeering and impressed. 'This place,' he informed

Hake (August 1871), 'needed so much getting in order to make it habitable that, Morris (my joint-tenant) having taken himself off to Iceland, my services become necessary in furnishing and ordering the place.' He was painting a replica of Hake's 'favourite Beatrice' and a little picture with a river background. He wanted to write a few things, if he might, 'but this is doubtful as my walks (my muse's cud-chewing times) are seldom taken alone'. There followed the usual variation of his strictures on the landscape. 'The river-side surroundings are lovely though rather unvarying, while the country everywhere so flat that objects are few to the eye – the house a quite unaltered relic of Elizabethan middle-class architecture, though whether actually built in Elizabeth's time or even perhaps a century later in this dozy, primitive, undeveloped region may be doubtful.' The word 'dozy' appears again and again in the letters of this season. He seemed to find in the calm of Kelmscott an immovable and antagonistic force which he admired without having the slightest affection for it, despised while he respected. So might Lucifer have spoken of the Garden of Eden.

3 A Trip to Iceland

Why did Morris go to Iceland of all places? 'What went ye into the wilderness for to see?' He went back as the Pre-Raphaelites continually went back. There were specific reasons. He had come to know a Mr Magnussen who was an authority on Icelandic literature, who went with him as fellow-traveller and guide. There was said to be a resemblance in build and looks between the Icelander and the poet, almost as if they had a common origin. Morris had also acquired an interest in the Sagas when writing the *Earthly Paradise*. With Magnussen he read the *Eyrbyggja Saga* and translated *Gunnlaug Worm-Tongue*. But above all stands out the resemblance to Holman Hunt and Hunt's journey to the Holy Land. As Hunt had gone to the scene of those great events which impressed him most, to seek a sign, an inspiration, so Morris went to the land 'dreadful with grinding of ice and record of scarce-hidden fire'. It was the cosmic homesickness of Pre-Raphaelitism again in another form. Hunt sought the Via Dolorosa and Morris Valhalla; the one penetrated to the place where the temple had stood, the other rebuilt in his mind a primal Utopian order at the Law-mound of the Thingvalla. It was as if he almost expected to find some community of heroes like gods, on a freezing mountain-top beyond the reach of time, speaking in mighty monosyllables, shaping

wood, metal and cloth with simple grandeur and acclaiming the chanted rune of the skald.

To Rossetti this was barbarous and incomprehensible, as indeed to Hunt it would have seemed barbarous too, though it was their dream of Florence and Jerusalem under another form. When Morris tried to interest Rossetti in *Sigurd the Volsung*, he said, upon the entrance of Fafnir into the story, 'I never cared much for all that stuff. . . . How can one take a real interest in a man who has a dragon for a brother?' It is related that Morris was stirred by this impious remark to an unusual sharpness, for him, that gazing fixedly at Gabriel he answered, 'I'ld much rather have a dragon for a brother than a bloody fool', an oblique allusion to William Michael.

It was by a thoroughly Pre-Raphaelite fatality that the strange search should lead to nightmare as it had led Hunt to the shores of the Dead Sea. Morris was ready to rough it. He built a little hearth in Burne-Jones' garden on which he cooked a stew to show how well he could camp out. 'By Gum the great,' he said, 'we shall have plenty of riding.' With Magnussen, Faulkner and a Mr Evans, an acquaintance who had been planning to go on his own account, he embarked at Granton, in the Danish mailboat, in July 1871.

But from the deck of the *Diana* he saw a terrible shore: a mass of dark grey mountains worked into pyramids and shelves looking as if they were half-built and half-ruined, striped with snow and streaked with cloud. There were toothed rocks down the side of the firth guarding 'a weary wide lea'. One scene after another revealed a fresh desolation, a new horror. There was the valley of the Markfleet whose cliffs were 'unimaginably strange', with caves in them like the hell-mouths in thirteenth-century illuminations; rent into flat-topped pillars on which sheep had got by some mysterious means. A cold wind blew over the glacier which dribbled white streams into the plain. The mountain-wall closed the valley with its stupendous rocks. There were the Geysers, the uncanniness of whose boiling mud and quivering earth was such that Morris would not go near them. There was the hair-raising exploration of the great cavern of Surts-hellir: the dismal journey past Erne-water where Grettir slew Thorir Red-Beard, but now was no sign of life save a swan that rose trumpeting from the lake-side. Morris' spirits dropped to zero. 'It is,' he admitted, 'an awful place . . . emptiness and nothing else, a piece of turf under your feet and the sky overhead, that's all.' But it was something to have seen the home-field of Njal's house, the place where

Bolli was killed and Gudrun died. To half-mythical murder and violence in the arctic twilight, to events that quite possibly never happened, he paid a sort of reverent homage as if he were inspecting holy relics – though in Iceland there were not many relics but only the legend of rough-sounding names. The satisfaction he gained from it was due to no outward circumstance, but the dream that shone in his mind.

The Viking Morris, his remoter atavism thus for the time being appeased, returned to England and Kelmscott in September. The force that impelled him to look for the beginning of things was at work to a larger end than as yet had appeared. The time for that end to be revealed, however, was not yet. He was still for a while to work happily and wholeheartedly at his art and his craft, finding full satisfaction in the doing. At the same time the process of estrangement which had inevitably split the earlier Pre-Raphaelite band was to separate him from his friends, all except the faithful Jones.

Mere pressure of work at first prevented him from realising the difficulties of joint-tenancy. Ordering quantities of the best Roman vellum, he turned to the art of illumination and expended colossal labour on the floriated patterns and characters of manuscript books. The products of his workshops claimed his time, so that after writing a sort of masque, *Love is Enough*, and an abortive attempt at a novel of contemporary life, he wrote little for some years, except translations. The workshops themselves were expanding; and in 1872 it became necessary to move his living-quarters from Queen Square. He found a town house at Hammersmith.

In 1873 he was induced to go to Italy with Burne-Jones. He found nothing there that pleased him. In fact, he was prejudiced from the start. 'Do you suppose I should see anything in Rome that I can't see in Whitechapel?' The scheme of life lurking beneath the surface of his mind is implicit in his refusal to look at the beautiful buildings and works of art in that country.

It was a genuinely Pre-Raphaelite feeling. For all the productions of the time of Raphael he had the greatest dislike. The Renaissance was an abomination: and not only for aesthetic reasons. He was seeking, like Hunt, some greater justification for art, the basis of a reform, though of this he was not yet fully conscious. The search led him in quite a different direction.

In disliking the art of Italy he disliked religion and aristocracy, its two inspiring and sustaining principles. In this he remained utterly consistent. He thought that St Peter's was the ugliest building in the world (after

St Paul's). On the same principle he hated Queen Anne houses in England. No doubt they suggested to him a society of useless, supercilious and sneering aristocrats. Even art before Raphael, in Italy, was open to the same objection. Comparatively pure as it might be in religious feeling, it was still the outcome of (to him) a useless emotion unconnected with the sturdy, practical framework on which he felt that society should be based.

After this visit he went again to Iceland. Already it was a sort of revolutionary movement in reverse. He went back to that empty, dismal land as a protest against the facile corruption that had grown with such ease in fairer climes. That in the state of primitive purity that was to be imagined in the emptiness, men had dragons for their brothers and were constantly chopping each other to pieces, disturbed him not at all. As a Pre-Raphaelite you could combine the most lucid and practical argument with the wildest discrepancy.

Work, travel, moving, caused Morris to see less of Rossetti than otherwise he would: but the joint-tenancy became an increasing disturbance. It may even have had something to do with keeping Morris away from Kelmscott. With the man whose influence had launched him in art he now had nothing in common.

Rossetti jeered at Iceland and seemed only to be interested in the frivolous side of the journey. He thought it very funny that 'Top' should have been called 'The Skald'. He made a caricature of him on the river with the verse.

'Enter Skald moored in a punt,
Jacks and Tenches exeunt.'

He was disappointed in Morris' diary because it wasn't funnier; though he chuckled over an account of Faulkner and Magnussen having their breeches removed by the lady of an Icelandic house as a ceremonial preparation for dinner.

As to Kelmscott, generally critical, he took an especial and irritating dislike to the tapestry in his room. It was an old, faded hanging that went with the house (and still hangs in its accustomed place). It had life-size figures in Roman costume, 'representing grimly enough the story of Samson'. To Miss Losh, to Scott, to Dr Hake, the tapestry was variously reviled. 'There is one very grisly subject where his eyes are being gouged out, while a brass barber's basin lies at his feet containing his shorn locks, and Delilah looks over her shoulder at him while the Philistine leader counts out her wages to her . . .' This was to Hake, August 1871. To Scott

he mentioned that the tapestry had 'that uncompromising uncomfortableness peculiar to this class of art manufacture'. Moreover, it flapped eerily in the draught. He was dying to take it down. He compromised by hanging his pictures on top. They improved it wonderfully, he said, by 'shutting out its hideousness'.

Nearness emphasised the difference in the co-tenants' tastes. On the upper floor at Kelmscott the rooms opened into one another. To get to the tapestried room it was necessary to go through Morris' own bedroom, where he would lie in a huge Elizabethan four-poster bed, his square beard curling over the counterpane, like some ancient god, superbly indifferent to what might be going on around him. Even this aloofness must have worn thin with a neighbour like Rossetti. He was a night-owl, while Morris was early to bed and early to rise. Rossetti could not sleep and then it was a temptation to wake up someone close at hand and talk on into the night, as in the old London days, instead of snoring away the dark hours like any country bumpkin with no brains or soul. Late in the morning, when Morris in his blue French blouse had already spent many happy hours on some never-ending pattern of flowers and birds, Gabriel, his eyes dark and pouched, wearing an old dressing-gown, would lurch in horribly and disturb whatever Morris was doing.

After the *Fleshly School* calamity, the unpleasantness was intensified: now he was not merely an irritating but an alarming companion. Indeed, he made the house untenable. Though he had in some measure recovered in Scotland, he was a drug-haunted, suspicion-ridden invalid: and joint-tenancy also seemed to comprise the transference to the country of his queer London entourage.

From the autumn of 1872 to the time of his leaving it in 1874, Kelmscott was full of Rossetti's friends. There was young George Hake, who was officially his 'amanuensis' and continued at Kelmscott the task he had undertaken in Scotland of looking after him. Rossetti had advised the doctor against journalism as a career for his son. It was 'an uphill drudgery . . . almost entirely dependent on happy-go-lucky chances beset with contemptible companionships'. An early apprenticeship was necessary to the 'rather pitiful mystery of it'. By sitting up all night in a newspaper office to receive late telegrams or doing shorthand in a reporters' gallery 'you may aspire eventually to push your way, much as in a scramble at the gallery doors of a theatre, through little better company and language'.

But the rôle of companion to a great poet and artist had its drudgery also, in which George showed much patience and good temper.

Bell Scott has described old Dr Hake, who was also there when he visited the house, as sitting in the room below with a pencil and paper, trying to write a poem: on the table in front of him a little heap of discarded papers, bearing his repeated efforts at the same couplet, 'in various transformations, sometimes expressing quite different meanings'. The ridicule thus implied may be discounted. Scott and Hake were both minor poets: friends of the same great and interesting man, rival memoirists in prospect; and it may be there was some little spite in the description, not unconnected with these facts. Much later Theodore Watts-Dunton, writing to Hake from 'The Pines' in 1892, told Hake 'it was always a great thing with Scott in his jealousy of you to make out that whatsoever was good of yours was the work of Rossetti'. The rival memoirs did, in due course, appear; and, alas for the doctor, he had written a dignified and reticent work with a manly, loyal regard for the sanctity of private life and the confidences of friendship, while Scott had crammed his pages with gossip. His outspoken comments were attributed to malice, stupidity, envy. They were generally deplored – but they were also read with avidity.

Apart from these respectable visitors we read, in a letter of 22 February 1873, 'Howell and Dunn are here . . . the former in bed – 3 p.m. twelve hours after 3 a.m. when we went to bed after endless palaver'. The soldier of fortune thus invaded the haunt of ancient peace.

Howell was running a private business in 'old masters'. Gabriel was anxious at the decline in his income due to his irregular production and to his absence from London. He now fixed on Howell as the man to act as his agent. Howell jumped at the idea. Necessarily he came out to discuss their co-operation. Numerous requisitions were made on Dupré & Co., the wine merchants, and the careless joviality of Kelmscott for the moment was like that of Cheyne Walk. It was at this time Gabriel was painting Jane Morris as *Proserpine*, 'the best picture I have done'.

Old Mrs Rossetti and Christina came to see how he was. 'My mother and sister enjoy the place vastly.' So did Ford Madox Brown. He 'has made a good start with his picture of Cromwell here – the immortalisation of that potentate extending at present to his horse's head and a lamb in one corner'. The lawyer Theodore Watts came. It will be convenient for the purposes of this narrative to describe him subsequently as Watts-Dunton, though it was not until 1897 that he added his mother's name of Dunton to the family surname of Watts. A qualified solicitor, he was by ambition a man of letters. He was now forty years of age, not yet launched as critic to the *Athenaeum*, to which journal be contributed articles on poetry from

1875 onwards; but deeply interested in the writers of his time. Assisting Rossetti in legal matters, he of course valued his literary friendship; as also that of Swinburne, on whom he lavished that quasi-parental devotion which resulted in their sharing house (the famous 'Pines' at Putney) for nearly thirty years. A cheque, not a poem, was the object of his critical examination at Kelsmcott. Rossetti late in 1872 had made 'a most vexatious discovery' – namely, that a cheque for £50 had been forged in his name. 'I do not think I could prosecute as I have reason to fear that the forger is a member of a family known to us from childhood.' Whoever the offender was, Watts-Dunton helped to settle the matter. 'I hardly know how to thank Mr Watts enough for the extremely kind trouble he has taken in that unpleasant bank business.'

One person only Rossetti refused to have at Kelmscott. That was Fanny, Mrs Hughes. He had an extensive correspondence with her, addressed variously to 'My dear Fan' and to 'Good old Elephant', enclosing cheques, not infrequently, 'for the elephant to take up with its trunk for present necessities'. But when Dunn told him that she had a great fancy for coming into the country, he wrote and told her quite definitely not to. 'Please don't ever press the matter again, as it is very distressing to me to refuse, but as long as I remain here it is out of the question.'

Though Fanny did not intrude, there was something about this sociable muddle that offended Morris' ideal of domestic order and calm. There was a shadow on Kelmscott, a restlessness that was no part of it, an undefinable taint. He said of Rossetti, 'He has all sorts of ways so unsympathetic with the sweet simple old place that I feel his presence there as a kind of slur on it.' When Rossetti finally left Kelmscott, ostensibly through a baseless quarrel with some anglers by the river, Morris heaved a sigh of relief.

Rossetti did not apparently feel much regret at leaving. His chief fondness at Kelmscott was reserved for the animals – the pony which was brought back from Iceland and was four feet in girth round the neck; and especially Dizzy, the dog. Many were his descriptions of it: 'nearly drowned in ditch full of half-melted snow and ice' and 'sitting with his forepaws on a ledge of snow like an early portrait' like a slab from Nineveh, 'so obscure and cuneiform in expression that in the absence of a Rawlinson to decipher him I am half-inclined to send him on to you to-morrow'; 'a rather decidedly old master with ruts in his surface and a general world-worn aspect'. When Dizzy was sick in the kitchen, 'I gazed at him

reproachfully and, putting my hand on his stomach, belched over his head in an unmistakable manner, whereupon Dizzy turned tail ... crawled under the sofa and was seen no more'. The dog accompanied Rossetti and George back to London. According to the former, when George stumbled accidentally into a low arch of Westminster Bridge and fell over, Dizzy immediately ran and called a cab. Morris was not fond of animals. He said once he might get to like a horse if he had the time; he had a mild affection for the pony he had brought back: but his mind was set on more important things than individual lives, animal or human.

4 The End of a Partnership

The individual life of what was called 'the artist' Morris had now had the opportunity of examining at close quarters, without any of the false glamour round it which was imparted by youth and innocence. That hooded glance of his had taken in every detail, one may be sure, had weighed its feebleness, its tawdriness its egotism, its self-indulgence, its sordid and furtive complications which rose like mud in a stagnant pool on some slight stir of the waters. What was to be set on the other side of the balance? – that after much fret and fuss, some expression of this emotional chaos was transferred to canvas or paper for the idle entertainment of a rich man who did not know what on earth to do with the superfluity of his wealth. There was Madox Brown also, a good kind fellow, without Gabriel's more peculiar feelings, but also leading this confused struggling existence with another absurd semi-domestic court, his wife and children and Hueffer and the poetess Mathilde Blind, to the same useless end of painting pictures. It was not Morris' world, though with these impracticable creatures he was still bound in a commercial partnership. They were his fellow-directors of the company.

Was it not time he got rid of them?

The firm had become his lifework and his alone. Much as he appreciated the devoted labours of the faithful Burne-Jones, there was no getting away from this main fact. He had done both the toil and the thinking. He had devised those new and improved forms of craft on which the firm depended. He had taken all the financial burden and vastly extended its financial worth. But still, as in the first blush of young optimism, the seven original partners had an equal voice in the management of the firm, an equal interest in its assets. Apart from Morris they had contributed only a trifling sum (if they had all done even that). They had been

paid for such actual work as they had done; but, if they chose to be unreasonable, they now had a legal claim on the business to the tune of some seven or eight thousand pounds.

Burne-Jones, Faulkner and Webb saw the matter in the same light as Morris. They refused to accept any consideration in respect of their claims as partners. Burne-Jones and Webb, indeed, did very well out of the many commissions it produced.

The other three were unreasonable. Ford Madox Brown in particular. The irascible, suspicious side of him came uppermost. What! Here was a rich man, doing what all rich men did, raising himself on the artist's back, then kicking him aside. What of the prestige, the reputation of a Madox Brown, a Rossetti? Where would the firm have been without it, without the circle of patrons it had brought? He had been done too many times. This time he would not be done. Let the goodwill be taken at three years' purchase and be included in the assets.

Rossetti supported him, more out of personal loyalty, it would seem, than any strong conviction of right. He did not intend to use the money obtained for himself, but to set it aside, for the benefit, probably, of Janey Morris. He wrote to Watts-Dunton, who, by general consent, was the lawyer appointed to handle the delicate and protracted negotiations, in rather obscure terms which point to Mrs Morris as the intended beneficiary. That he drew later on the amount himself is a matter apart from the generosity of the intention.

Marshall, the sanitary engineer, made an intransigent third.

It was a disagreeable business, as are monetary dealings among friends; and, as so often happens, it terminated the friendship. The break between Morris and Brown lasted for a long time, though eventually they came back to speaking terms. The breach between Morris and Rossetti was final. Never again did the former appear at Cheyne Walk. Thus snapped the last main link in the chain of brotherhood.

The bickering, early in 1875, being over, the documents signed and the company shortened to Morris & Co., its presiding genius felt that he had a new lease of life. He was forty-one. His earlier artistic gods were now receding specks on the horizon. The Christian scruples of Hunt, the pliant brilliance of Millais, the miseries of Rossetti belonged to another sphere. Strong in body and mind, industrious and able, virtuous and fearless, happy and wealthy, he stood at the height of a flawless career, little aware that before it should be finished he was to shock his friends, grieve his family, raise up a host of enemies, appear in a police court and fail in the

biggest of his undertakings – through a further application of Pre-Raphaelite reasoning to a social and political end.

<center>3</center>

1 Glittering Prizes

The latter half of the Victorian Age was a golden time for painters and sculptors. The national wealth was steadily mounting, and of every rich man's surplus something went to buy a work of art. The culture propaganda of Ruskin, the Pre-Raphaelite system by which artists helped one another and generously shared the spoil, contributed to this happy state of things; but it did not follow there was more than a limited interest in Pre-Raphaelite pictures as such.

Never, certainly in the history of England, were so many pictures (including some of the worst that have ever been produced) painted and sold. It was a distinct and accepted fashion. In the 1870s and 1880s, each number of *Punch* had its joke about a painter, or his patrons.

The artists made fortunes. The studios they had specially built for themselves, palatial caricatures of the top-lit bohemian attic, remain the astonishment and envy of subsequent generations, an abnormal growth unique in architecture.

Millais found himself, after his 'Sermons', swimming easily with the tide. In 1867 he calculated he was making a hundred a day from his watercolour copies alone. 'I have finished *The Minuet* and part of *Sleeping* to the utmost, almost like Meissonnier. They are certainly the best paying things I do.' Working with the smooth speed and ease of a machine, he calculated on receiving between £30,000 and £40,000 a year. At a dinner-party in the 1880s, according to the publisher Kegan Paul, the host was a famous surgeon, the guest of honour was a royal prince, the other guests included the then acknowledged leader of the English Bar, and Millais, among others. The prince was interested in the question of professional incomes. 'What', he inquired, 'does a first-rate surgeon make in his profession?' 'I should say', answered the surgeon, 'fifteen thousand a year would be the mark.' 'And what does a great barrister make?' 'I suppose, Sir,' replied the barrister, 'twenty-five thousand.' Millais was the third to be questioned, on a painter's income. 'Possibly, Sir, thirty-five thousand a year.' 'Oh, come, come', said the prince, incredulous. 'Well, Sir,' returned Millais, nettled, 'as a matter of fact last year I made forty thousand, and it would have been more if I had not been taking a longer holiday than

<center>140</center>

usual in Scotland.' Browning (who always seemed to be present on these occasions) put his arm through that of Matthew Arnold and the publisher. 'We don't make that out of literature, do we?' he said.

The landmarks of Millais' career were tremendously popular subject pictures. The *Boyhood of Raleigh*, a schoolroom favourite, was painted in 1870, at Lady Rolles' house on the Devonshire coast, two of the Millais boys, Everett and George, posing for the youthful Sir Walter and his friend, listening to the tales of a Genoese sailor. The *North-West Passage*, finished in 1874, had every ingredient of success – a suggestion of adventure at sea, a gallant old sea-dog with his map before him, and his young and pretty daughter reading aloud, doubtless some stirring passage of Polar exploration. Sir George Nares, who commanded the expedition to the North Pole in 1879, wrote to Millais in its praise – and engravings of it found their way to every corner of the land. The sea-dog was Trelawny, the relic of an earlier generation, the friend of Byron and Shelley and author of that piratical autobiography, *The Adventures of a Younger Son*.

A bull-necked old man of eighty with a grim mouth and massive chest, he retained the scornful attitude of a Regency eccentric. Holman Hunt met him at Sir Thomas Fairbairn's house in Kent. He asked him a great many questions about the personal appearance of the two poets, and received very gruff answers. Whether because he disliked being questioned, or for other reasons, Trelawny was found one day to have left without a word of explanation. The butler had seen him sitting in the lake all the afternoon, up to his neck in water, reading a book.

He came across Millais at the funeral of John Leech – 'the finest gentleman he had ever met', he said. He only agreed to sit if Mrs Millais would assist a company for the promotion of Turkish baths, in which he was interested, by taking six Turkish baths there with his niece. He was extremely angry when, after the sittings were over, Millais placed a glass of grog at the elbow of his pictured self. The old pirate was a strict teetotaller. He was, also, the one type essential to the picture's success.

A Yeoman of the Guard was the work of 1876. Major Robert Montagu sat for the 'Beef-Eater'. Over eighty and somewhat infirm, he was supplied with soup at fifteen-minute intervals. Millais dashed in the head and hands and finished them in a few days. It was this picture at the Paris Exhibition of 1878 that opened the eyes of Meissonnier 'to the fact that England had a great painter'. Millais met him in that year when he went to Paris with Frith. A little man with a long grey beard, in black

dress-trousers and a blue silk blouse over a bright red shirt. Meissonnier was fantastically rich and successful. 'Millais and Leighton are pretty decently lodged,' said Frith, 'but Détaille and Meissonnier outstrip them in splendour.' This was what Paris then meant to the visiting English artist. Frith probably never heard of Manet or Dégas.

Every now and then Millais painted a Scottish landscape – like the curiously photographic *Chill October* of 1870, done from a backwater of the Tay, near Kinfauns, alongside the railway; the *Fringe of the Moor*; *The Deserted Garden* of 1875, which Ruskin attacked as unworthy of the painter of *Autumn Leaves*.

The children he painted were legion. *Cherry Ripe* of 1879 was a sweetly pretty example. The model was Edie Ramage, daughter of the editor of the *Graphic*, dressed as Reynolds's *Penelope Boothby* for the *Graphic*'s fancy-dress ball.

The picture was sensationally popular. Of the colour reproduction which appeared in the *Graphic* for 1880, 600,000 copies were sold. Orders unsatisfied would have brought the total up to a million. The publishers had to return several thousand pounds in cash and were sued for non-delivery. Australian miners, Canadian backwoodsmen, South African farmers wrote their praise. It caused, indeed, a worldwide outburst of sentimentality. Millais' recipe was universally acceptable. *Cherry Ripe* found its way to a Tartar's hut and *Cinderella* to the house of a Samoan chief. John Guille Millais discovered a German oleograph of the *North-West Passage* in the shelter of a Hottentot shepherd on the Great Karroo. The shepherd pointed to the Union Jack in the picture and said in broken English, 'I like that cotton goods. It would make good clothes'. As an art critic the Hottentot was well up to the white man's standard.

All this was apart from portraiture. The two great political leaders sat for him: Mr Gladstone, who once confided to Woolner that he believed himself to have done one and only one good thing for art, namely, to 'have been the first to preach and teach that the secret of excellence in the art of Greece lay in the anthropomorphism, or as I commonly call it, the theanthropism of the Olympian religion'. Perhaps he told Millais about this useful discovery. He talked of a number of things: the early Italian painters, the latest *bon mot* from the clubs, fishing, early Scottish history (with deference to Euphemia), music, science. The portrait was painted at the time of the Bulgarian atrocities for the Duke of Westminster, the friend of oppressed nationalities in the East. Later, when Gladstone took up Home Rule for Ireland, the Duke, less sympathetic to oppressed

nationality in the West, would no longer own the portrait. He sold it to Sir Charles Tennant.

Disraeli, ill and near the end of his life, came only three times to be 'immortalized by the illustrious pencil'. 'My dear Apelles,' he wrote in April 1881, with graceful humour, 'alas I am in the gout.' A few days later he was dead. Queen Victoria commanded that the portrait, finished or unfinished, should be shown at the Academy. Her Majesty took a great interest in it and in a completed replica for which she sent three photographs. She favoured one in particular, which gave 'something of the peculiar expression about the corner of the mouth suggesting a keen sense of humour, which contrasts with the extreme seriousness of the upper part of the face'.

When it was finished, the Queen was pleased to remark, 'Mr Millais has given the peculiar, intellectual and gentle expression of his face'. But the Royal favour did not extend to the portrait of Mr Gladstone.

Tennyson and Carlyle, who, entirely devoid of interest in the arts, sat for everyone, seeming to look on the performance as one of the necessary penalties of greatness, were, of course, among Apelles' subjects. There was only one work in Millais' studio which evoked interest from Tennyson. This was a study of Dickens, as he lay on his death-bed. He looked at it for some time, then suddenly exclaimed, 'That is a most extraordinary drawing. It is exactly like myself'.

When Cardinal Newman came to sit, Millais was in hearty mood 'Oh, your eminence, on that eminence, if you please', he said, pointing to the models' throne; and the attendant priests were somewhat scandalised when, seeing the cardinal hesitate, he added, 'Come, jump up, you dear old boy'.

Men's clothes he found ugly and uninspiring, but feminine fashion suited him very well. He painted the Marchioness of Ormonde and the Countess Grosvenor with the frilled and coquettish headgear of the time: Mrs Bischoffsheim, heavily jewelled and belaced, with a flowered, widespreading dress; Mrs James Stern with the wasp waist, the fan and the low, elaborate corsage of the 1880s.

It was the success which he had confidently anticipated; which his parents, who latterly lived quietly and happily at Kingston, had hoped for in the Gower Street days. In the salons alive and ablaze with every fantastic luxury, he and his wife consorted as equals with the greatest in the land. At Stafford House, which moved Madox Brown to bitter reflections, they delighted in the spectacle of Garibaldi in his red shirt

with the Duchess of Sutherland on his arm, surrounded by a company in gorgeous array. They were present at a State Ball given for the Shah of Persia, where diamonds beyond the dreams of avarice, 800 tiaras, flashed and flamed on the persons of women beautiful and resplendent. Of this life Millais was now not a spectator but a part. All criticism had died away, save that of Ruskin, and the voice of Ruskin was far off, in another universe. The sharp words uttered by that distant voice were surely but an insane peevishness, when those who had achieved the greatest heights, not in some impracticable theorising but in the real business of the world, in the arts that touched one and all, consented unanimously to do him honour. Mr Gladstone, Lord Salisbury, Lord Rosebery, Sir William Harcourt, Viscount Wolseley, among the politicians and men of action; Sir Henry Thompson, Sir James Paget and Sir Richard Owen among scientists; a host of writers, including Meredith, W. S. Gilbert, A. W. Pinero, Mark Twain, Bret Harte, Henry James, Matthew Arnold, Robert Browning: Sir Henry Irving, the Bancrofts, the Forbes-Robertsons, the Jersey Lily, Mrs Langtry: Joachim the violinist, Sir Arthur Sullivan, Mme Albani and many another in the world of music – all these paid conclusive homage. To their flattery was added in these mature years that of his fellow R.A.s, whose 'cabals' no longer murmured against him. 'It should be a proud thought for you', said Stacy Marks, R.A., 'that, having never swerved from the right path, and having fought the good fight against all odds, you are recognised by your brothers as the distinguished head of the profession.' 'Your work,' said James Sant, R.A., 'will for ever prove a lesson to those who follow the "serene and silent art".' Others joined the chorus.

Hunting, shooting and fishing completed the pattern of his hard-working, hard-playing life, and apart from the studio, the club and the social events of the season, provided the main incidents in it, balancing him equably between London and Scotland. Few artists, probably, have laid low so many stags and birds or landed so many salmon. How far away he seems in this, as in other ways from Rossetti, the animal-lover who found sport so hard to understand. In 1873, when giving Dr Hake an account of his son, Rossetti remarked, 'George is carrying murder gradually upwards in the animal creation, having now got from fishes to birds – several of his moorhens have already cried "How Long, O Lord" on our dinner-table. When the quadrupeds begin to fall before him I will furnish myself with a pocket pistol and write to you that you may remain at Bath pending his next final graduation in murder.'

What would he have said of the doings at Birnam and at Murthly, which the Millais rented in 1881? There the possibilities of murder were unlimited. There were pheasants, partridges, grouse, blackgame, woodcock, capercailzie, hares, rabbits, roedeer, duck, teal and snipe. Millais shot at them all. He enjoyed the 'jolly days at the Bog'. His guests were expected to share this enjoyment. They might be bitten by mosquitoes. They might be wet to the middle. They might be the poorest of shots. Nevertheless they had to join in. Rain or fine he flogged at his favourite pools with a typical enthusiasm. One day he and his son landed a 'calf', a monster fish of forty-six pounds. Their delight was unbounded.

In the thickets of Glen Artney with Sir William Cunliffe-Brooks and in many other parts of the Highlands, he perseveringly stalked and slaughtered the deer. He felt a 'tail-between-legs' dejection when he missed and the animal, instead of biting the dust, kicked it up viciously in his face, an elation when he hit the great stag which Sir William had marked for his own. The latter (as a true sportsman) had said, 'If he is anywhere about your line of march you had better kill him.'

The ruling passion was always in his mind. On one occasion he was painting in the open, when a blackcock flew overhead. Millais dropped his palette and brushes, seized the gun close to his hand, shot the bird and went on with his picture.

At Murthly, when out with a party, he aimed at a snipe, missed, and peppered an old lady sitting at her cottage door, breaking the glass in the windows also. It is regrettable, though in the light of Rossetti's remarks interesting, that a shriek of delight went up from the assembled sportsmen.

Baron Marochetti, the bad sculptor, got up a shoot for him at his château near Passy. It was sport on the Continental model. The huntsmen were attired in Lincoln green coats, high boots with tassels, slouch hats with feathers, each with a huge curly horn on his back. They sat on chairs and blazed away at rabbits. When one of them hit a rabbit he tootled his horn. Millais thought it rather ridiculous. Even in killing things there was a certain propriety to be observed; and only the English way was really manly and proper.

'A good chap, Millais'; 'a sound fellow'. A great artist with no artistic nonsense about him and a genuinely keen sportsman was armed with a social passport. The gun dispelled at once any suspicion which might be aroused by the brush.

Thomas Carlyle, the 'joyless philosopher' came in 1882 to the house Millais had built for himself at Palace Gate, four years before. It was a great square house, whose details were not Pre-Raphaelite but Renaissance. Its columns were Roman, Doric and Ionic. The main feature of the side looking towards the park was the huge studio window.

The joyless philosopher stumped into the hall. It was about thirty-five feet square, split up by white marble columns, with a marble pavement and dado. It led to the great staircase, which rose in three flights to the first floor. At the right was the morning-room, the walls almost hidden under etched, engraved and photographed reproductions of the artist's works.

Leaning on the arm of his niece, the philosopher climbed the imposing stair. On the first floor to the right was the dining-room, hung with two enormous pier glasses in carved Italian frames; and with Millais' own works. On the other two sides were drawing-rooms, on the fourth, the studio, forty feet long, twenty-five feet wide, twenty feet high. The famous fountain with the black marble sea lion by the Viennese Boehm, sculptor in ordinary to the Queen, splashed and tinkled in the middle. Behind it was a tapestry. Busts stood around.

'Has paint done all this, Mr Millais?'

Carlyle is supposed to have made the inquiry. Tradition has it that he added the reflection, 'It only shows how many fools there are in the world'. Millais' son maintained that it was Carlyle's niece who asked the question, and not Carlyle himself. Apart from reducing the effectiveness of the story, this makes no essential difference. The question was asked. And, of course, there was only one answer. Paint had.

In these Palace Gate days Millais himself was a little but not much changed in appearance from the Pre-Raphaelite Millais. He had never followed the hirsute fashion of the day, and had remained faithful to the side-whiskers and clean-shaven chin of the Georgian John Bull. He completely lost the French which, as a Channel Islander, he could speak when a boy and was in every respect a Briton, 'a great jolly Englishman, Anglo-Saxon to the core'. So he appears in M. Paul Renouard's pen-drawing, firmly planted in a semi-circular chair before his fire, a pipe in his mouth, a checked deerstalker cap on his head, reading *The Times* after breakfast. Rossetti used to say that he looked like an angel in his twenties. In maturity his features, still handsome and clear-cut, had more in them of the squire – a harder set to the mouth and jaw, a bluff and breezy expression proper to the sporting man.

About one thing everybody was agreed – his boyishness. He was the bright, high-spirited, candid, self-centred boy to the last. A hearty paterfamilias, he roused the family at eight o'clock with cheery voice and rousing knocks; he delighted his friends with his simple fun; and with this pleasant simplicity went an absence of interest in things of the mind which was not noticed, or if it had been might have been praised as a refusal to tolerate nonsense or affectation. He read little: the daily papers, a magazine or two, *Punch* of which he was extremely fond, *The World*, *The Illustrated London News*. He read some of the novels of Thackeray and Dickens, though it is a curious fact that he had to borrow a volume of *The Old Curiosity Shop* from Kate Perugini, the novelist's daughter, in order to draw a special set of illustrations. Trollope he could scarcely avoid reading, and he liked also the work of Miss Braddon; but he preferred to read books of travel and adventure; and was still more interested in the illustrations. 'Deuced clever fellow, that Woodville,' he used to say of Caton Woodville, the war-correspondent artist of *The Illustrated London News*. 'He'd be an R.A. if I had a voice in the matter.' Keene and du Maurier in *Punch*, Edwin Abbey and Alfred Parsons with their fine pen-drawings in *Harper's* were other draughtsmen he greatly admired.

He took a greater pleasure in music than in literature; with a direct emotional rather than technical appreciation. 'I won't say no to a little music' was his remark as the hour for painting came round. His daughters Alice or Mary would play something on the piano, and if he liked it he would appear in the doorway, palette and mahl-stick in hand, saying 'That's all right: that fellow knows all about it: play it again'. His taste was quite uninhibited. He admired Bizet, Wagner, Bach, alike. In this, as in so many other respects, he remained with an entire consistency the same as the boy he had been in Gower Street.

But a Pre-Raphaelite he no longer was; in fact, he seemed the very opposite. He defended the animals of Sir Edwin Landseer, once among the anathemas, and finished Sir Edwin's last picture for him in a style indistinguishable from the part completed by its original author. The Rothschilds bought it, on Landseer's death, a life-size picture of Nell Gwynn on a white horse. They asked Millais to finish it. 'How easily', said a critic, 'one can recognize Landseer's dogs', examining a deerhound which appeared in the picture. 'Yes,' said Millais, lighting another pipe, 'I finished painting that dog yesterday morning.'

With Frith, the painter of *Derby Day*, he visited the galleries of Holland. Frith lingered over the finicking details of Metsu and Gerard Dow.

Millais admired Hals and Van der Helst, and even Rembrandt. Frith could not understand his appreciating rough paint put on with a knife; though Millais, conservative enough about anything new in painting, had a keen sense of the shortcomings in the Old Masters as well. He thought Velazquez' horses were poorly drawn, and that none of them could touch Meissonnier in this respect. Anything unusual came under his ban as either incompetent or unintelligible. Whistler he regarded as a great power for mischief, amongst young men – a man 'who had never learnt the grammar of his art'. He said that if a spectator has to ask himself 'Is this right?' he might be pretty sure it was wrong. Browning, for instance, was unintelligible to him. Therefore Browning was wrong. Among the 'Moderns' he frequently deplored superficiality – their lack of a sense of beauty. In all of which what was wholesome and sensible in his nature approached and subtly merged with what was banal and commonplace, the dangers from which the Pre-Raphaelite influence had, for such an amazing interval, rescued him.

A very interesting fragment of his *Notes on Art* remains. It deals with the subject of Fashion. Who, Millais asked, were the painters most in fashion? Our own portrait painters, Reynolds, Gainsborough and Romney. What was the reason for their popularity? They are often (he does not say always) beautiful as works of art. But, in addition, 'the happy owner daily lives in the best society'. They lend distinction to the house. They go with the period plate and furniture. They are more socially agreeable than any other, 'whilst the portraits of Titian, Velazquez and Vandyke are *severer* and are therefore not . . .'

The rest is missing. What were they not? To what conclusion did Millais' argument tend? That a better work of art was not so socially agreeable? Did he himself recoil before the implication that art was not truth, not an unswerving and religious devotion to a standard, not an eternal hope beyond place and time, but a slave, an extremely clever and well-bred slave, politely fitting in with the chattels, and agreeably flattering to the master and mistress of the house, a slave of polish and talent, but as sunk in the ignominy of servitude as the lowest of serfs with an iron collar round his neck?

It is somewhat tantalising that Millais did not finish these notes. It may be significant that he did not. In his talks with Hunt he did, however, make himself clear. If the talks were as reported by Hunt his conclusion was terribly lucid. 'You argue', he said, 'that if I paint for the passing fashion of the day my reputation some centuries hence will not be what

my powers would secure for me if I did more ambitious work. I don't agree. A painter must work for the taste of his own day.' He wanted proof that the people of his own time enjoyed his work; and what better proof could there be than that his contemporaries should give money for his productions and bestow honours upon him? If Hunt could not paint large pictures because there was no demand for them, it showed his system was wrong. He, Millais, painted what there was a demand for. If the public wanted little girls in mob caps, the public should have them. When it got tired of them, he would paint whatever else the public might demand.

Hunt demurred that on these principles the world would never advance at all; that it was contrary to the spirit of such reformers of thought as Socrates.

According to Millais Socrates was wrong.

Why should he try to interfere with the beliefs and religions of the day when there was a priesthood established to teach the people? It was not his business to oppose them in their duties. It was quite natural they should put him to death, to stop him making mischief. If he had minded his own business no one would have disliked him. 'A man is sure to get himself disliked if he is always opposing the powers that be.'

Hunt was wrong to oppose the Academy. He, of course, was sincere, but to Millais nine out of ten were simply anxious for its reform in order to get into it themselves. He advised Hunt to give up thinking about the future and live in and for the present. 'If I were to go on like you do I should never be able to go away in the autumn to fish or to shoot . . . I should become a "distressful" person if I did not get my holiday.' He had just sold a picture done in two weeks which would pay the expenses of all his family, shooting and fishing too, for their whole time in Scotland. 'Take my advice, old boy, accept the world as it is and don't rub up people the wrong way.'

It was very plausible; and as far as work was concerned he seemed to work as hard as ever he had done. The way in which he threw his whole heart and soul into the work struck Mr Gladstone particularly, but was there not in some of this bluff, downright honesty of expression a kind of fear, in the brisk correction of modern error a little of the dark and ugly bile of the tyrant, in the self-assurance an element of self-reproach?

The rewards came in profusion. In 1880 the degree of D.C.L. was conferred upon him by the University of Oxford. At the end of the Public Orator's address in Latin, an undergraduate lowered down from the

gallery a huge pot of Brunswick blacking, in playful reference to the famous picture. In 1885 Mr Gladstone's Government offered baronetcies to him and to G. F. Watts. Watts declined the honour, but Millais accepted. Congratulations were showered upon him. Mr Frederic Leighton, R.A., said that 'English artists will rejoice that the position of Art in the national life has been recognised by an English prime minister': but the climax of his career may best be marked by the sensation of *Bubbles*, the most universally famous of all his pictures.

2 *Bubbles*

Millais painted *Bubbles* in 1885 from his little grandson, Willie James, who was one day blowing soap bubbles from a clay pipe. It was a speaking likeness of the boy, aged four. In order to paint the bubbles with accuracy the artist had a sphere of crystal made to give the correct light and colours.

Sir William Ingram bought it for *The Illustrated London News*. The chromo-lithographic reproductions of Millais' child pictures were already a popular feature of that paper and of the *Graphic*. Sir William had previously obtained for the same purpose *Cinderella*, *Puss in Boots*, *Little Mrs Gamp* and *Cherry Ripe*. The copyright was sold with the pictures.

A little later a Mr Barrett came to Palace Gate. Mr Barrett was the manager of Messrs Pears, the soap firm. He had with him colour reproductions of the latest work Ingram had taken. He explained that the proprietors of the picture had sold it to Messrs Pears, who perceived in those iridescent bubbles blown by a beautiful child a splendid advertisement for their soap.

At first Millais was horrified and angry. He had never dreamed of his painting's being applied to such a purpose. Then he cooled down. *The Illustrated London News* was perfectly within its rights in thus disposing of the copyright. The reproductions were very good – and – it was a marvellous advertisement. In the end he raised no objection.

The sensation was enormous indeed. As a stroke of publicity it was unsurpassed. Pears' Soap became a name to conjure with. Its makers had sent it winging, with unerring aim, to millions of sentimental hearts. More, they had given commerce a new prestige; they had shown that an advertisement need not be vulgar; that it might enlist the services of as great an artist as could be found.

At the same time people were shocked. There were not lacking those

who complained of the 'degradation of Art'. That is to say, in Victorian fashion, they did not mind a work being trivial to please a public that liked trivialities, so long as it remained in its proper place. The same work in another set of surroundings was at once 'degraded'. The sensitive soul of Marie Corelli, the popular novelist, was very much excited. In *The Sorrows of Satan* she made one of the characters say,

> 'I am one of those who think the fame of Millais as an artist was marred when he degraded himself to the level of painting the little green boy blowing bubbles of Pears' soap. *That was an advertisement*, and that very incident in his career, trifling as it seems, will prevent his ever standing on the dignified height of distinction with such masters in Art as Romney, Sir Peter Lely, Gainsborough and Reynolds.'

Millais set her right on the facts. He had not painted the picture as an advertisement. 'What', he asked, 'in the name of your "Satan" do you mean by saying what is not true?'

From Wampach's Hotel, Folkstone, the author of *The Sorrows of Satan* wrote her amends. Millais' letter, she said, had had 'the effect of a sudden bomb thrown in upon the calm of my present seaside meditations'. She meant no harm. On the contrary it was because of her admiration for the 'king amongst English painters' that she became wrathful when she thought of *Bubbles* as a soap advertisement. 'Gods of Olympus!' exclaimed Marie Corelli, she had seen and *loved* the original picture; but she looked on all Pears' posters as gross libels of Millais and his work. She couldn't help it. She was made so. She hated all blatant advertisement. Millais had suggested that 'thousands of poor people' would be introduced to real art through the advertisement. They, in Marie Corelli's opinion, were no doubt well meaning in their way – but they could not be said to understand painting. *Bubbles* ought to hang in the National Gallery, where the poor people could go and see it with a proper veneration. As a token of her esteem she sent Millais a Christmas card, the portrait of her small sweetheart, the little boy he had admired who personated Bubbles in a tableau at the Queen's Hall.

The noble fire of Geoffrey Tempest, the hero, was damped down in subsequent editions of *The Sorrow of Satan*. He no longer suggested that Millais had lost his chance of standing on the same dignified height as Sir Peter Lely. The speech was cut. Ever afterwards Marie Corelli was a friend of the family.

The process which Millais had at the back of his mind, namely that of sugaring the art pill, had worked to perfection. If it were beneficial to have caused exclamations of delight in all parts of the globe, from the polar wastes to the dusty sun-baked veldt, to have impressed prime ministers and gladdened the humble, then his output had been a boon to humanity.

The catastrophe in this may not be at once obvious. It may be questioned whether there were any catastrophe at all. The tragedy, if tragedy there were, was a matter of that impalpable and slight thing, the artistic conscience. In that minute deviation from what he knew was the best he could do to what he knew would be acceptable, it lay – if it did lie. It could only exist if he himself felt that it existed: if he still measured his work not as a commodity but as a measure of himself.

In 1886 there was a great collection of his works, early and late, at Sir Coutts Lindsay's Grosvenor Gallery. He intended at first to arrange them in chronological order; beginning with the *Isabella* of 1849 and ending with the *Ruling Passion* of 1885. He gave up the idea. It would certainly have made very obvious the difference between his Pre-Raphaelite and his older self. The Pre-Raphaelite works were relegated to a small room.

Lady Constance Leslie went to the exhibition. She met the painter on the stairs, going out, his head bowed down. She spoke to him and saw there were tears in his eyes. 'Ah, dear Lady Constance,' he is reported to have said, 'you see me unmanned. In looking at my earliest pictures I have been overcome with chagrin that I so far failed in my maturity to fulfil the forecast of my youth.' There it was.

'Surely', observed Holman Hunt, 'it is the grimmest form of censure that would condemn an artist with such a noble claim to heroism in his youth, because he showed some human weakness in turning aside for a while to the only chance which his country left of gaining the means to continue the struggle.' Some human weakness might well be excused when the means to continue the struggle were forty thousand a year. Great would have been the strength required to offend those multitudes who were so well pleased. When he tried to escape the tyranny which supported him in style, to paint what he liked, 'People pass it and go to a little child picture and cry "How sweet". Always the way with anything serious.'

But grim as the censure might be, William Morris could make it. He

dismissed in two contemptuous words the whole of this unceasing industry: 'Wretched daubs'.

This brief damnation comes in a letter Morris wrote in 1886. He mentioned that Millais' *Vale of Rest* had fetched a 'long price' but 'at any rate,' he added, ''tis worth a cartload of the wretched daubs he turns out now.'

4 The Victims of Jacob Omnium

The soaring graph of Millais' fortunes was paralleled by that of the other former Pre-Raphaelite, Woolner. His portrait reliefs were set in oval gilt mounts and hung framed on the wall like pictures. If the demise of some ornament of a university seemed near, no time was lost in inviting Woolner to 'do him'. Men of learning, like Professor Adam Sedgwick, the geologist, who 'did not much like the kind of durance that is inflicted in a sitting', ignorant of the secrets of the craft but pushed on by friends, came to him quaking with apprehension lest he should have to lie on the floor and be covered with liquid plaster.

The learned world was a speciality with Woolner, and he was proud of his own gifts of scientific observation. He put Darwin on the track of a discovery by drawing his attention to the enfolded tip of the ear and its relation to the animal ear (as in his early *Puck*). The observation was duly noted in *The Descent of Man*. Darwin, grateful, said it ought to be known as the 'Woolnerian tip'. The great scientist was always full of questions. How do babies pout? he asked Vernon Lushington, in paternal capacity. Could Woolner, he inquired, persuade some trustworthy man 'to observe young and inexperienced girls who pose as models *and who at first blush much*, how far down the body the blush extends?' A French artist had said they blushed all over. Darwin would like to know the experience of cautious and careful English artists.

An enormous number of commissions rolled in; and Woolner became one of the principal manufacturers of those stony frock-coats and marble trousers which have impressed and amused later generations. His is John Stuart Mill, brooding coldly on the Thames Embankment and Lord Palmerston in Parliament Square. He sculpted Queen Victoria for Birmingham, Sir Stamford Raffles for Singapore and Sir Edwin Landseer for the crypt of St Paul's. 'Lo, re-embodied now by Woolner's art,' wrote William Allingham in *Fraser's Magazine*, Captain Cook would once more '. . . voyage to the Australasian shore.'

Woolner became wealthy. In 1861 he was able to buy a house in

Welbeck Street. O'Shea the stonemason, who distinguished himself in the adornment of the Museum at Oxford, made the corbels burst into violets, roses, geraniums and thistles. Woolner bought an estate near Horsham in Sussex, and had built that kind of rich artist's country house which is another of the architectural features of the later nineteenth century, a not quite Tudor, not quite manor house, with large and decorated chimneys of brick, and a look of having grown beyond its normal size. Limner's Lease, G. F. Watts' house near the Hog's Back, was a house of the same kind.

Contributing to Woolner's prosperity was the old arrogance and assertiveness of the Brotherhood days with that sense of grievance, which seemed to grow with success rather than otherwise, and even become a weapon to eliminate competition. The cut-throat ferocity of the art industry has been noticed in the career of Millais. Woolner's career is similar. To be recognised as the great sculptor he believed himself to be, he must get rid of rivals – that is, he must show that they were contemptible and incompetent. More effectively than by word of mouth this could be done through the Press. Who could be a better critic than his friend of the *Golden Treasury*, Francis Turner Palgrave, who was inclined to agree with Woolner that Michelangelo was much overrated and subscribed to his strictures on Marochetti and Munro? On Woolner's recommendation Palgrave wrote the handbook for the International Exhibition of 1862. It was unfortunate that the strictures coloured his description. The formidable controversialist of *The Times*, Jacob Omnium, scented an abuse. He went systematically to work on both Woolner and Palgrave and tore them carefully and with savage enjoyment to pieces.

'A critic', said Jacob Omnium, 'named Francis Turner Palgrave, who describes himself as a Fellow of Exeter College, Oxford', had been employed by the Commissioners to write for the use of the public *A Handbook to the Art Collections in the International Gallery*. 'There is a novelty and vigour in the slang of art criticism in which he indulges which is very remarkable; he does nothing by halves; those whom he praises – and he praises some very obscure people – he praises to the skies; those whom he condemns – and he condemns a large number of very distinguished men – he damns beyond the possibility of any further redemption.' Jacob Omnium then proceeded to give at length some specimens of Palgrave's style. Marochetti was 'a mountebank', who made a human figure 'like a round of brawn' and legs like waterpipes. Munro was childishly incompetent according to Palgrave. In one group of sculpture the 'eyes

are squinting cauters, the toes inarticulate knobs'. It was 'the work of an ignoramus, grotesque and babyish'.

'Pleasant for Mr. Munro, is it not? How truly grateful,' said Omnium with sarcasm, 'he must be to the Commissioners for having first borrowed the statues for exhibition and then considerately discovered in Mr. Palgrave a critic competent to appreciate them.' But 'there is one on whom he lavishes pages of high-flown praise which would have made a Phidias blush: that sculptor is Mr. Woolner'. Having done with sarcasm Omnium began to talk plainly. 'The object of this is evidently to fill Mr. Woolner's pockets at the expense of his fellow labourers. If Adam's *Wellington*, Munro's *Armstrong*, etc., are a disgrace to English art ... there is a chance that people desirous of ordering busts may rush to Mr. Woolner.'

He then produced his trump card – the fact that 'it is at 29 Welbeck Street that the British Phidias is to be found, and I grieve to add that Mr. Palgrave, the regenerator of British art – the man who believes in Woolner and Woolner alone ... actually keeps house with the said Woolner'. 'Was it not just possible', enquired Omnium, terrible in his journalistic shrewdness, 'that the Critic and Phidias had talked over the competitors of the latter at breakfast time?'

Watts and Millais also wrote to condemn the catalogue, which was suppressed. The defence of Woolner and Palgrave was feeble. But the criticism had done for Munro. He lost heart, fell ill and died at Cannes.

It would be unfair to accuse Woolner of killing him. The sculptor need not perhaps have taken so much to heart a piece of distorted and prejudiced criticism; but the incident reveals something of the intensity of the struggle for the glittering prizes of the age. The Darwinian principle of the survival of the fittest, which arose naturally in a time of *laissez-faire* and competitive industry, extended also to art. Like fish contending for the warmer and more sunlit waters with their ampler supply of food, like the factories and commercial houses straining every nerve to beat and crush their rivals and drive them out of business, so even artists could deal with their fellows; and the least competitive of human instincts, the worship and creation of beauty, become a net and a sword in the hands of gladiators bundled into the arena whether they liked it or not and irritated to blood lust by the watching eyes of the public and by the panic desire to survive.

This was the real world – the non-Pre-Raphaelite, Victorian world. This was the reason or one of the reasons why sensitive Victorians escaped into a land of dreams. This also was a reason for attempting to supplant reality with the dream brought into actual existence.

1 Uneasy Souls

The dream escape was attractive to the sensitive mind. With Charles Lutwidge Dodgson and Edward Lear it took the form of extravagant fun. The mathematician and logician fitted together the elements of his learning into a new and absurd significance. The correct water-colourist permitted himself an unbridled orgy of nonsense. Logic led to the chess-board of *Alice in Wonderland*. Travel in the Near East led to the land of the Jumblies. There was a natural sympathy between the authors of these transmuted realities and the painters who depicted so faithfully the things that did not exist. The author of *Alice* took photographs in the garden at Cheyne Walk of the whole Rossetti family, of Gabriel playing chess with his mother, or seated holding his wideawake, of Christina and Maria. Lear wrote many letters to and about the Pre-Raphaelites in the nonsensical vein. Woolner was his 'deerunkel'. Holman Hunt was Pa and his 'blessed parient'. 'I approve', he said, 'of both your dancings – a couple of little apes as you be.' Indeed he constructed a comic relationship with the circle. He would ask Woolner to give his love to 'my dear pa' (Hunt) 'and to Brother Bob Martineau and to my grandfather Madox Brown, which I always keep seeing his picture of Work before me – (O my!).' From the Maison Guichard in Cannes in 1870 he sent Woolner a sketch of the house he was going to have built, making it like a funny face. He said he lived on little figs in the summer and worms in the winter; that he was going to have twenty-eight olive trees and a small bed of onions and a stone terrace with a grey parrot and two hedgehogs to walk up and down on it by day and by night. Seriousness, however, broke in. In this same letter there is a sober passage about Hunt, from whom he had received a long screed. To Lear it appeared very alarming that Hunt should be so much in earnest.

'I find I knocked my head against a brick wall for supposing that he was, as he used to be – of what you and I should call, advanced or liberal principles in religious matters. I had spoken about the increase of rationalistic and anti-miraculous thought and hoped his future pictures would point or express such progress. Whereas I find I never made a greater mistake and that on the contrary he is becoming a literalist about bible lore.'

The result of that first journey to the East had been both unbalancing and convincing. Absence in itself had to some extent done what Egg predicted. It had made Hunt lose contact with friends and thrown him

out of the running for the prizes which they were contending for. He laboured with the old patient thoroughness, but in a fitful and unprogressive way. He clung to Millais and even to Woolner, but he was by no means in sympathy with their fierce and unrelenting pursuit of success. He excused Millais on the grounds of the provocation he had suffered, but scarcely hid the fact that he was condoning a departure from the straight and narrow path; indeed with a little unconscious vanity he made it appear in quite definite contrast to his own practice. For Woolner, in the affair of the Handbook, he put up a half-hearted defence which made it painfully apparent that he considered Woolner to be in the wrong. He still put his trust in that greater force which would remove his art from the stains and temptations of sordid commerce or vicious luxury. He was more than ever convinced that that force must be sought outside England. In 1863–4 he was discussing with Vernon Lushington a second visit to Jerusalem. Vernon proposed he should take Boswell's *Life of Johnson* with him. Hunt could imagine nothing better, 'the great advantage of it will be in the interest it will give me in my own country and the power of keeping me from becoming an oriental, as many long residents in Egyptian and Syrian latitudes do'. He thought the country was not in such a disordered state as it was in 1854 and 1855, 'and that I may therefore escape the necessity of fighting. I shall nevertheless take a six shooter with me and if necessary draw it – but I hope to God I may not have to fire it at any human being or in any case that if I do it may only be to save life, that is to save other and better lives than that of my antagonist.'

But there were delays, disappointment and grief between. He married Miss Fanny Waugh. In 1866 they started out for the East, but the cholera barred the path. Stopped at Marseilles and then at Leghorn, they went to Florence. The following year Hunt returned to England, a widower with a motherless child.

A few months later he went back to Florence, to complete the monument he had begun to his wife. He stayed in Italy, painting a picture or two. He made a pen-sketch of himself, a massively bearded, solitary figure sitting alone in a restaurant musing over a bottle of Chianti.

He ran across Ruskin in the square of St Mark, at Venice – Ruskin, fifty, spare of figure, faultlessly dressed, with freckled face and little violet wrinkles about the eyes, accompanied by an unobtrusive valet who carried a copy of *Modern Painters* under his arm. Together they took a gondola to see the Tintorettos in the Church of San Rocco. They stood before Tintoretto's *Annunciation*. 'Now, my dear Holman,' said Ruskin, 'we will

see what I said about it twenty years ago.' He beckoned to the valet, who came forward with the book and handed it to him. Turning to the place Ruskin read aloud:

'Severe would be the shock and painful the contrast if we could pass in an instant from the pure vision (Fra Angelico) to the wild thought of Tintoretto. For not in meek reception of the adoring messenger, but startled by the rush of his horizontal and rattling wings, the Virgin sits, not in the quiet loggia, not by the green pasture of the restored soul, but houseless under the shelter of a palace vestibule ruined and abandoned . . .'

Both he and Hunt decided that the famous purple passage (read right through to the end) was as good as ever; and of the further descriptions of the *Adoration of the Magi*, the *Flight into Egypt* and the *Baptism*, which they chorused reverently, Ruskin also said, 'Yes, I approve'.

The two lonely souls dined together at Danieli's. Having met in a foreign city they talked with the less reserve. Ruskin asked why, for so many years, Hunt had never been to see him. The latter explained 'there were reasons for a time to obstruct our intimacy' – by which, needless to say, he meant Ruskin's friendship with Dante Gabriel; and that Ruskin had surrounded himself with objectionable people, in which respect he may have been thinking particularly of Howell. According to Hunt, Ruskin agreed that he *had* surrounded himself with objectionable people and that he was no good judge of character: and finally they came round to the subject of religion. Ruskin declared himself an atheist: that there was no Eternal Father and that man was his own helper and only resource.

The critic and the painter made a contrasting study in unhappiness. Each felt himself cheated out of friends and affection: each was disappointed in his effort at reform. The uneasy balance of Ruskin's mind is noticeable in many ways. It can be studied in two letters he wrote to Lushington in 1865 – curious variants on the usual formal congratulations to a man going to be married. 'I wish I could write you a nice letter only I can't', wrote Ruskin, 'only I'm very grateful to you for writing to me, and if this makes you really twice yourself, as it should, I shall be twice as glad (though that is very difficult for me to conceive) to see you – double you – as I was of old. I've carried your letter about in my pocket every day since it came till past post time.' Then followed the typical postscript: 'I can't think why people usually say "they wish their friends most happy" – of course, and they ought to wish anybody else to be happy too'. This led to a further reflection, 'I don't wish more at one time, not for one person –

than at all times – and for all – who are nice'. Finally, hanging upside down, comes the parting shot: 'To be sure I wish many? some people to be *un*happy – so I must not generalise too exactly'.

Vernon thanked him politely for this peculiar statement of good wishes, which Ruskin elaborated in the following month (February 1865):

DEAR LUSHINGTON,

It is very nice of you to care so much for my letter – miserable as it was – indeed I have as affectionate regard for you as it (is) in me to have for anyone – having had my regards pretty nearly knocked out of me in various ways: and finding all my pleasure such as it is in stones: and all my pain in such memories or remains of human affection as hang about me still.*

So that I can't write nice letters to happy people – but I should like you to be happy and distinctively too – and do not doubt that you will – and that you will both love and be loved – more than most men can ♭♯ (crossed out) or ♯♭♯ (crossed out) – can be.'

<div style="text-align:right">

Ever affectionately yours,

J. RUSKIN
</div>

The star leads to this (inverted) postscript:
* for instance I had a little pet of a girl who was a great deal more than a dog or a cat to me – and she went half mad with religion and nearly died – and now she can't write or think consecutively so that it's just as if she were dead.'

Such was the state of mind of the well-dressed tourist in Venice. From a similar unhappiness Hunt had come to an opposite conclusion, which he explained to the disillusioned Ruskin at considerable length. He was once more fortified in his belief by opposition. They went their opposite ways – Ruskin back to Camberwell – Hunt to the Promised Land.

2 A Strange Martyrdom

Richard Burton, the traveller and translator of the *Arabian Nights*, wrote to Leighton in 1871 and mentioned that he had seen Holman Hunt in Jerusalem and that he was looking 'worn' – 'like a veritable denizen of the Holy City'.

Once more Hunt settled down among the strangely mixed population – the Arabs (he rather prided himself on his Arabic – 'How can you get on in London', he asked Bell Scott, 'without such words as *Tyib, mafish, inshallah* and *wakri*?') – the Jews, the representatives of the Latin, the Greek, the Syrian, the Coptic Churches, jealous of their privileges, the

pilgrims from the old world and the new, each with a theory, an ideal, an obsession.

He stayed from 1869 until 1874. History in the making came in little contemporary gusts into the timeless Oriental life. The Suez Canal was opened when he was at Port Said on the way out. The Franco–Prussian War was fought. After the French defeat the French at the Consulate no longer came out for their evening promenade between five and six, but walked in shamefaced dejection after dark. Hunt was not surprised they were beaten: 'What could be expected from a set of immoral braggarts like the French soldiers against a set of vigorous husbands and healthy lads with honest sweethearts behind them – as the Prussians are.' He was anti-Prussian, however, 'because they seem at this juncture to be Machiavellian-led'.

For the most part he was alone. He had a roomy desolate house in Jerusalem, overlooking the whole of the Temple area. He built a shed on the roof so that he could paint in the light with protection from the sun. He set to work on a picture of Christ in the Carpenter's Shop – the raised arms of the Lord were to throw on the wall the shadow of the Cross. He visited native carpenters at work and at Bethlehem he searched for the traditional tools of the craft, which he found were being replaced by the European variety. The final model for the figure of Christ was a man of Bethlehem, a staunch member of the Greek Church called Jarius Hasboon.

Hunt worked hard at the picture, but he had a good deal of time on his hands. He read the New Testament, marking questionable points and comparing different passages. He frowned over Renan's *Life of Christ*, which he thought shallow and insincere; and he wrote home long letters in his heavy laborious way on the subject of his solitary meditation. Away from the influence of the artificial life of Europe his mind was fixed on the mysteries beyond material being.

He was fascinated by spiritualism. Samuel Bergheim wanted to arrange an Arab incantation at his house – the equivalent of a séance. He would have been willing, save that all the party without exception would be called on to invoke the name of *Shaitan* – which Hunt could not bring himself to do. A visiting artist told him of the surprising results achieved by Mrs Marshall, and that all the Academicians were taking it up. He distrusted the evidence of the artist because he was the sort of man who could be deceived by anything. At the same time, what is and is not supernatural seemed to him by no means infallibly determined. As an artist it was clear to him that you could put an idea into the most precise of

material forms. It was what he was doing every day. Why should not God put an idea into material form? What better way of suggesting that One escaped death than by making Him visibly ascend from the earth? And, argued Hunt, 'since we are told that a condensation of gases in the atmosphere can make a solid body like a thunderbolt, it is competent for us to imagine that His body was resolved into its original elements, to be reorganised at a later time'.

Hunt's language took on a biblical, a prophetic cast as he became the more convinced. He scourged the 'poetic atoms, newly moulded from the earth, but now published as settled with omniscient penetration of mind that can reach within the innermost veil of all, and discover there is nothing, where poets before them have dreaded even to peep, lest an awful majesty should avenge itself. Thus foolish generations,' he obscurely proclaimed, 'have died in the hope of reward for their awe at least.' He himself had 'occasional presentiments and other psychological consciousnesses' which forbade him to think we are 'mere burning bonfires to cease with the consumption of the fuel'.

Into the picture he put the intensity of his feelings. In the middle of the summer he thought it would be the death of him. He got only four hours' sleep a day. He dreamed of it 'until my eyes sank deep into my head and I became green and my body seemed such a heavy, still and unelastic corpse that I thought the next stage must be coffinward'. Bell Scott, who received these confidences, with a piece of genuine maidenhair fern from Nazareth – for Mrs Scott – thought he was getting morbid and working too hard.

The Shadow of the Cross, finished picture, first study and an elaborate quarter-size copy for the engraver to follow was sold to Agnews for £5,500.

Materially, it could not be considered an unsatisfactory result. Nor, apparently, was it without spiritual effect. Hunt was gratified by the interest of artisans and working men in the North. A number of them asked to purchase the two-guinea print by weekly instalments.

He returned to England in 1873, but did not stay long. He fretted with impatience to get back to the East. He remained long enough, however, to get married to Miss Edith Waugh and to have a furious quarrel with Woolner. Neither spoke about the matter publicly. Hunt asserted that the quarrel was due to his having doubted the authenticity of some of Woolners' collection of pictures.

For a third time Hunt set out for Palestine. His work on this trip was

pursued by accidents which he almost seemed to invite. The picture for this occasion was *The Triumph of the Innocents*. It brought him into direct conflict, as he thought, with the devil.

The cases containing his materials were delayed. He had given precise instructions to his friend, F. G. Stephens, who had promised to see them safely packed and forwarded; but the days passed and no cases came. Hunt considered going to Alexandria or even to Naples to get a fresh supply, but did not care to leave his family without protection. Consequently he bought some of the best linen in the bazaar and a small painting of the P. & O. boat proving satisfactory on this ground, he began to use it also for the *Innocents*. By the time the packing cases turned up he had done so much he did not choose to abandon it; but the bazaar linen proved to be unsatisfactory in texture just at the place where the heads in the central group were to come.

The house he had previously occupied was no longer suitable. He bought a piece of ground and had a house and studio built on it. This was another delay. When the house was finished the rain came through the roof.

Two and a half years went by.

He came back to England with the unfinished picture haunting him. Then he got typhoid and was again withheld from bringing it to completion. It was a source of worry to him also that he had nothing of importance to send to the newly opened Grosvenor Gallery. He, the only Pre-Raphaelite left, as he now considered himself, was missing the greatest opportunity that had so far come the way of artists on the wrong side of the Academy gates.

The Grosvenor Gallery, started by Sir Coutts Lindsay, was the sort of thing the Pre-Raphaelites had always wanted. Its founder was a man of wealth and something of an artist, had the deliberate intention of overcoming just those drawbacks and abuses of which artists complained. First the pictures were to be given their due. No skying, no concealment in dark corners. Each was to be hung where it could be seen. Six to twelve inches of wall space was to separate it from its neighbours. It was to get the light most favourable to it; and those harsh contrasts of scale, style and colour which committed wholesale murder at Burlington House were to be scrupulously avoided. Admission was not a competitive struggle or a prescriptive right but by invitation – the list of those to be invited being left open for new talent. As far as possible a man's work was to be hung by itself and in the way he himself wished.

162

During the 1880s, until it lost caste by introducing club and concert rooms and making the pictures a background for 'tobacco and flirting', the Grosvenor Gallery was both the modern and the fashionable centre. On private view days and Sundays the world of society, from the Prince of Wales downwards, was to be seen there. Some of the projects did not turn out quite as planned. The upholstery, as Ruskin pointed out, was too bright for the pictures. The lighting was not all it should be and the tables were reflected in the sheen of the glass. It was, in spite of these flaws, a great success.

And Pre-Raphaelitism missed the bus. Invited, courted, besought to take part in the ideal gallery it had wanted, it declined. It would not now have been a satisfactory substitute for the Academy to Millais; but the idea that Millais and the Academicians might exhibit put off Brown and Rossetti. Brown, in that indignant artist's temper which delighted in being able to say 'no' to something, refused to have anything to do with it. Rossetti also. In a letter to *The Times* in 1877 he corrected the impression that his refusal had anything to do with ill-health. He expressed the opinion that the Academicians had enough space of their own and that it was wrong to introduce them. But the main reason, he said, was 'that lifelong feeling of dissatisfaction which I have experienced from the disparity of aim and attainment in what I have all my life produced as best I could'. Distrust of himself, he said, and not of others was the cause of his 'little-important reticence'.

And to Hunt the supremely aggravating thing was he had nothing to show. He had painted little in quantity because of the enormous pains he took with each picture. Most of his pictures were already disposed of; and the wretched piece of bazaar linen with its irregular surface prevented him from showing his great last work, *The Ship*, his study of the P. & O. boat; a refurbished portrait of Rossetti and one or two oddments were the best he could provide.

If the idea that artists were difficult people ever occurred to the organisers of the gallery, no doubt it occurred now. The Pre-Raphaelites, given a marvellous opportunity, now coyly and angrily hid themselves. The only one who came forward to save the situation (and to scoop the pool) was Edward Burne-Jones. He and Whistler were the star exhibitors; and so distinct were Burne-Jones' pictures in style and so numerous that the public accepted them as being the essence of Pre-Raphaelite art instead of a stylised by-product of that vital force. The pale and languid damozels of Burne-Jones were seen alongside the dim and delicate nocturnes of

Whistler. It was perhaps natural that the public should confuse the two. It was another irony of Pre-Raphaelitism. Instead of an intense imaginative heat it now appeared as a pallid, sickly and languid 'aestheticism' whose appropriate disciple was the 'greenery-yallery Grosvenor Gallery foot-in-the-grave young man' of W. S. Gilbert's comic opera.

Grim and conscientious Hunt went on with his lonely struggle, forswearing the promised delights of the new gallery with puritan firmness. He called in Millais to ask his advice. Millais came with a hearty bedside manner. He knew a man who would put the surface right and make all 'tight as a drum'. So the *Triumph* was sent to the restorer and came back looking quite sound. Hunt worked on it for eight months more. And then a further calamity revealed itself. The wrinkled linen had been smoothed out over a soft composition which gave way when pressure was applied to it; and so after all he had to give it up and start again on a new canvas.

At this he toiled long and late. It robbed him of sleep and made him ill again. He had to go to Switzerland to recover. Even now with his old obstinacy he could not let the original picture alone. He again called in the restorer to see if they could cut out the offending texture and insert a fresh square of canvas. By unravelling the edges of this, weaving them into the cloth of the main area and laying all down on a new backing the surface might be made without flaw. It was done. Once more he toiled on the heads of Joseph and the Virgin. Millais lent a hand – on this or the second picture. In fact tradition has it that he painted a good deal of the second version – an act in keeping with his loyalty and generosity in aid; and at length the work approached completion.

But by this time Hunt had invested it with a supernatural character. He had got as near in the picture as he could to painting a spirit. The children who surrounded Joseph and the Virgin on their flight were neither angels nor cherubs but, so he intended, the souls of the children massacred by Herod. He explained this with some care to Bell Scott, who questioned the appropriateness of the 'phosphorescent nimbus' by which they were surrounded. They had just left this life and were not altogether established as celestial creatures. They were somewhere between actual presences and a vision perceived by the mind of the Virgin. Therefore the light on and around them was partly real, partly unreal. As the real and the divine were produced on the canvas so he argued that in the difficulties besetting it the real and the diabolical were engaged. The devil himself must be fighting against the canvas. It was the Father of Mischief who had put it in

the mind of F. G. Stephens to stow the materials destined for Palestine in one huge packing case (which was jocularly known as *Goliath*) instead of the three smaller cases, as instructed – thus causing that fatal delay at the outset. For years the Father of Mischief had plagued him. In the large dark studio in Jerusalem where he had laboured each night the devil had seemed to throw all in disorder again the next day.

3 The Devil in Manresa Road

On Christmas Eve, 1879, a dark figure could have been observed going into a group of studios in Manresa Road, Chelsea. The hour was late, the fog hung thick; but neither the hour, the fog nor the festive season could keep Holman Hunt away from his picture. He had a new plan for curing the twisted surface and could not rest until it was tried. He laboured now with a candle in his hand through the silent dark hours; he thought suddenly that it looked better. Half to himself he exulted:

'I think I have beaten the devil.'

Then the whole building shook with a great convulsion.

The source of this phenomenon appeared to be behind his easel. It was as if a great creature were shaking itself and running between him and the door.

'What is it?' called Hunt.

There was no answer and the noise ceased. It was between half-past one and two. The door was still locked as he had left it. There seemed to be no one about. Half an hour later he heard a fellow artist come up the stairs who said, 'It is no use going in, it is as dark as pitch', to someone with him, and went out again. This was the only sign of human life he noticed between eleven and half-past three in the morning.

Bell Scott, Mrs Scott and Miss Boyd were all very interested. Scott suggested that the cast-iron stove might have cracked and thrown out a rivet with a loud report. Hunt, in writing it down, seemed to realise the story was a little bit thin. But, he said, as there is 'a divinity that shapes our ends', the question to him was not whether there *was* a devil or not but whether the noise was opportune. Thus he concluded – or at any rate hoped – that the devil was defeated in Manresa Road at half-past one on Christmas morning.

The sceptic Scott was glad when the picture was finished: the state of mind it had involved was to him quite strange and rather ridiculous. He was surprised, he wrote to Vernon Lushington, having seen the finished

work, by 'the healthy, or rather, comparatively happy expression of his face. I say surprised because for two years at least there has been on his countenance, so well known to me for so long a time, something of a *lost* undercharacter of expression that has made me unhopeful about the picture. Now he has toned the whole surface into unity and got the pervading moonlight excellent, so that one wonders why, when he could do it at all, he did not do it at once, instead of showing the crude effect for so long.'

As Dr Johnson said, 'Sir, you may wonder'. Hunt made all the difficulties himself as a mediaeval friar might put peas in his shoes. There is little in *The Triumph of the Innocents* that could not have been painted in comfort without leaving Chelsea. The long-drawn-out expedition, the consignment of gigantic cases of material, the building of a house in Jerusalem, were quite useless, unless considered as symbols of a difficult road to be trod. But again the Pre-Raphaelite idea fused the spiritual and the real life, so that difficulties were not only surmounted but positively devised. And in the end the picture was launched with a splendour befitting the trials it had been through. The reprint of Ruskin's words of praise was a clarion blast to the faithful. The large descriptive brochure on superfine deckle-edged paper was a solemn thanksgiving. The reproductions were three, five and eight guineas apiece.

5

1 From King Arthur to Karl Marx

The efforts of all these labourers in the vineyard of the 'fine arts' were quite outside the sympathy of William Morris. In so far as they failed he did not consider their failure tragic – because he did not believe in tragedy – at least, of that kind. For that species of drama it was necessary to attach importance to the individual emotions. He attached no such importance to them, in themselves. They were symptoms merely of a certain condition of society. Diseased, that is to say unhappy or tragic emotions were symptoms of a diseased social order. To elevate them into a position where they commanded respect and admiration was to pamper egotism, encourage a perversion. The proper course for the man of intelligence was to remove the cause of error and not to weep over the symptoms it produced. 'Have you noticed', said Rossetti, 'that Top never gives a penny to a beggar?' It was true. Morris never did. Instead of maintaining the beggar in the state to which he was reduced, he would rather re-

move the conditions which made for beggary. Rossetti would give care-lessly and liberally on the spur of the moment; but in the first causes of the ragged, whining figure with outstretched palm he was not at all interested. Doubtless there always had been beggars and doubtless there always would be. Morris himself saw all this quite clearly. The attitude of Rossetti in itself was a symptom – a symptom of pessimism. To accept these distressing conditions as natural meant you saw no hope of improve-ment. 'The truth is', he said of Rossetti (in the year after the latter's death, 1883), 'he cared for nothing but individual and personal matters; chiefly of course in relation to art and literature, but he would take abundant trouble to help any one person who was in distress of mind or body, but the evils of any mass of people he couldn't bring his mind to bear upon. I suppose, in short, it needs a person of hopeful mind to take a disinter-ested notice of politics, and Rossetti was certainly not hopeful.'

The habit of going back into the past, for pleasure and inspiration, to the Court of King Arthur, to the never-never country of the Sagas, was the material form of a mental process. So it was indeed with Hunt. He had repaired to Syria and Palestine in order to give material expression to his religious faith. There was this difference with Morris: that he sought not a faith but some antecedent reason: and his love of the past was, in effect, a question. He asked Why? What were the circumstances that had pro-duced this good thing, this bad one? Why, among other interesting questions, did picture painting exist? What was this mysterious activity doing in the world and where did it come from?

He found no satisfactory answer to the question and he looked on painting pictures as an unsatisfactory thing. As a social activity he per-ceived it in a different perspective from its practitioners. Painting, ra-tionally considered, was a method of decorating surfaces. On a large scale this decoration of surface could best be achieved by frescoes, or, dispensing with paint altogether, by tapestries. On a small scale painting was most fittingly the decoration of a small area, as it used to be in the illumination of the old manuscript books – or an extension of this idea like the work of Van Eyck. As a record, or as a decoration, it had some use-fulness and reason. But as a more refined sensation – a surface charged with feeling and presuming to transmit feelings to others – then it seemed to him a folly and a luxury without real or useful purpose. The high pay these artists received was altogether beyond their desert and was given them in recognition of their being the parasites of the 'possessing classes.'

The examples were before his eyes. Judged by Morris' standard, Millais crumbled into nothing. His work was a sort of prostitution, a titillation of shallow emotions in a shallow, brainless crowd of worldlings; symptoms, both, of something wrong with the social order. And if Millais represented the prostitution of art, Rossetti represented its dissipation, the indulgence of self with all the oppressive burden, the sterile misery that was bound to result: while Hunt was lost in theology, trying to benefit the soul in some roundabout, ineffective fashion, instead of making a direct approach to the problem. He was too orthodox and an orthodox reformer, to Morris, was a contradiction in terms.

The quality that had attracted Morris in the early Pre-Raphaelite pictures was that they were militant, aggressive in spirit. Without that, or when the spirit had lost its power to startle and shock, they were nothing, neither an honest craft nor an honest means of improving mankind.

In arriving at this conclusion Morris by no means abandoned Pre-Raphaelitism, though little concerned, consciously, whether he did it or not. He carried it a stage further, that was all. He applied it in his own way; yet in certain principles he was strangely consistent with the original scheme and he described the same circle of reasoning as John Ruskin and even Ford Madox Brown.

The circle curved steadily through the wild mass of contradictions and quibbles, the splutterings, the thunders, the purple-stained profundities and fantastic by-paths of the Ruskinian opus. Ruskin had begun as a lover of pictures, with a special admiration for Turner. Moved to write a book in defence of Turner he had perforce to consider what was right or wrong in his painting, when comparing him with other painters. Having decided that Truth to Nature was the standard, he had been impelled to study the truth in nature. Nature was built according to certain beautiful and eminently workable structural laws. This discovery had inevitably led him to study architecture as the form of art most clearly allied to natural form and its structure. The structure of a building in turn clearly had a relation to the structure of a city – a society. To examine the structure of society was the next obvious step. Having decided that, by comparison with the past, the existing structure of society was most unbeautiful; that Rochdale could not hold a candle to Pisa; that life was identical with art in its ugliness, it was a matter of plain conscience to describe what life ought to be, and to attempt by means of setting undergraduates road-making, by the St George's Guild, by practice as well as theory, to make the desired

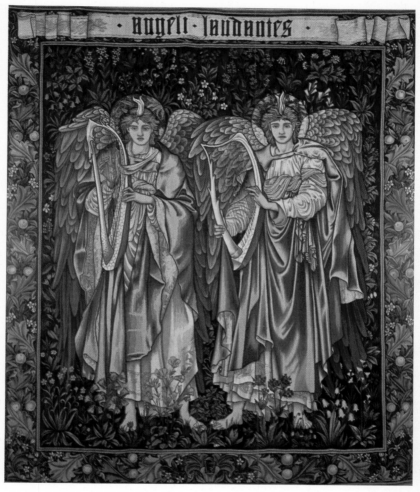

9 *Angeli Laudantes,* tapestry in wool and silk, designed by
Burne-Jones in the 1870s and woven by Morris & Co. in 1894

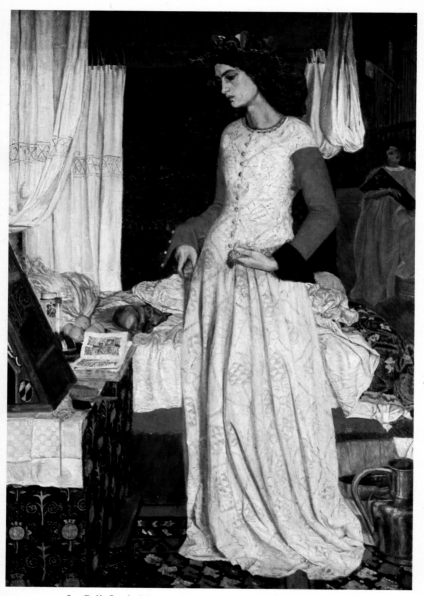

10 *La Belle Iseult* ('Queen Guinevere') by William Morris, 1858

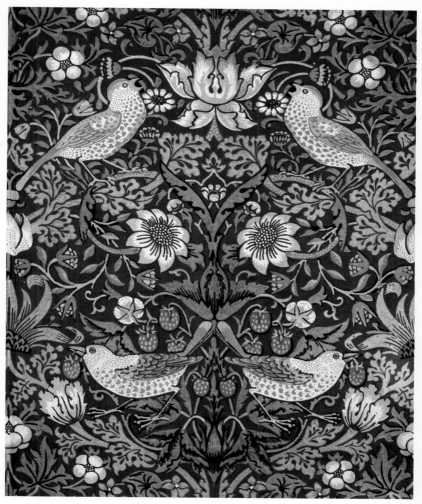

11 *The Strawberry Thief*, textile by William Morris, 1883

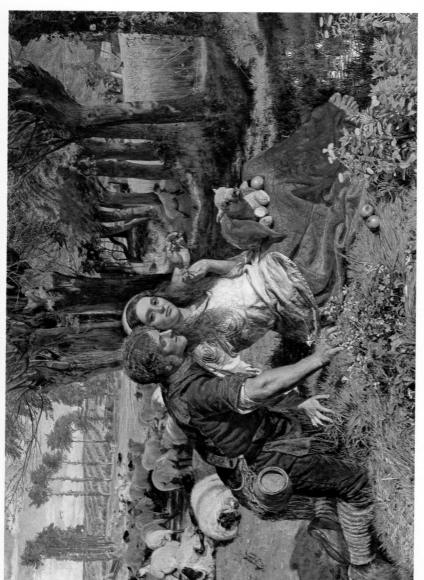

12 *The Hireling Shepherd* by W. Holman Hunt, 1851

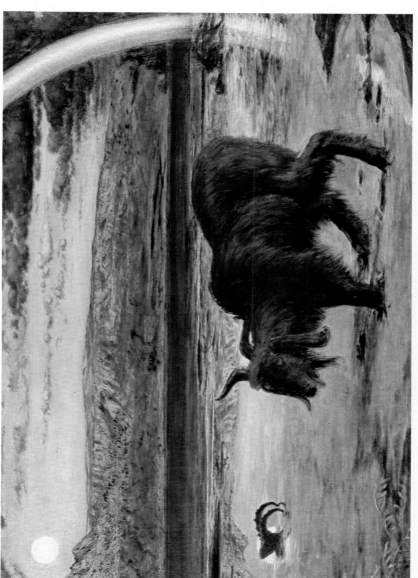

13 *The Scapegoat* by Holman Hunt, 1854

The Death of Chatterton. Henry Wallis

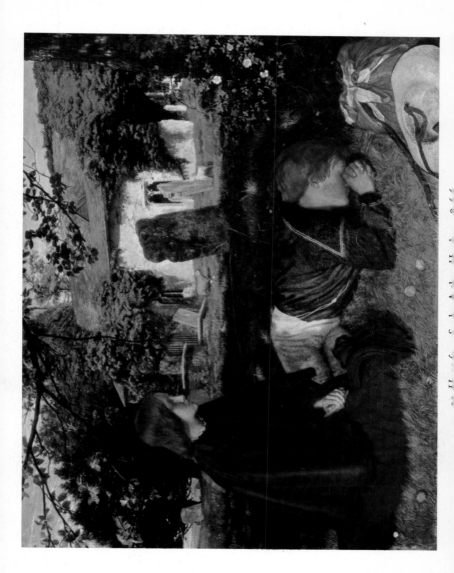

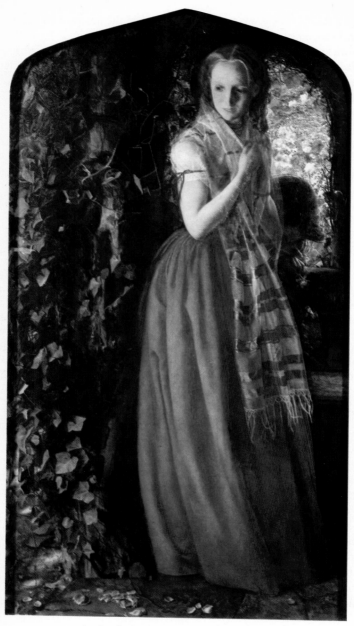

16 *April Love* by Arthur Hughes, 1856

change a reality. There was no break anywhere in the process that made a political economist and social reformer out of the art critic.

Brown knew by personal experience the drawbacks of painting pictures, and had a hearty contempt for most of the people who did. He, of them all, made the most gallant and ambitious attempt to escape from the tyranny of the easel picture in his frescoes for the Manchester Town Hall, one of the first Victorian essays (in any form) to record social history and to give a coherent account of the development of a modern town.

To observe social conditions seemed to him a duty of the intelligent artist. This duty led him to depict John Kay, the inventor of the Fly Shuttle, and Dalton collecting marsh gas, as well as the Romans building a fort at Mancenion. His part in the foundation of the Co. was evidence of his wish to design the things people really wanted and used. This in turn led him to consider what people really did need – what was wanted. Thus he, too, came to desire a social reform. The luxury of Stafford House, which had evoked complacent admiration in the Millais', was, to him, futile and wrong.

> 'Oh how strange a place is this world!' he said. 'Only those seem to possess power who don't know how to use it. What an accumulation of wealth and impotence! Is this what is gained by stability and old institutions? Is it for this that a people toils and wears out its myriad lives? For such heaping up of bad taste, for such gilding of hideousness, for such exposure of imbecility as this sort of thing is! Oh how much more beautiful would six model labourers' cottages be, built by a man of skill, for £100 each.'

He shocked Hunt by his avowed sympathy with the Paris commune.

Morris' ideas took a similar course.

In politics he was, to begin with, a mild Liberal – convenient description for the vaguest benevolence towards the human race.

For years he had been entirely immersed in his own happy and innocent labours as a designer and poet. Two sets of atrocities in 1877 stirred him into an activity outside this – one was at Burford, the other in Bulgaria.

The Burford atrocity was the restoration of its beautiful parish church. Restoration was a part of the Germanising of Victorian England. The churches were made neat, tidy and soulless on a Teutonic pattern of Gothic. Lovely detail was ruthlessly destroyed in the process. The arch-restorer was Sir Gilbert Scott.

Already damage beyond repair had been done – with little protest.

Etty, the painter, moved by threats to his beloved York Minster, was one of the first, if not the very first, to complain. F. G. Stephens, the Pre-Raphaelite art critic, had hammered away against restoration in the *Athenaeum* for years. It was to the *Athenaeum* Morris wrote his protest. He attacked equally the architect, the parson and the squire; but he did not limit himself to invective. Tewkesbury was threatened. Something must be done to save it and

'whatever else of beautiful and historical is still left us. What I wish for, therefore, is that an association should be set on foot to keep a watch on old monuments, to protest against all "restoration" that means more than keeping out wind and weather, and by all means, literary and other, to awaken a feeling that our ancient buildings are not mere ecclesiastical toys, but sacred monuments of the nation's growth and hope.'

He was clear, reasonable, practical. As a result The Society for the Protection of Ancient Buildings was formed. Morris was the secretary. He invented the short name for the society of 'Anti-Scrape'. It was brought home to him that a connection existed between his own preferences and the general amenity – that 'good taste' had social responsibilities.

The Bulgarian atrocities were a long way from such a question as this. It seems curious at first that Morris should have taken a sudden interest in a political issue arising out of the collapse of Turkey in Europe. But with his awakened faculty of social reasoning he saw himself and his cherished business to be directly involved. The danger was that in order to bolster up the atrocious Turks, England would have to go to war with Russia, because national policy was more concerned to oppose Russia than to condemn the Turkish butchery. Morris was against the Turkish government; but his main concern was England and the motives of England – and, naturally enough, the firm of Morris & Co. If there were war the firm would suffer. For what reason? Because 'greedy gamblers on the Stock Exchange, idle officers of the Army and Navy, worn-out mockers of the clubs, desperate purveyors of exciting war news for the comfortable breakfast tables of those who have nothing to lose by the war', would lead us into it. It was precisely because the question had nothing to do with him, save to make his cherished occupation helplessly suffer, that he busied himself with it. A system in which he and his fellow workers had no say could hurl them into a palpably unjust war. This meant that, whatever the issue, he and his fellow workers were at the mercy of an unprincipled system. The more it

was analysed the more intolerable was such a state of affairs. To get rid of the system, therefore, was clearly the social duty of such men as he.

He threw all his energies into this agitation. It brought him in touch with the radical leaders, the working-class socialists. When the excitement died down he went back to the dye-vats. Carpets were now being produced. Tapestry was meditated. Bazin, a weaver from Lyons whom Morris alluded to as Froggy, together with 'a poor old ex-Spitalfields weaver', were enlisted. Between dyeing silks in cochineal, running Anti-Scrape, visiting clients, his time was full. With a load of patterns, carpets, silks, chintzes, he went over to Ireland to advise the Countess of Charleville on the decoration of her home at Tullamore, King's County. The Dublin mountains reminded him of Iceland.

In 1878 he took a house on the Upper Mall at Hammersmith. It had been called the Retreat – a name which he quickly changed to Kelmscott House. He liked to think the same river linked the two. The following year he was 'in a whirlwind of dyeing and weaving'.

But he could no longer rest content. Two kinds of ugliness had challenged him: the ugliness of what was produced under the guise of art; and the ugliness of conduct which seemingly had nothing to do with art at all. Was there any connection between the two? Yes, thought Morris, there was.

Both were the products of modern civilisation. Obviously, then, civilisation was wrong. If civilisation were wrong, what was required to set it right? These were the questions which haunted him. Was it enough to live in pleasant places, to do work that you loved and write poetry and again more poetry, and bother no more? 'As to poetry,' he said, 'I don't know and I don't know.' The urge was gone; and 'to write verse for the sake of writing is a crime in a man of my years and experience'. Even the beauty of Kelmscott seemed a reproach, as if he were shirking some great issue. As he sat in the tapestry room and looked on the moon rising red through the haze and heard a cow lowing in the fields, the peace and quietude disturbed him. At Hammersmith there were shrieks and yells, brutal, reckless faces and figures. Good luck had put him on the right side of the fence, made him respectable and rich, given him delightful books and works of art. He might, but for this chance, have been on the other side, in the empty street, the drink-steeped liquor shops, the foul and degraded lodgings. Yet the happy chance did not absolve him from responsibility. Conscience insisted, not that he should be as wretched as the drunken, brutal louts of the town, but that they should be made as civilised and content as he.

There was nothing unique in a man's becoming a socialist in the 1870s and 1880s. The rising tide of wealth which moulded the rich into aristocrats and patrons of art was, at the same time, moulding the poor into a class. As they became a little better off their grievances were more defined. In the chaos of the earlier period their misery had been like a calamity that happened, no one knew why or how, a visitation from above. Now, improved in condition to the extent of being self-conscious, they looked for a more exact explanation. They drew together to protect themselves, as men against men. The Trade Union was as effectively the maker of a caste as the Public School.

And Morris was a tradesman. He worked with his hands and kept a shop to sell what he made. Therefore it seemed to him that his interests were identical with those of all others who worked with their hands. 'A poetic upholsterer.' That was what Sir Edmund Beckett called him: 'meaning (strange to say)', he said, 'an insult by that harmless statement of fact'.

He was nevertheless not a tradesman who would be recognisable as such to trade. He was a gentleman, a poet, with a comfortable industry whose revenue was derived from supplying luxuries, meritorious as they might be, to those who could pay for luxury. Self-interest would have placed him on their side. The reasoning which placed him on the other was, to the Becketts, incomprehensible. And his Socialism was not, similarly, other people's socialism. It was Pre-Raphaelite Socialism: it derived from that idea which lurked even in the original discussions of the long-evaporated Brotherhood – that everyone should be an artist.

Rossetti had always asserted it, not as a social argument but as a thing to him so evident that it did not require any argument at all. To him an artist meant a painter. To Morris it meant something different; but the principle was the same. Morris sought to define it. He generalised from his own experience. What was, what should be art? He was happy in his work. His work was art. Therefore art was a thing which you were happy in doing.

'Art is the expression of pleasure in labour.'

Happiness was the end of life. If art were happiness in work, then art was or largely contributed to the end of life.

Popular art, in the true sense, was not an entertainment produced by a few individuals. It was the work produced freely and spontaneously by the people. It was a useful art, for useless art was waste and waste meant wealth and usury. Where was the example of this useful art to be found?

Again he generalised from his own experience. In the Middle Ages: in the old England. There rose up before him Oxford as he had known it in the days of his youth – the city rather than the university – clear cut in the meadows as if there had been a wall about it, a city of grey stone whose old houses were lovingly ornamented with wood-carving and sculpture. And Rouen as he and Burne-Jones had seen it, in which the craftsmen of old had laboured to produce in house and church a pure and wonderful delight. There were traces of this ancient and lost happiness along the Thames and around dear Kelmscott, little unknown churches, and inns in which there were honest pewter and crusty warm-toned pots which Englishmen had found love in making – as long ago, maybe, as the time of John Ball, when Englishmen dared to be free. The excursions he took by river with the family and friends brought the whole panorama of change before him. On one such occasion his massive head, noble in its full manhood, eyes seeming far away yet sharply observant of the slightest detail, he sat in their boat, the *Ark*, with Jane beside him, Faulkner and Crom Price, chaffing merrily, and William de Morgan, the potter, toiling at the sculls. 'Cockneydom' was gradually left behind. Henley was gay with regatta. The party was light-hearted. They had a battle-royal as to whether Mrs Harris existed or not. Faulkner said she was a concrete idea; but Morris asserted she was not even a character in fiction as she was only the invention of Mrs Gamp, who herself was a character in fiction. Yet underneath the display of high spirits there was a brooding preoccupation. The change from Hammersmith to Kelmscott was unsettling in its demonstration of England's loss of true values. A ramble too from Kelmscott along the Foss-way and the valley of the Coln was a ramble into history, the happy anonymous history of a people of artists and craftsmen. It was not the fact that the village churches were Christian that impressed him. It was the fact that the people made them – in the cathedral at Rouen he had found the same thrill – the thought of a whole community of free workers, free to indulge their fancy, to make each corbel or capital different from another, if they felt like it, co-operating harmoniously and equally together. He found the vital secret of Gothic not in Christianity but in Socialism.

What separated us now from this existence whose desirable nature was shown by the things it had left for the admiration of future ages? A community of interests had existed once, the evidence was before his eyes. A community of interests might exist again, on a scale greater still. All civilised nations might form one great community, agreeing together as to

the kind and amount of production and distribution needed, working at such and such production where it could best be produced. How much waste would thus be avoided, how much the wealth of the world would be increased by such a revolution. What hindered it?

Commercial war. The competitive system between the 'organisers of labour', between nations. The slavery which was the essential part of this system, that is to say, forced, mechanical, unintelligent labour, with a reserve of unemployed. The workers themselves, under the compulsion of the system, were forced to compete, that is, fight, with each other. The distinction between commercial war and national war, conducted with mechanical weapons, was a distinction of scale and number but not of kind.

Machinery had played its part in this enslavement; but the machine was also produced by and could be controlled by man. Thus controlled it would not be regarded as an inevitable thing to be kept going at all costs: if on consideration it might seem that work could be carried on more pleasantly as regards the worker and effectively as regards the goods by using handwork instead, then get rid of the machine. It would be perfectly feasible in an order where it had not, for the sake of profit, to be kept going at all costs. The abolition of competitive industry, private profit, class distinction, coincided with the views of the political Socialists. Therefore he fell into line and joined up with them. If he felt his ideas were right he was prepared to go wherever they might lead him; even to lose for a time and see lost in the world the art he loved so much if that also were necessary for the making of a new art, a new life. His early attachment to King Arthur had led him irresistibly to Karl Marx. The Round Table was a preparation for Communism – indeed a sort of communism in itself – for he contrasted to his lecture audiences the knightly hall in which the workers might banquet together with the misery of their single rooms in mean tenements. The art of the fourteenth century was a plank of political revolution.

He began to lecture, hammering at these ideas, making them ever more clear and definite. He used short, simple, definite words, like those of his poetry. Clear patterns and colours, clear, if unusual, thoughts were a necessity to him. When a client asked for some dim, mixed hue, he said, 'If it's mud you want there's plenty in the street'. Doubt or hesitation or muddle were dirty. To be definite in word or act was clean. Political ideas had to be clean and hard like the story of Beowulf, like the stark lands of the North purged of impurity by the icy waves, like the detail of those early

Pre-Raphaelite pictures. No socialist was ever more uncompromising than Morris, more wholesale in condemning the conditions that existed, more precise in the aim of stirring up rebellion.

In such action as might be taken he also drew on his own experience – in his craft. He had come fresh to the work. He had studied and, after a false start or two, mastered a number of technical processes. By enthusiasm and energy he had made himself an expert craftsman: to the extent of being able to revive and healthily develop crafts that were dying or dead. There was no mystery about these human affairs. If you wanted to do a thing you did it – that was all. You worked hard, took trouble to find out the right recipes and processes, used them as they were meant to be used and the solution of the difficulty followed as surely as day follows night. In this way you made carpets purged of that horror which had come upon Oriental carpets owing to the influence of the West: stuff, hand-woven and stained with beautiful dyes: glass unlike that of the clerical tailors and outfitters. The works, acquired at Merton Abbey in 1881, were a demonstration of the wicked absurdity of existing factories. Seven miles from Charing Cross, between London and Epsom, Merton Abbey was converted to his purposes out of the sheds of a silk-weaving factory started by Huguenot refugees, on the banks of the Wandle. Here Morris began the large-scale manufacture of his chintzes. The place looked as little like a factory as could be. Tall poplars fringed the mill pond; the cottons lay bleaching among the buttercups; the leaf-broken splashes of sunlight fell on the vats; the trout leapt outside the windows of the dyeing-room. Visitors took tea in the house and left with a load of marsh-marigolds, wallflowers, lilac and hawthorn.

You could do the same thing with human beings. Had he not taken whatever human material came to hand – in building up the firm – converted waifs and strays into happy, successful and self-respecting craftsmen – made a first-rate business manager out of a man whose life had been driven into an erratic course by the careless, heedless, monstrous system – made a factory into a dream of delight.

What could be done with wood and cloth and glass, with a single place of labour; what could be done with individual human minds and hands, could surely be done with a number of individuals, with whatever number, with society itself.

If you wanted to alter society, you went and altered it.

'My business', said Morris, 'is to stir up revolution.' He did not talk for the sake of talking. *Art, Wealth and Riches, How We Live and How We*

Might Live, and the rest of his plain and lucid socialist addresses were the prelude to action.

Merton Abbey, successful as it was, delightful in itself, was only a fore-taste of what was possible. Its usefulness and effectiveness were a mockery and a failure so long as the world outside remained ugly and sordid. 'Am I', he pondered, 'doing nothing but make-believe – something like Louis XVI's lock-making?' On principle he did not think the personal conundrum had any importance. His worry was not about himself but about what plainly appeared a duty to mankind. Merton Abbey would cease to be make-believe when the world consisted only of Merton Abbeys. To turn a dream into a reality it was necessary to make everyone dream.

Friends saw little of what was going on in his mind in these late 1870s and early 1880s. They were somewhat at a loss as to how and when exactly he was turned into a political reformer. Karl Marx he ploughed through with some dispirit. He was better pleased with the old English Utopia of Sir Thomas More. He once said to George Bernard Shaw that he was converted to socialism by reading Mill's analysis of Fourier's system in which he 'clearly gave the verdict against the evidence'. The seemingly fantastic explanation that he was converted to Socialism by the *Morte d'Arthur* and Rouen Cathedral was nearer the truth: he was not, indeed, suddenly 'converted' at all. His ideas grew out of his whole experience. He went where they took him.

2 A Cloister in Fulham

Yet even those who had been subjected to the same influences – even one so close to Morris as Burne-Jones – had extracted a very different scheme of life from the same Pre-Raphaelite source. Burne-Jones too had been happy in his life and work; and his work had been a part of Morris' own. He had done endless things for the Firm – hundreds of designs for stained-glass windows, all over the country; designs galore for mosaic, needlework, tapestry. The Arthurian Legend planted by Rossetti and Morris in his receptive mind put forward each year a new shoot in his painting, added steadily a Tristram and Yseult, a Morgan le Fay, a Beguiling of Merlin and a Holy Grail to the list of his canvases. He liked these subjects because he was a faithful soul and because they had been the affection of his happy early days and of the friends he adored. He liked them also because they had nothing to do with life. When he did not paint them he painted some

other remote, enchanted theme – exchanging Joyous Gard for the Garden of Pan. On their visit to Italy together Morris had disliked the art of the country as being superstitious, the picturesqueness of the inhabitants as being proletarian. But Burne-Jones responded to the paintings of Botticelli, Signorelli and Mantegna – to a beauty twice concocted and thus the further removed from the real – the pomp and pagan lure of ancient Rome, deprived of harm by the intervening imagination of an artist who was not an ancient Roman. Physically delicate (there was that awful day when he began to spit blood and Georgie, terror-stricken, hurried him in a cab to the doctor), he had shunned the hurly-burly of life; and had even cultivated a corresponding mental delicacy. Existence had become a cloister in which he shut himself up without thought of what was outside it until the very idea of clash and conflict and imperfection was dreadful to him.

His was a path which G. F. Watts also had followed, the path of the isolated dreamer. Ruskin disapproved of it. 'Paint that as it is,' he shouted fiercely at Watts one day when they met outside Burlington House during a winter exhibition of Old Masters, pointing to a heap of scavenger's refuse at the foot of a grimy lamp-post; 'that is the truth.' He and Watts had some correspondence on the matter. Ruskin spoke both to him and to Burne-Jones 'as a poor apothecary's boy who has earnestly watched the actual effect of substances on each other might speak (when he got old and did not know precisely what gold and lead were) to two learned and thoughtful physicians who had been all their lives seeking the philosopher's stone'.

There was some aptness in the Professor's parable; but to Burne-Jones the search for the philosopher's stone was preferable to dabbling in mud and the base metals of ordinary currency. He could not afford, he said, to be made unhappy; and so by every means it was necessary to shut out reality, the supreme cause of unhappiness: to engage in a quest which had the merit of not being real. The nagging arguments of politics, the cruel inquisitiveness of biographers, the passionate controversies about art, the dreary, pessimistic outlook of modern novels, all these were unhappy things. With a Russian novel, for instance, he knew what to expect and could not bear it. If he were to be harrowed it must be in a lofty and heroic rhyme, in the beautiful words of ancient romance, which ceased to be harrowing because they were ancient and beautiful. His own name – *Jones* – even though the harsh impact was modified by *Burne* – was a kind of reality he did not care for. He preferred to think of himself as a Celtic Jolyn. He wished he had been born in a little town in the Apennines and

called Eduardo della Francesca. They might perhaps have nicknamed him Buon Giorno.

His experience of reality convinced him of its unhappiness. It meant people leaving their books and pictures and fighting each other. It meant the sarcasm, the ridicule, the divided friendships of the law-court. He, Burne-Jones, was dragged into giving evidence in the famous Ruskin versus Whistler case of 1878. It might be 'nuts and nectar' to Ruskin (as he said it was) but misery to him, for he was a friend of both parties, and could see some justice on both sides. Ruskin should not have called Whistler a Cockney coxcomb and talked of his flinging 'a pot of paint in the public's face'. On the other hand, truth compelled Jones to state that he believed in 'finish': that the *Nocturne in Black and Gold* by Whistler was not 'finished' and therefore to side with Ruskin. 'I wish all that trial thing hadn't been,' he wrote to a friend, 'so much I wish it, and I wish Whistler knew it made me sorry – but he would not believe.' He told Rossetti, 'the whole thing was a hateful affair and nothing in a small way ever annoyed me more: I try not to think of it all more than I can help.'

And Rossetti was another example of what this frightening world did to you if you were not able to shut it out and keep it at bay. The memory of what Gabriel had been to him, the wonderful and venerated master of those days when the sun always shone, was as vivid as ever. But by 1880 Gabriel was so queer, difficult, unapproachable, lost. It was nine years since he had visited the Grange and he had 'changed enough for seven of us'. He had given it all up, would not try any more, did not care how things went. You came back from a ghostly evening with him, heavy-hearted and even horrified. It was all past hope or remedy and you could hardly tell how it had come about. Jones vowed to isolate himself still further, go out no more, avoid all change in his plan of life and way of thought.

When Morris took to socialism he was very melancholy indeed. The bottom seemed to be dropping out of the universe. He could not understand this meddling with politics, positively he could not fathom his dearest and most intimate friend.

He tried to console himself by thinking that Morris would do the socialists good – subdue their ignorant, mistaken, conceited rancour. With his genius for giving a bird's-eye view of things he might put some perspective into their ideas, teach them humility and obedience. Of course, Jones reflected doubtfully, some men *had* an ideal of the world they wanted and it was a religion to them – so perhaps Morris *was* right – but oh! if only he would be out of it all and be content with his workroom, his

divine books, to be simply poet and artist and to talk of nothing much later than the ninth century, about Quintus Smyrnaeus and why the mediaeval world was always on the side of the Trojans and how Penthesilea came to be tenderly dealt with in the ancient tales.

There was another thing about this socialism.

Burne-Jones, while delicately aloof from reality, by no means excluded himself from 'society'; and this was due to their not being identical. He liked society because it was unreal. The glittering dinner-table set with rare wines and tempting dishes, the beautiful bejewelled women in costly dress, the cultivated men talking easily and lightly of gay and harmless things, pleased him. The creatures of luxury were doing what he did: shutting the door against squalor and Seven Dials and all that sort of thing and cultivating a graceful fantasy. If he had a weakness it was to sit at such tables, a magus and a maestro, with his bony cheeks and pointed beard, like some genius of old Italy summoned to the court of a prince and telling little golden fables about Apelles and King Eynested of Norway and Benozzo Gozzoli in his *amorosa e delectavole città* and Caer Caradoc where Caractacus was King and Amesbury where Guinevere was sorry in black clothes and white. Grateful to him was the cultured appreciation of his artist's magic, pleasant the admiration of Lady Horner, Mr Graham's daughter, who thought him the most brilliant of men; delightful his association with 'the Souls', Arthur Balfour, Harry Cust, R. B. Haldane and the rest, who lived for pleasure, but for pleasures of a rarefied and intellectual kind; who eschewed racing and card-playing, who sought for sentiment and romance. Only Georgiana was inclined to think he was a little too fond of this seductive world.

It was a shock to realise that this was the world which Morris was firmly bent on destroying; that he meant positively to eliminate the agreeable people they both knew in favour of a distasteful crowd one never could like. There was Mr Graham, with whom one dined in Grosvenor Square, who loved pictures so much that every room was lined with them from floor to ceiling – Millais and Rossetti, Hunt and Fred Walker, his, Burne-Jones' own, to say nothing of all the early Italians. How was it possible to see a brutal slave-driver in this charming and sensitive man, of whom he had painted a portrait, looking rather like an artist with his big forehead and pointed features? What would become of him in this new heaven and earth of Morris', where there was to be no class, no wealth, no luxury? What would become of Morris' own livelihood? No longer would they be able to go together to the Howards' house in Palace

Green, to deliberate whether the gold paper went with the Burne-Jones *Cupid and Psyche*, to work out a scheme for the boudoir in madder-printed cotton with the woodwork painted a light blue-green colour like a starling's egg. There would be no boudoirs. The riches that supported their own art would be gone. So it would seem that Morris, in proposing to destroy society as it was, would destroy himself.

It was typical of that man's incorruptible determination that neither this nor any other counsel of prudence affected him one jot. Georgiana worried about him as much as her husband. In fact both she and Jane looked on Morris with the horrified concern that women must feel for a man in the grip of an idea. The idea was a threat to love, to home, to everything personal in life. Georgie reminded him of his poetry. 'Poetry goes with the hand-arts, I think', Morris wrote to her, 'And like them has now become unreal: the arts have got to die before they can be born again'. And if the artist must die, so that the arts may be born again – well, then what must happen in the cause of right – must happen.

3 A Desperate Design

The Democratic Federation being the only active socialist organisation in England, Morris joined it in 1883. He signed his card simply as 'William Morris, Designer'; and found himself at once in a new, strange world. He had, perhaps, anticipated that the workers he was going to join were so many Morris', with some difference of clothes, speech and physique. He found them quite unlike. They did not even resemble each other. There was the smooth, glib, educated agitator, out for political advancement; the comic ignoramus to whom socialism was an excuse for slipping out to a game of billiards and a pint of beer; the sinister refugee from the Continent whose aim was chaos and pillage; the fiery artisan with sufficient intelligence to feel inferior – and the muddle-headed labourer whose real ambition was to become a respectable member of the middle class.

With this peculiar mixture of types went a peculiar mixture of theory. The aim that seemed so obvious and so simple was distorted and compli-cated by passions, prejudices, intrigue and sheer ignorance. And, of course, nobody knew anything about art or thought that art had got any-thing to do with socialism. Morris was faced with the curious fact that the simple thing is the last human beings arrive at; that the attainment of their avowed objects is the last thing many of them want; that the man in

earnest to accomplish is an object of suspicion to those he works with. He gave an account of a meeting (in 1887) at Cleveland Hall, Cleveland Street, 'a wretched place, once flash and now sordid, in a miserable street', which illustrates this genius for complexity and frustration. It was the head-quarters of the 'orthodox Anarchists', most of the foreign speakers be-longing to this persuasion; but a Collectivist also spoke, and one, at least, from the Autonomy section 'who have some quarrel which I can't under-stand with the Cleveland Hall people'. A Federation man spoke, though he was not a delegate; also MacDonald of the Socialist Union; the Fabians did not attend on the grounds that the war-scare (which was the subject of the meeting) was premature: 'probably, in reality, because they did not want to be mixed up too much with the Anarchists'. The 'Krapotkine-Wilson crowd' also refused on the grounds that bourgeois peace *is* war. Here, then, were seven different factions who could neither combine nor agree.

Two circumstances made Morris a leader. One was that he meant what he said; the other that he had money. Even socialism required capital To provide funds he sold his cherished copy of *De Claris Muliebris* and the Icelandic Sagas printed by the Skalaholt Press. The proceeds went to support the propaganda journals of the movement, *Justice* and the *Commonweal*, and the free pamphlets and papers which were all the casual public could be induced to take, mainly because they were free. He was patient and disinterested. He tried hard to reconcile the internal differen-ces of the Democratic Federation (which became the Social Democratic Federation, in an attempt to make its Socialist position clear); but many, Morris included, distrusted the clever, well-educated leader, Hyndman ('that is if Trin. Coll., Camb., is capable of educating, which I doubt'). The split came over the secession as a separate body of a party of Edin-burgh socialists, who had been addressed by Morris and organised by another leader of the Federation, Scheu. Hyndman called for the dissolu-tion of the new body in the name of the Federation. There was a row. Hyndman was denounced as a tyrant, Scheu as a foreign traitor. The Federation was abandoned to Hyndman and in 1885 Morris found him-self the moving force of the 'Socialist League'. He had to pay for the organization's rooms and the Windsor chairs to furnish them.

Socialism had meant to him the stainless perfection of beauty and religion. Socialists were revealed as jealous, spiteful, selfish. It was sad-dening, though it did not alter his determination, which was concentrated on the real object of his attack – the middle class – the tremendous,

implacable power of which, beneath its surface 'good nature and banality' he seriously appraised.

As long as he talked about art it was all right, because art did not matter. He could even have safely talked revolution if he had not meant what he said; but there was an instinct, an extra sense, by which the organised world separated the sincere from the insincere and rose in arms against the menace of sincerity. The attack on him took several forms: the hostility of people he knew, the brickbats of the press, the disorder of meetings, the grasp of the law.

The *Saturday Review* pointed to him as a spectacle of 'intellectual disaster'. That the man who had written *The Earthly Paradise* could imagine so ludicrous a state of affairs as a life in which every human being finds 'unrestricted scope for his best powers and faculties' – that was disaster indeed. Enemies searched for the weak spot. It was not long before comment was made on the fact that Morris was himself a rich man, an employer of labour. Why did he not practise what he preached? He met the charge. The position, he admitted, was a false one; but nothing would be gained by such piecemeal change as he himself might make. He went into his own figures. If he gave up his share of the profits and interest on the capitalised value of the firm, £15,000, and took a sum of £4 a week or £200 a year there would be an amount divisible which would represent £16 a year – six shillings a week for each workman. A nice thing for them but not one that would alter the position of any of them: unless it enabled some of them, in time, to become capitalists in a small way on their own – that is to say, breed the very animal he wished to see extinct.

At Oxford he scandalised the Master of University College by talking socialism in a lecture on *Democracy and Art*; and in 1885 the young Tory bloods arranged a warm reception for him. The meeting was in a music-room in Holywell, just opposite to where Janey used to live. In spite of changes Oxford was looking its beautiful best. The ingenuous faces round him made him feel rather old. Town and gown were there, with red ribbons and an organised opposition which howled and stamped. Some-one had brought in a bottle of chemical which made a stink. A threatening move towards the platform broke up the meeting.

For all that he was at home – at home with the flushed, burly, hand-some, arrogant, ignorant young men who yelled at him. He yelled back, and began to enjoy himself. They were his class.

He realised, for he never consciously attempted to disguise facts, the full misery of the great class gulf. It took unexpected forms. In the

country the working people looked down on those who were trying to lift them up – they suspected their deliverers. At Kelmscott the inhabitants of the Manor were described by some as 'a lot of gippos'. The unconventionality of the Morris garb was despised as gypsyish and not proper to gentle folk. And in Stepney, he could not 'get at them'. There was no *reason* why people, 'doomed by the accident of birth to misplace their *h*'s', should be any worse or any different from the refined idiot; but there was a difference. In the vast mass of utter shabbiness and uneventfulness that was the East End of London, there was a dead weight that 'took the fire' out of his 'fine periods'. He wished he could talk to them roughly and unaffectedly; though he could not have been plainer and more simple in language. He was, he at last perceived, 'too simple to be understood'. He discovered that the mass of men love sound and fury and only with pain and suspicion follow the most pellucid reason.

One Sunday morning in 1885 a noisy crowd gathered at the corner of Dod Street and the dismal Burdett Road. They came to see some 'fun'. The police were jeered and hustled. The speakers shouted away; but as nothing much happened the crowd gradually dwindled, drifting off to the pubs. The police charged the remainder, knocked down two banners and arrested eight men.

Morris went to the Thames Police Court. The magistrate, Mr Saunders, imposed one sentence of two months' hard labour and fines all round. There were hisses and cries of 'Shame'. A noble, bearded figure in a blue shirt was seen struggling in the grip of an angry policeman bent on restoring order. It was William Morris. The famous designer was come to this – a charge of disorderly conduct and striking a policeman. The interchange that followed is well known:

MR SAUNDERS: What are you?

PRISONER: I am an artist and a literary man, pretty well known, I think, throughout Europe.

Such distinguished prisoners were rare at the Thames Police Court. Mr Saunders, mild and somewhat uncomprehending, let him go at once and Morris, stung into the only self-assertive statement he ever made, went defiantly off.

He was eager to have done with talk and get to the point when the real work of socialism could begin: yet these clashes with authority did nothing to increase his confidence in the working class.

In 1886 a meeting of the unemployed was held in Trafalgar Square. Stones were thrown through the windows of West End clubs. Roughs stopped

carriages and demanded money with threats. To Morris this riot considered as a riot was contemptible. If violence there had to be – and he did not shrink from it though he would have preferred to conquer by persuasion – it must be violence directed with purpose and the determination to achieve it. The behaviour of the British workman caused him to think that violence would not succeed. Pilfering was the last thing he desired, of course. But this was not the main ground of the contempt which he now began to form for the class he defended. One of the main grounds was its obstinacy. It did not know and would not or could not learn what socialism meant. Hoxton was as muddle-headed and Philistine as Hans Place. He scarcely knew which were the more stupid and frivolous – the rich or the poor. The British workman, moreover, was inert. That was Morris' quite dispassionate conclusion in which there is a certain aristocratic disdain. When it came to the point the worker had no stomach for resistance; his declared hatred of the upper classes was mere wind; the slightest exertion of his master's authority put an end to his bluster and sent him home with his tail between his legs. This cowardice was not only due to oppression. It was due to an absence of belief. At heart they approved of the system. They loved to mouth vain words about 'bloodsuckers', 'grinding the faces of the poor', but, given half a chance, they would gladly join this same 'bloodsucking' group. To these silly sheep a revolutionary debate was a social evening; a public assembly was not a rising of the masses but an open-air entertainment. Sceptical and cold-blooded, they were middle-class at heart. The famous designer, it seemed, was the only desperate man among them.

4 Bloody Sunday

The thirteenth of November, 1887, was a bleak, gloomy day, Like the power of the bourgeoisie, the grey pall of climate lowered, cold, discouraging to passionate enthusiasm of any kind. The violence of the sun, the electric charge in the atmosphere, which makes a bull-fight possible and keys the human organism to drama, was absent. It was hard to feel excited under this toneless, expressionless sky.

Yet excitement, of a kind, there was. Another of the mysterious and recurring trade depressions had made unemployment acute. The unemployed were restive. The Irish question and the Irish policy of the Government had aroused an irritation. A meeting of protest was to be held in Trafalgar Square. It looked like being a huge, a lively meeting; and the

authorities made up their minds to put it down, with the aid of troops if the police were not enough.

A general converging movement on Trafalgar Square had been planned by the demonstrators. Five or six thousand started out from Clerkenwell Green. With them marched William Morris.

This, at least, was a test. The forces of socialism were massed against the forces of the System. If the workers were in earnest they should now be overwhelming. They could overturn the whole rotten fabric at a stroke. It might be they were ushering in a new and glorious era in the history of man.

They were not.

The powers of the land had conceived a simple but effective plan to check the demonstration.

The strategy of these powers was to intercept the converging coulmns before they could combine in the square. Morris' contingent was attacked on three sides at the corner of Shaftesbury Avenue by a strong force of police. Other contingents broke before the prancing horses and flashing steel of the Life Guards.

'Look aht. The sojers.' There was something monstrous in this pageantry set loose, the unnatural brightness of vermilion red and pipeclay, the rattling swords, among the sombrely dressed crowd, dingy like the weather. If they had even been dressed for the part they might have put up a greater resistance. As it was they did not seem even to want to resist. They thought not of the triumph of the proletariat and the new day that was to dawn but how unpleasant it would be to get their Sunday best torn or muddied; how much more sensible to be safely at home by the fire having tea on this dismal and dangerous day: how foolish to stand in the path of these indiscriminate sabres and trampling hooves: more, how wrong they were to get up against the law.

They broke and ran.

Scattered remnants straggling towards Nelson's Column found themselves met by serried ranks of wooden-faced infantry with fixed bayonets and twenty rounds each of ball cartridge. The revolution was averted.

Some, though comparatively little, bloodshed there was on this Bloody Sunday. There were those who tried to put up a fight, or were stirred by the sudden anger of a blow to hit back: some unfortunates who, happening to be in the track of the charge, could not get out of the way in time. A young man called Alfred Linnell died of injuries a month later. A public funeral was arranged. Morris tramped with the procession of mourners in

pouring rain from Soho to Bow Cemetery where the burial service was read by the light of a lantern. Tims of Battersea, Dowling of the Irish National League, Quelch of the Social Democratic Federation delivered themselves of the usual clichés about hired assassins and trembling tyrants. Only Morris tried to retrieve the occasion from an utter and squalid hopelessness. In a few simple and gentle words, spoken in the dark to a dwindling crowd, he returned to the idea which had never left him, through the confusion of these active years, that of a beautiful life. 'Our friend who lies here has had a hard life and met with a hard death, and if society had been differently constituted, his life might have been a delightful, a beautiful and a happy one. It is our business to begin to organise for the purpose of seeing that such things shall not happen; to try and make this earth a beautiful and happy place.' Under the circumstances such a funeral oration was a triumph of optimism.

He was nevertheless convinced, now, that society could not be decisively changed, as he had seriously thought it could be changed, with the human material available. The people were harmless, helpless and hopeless. Their inane good-humour, their complete inability to take in an idea put to them as it might be in words of one syallable, their refusal to act, their secret unanimity with the other side, all this blunted every effort. After a life of unbroken success he was defeated on the crucial issue – the dream had charged full tilt into reality and nothing had happened at all.

V

The Last Phase

1 The Recluse of Cheyne Walk

The last ten years of the life of Dante Gabriel Rossetti were a withdrawal from the world. All his old friends dropped or were driven away. There were no expeditions now with Vernon Lushington to the *Seven Thorns* on the Portsmouth Road. His relations with his best buyers became stiff and distant. Mr Graham's daughter was sorry when her father gave up his visits to the queer, picturesque house, and the fascinating painter who said 'Sunk into the earth, by God', when he had mislaid his hat. With Hunt, Millais and Morris he was done; and Burne-Jones he did not care to see. The family paid him ceremonious visits; his mother; Maria, by 1874 'in canonicals! – a Sister of Mercy! – as cheerful as possible and seeming to find the life of privations congenial to her'; and Christina, who had increased steadily in piety. William Michael was a less frequent visitor after 1874 when he married Lucy Madox Brown, the marriage in Gabriel's opinion being 'a great boon to his somewhat fossilised habit of life for years past'. Swinburne drifted away in the late 1870s. He wrote a bitter complaint to Watts-Dunton in 1877 on Rossetti's 'way of loyalty and friendship'. The shadow of 'The Pines', Putney, was stretching towards him, the kindly tentacles of the literary lawyer were closing round him; the weaning process from unlimited brandy to a single bottle of Bass was imminent.

Watts-Dunton was managing both their affairs, busily disentangling the strange confusion into which Howell had thrown them. He was like a hound on the scent, with the persistent detective habit of his vocation, which he extended also to literature. 'My method of study is somewhat singular. I stick at a subject right on till, as far as can be, I exhaust it. By this means and maugre business interruptions I manage to pack in and properly label more than a good many fellows with good health, no business and lots of time and better abilities.' The faculty for sticking at it was in request. He had to deal, on Rossetti's behalf, with a plea from Howell

for £200, from the 'point of view of justice and humanity'; with Howell's habit of borrowing considerable sums in Rossetti's name – 'as loans to me indeed,' said the latter; 'at least it looms on me in that light, but is desperately obscure': and with other similar obscurities. In February 1876 this obscurity hung over a dress which had been used as an artistic property by Rossetti, and for which a Mr Levy proposed to sue Howell for £40. Watts-Dunton was the intermediary in the settlement. Rossetti wrote to Howell in the matter, a letter in which there was a kind of admiring appreciation. 'I hear you rather coolly propose that *I* should pay the £40 due from you to Mr Levy! Why?' He gave a lucid summary of Howell's complex business methods. Rossetti had lately paid him £90 – due in work only, being the balance of commission on *Venus Astarte* (the picture for which Jane Morris sat, bought by Clarence Fry, the photographer). 'Now you want to wrest from me, who, as you know well, can ill afford it, another £40 on the same transmuted plan of payment.' He had learnt, moreover, that Levy's real charge for the dress was £15. Howell had charged him £35. 'What then am I to think of your statement in other similar cases that your charge to me has been the same as you paid yourself? Of course there is no earthly need that it should be so' (he expected to be done to some extent), 'but why not state things as they are?' He sent Watts-Dunton £20 towards Levy's claim. He asked Howell first to hand over to Watts-Dunton 'the pearl pin, as I need and cannot be without it'. The pearl pin was also mentioned in a letter to Fanny of the same date. In some absentminded way, with the most trivial displacement of *meum* and *tuum*, the pin had transferred itself to Howell. Rossetti, however, maintained that he had never done better with his pictures than while Howell acted as his agent. He also asserted, and this at a time when he was morbidly suspicious of everyone round him, that Howell was never directly unfair to him in their dealings. It may have been that roguery, a natural, amiable roguery, raised less suspicion in him than a priggish rectitude; that it brought out his queer delight in watching the behaviour of one who was true, at least, to type. But Watts-Dunton intervened. It was necessary to rescue his Swinburne from the unprincipled man, and at the same time he rescued Rossetti, in spite of himself. By 1877 the Gil-Blas-Robinson Crusoe hero had transferred his attentions to Whistler and with Rosa Corder, his mistress, was printing and selling the latter's etchings for him at a surprising rate.

In the same year Gabriel's connection with the Hakes was severed. He quarrelled with George. His fits of irritability became unbearable. He

suspected that his drug was being cut down. This, for example, is a curt and suspicious note addressed by Rossetti to George Hake, on the ever-recurring problem of the dose of chloral. 'Please don't omit to let me have a bottle of chloral without fail by to-morrow (Monday) night. Next time I must be my own assayist, as I found what you stated to be 2 tumblers and a half to be very decidedly under two.' Such demands led to scenes between them and to the cutting and querulous words that a half-demented man would say. Then Rossetti, restored to his normal self, tried to make amends. After a more than usually acute disagreement, when wild things had been said, George Hake evidently reproached Rossetti for his behaviour. The latter replied, 'Whatever I said (and I really cannot remember saying anything as absurd as you quote) – was said in sudden temper and meant nothing. Do let us forget what we both said, for it was in reality all without meaning.' But George Hake had had enough. William Michael Rossetti, being informed of his determination to give up the care of Dante Gabriel, expressed 'regret but not surprise'. He was sure, he said, that George had endured much 'unpleasant and capricious demeanour'. As Assistant Secretary to the Board of Inland Revenue, author of *Lives of Famous Poets*, etc., he wrote a handsome reference for the long-suffering amanuensis.

One attachment of the early days, however, continued to be close – the attachment to Fanny.

2 An Elephant and a Rhinoceros

The magic ray of Pre-Raphaelitism, about the year 1880, touched a wealthy American, Samuel Bancroft, Jr, of Wilmington, Delaware. He was visiting his friend William A. Turner, in Pendleton, one of the manufacturing suburbs of 'smoky old Manchester'. As they sat down to tea he got a shock, a shock of delight. *Fiammetta* by Rossetti, was incandescent on the wall, a visionary glory of paint. For a while he was unconscious of his surroundings. He determined to make a memorial of his admiration. Year by year the Samuel Bancroft, Jr. Pre-Raphaelite collection grew. It is now housed in the Delaware Art Center, Wilmington. It includes as well as paintings, drawings and first editions a number of letters from Rossetti to the redoubtable 'Elephant'.

Mr Bancroft did nothing by halves. Everything connected with the great artist and poet was of interest. Long after Rossetti's death he visited Fanny, with the reverence due to a hallowed Pre-Raphaelite

relic. If he could have put her bodily into the collection, doubtless he would.

She enjoyed talking about old times to the American gentleman. She gave an account of her meeting with Gabriel, the dates and circumstances of which were, it is likely, very inaccurate. These have been subsequently sifted and weighed in the balance with other dates by the experts of Delaware. Such is the impression left by Dante Gabriel Rossetti that the year in which he met a hussy has become a matter of grave research.

The proprietress of the Rose and Crown Hotel in Jermyn Street saw herself in retrospect, in the summer of 1856, as a beautiful maiden, fresh from the country, come up to stay with an elderly cousin living in London. Florence Nightingale was back from the Crimea, and with her Rossetti's aunt, Miss Polidori. There were fireworks in welcome. With the respectable cousin she had gone to see the fireworks in the Old Surrey Gardens. There she had met a party of artists, Ford Madox Brown, Dante Gabriel Rossetti, Edward Burne-Jones and 'Crom' Price. Attracted by her beauty and her golden hair, one of them had pulled it down 'accidentally on purpose'. Introduction being thus effected, she went next day to Blackfriars Bridge (always with the respectable and elderly cousin). There 'he put my head against the wall and drew it for the head in the calf picture'.

She said she came from Steyning 'in Surrey'. Steyning is in Sussex. Perhaps Mr Bancroft made a pardonable confusion between the two English counties. Perhaps Fanny was confused. She may also, as a lady might, have post-dated this first meeting so romantically remembered. Her later life was described to Mr Bancroft with the same vagueness of date. 'Her husband (Timothy Hughes) died within a year or two after their marriage'; and when after the death of his wife Rossetti went to live at Cheyne Walk she 'resided in the neighbourhood and virtually took charge of his housekeeping arrangements and sat to him for a great number of pictures'.

These sentimental memories, edited for the benefit of the transatlantic visitor, may not have been as accurate as a scholar could wish them to be. They recall, however, for how many years she had been a fixed star in the Pre-Raphaelite firmament. This, through the later vicissitudes, she remained. She was the ruler of Cheyne Walk, the reason why some did not call and others were not invited, and many of Gabriel's friends wished he would not go back there after the Kelmscott convalescence.

Ford Madox Brown thought he ought not to go back there. Dr Marshall

thought so too; 'should he do so probably the worst symptoms would return'. 'It has also been the headquarters of rapine and waste of the most ruinous kind', said Brown.

The rapine and waste were doubtless divided, according to the genius of each, between Fanny, Howell and the Scotch cook, who pawned his belongings. He did write Fanny a somewhat stern letter from Kelmscott concerning a missing treasure; that is, if a letter beginning 'Hullo, Elephant', can be called stern. 'Just you find that pot! Do you think I don't know that you've wrapped your trunk round it and dug a hole for it in the garden.' The letter was accompanied by a weirdly grotesque drawing of an elephant digging, with a vase in its trunk. It was characteristic that he promised faithfully to return it, while pointing out that Fanny had no business with it at all.

He continued to write to her; and almost every letter contained, promised or referred to a cheque – 'a tidy cheque for the poor Quad-rupin', 'a small cheque for the Elephant's trunk'; 'Economies Eléphantines', a pen-drawing included with one of these letters, depicted a sly-looking elephant, with a castle on its back inscribed with Fanny's address, 36 Royal Avenue, about to place a cheque in a wall safe. The elephantine economies were a reason why Gabriel – the 'old Rhinoceros' as he was pleased to call himself – never had fifty pounds to call his own. Between 1875 and 1876 he did try an alternative to Cheyne Walk. He rented Aldwick Lodge, Bognor.

Fanny's day, as a model, was done. The time in which she appeared constantly in his pictures was in the first Cheyne Walk period, between the death of his wife and the fatal return to poetry – when she posed for *Fair Rosamund*, *Fazio's Mistress*, *Bocca Baciata* and *Lady Lilith*. After 1866 she was replaced by Jane Morris and by professional models. She was 'getting on'. The illusive beauty of the flesh was fading. The soft ripeness of the mouth was taking a hard line, the blonde tresses were losing their lustre. There was a calculating glitter in the blue eyes, a twist of temper about the nostrils. A magnificence of proportions was now tending to fat. She seemed to suffer much from colds, bronchial and rheumatic affections. At least they were constantly represented to Gabriel as a source of bother, and he expressed continual anxiety on this account, requesting her not to sit in draughts at theatres.

She was jealous – in particular of Alice Wilding, a damsel of respectable parentage whom Gabriel had seen casually in the street and who now sat for him. He explained there was no reason for jealousy. 'As for my making

Miss W. handsome presents when I sell my pictures of her, I gave her something extra on *two* occasions only.'

She was inclined to be touchy. She quarrelled with Dunn, the assistant. 'It seems poor Dunn is going to Croydon – I suppose with the intention of flying from your wrath.' She took offence at Watts-Dunton. 'I assure you it is quite unfair to suppose for a moment that Watts could have meant the slightest rudeness,' said Rossetti, defending the lawyer. 'He merely meant to be playful and friendly in using a familiar word.' What playfulness on the part of Swinburne's guardian this was is not exactly stated. He can scarcely have approved of Fanny, even from a purely financial point of view. The open or implicit dislike of Gabriel's friends made her suspicious and hostile. 'You may get the reputation of being a Rogue Elephant altogether!!' Gabriel warned.

As to her acquisitiveness – that is evident. She wanted money. It is the masculine fiction that beautiful women should have no thoughts out of harmony with those poetic sentiments that their beauty inspires. If they want money they are harpies – Fanny was a harpy if you please, certainly realistic. An ageing woman, with no source of income other than a whimsical and invalid painter, she got as much as she could out of him. Doubtless, she argued, that if she did not, he would only waste the money in some other way.

A genuine primitive, she had not, like Lizzie, improved herself. She carelessly added and subtracted the tell-tale *h*. 'O my,' Allingham had reported her to say, 'Mr Scott *is* changed! He ain't got a hye-brow or a hye-lash – not a 'air on his 'ead.' As if praising a backward child, Rossetti complimented her when her spelling and writing were particularly good.

For all these reasons, strange as it may seem, Rossetti liked her. Amusement with him was akin to love. Like Howell, she was true to type. Her temper, her greed, her commonness had a sort of functional character. Without them she would not be the splendid animal she was. In a world of sinister morality, of brutal prigs and baleful hypocrites, such animals were now, to him, the least dangerous of the human tribe.

But the faint gesture of escape implied by Bognor and subsequently by his removal to Hunters Forestall near Herne Bay, was taken by Fanny to mean she must have a changed and definite plan. His hints of 'settling down in the quietest and cheapest way' with his mother and sister were not encouraging. The absolute necessity of refraining from expenses, the possibility that 'my small funds will run out altogether' seemed to foreshadow the total stoppage of supplies. She made arrangements to get

married again; she wrote upbraiding him; and she left Royal Avenue, thus symbolically asserting her freedom of action. 'Your letter has upset me extremely,' he wrote from Herne Bay; 'to be uncertain of your whereabouts and wellbeing is greatly to add to my anxieties.' 'My dear Fan,' he said in September 1877, 'in your angry letter you seem to forget that you are writing to me who is at present a hopeless cripple, with no means of judging as to future livelihood.' Watts was implored at the same time to go to Royal Avenue and find out where she had gone.

Fanny's letter in answer is preserved. It conveyed a considered estimate of the situation, while neatly placing Gabriel in the wrong and delicately intimating the change-to-be in her condition. 'You surely cannot be angry with me for doing what I have done after receiving such a letter from you telling me I must forget you and get my own living. You could not expect me to remain in the neighbourhood after what had taken place.' There follows a sentence so entirely without punctuation, and so closely knit in form and substance that, long as it is, it must be quoted entire:

'Dunn frequently passed my place on the other side of the way and in the middle of the Avenuye with a sneer on his face and concluded that he was rejoicing in my downfall, of course my intentions were to remain there until I saw you again I have been living on my savings for sometime but your letters led me to suppose you were tired of me, you shall never say that I forsook you although I felt it very much when another woman was put in my place when not wanted the keys taken away from me and that is the way I was treated for taking your part I hope I shall see you again and be with you as before but I never wish to meet any of your friends after the cruel way in which I have been treated.'

She then revealed her address, 96 Jermyn Street, 'which is the St. James's Street end and is an hotel'. She indicated her proprietorial status: 'I keep three servants and an accountant'; and a partnership: 'Mr. Schott still interests himself for me'. She married this man, John Bernard Schott, a widower with two children, in 1879. He was known to Rossetti; in fact, he had more or less replaced Howell as his agent. Gabriel was writing to him in 1877 about the sale of pictures and about houses alternative to Cheyne Walk. Rossetti did not break off all relations with either.

3 A Boswell from the Isle of Man

New men were seen about him in these later years. Frederick Shields the artist, Philip Bourke Marston, the blind poet, son of the editor Dr

Westland Marston, young William Sharp, introduced to Rossetti by the Scots painter Noel Paton, who was to distinguish himself as a poet under the name of Fiona Macleod. There were many candidates for the position of Boswell to the Anglo-Italian Johnson. Even Burne-Jones, with his rooted dislike for personal revelation ('these biographical morsels make me shudder'), jotted down some notes: 'Gabriel – His talk, its sanity and measure of it – his tone of voice – his hands – his charm – his dislike of all big-wig and pompous things – his craze for funny animals – generally his love for animals – his religion – his wife'. What words could tell of his talk and look and kindness? Burne-Jones hesitated, 'If it is a perfect image and all overlaid with gold, it will be truer really than one that should make him halt or begrimed or sully him in the least'. He never wrote the projected monograph. 'Would', said Georgiana, 'that he had.' The fact remained that Rossetti appeared in some mysterious fashion really to be overlaid with gold. The total absence of privacy, even in his seclusion, had something royal about it. The exact dose of his drug, the humorous fatuity of his intimate letters had become matters of general concern. Things could be said about him which could not be said – even if they were there to say – about his former Brethren. The King can do no wrong.

Theodore Watts-Dunton was a strong favourite for Boswellship. Here was a man who knew him well, from whom as a lawyer no secrets were withheld, yet possessing the necessary reverence, steeped in the romantic spirit, a literary critic of repute, withal respectable to the last degree, one who would know what and what not to say.

To the horror of the Pre-Raphaelite circle, a rank outsider romped home. The Pre-Raphaelite Boswell came, by way of Liverpool, from the Isle of Man. The magic ray still made unknown converts. It lurked in the dusty shelves of Free Libraries in provincial towns. Young pulses quickened to the cadence of Ruskin's prose, of Rossetti's poems; young heads filled with the discovery of beauty, the pomp of distinction between True and False, with the search for Nobility in Life that lay somewhere beyond the dreary streets that hemmed them in. There was one such convert in Liverpool called Hall Caine.

The young Hall Caine had spent his time between the curious remnant of Celtic peasant life that continued on the island where his family had long been farmers and crofters, and the middle-class life of the huge industrial city. At the Liverpool Library he read everything he could lay hands on. Ruskin's *Fors Clavigera* filled him with aspirations for a better social order. He began to contribute to the *Builder and Building News*

florid imitations of Ruskin's criticism, attacks on the restoration of ancient buildings. He and other Liverpool boys got up a 'Notes and Queries' society, the Notes being sometimes provided by Ruskin and Morris. One of the boys was William Watson, the poet. He stirred up Caine's interest in Rossetti's poetry. Visitors to the meetings of the Society at the Royal Institution gave him scraps of information; Hawthorne's friend, H. A. Bright, described Rossetti as a little dark Italian. Lord Houghton, the patron of letters and champion of Swinburne, spoke of him as having been a young fellow 'of strong Bohemian habits', poet and leader of an eccentric school of art. There were other glimpses of a mysterious, reclusive later life. In 1878 Hall Caine gave a lecture on Rossetti's poems at the Free Library. He found apparently a moral influence in them, a 'passive Puritanism' in *Jenny* and in the most ardent of the sonnets. The lecture was printed: he sent a copy to the poet; and, wonderful to relate, he got a reply. It was no formal acknowledgment. Rossetti declared himself to be 'much struck' by the enthusiasm and ability of the lecture. 'Your estimate of the impulses influencing my poetry is such as I could wish it to suggest.' Positively the poet would be glad to know him, suggested even exact times. 'The afternoon about 5 might suit you, or else the evening about 9.30.'

The friendliness of the letter may seem surprising; yet not so surprising after all. It was one of the earliest, most consistent tenets of Pre-Raphaelitism that the pursuit of art was a thing universally to be shared. Social, if not necessarily socialist, it encouraged any spark of interest or ability whencesoever it came. Much of its power had come from this agreeable habit. Ruskin, himself, had written from Coniston or Venice to the young Liverpudlian, as spontaneously and freely as if to the most intimate friend, though by this time, his mind, shaken with the roaring horror of Victorian life, deceived, disappointed and mocked by the world as he imagined, he had become a sort of King Lear, the most fantastic incoherence alternating with a wild clarity. 'I have of course the deepest interest in your work,' he had told Caine, '– and *for that reason* must keep wholly out of it. I should drive myself mad again in a week if I thought of such things. I am doing botany and geology and you, who are able for it, must fight with rascals and fools.'

It may be that Rossetti was pleased to find someone who thought his poems moral. It may be that he contemplated the chance of making a new genius, a new set of geniuses, of compelling with his personal wizardry a third Pre-Raphaelite flowering. The Prospero of Cheyne Walk, he waved

his magic wand and summoned from the vast deep of the provinces the future author of *The Manxman* and *The Deemster*.

Before they met a deal of correspondence passed. Delicately probing, Gabriel asked whether Hall Caine were a Roman Catholic, married, a poet, of what age. That he was unmarried and twenty-five were suitable qualifications for discipleship. His poetry was not up to much. Rossetti did not 'mean essential discouragement' when he said that 'your swing of arm seems to me firmer and freer in prose than in verse. . . . There is no need that every gifted writer should take the path of poetry.' There was no need for poetry to be a qualification for friendship after all. The lonely Rossetti thought the young fellow had something in him, and that he might even be an agreeable companion. He gave Hall Caine a letter of introduction to Madox Brown, who took the opportunity of using him as a model in one of the Manchester frescoes and returned a favourable report to Chelsea. It is revealing of Rossetti's solitary sleepless nights that some of his letters were twelve and even sixteen pages long.

They met in 1880. Hall Caine was invited to dinner. In a state of reverent excitement, prepared to record each and every detail of this, the greatest event of his life, the Manx Boswell came to Cheyne Walk. He noted the signs of decay and neglect about the house; trod gingerly over the strip of worn coconut matting on the marble floor; and beheld at last the genius himself, who extended both hands in greeting, with a cheery 'Hulloa!'

Rossetti was fifty-two. He was fat and pale, his beard streaked with grey. He still wore his old sack-coat, buttoned at the neck and hanging to his knees, with deep pockets in which he thrust his hands. He at once set the visitor at his ease. He talked gaily, of his friends, quoted some of his limericks, read some of his new poems. Putting on a second pair of spectacles over those he usually wore, he recited in moving accents *The White Ship*. It was a delightful evening. The poet's full-chested laugh followed Hall Caine out as he went off in a cab (accompanied by William Michael) to the out-of-the-way hotel where he was staying the night.

Hall Caine's second visit was a fortnight later. This time there was a subtle change in the atmosphere. Rossetti looked tired and ill. The skeletons peeped out of the cupboard, though discreetly and with an air of pathos and romance. Hall Caine told him of an incident which occurred when he was giving the lecture on Rossetti's poetry at Liverpool. The chairman had described Rossetti as the most sensual of English poets and, in the capacity of artist, as 'the greatest *animal* painter alive'.

Rossetti listened 'with drooped head and changing colour'. His persecution mania appeared. It was always the same, he remarked; a widespread, a remorseless conspiracy against him.

There was a further revelation. A wired lantern containing a candle and a volume of Boswell's *Johnson* were placed at his bedside. 'My curse is insomnia. Two or three hours hence I shall get up and lie on the couch and, to pass a weary hour, read this book!'

On the table were two small bottles and a measuring glass. The chloral.

'I have just taken sixty grains of chloral,' he said, a little later, coming into Hall Caine's room. 'In four hours I shall take sixty more and in four hours after that yet another sixty.' With a sort of pride that distressed the visitor, he confided the amount of the dose. 'Marshall says if I were put into a Turkish bath I should sweat it at every pore.'

In the morning the window of Rossetti's room, which looked out on the forlorn garden, was shuttered. Caine breakfasted alone. A note had been left for him. 'Don't, please, spread details as to the story of *Rose Mary*. . . . I hope it won't be too long before you visit town again.'

The correspondence continued. Rossetti advised, criticised. He told Caine not to use long words, not to publish articles in magazines which were 'farragoes of absolute garbage', or to write to all and sundry among the great – 'I know the sort of exclamation that rises to the lips of a man as much beset by strangers as (say) Swinburne when he opens a letter and sees a new name at the end of it.' He deprecated Caine's taste for fine writing; 'Conception, my boy, Fundamental Brainwork, that is what makes the difference.' He would have nothing to do with his dabbling in Art and Politics – in view of what he called 'the momentary momentousness and eternal futility of the noisiest questions'. He corrected the presumptuousness of his literary judgments. Chatterton, whom Caine called a blackguard, was 'as great as any English poet whatever . . . might, had he lived, have proved the only man who could have bandied parts with Shakespeare'.

Caine had become a habit. Writing to him took Gabriel's mind off his condition, now more deplorable than either letters or casual meetings could show. He clutched at the friendship in a despairing sort of way. When Caine burnt his boats and decided to strike out for himself as a free-lance writer in London, Rossetti proposed that he should take up his quarters at Cheyne Walk. 'You have got a sufficient inkling of my exceptional habits not to be scared of them'; and when Caine decided first, for reasons of health and economy, to try Cumberland, Rossetti suggested

that he should go with him. The arrangements were made in London. Pending their completion, Caine came to stay at Cheyne Walk.

It was 1881. Rossetti looked thinner now, his eyes were dull, his step feeble, he complained of a partial deafness. His friends were anxious. Brown, grey-headed and sententious; Bell Scott, bitter and bewigged; Watts-Dunton, small and fussy, were visitors. They cast curious glances at this new interloping discovery of Gabriel. There was an air of constraint. Occasionally Jane Morris, sad and sweet, would call. Occasionally also the blind poet Marston, silent, pallid, untidy, brought with him a morbid gloom, devoted though he was to Gabriel. 'Why is he not some great exiled king,' the blind poet exclaimed in his hero-worship, 'that we might give our lives in trying to restore him to his kingdom.'

Gabriel now seemed in no hurry to go to Cumberland. Indeed, he invented reasons for not going. Days grew into weeks, months, and still Caine stayed on in the isolated house. It was a fortress shut against the outside world. No newspaper entered it. Of contemporary events crime most interested the aloof master; but he still liked to know what was being written. One day a book bound in parchment and inscribed in gold was sent to him. It was the first book of poems of a young man called Oscar Wilde. He was quick to recognise its merits.

He had some reasons for pleasure. His second volume of poems, *Ballads and Sonnets*, was now published and was highly successful. Caine had bestirred himself and got the big picture *Dante's Dream* sold to Liverpool for 1,500 guineas. But his despondency was growing. Cumberland seemed an absolute necessity.

In September 1881 they took their places in a special carriage at Euston, labelled for Keswick and packed with a tremendous load of books, bags and artist's trappings. 'We two and the nurse.' The nurse was Fanny.

It was a curious party – something of a handful for Boswell. He looked in his handbag at Penrith. To his distress he found that one of the bottles of chloral had gone. Arrived at the Vale of St John, Caine surprised Gabriel in the act of drinking the contents of the stolen bottle. 'There was something almost cruel in the laugh with which he received my nervous protest.'

Next day the sun was shining, the mountains looked grand and beautiful. Rossetti seemed better. He proposed they should climb a mountain; he actually got to the top. He reported the episode to Mr Schott. 'Fanny and I and Mr. Caine walked up the great Hough which is 1200

feet high. For a portion of the descent I found it convenient to adopt a broader natural basis than the feet while Fanny lay down and almost burst with laughter.'

The 'evil influence', the 'fiendish woman', as Fanny has been described, was also reported to be 'wonderfully active, climbs and takes leaps and looks wonderfully well'. A few days later he wrote to Watts-Dunton, 'This morning F. went with Caine up a mountain, twice as high as the one we went up before.' The thought of Fanny and Hall Caine scaling the heights together is indeed impressive.

Gabriel told Watts-Dunton that with her assistance he was cutting down his chloral. According to Hall Caine, he now wanted more than ever. Rossetti begged him to increase the one bottle stipulated by Dr Marshall. Caine used to hide the key of the cupboard where it was kept; but Rossetti saw it one day and the other felt certain he would try to get at it in his absence; so he emptied a bottle and filled it with water, remaining on the watch; and saw Rossetti creep to the cupboard, and make off with the supposed drug. A little later he was found asleep with the empty bottle at his side.

This looked, hopefully, as if suggestion would do all that the drug had done; but 'the nurse', Nurse Fanny, gave the show away. She told Rossetti that he had been given water instead, and this made things twice as bad. Far from being put to sleep by water, he would not now believe that the genuine chloral was not water; and the power of suggestion prevented him from getting any sleep at all.

His spirits went down. The mountains and the approach of winter had begun to depress him. Told that the world was ringing with the praises of *Ballads and Sonnets*, he remarked 'That's good, very good', without enthusiasm. There was no more mountain climbing. He would not go to the places suggested by the reverential Caine: Grasmere (sacred to Wordsworth), Greta Hall, Keswick (sacred to the memory of Southey's stainless life), Castlerigg, reminiscent of Shelley, or Boradaile of Coleridge. In fact, he got no farther than the Nag's Head at the end of the valley. As the evenings grew longer the prospect of talking to Caine about Fielding and Smollett became less tolerable. He could no longer be soothed into a drowse by the Manx legends which his friend used to tell. Fanny left suddenly, while Caine was away in Liverpool for a day or so. Gabriel wired to Schott to get Cheyne Walk ready for him.

Going back to London now seemed as essential for his health as had going to Cumberland a little while before. Caine, wilting under the burden,

acquiesced. Once more a special railway coach was chartered and coupled on at Penrith to the Scotch express.

The long journey back was agonising for both. Gabriel did not attempt to sleep. He sat bolt upright in an uncomfortable waiting attitude, wearing hat, overcoat and gloves. It was now that he made that confession which Caine so tactfully enveloped in verbiage that it is difficult to know what either of them meant, which may or may not have implied his love for Jane Morris.

They came to Euston in the chill grey of dawn. 'Thank God', said Rossetti when they got to Chelsea. 'Home at last and never shall I leave it again.'

Friends gathered and Hall Caine was relegated to the background. There was perhaps some slight indignation that Gabriel had been 'passively carried off', as Bell Scott put it, by this young man, 'to whom he had suddenly become exclusively attached'. Of course, they thought, the sea would have been better for him than mountains; though the ups and downs of his condition continued to baffle them. Detached, uncomprehending, Morris asked if Rossetti were really ill or only acting.

There were new anxieties in his mind: a fear of poverty and of death itself. To Scott it seemed very painful that he should demand a priest to give him absolution for his sins. It was a lapse, in the opinion of that consistent atheist, from the true absence of faith. Rossetti had gone back to the Middle Ages, even in extremity. He could make nothing of Christianity, but he must have a confessor – like a superstitious Italian of the fourteenth century. And at the same time he believed in a future life. 'Have I not heard and seen those that died long ago?'

A short attack of paralysis reduced him to helplessness, made it possible to try a drastic cure for his addiction to chloral. Under Dr Marshall's direction, he was given subcutaneous injections of morphia, gradually decreased and diluted until only water was injected. From this treatment he awoke enfeebled but cured of the craving for the drug and of the delusions he had suffered from.

But the idea had gone abroad that he was sinking. There was a stir of outside interest. Old Sir Henry Taylor, whose poetry Rossetti had liked so much when he was still a boy, wrote to express his sympathy. The Russian novelist Ivan Turgenev, then in London, proposed to call. Even Holman Hunt wished to see him and broached the matter to William Michael, but brother William looked doubtfully down his nose and thought that on the whole it might not be advisable. The Rossetti family

was now active in ministration, and in November 1881 Gabriel wrote to Fanny for the last time. 'Such difficulties are now arising with my family that it will be impossible for me to see you here till I write again.'

Buchanan, the cause of much trouble, made 'amends'. 'Generously and bravely', in the view of Caine, he took back everything he had said. In the lines prefixed in his romance *God and the Man*, he addressed his 'Old Enemy':

> 'I would have snatched a bay-leaf from thy brow
> Wronging the chaplet on an honoured head;
> In peace and charity I bring thee now
> A lily-flower instead.'

The journalist somewhat resembled those American gangsters who are reputed to have laid elaborate floral tributes on their victim's hearse. The difference between the original attack and the belated discovery that the purpose of his victim was pure and the song blameless does not seem to imply any great sincerity in either. Words were his trade – just words. Rossetti could scarcely credit that the 'amends' was intended for him. He never referred to it afterwards.

4 A Bungalow at Birchington-on-Sea

J. P. Seddon, the architect, had been building bungalows at Birchington-on-Sea. The advance guard of a holiday town, they stood bare, and raw, in the fields near the sea and the old-fashioned Kentish village. He placed one at Rossetti's disposal. Another change, another escape, was arranged. Passively he submitted, with mildness in which there was now no hope. Once more a great load of books and material was packed. Hall Caine, Caine's sister Lily, and a real nurse this time, went with him. His liking for fanciful analogies and hidden allusions was still persistent. He explained to Lily that the initials on the rug in the carriage were hers and his – L.C. & D.R. – the London, Chatham and Dover Railway – Lily Caine and Dante Rossetti.

The bungalow was a wooden building with bedrooms at front and back. Gabriel chose one at the back so that he would not hear the sea. It was a mournful place in the early months of the year. The wind roared round it, the rank grass rustled in a melancholy fashion, an occasional ship was the only sign of the life of the great world. They set up a telescope through which to scan the grey horizon.

The strange man painted and wrote poetry again. A comic ballad called *Jan van Hunks*, telling of a Dutchman's wager to smoke against the devil, 'made the place ring with laughter'; but he had lost real interest in life, at bottom there was apathy and indifference from which he was temporarily roused by the visits of friends only to relapse when they had gone.

The soldier of fortune, Howell, came to see him. Hall Caine was furious. The presence of Howell seemed a blasphemy. The strange thing was that Rossetti seemed cheered up by his presence. Howell explained to the disapproving Caine that when young he had written most of Ruskin's books for him.

'What are you doing now, Charlie?' said Rossetti.

'Buying horses for the King of Portugal', was the reply. Rossetti laughed till he nearly rolled out of his seat.

It was almost the last laugh. 'Your friend', said the local doctor, 'does not want to live.' Mrs Rossetti and Christina came down from London. William Michael, Watts-Dunton and Frederick Shields arrived on Good Friday. He was weakening fast. Little memories came into his mind. He recollected how George Hake used to rise in the night to squeeze lemon into his claret for him. 'Have you heard anything of – ?' he whispered to Caine. It was Fanny he meant: though in the will which Watts-Dunton drew up and which he signed with a trembling hand, there was no mention of her. On 9 April 1882 he died at the age of fifty-four. The immediate cause of death was Bright's disease. Weeping hysterically, Shields made a drawing of him as he lay calm and still in death.

He was buried, far from Lizzie, at Birchington. A few friends came to the funeral. Scott and Brown were ill and absent – Burne-Jones got as far as the railway station then turned back, unable to face it, but William Graham and Vernon Lushington were there. Fanny was coldly and firmly deterred by William Michael. 'Dear Madam,' he wrote on 14 April: 'Your letter of the 12th only reached me this morning about 9. The coffin had been closed last evening and the funeral takes place early this afternoon – there is nothing further to be done.'

It was long since Vernon Lushington had seen Rossetti, many years since Rossetti had painted the little water-colour of his wife. He walked with the other mourners to the old church overlooking the sea, noticing the grey tower and the spire going up into the pure blue sky. The churchyard was nicely kept. It was bright with iris and wallflowers in bloom and close to Gabriel's grave there was a laurestinus and a lilac. It seemed a sweet open spot. The old mother, supported by William and Christina,

was very calm. Among the friends there were several he did not know. The vicar read the service well. They threw in their last farewells – azaleas and primroses – William, a lily of the valley. It was sad, but simple and full of feeling. The fresh beauty of the day added to its pure simplicity. He shook hands with William and went back to town with Graham; and Gabriel remained, an exile in death, beneath the rustling grass, near the ever-murmuring sea.

Hall Caine lost no time. In the same year he published his *Recollections* of Rossetti, thus effectively forestalling any rival Boswells. It was feared that he would 'take the bloom off Gabriel'; though the descriptive passages were carefully and even modestly written, the sentimental flights fewer than might have been expected. 'The portrait drawn is friendly and life-like,' admitted Christina to George Gordon Hake, 'but one-sided and overcast, restricted in great measure to the wreck of one who at his best was certainly not only much loved but very lovable.'

The *Recollections*, in revised form, made a substantial part of Caine's Autobiography of 1909. For the centenary of Rossetti's birth in 1928 it was again revised and re-issued. *My Story* by Sir Hall Caine, K.B.E., knighted for his contribution to Allied propaganda, the author of novels whose sale ran into millions, included for a myriad of sixpenny book buyers a rather interesting account of some artist they had never heard of, whom the author of *The Woman Thou Gavest Me* once knew. Poor Gabriel had spotted a winner indeed. Nurturing a best-seller in embryo, he had provided the material of the publicity from which he shrank, on a scale vaster than he could ever have conceived and had become, by a last ironic transmutation, practically a character of fiction.

Fanny Schott, the 'evil influence', lived to be eighty-two; and another strange mutation took place. 'Schott & Co.', that is, Fanny and her husband, used the pictures they had acquired to found a 'Rossetti Gallery' at No. 1A Old Bond Street. A notice was issued that Mr John Bernard Schott would receive orders for prints of a portrait of Rossetti by George Frederick Watts – the portrait Gabriel disliked so much. The Exhibitions of 1883 at the Academy and the Burlington Fine Arts Club were completed by the regrettable, the embarrassing homage of this private concern. William Michael took pains to disclaim any connection with it. Its stock and a long-standing I.O.U. of £300 to Fanny from Rossetti were the subject of some correspondence. 'Perhaps,' mused William Michael to Watts-Dunton, 'one might *terrorize* a little with that portrait by Watts. My

full and genuine belief is that G. never *gave* it to Mrs S., but only, not much liking it, transferred it from his own hands and house to hers.' But here Fanny had shown a justifiable, according to her lights, shrewdness. She had a clear, signed title, not only to the portrait but to all the pictures and furniture under her care at 96 Jermyn Street. As clearly the I.O.U. did, in written form, exist. A compromise payment of £65 was offered and accepted.

The tormenting emotional conflict which had made Gabriel's life so much a matter of imaginative experiment and escape was inverted in the life of Christina, the sister with whom he had so much in common. Her conscience, her inward anguish, perhaps to some extent explain his. She grew, as he did, more depressed, though it was with the growth of piety; and wrapt in the determination to be, to do good, her depression, her conviction of sin, increased. 'How dreadful to be eternally wicked,' she said to William, 'for in hell you must be so eternally.' In apprehension she awaited death, which came to her, after a singularly blameless life, in 1894 when she was engaged in silent prayer.

The good and faithful William Michael, tortoise Boswell to Caine's hare, who had seen that little friendly club of boyish idealists grow into such a famous thing and take on itself so many forms, was left with a huge literary task which he conscientiously and tactfully performed. His grave and self-sacrificing devotion to his brother, recalling that of Theo van Gogh, continued after his death, in the publication and editing of memoirs and letters. He had plenty of time. In 1911 Wilfrid Blunt found him 'hale and hearty, though eighty years old, with a clear healthy complexion, somewhat bronzed and showing his Italian origin'. He lived on through the Great War and died in 1919.

5 A General Misunderstanding

But Holman Hunt did not approve of his labours. 'Have you seen William Rossetti's book?' he inquired of Vernon Lushington in 1896. 'It is, with all its studiousness of manner, a most dense revelation; conscientious it is as every act of his is, but his brother, I think, would on the whole have wished that he had said nothing whatever or even have told all he knew.' To his precisian mind the whole of the Pre-Raphaelite history had been garbled, confused and misapprehended. Pre-Raphaelitism had been to him a religion, and his later years were saddened by the heresies that flourished like luxuriant weeds, that seemed likely altogether to overgrow

the pure, the original doctrine. Had they all forgotten what it was about? Had they forgotten the noble rule of truth to nature? With a certain melancholy pleasure, he recognised that early Pre-Raphaelite devotion in a remark made by Vernon:

'Your observation of the witness who came into court with the ears flaming with the red blood of life, is a good example of the increased interest in the world which the artistic sense gives. I don't think every judge would have been interested to determine what the flush of crimson on the margin of the woman's head came from; but would have probably concluded it was the passing twirl of a crimson ribbon and so proceeded with the business without a new wrinkle in his mind of the endless variety of changes which circumstances go on presenting without end.'

He had noted this effect himself. 'When you see the *Strayed Sheep* next you will see that a foremost sheep has the sun shining through his ears and making them so rosy that the prosaic unobservant spectator has often said that the colour must be unwarranted.' And when he had risen early one May morning to go to the top of Magdalen Tower and paint there the choir, he had faithfully shown the rising sun shining through the ears of the music-master. These things were true, and truth was divine, and the glow in the music-master's ears was a manifestation of divinity.

Mayday, Magdalen Tower, the lovely picture of the service of song held since time immemorial in Oxford, was exhibited in 1891 and was one of the last of his complete works. The *Miracle of the Sacred Fire*, exhibited in 1899, is the only other important work of his later years. He had reached the time of retrospect and general view.

He stood, in his own estimation, alone as the one true prophet of the movement, the only one equipped to expound the articles of faith.

Do what he would, a blind and frivolous world had accepted Rossetti and Ford Madox Brown as the leaders. The more he thought about it, the more he became bitter.

With age, the puritan bias in his blood became stronger, intolerant, implacable. Asperity flowed into the pen with which he wrote his memoirs. Vernon Lushington, who saw the manuscript, persuaded him to some cuts, some softenings of expression. Hunt had forgotten that he had ever looked up to Rossetti; that from Fairlight, in 1852, he had avowed 'sometimes when troubled or impatient, I am glad to call out to you and to feel that comfort in your answer which a child feels in the fearful dark, knowing he is not alone'.

It was clear to him that Rossetti had been simply his pupil; that with or in spite of the technical skill so acquired, he had perversely gone off into a sort of mediaeval revivalism which was contrary to the original plan. William Michael Rossetti had made out this to be the real thing, and instead of the 'true P.R.B.–ism' a 'surreptitious bantling' was honoured in its place. Malignant in heresy, also, was Frederick George Stephens, the critic, a close friend until the unhappy business of Goliath, the packing case, who showed the same romancing humour. Hunt suspected him of being the anonymous correspondent who, in a letter to the *Pall Mall Gazette*, had accused him of introducing Charles I swords and some Louis-Quatorze material, to mar the accuracy of *The Two Gentlemen of Verona*. He knew him to have flippantly stated that the same picture was sold 'for £128 and £60 in sherry'. The fact was that some months after selling the picture, he had received a case of champagne from an anonymous donor. So much for Stephens' accuracy. Stephens had also referred to the 'dismal' studio in Cleveland Street. He had described it as dusty and 'smoke-stained'. Nothing of the sort. It had been thoroughly whitewashed and distempered before he and Rossetti had moved in. Was this a critic to be trusted? This was the man who had found in Hunt's *Claudio and Isabella* 'a suspicion of the fancy ball, the station house and a broken shin'. His misstatements were all the more calamitous because he had been one of the Seven and therefore many thought he must certainly be right on the facts; as did M. de la Sizeranne, for instance.

The French critic's guess was that Madox Brown started it all. Hunt expostulated. M. de la Sizeranne wrote an amiable reply, emphasising that his only interest was truth – and that therefore he had gone scrupu-lously to the original sources. Hunt said that Rossetti was only the *nominal* pupil of Brown. Bien. But – *voici ce que je lis dans les memoires de votre ami W. Bell Scott*: 'Ford Madox Brown came in, to whom I found Rossetti had been indebted for some lessons, generously afforded. This he acknowledged with much effusion.' Would Rossetti have acknowledged them with much effusion if they had been 'nominal'? William Sharp referred to 'M. F. Madox Brown, to whom the young artist (Rossetti) was ever through life willing to admit his early indebtedness.' Knight had spoken of 'the movement which had been, in fact, *anticipated* by Madox Brown'. Esther Wood: 'Soon came Madox Brown to encourage their tentative efforts.' Harry Quilter: 'Brown was, in all but name, the real founder and leader of the P.R.B. movement.' And M. G. F. Stephens (*que j'ai dû croire bien placé pour savoir ce que passait dans la Confrérie,*

puisqu'il en était): 'There can be no doubt whatever that to Brown's guidance and example we owe the better part of Rossetti as a painter, *per se* . . .' and 'Naturally enough Brown was *solicited* to become a Brother but . . . declined to join the Society.' If, M. de la Sizeranne observed with politeness and logic, he was, as M. Hunt asserted, 'quite misinformed', then all the historians of Pre-Raphaelitism were misinformed and had misinformed everybody else. He would await the development of the thesis with interest.

Holman accepted the challenge. They were both misinformed and misinforming. Nobody knew anything about it except himself. He was almost prepared to deny that the Brotherhood ever existed, in order to establish that it was his creation. William Michael Rossetti had declared his own brother to be the leader, but his writings inadvertently proved that he did not know what Pre-Raphaelitism meant. F. G. Stephens he had shown, he considered, to be prejudiced and inaccurate; and one who, like William Michael, had never grasped the meaning of the movement. Knight and Sharp and the rest just repeated the statements of the originators of error.

And what *was* the meaning of the movement? Here again an Augean stable had to be cleansed. As with the men, so Hunt now reduced the idea almost to vanishing point in his rejection of fallacy. It had nothing to do with the work of those affected Germans, with Herbert or Dyce among the English. It was not necessarily against the Academy. It had nothing to do with the Middle Ages. It was *not* inspired by Puseyism. It was, said Hunt, 'it cannot be too clearly asserted', – 'the frank worship of Nature, kept in check by selection and directed by the spirit of imaginative purpose' – which seems to be a fairly broad definition of art of any kind. Well might William Michael observe that 'Truth is a circle'.

As to Dante Gabriel himself, who, in all this, seemed to be playing a posthumous trick on him and Millais, Hunt, it is said by Ford Madox Hueffer, arrived at a surprising conclusion.

He was a thief.

An ancient overcoat worn by Hueffer inspired the remark.

This Pre-Raphaelite heirloom, aeons ago, had been his, Holman Hunt's. Rossetti, he maintained, had stolen it from his studio.

Unrelenting to the sheep that had strayed, Holman Hunt deemed all those who had never been within the fold, nor had seen, as he saw it, the true light, to be wolves. The fumes of festering decay were rising. The Lord of

Misrule had usurped the throne. Licentiousness and deformity were rampant.

In the churchyard surrounding the ruins of the ancient parish church of Girvan, during the 1880s, there was held an open-air preaching. It suited the Covenanting spirit of the place. The farmers, the shepherds with their dogs, the Scots lassies in their Sunday clothes, sat among the tombstones. The minister was darkly silhouetted against the broken walls of the church, gilded by the rays of the setting sun. His text was 'Behold I stand at the door and knock'. He described the work that 'a living artist of great fame had painted'.

The *Northern Vitruvius* (another of the many titles by which Rossetti had facetiously labelled Bell Scott) sent word of the event to Draycott Lodge, Fulham. It was comforting news to Hunt. 'And so,' he commented, 'in the roofless, wall-less, doorless church, there was the lesson thought to be profitable, which came for my hand to be made intelligible through the eye when I was young ... for indeed I painted the picture with what I thought, unworthy though I was, to be divine command.' Consoled as he was, he grieved for the things in store for a faithless generation – the 'fatal consequences of which we as yet see not the end, which, as I believe, will be very terrible before long'.

'He is, I fear, in a very fretful state, apparently disappointed that the world is not making more of him.' So wrote Scott in 1886 to Vernon Lushington.

Scott was now an invalid. The year before, in London, he had been seized with an agonising heart pain. Like Rossetti, he had been removed in a special coach; from Euston to Penkill. Æ had administered his medicines as the carriage swung and rattled northwards. Through a long following illness she nursed him with devoted care. He recovered sufficiently to sit up and write, even paint a little, though not again to move far. He bore it with philosophy, though after a life 'in the society of sets or coteries' he was sometimes in 'a lowish key'. Friends came to see him: Morris, Ford Madox Hueffer, Vernon Lushington and his daughters, Arthur Hughes, J. W. Mackail. The 'dear old Hermit' they called him. When the lamps were lit, he sat in the great hall, like an Inquisitor in his scarlet biretta and cape, with a glass of hot grog by his side, writing endless letters. There was a whole series on Dante written to Vernon. Scott considered Dante to be an 'odious, selfish, mediaeval commander of the faithful'. Religion always made him critical. In Hunt he attributed it to egotism; which Hunt expressly denied. Certainly he had been comforted by hearing of the many

who knew nothing about art, but to whom *The Light of the World* had given hope. 'It is not egotism that makes me pleased at this. I look to it as one of the testimonies – a very little one – of the greatness and necessity of the creed it illustrates.'

As art to him was religion, so, necessarily, the art of which he dis-approved was irreligious. It was without faith, vicious, brutal, idle, false. Evil things were coming upon the world; and there was one great evil among the rest, the evil thing called Impressionism – an outlandish, abhorrent threat to the pure and healthy island race. Themes based on moral turpitude and the latent horrors of life were creeping in – in art, in letters, on the stage. Impressionism, a wild revolt, was the excuse for hideous canvases, chaotic in form, plastered offensively with sullied pig-ment, for painting and moulding an evil-proportioned humanity. There is a familiar ring in the phrases. Suddenly one realises they were phrases that had been used of Pre-Raphaelitism itself. The great rebellion, as far as Holman was concerned, had reached its end. It had become conservative.

Where, said Holman, had this Impressionism come from? From Paris. And what was Paris? He quoted fiercely from one of those books written by an American about the Latin quarter – a description of the 'Saturnalia' of the 'Quatz Arts'. An orgy of abandoned models dancing naked, of un-bridled debauchery and libertinage. This, this inferno of infamy and des-pair, how different from the art upheld by the German Emperor who, re-fusing to accept the craze for materialistic art, directed painters and sculptors to 'an ideal of elevating character'.

Holman Hunt was awarded the Order of Merit. He enjoyed wealth and esteem. He had painted excellent pictures; but to the end of his days he had a grief and a grievance: grief that he had not more powerfully moved the world into the way of faith and righteousness; a grievance at the misunderstanding of the part he had played in the Pre-Raphaelite movement. A patriarch of eighty-three, he died in 1910, in London. He was buried in St Paul's Cathedral.

6 The End of a Good Time

In the early 1890s a banquet in honour of art and literature was given by the Lord Mayor at the Mansion House. Next to the Lord Mayor at the high table sat Sir John Millais, representing the President of the Academy, Sir Frederic Leighton. A silvery fringe of curls set off his ruddy com-plexion, his clear-cut smiling features. Easily and pleasantly he chatted

and joked with the great men around him. They were Academicians, little different from those stately men described at the beginning of this history, though their pictures, changing with the taste of the age, were less epic and sublime and not so dark. Hunt was there, rugged and hirsute as Sir W. B. Richmond painted him; and on the other side of the table, directly opposite Millais and the other Academicians was – Ford Madox Brown. It is unpleasant to have to record that he was angry. He remained silent throughout the evening. He frowned across at Millais. Hunt asked him to take the chair next to him, there being several vacant places between.

'Thank you,' said Ford Madox Brown, 'I would rather sit here.'

His wife was dead. His son Oliver was dead. He was £700 in debt. Inadvertently a kindly plot among his friends to buy one of his pictures was revealed. He was furious. He had genius. He had worked hard with his whole heart and soul all his life. He had struggled faithfully and honestly to meet his obligations. Now he was over seventy and as badly off as ever. His honest sailor blood boiled. He would like to punch somebody on the jaw. They were all sneaks and slaves and sycophants. He would have liked to wreak havoc among that grinning imbecile academic crew. He would like to sweep out of existence these overfed idiots from the City. These great careerists, who had dropped Gabriel because, forsooth, they did not approve of him, he hated them. But at least they should know that he, Brown, was recognised as a representative of art. They could not conceal that fact at all events. He would take his place and, on this convivial occasion, sit in it, proud, indignant and alone.

But Millais no doubt enjoyed the banquet as he enjoyed all the official, the ceremonious occasions of life. His career was drawing to a close in an undimmed blaze of glory. Apart from the slight depression which came over him at the Grosvenor Gallery when he was confronted by his early works, there was no cloud in his sky. He may not even have noticed the glowering Brown. His friends were so unanimous in praise of his charm, his geniality, his artistic power, that he had almost forgotten the existence of enmity. He was, Professor Hubert Herkomer told him, 'one of the few men in this world who are loved by all'.

The main uneasiness which he suffered was physical. In 1892 he had a bad attack of influenza. He seemed to be better after it except that his voice was sometimes inaudible and husky.

A lump in his throat which did not diminish caused him some anxiety, and gradually an unwonted despondency began to steal over him. He was 'overwhelmed by a recurring conviction that the game is played out – no

more pictures wanted'. He took more and more interest in the illustrators, the *Punch* men who drew in pen-and-ink. He was excited by the work of a young man called Charles Dana Gibson, which du Maurier showed him. In these illustrators with their facile brilliance, the power of unlimited reproduction, he saw the birth of a new art, the true extension of the powers he himself possessed.

Honours thrust themselves upon him inexorably – Leighton, retiring to end his days in Algiers, in 1895 proposed him for the Presidency of the Academy. He accepted, though expressing doubts as to whether he would be heard. When he had to deliver his speech he croaked, huskily, a Presidential address which Lord Rosebery declared to be enchanting. Thus at length the Child came to the honour that had been always predicted for him, was finally absolved from Pre-Raphaelite error.

He came to the varnishing day of the 1896 Exhibition leaning heavily on the arm of the Secretary, and congratulated some young artist in a scarcely audible whisper. He screwed up his failing strength to attend the Prince of Wales on his visit; but as they went round the pictures he lagged behind. The Prince insisted on his going home. He left – not to return to the Academy again.

'It will kill me', he had said to Philip Calderon, R.A., pointing to his throat. 'But I am ready and not afraid.' And, in his hoarse whisper:

'I've had a good time, my boy, a very good time.'

His mood was mellow despite his illness. He had had a good time. 'I have no enemies', he told Val Prinsep; 'there's no man with whom I would not shake hands – except one, and by Jove! I should like to shake him by the hand now.' There can be little question as to whom this one was – he meant Rossetti.

Old friends came to see him in his last illness – old friends, that is, of his own world – the Duke of Westminster, Sir William Harcourt, the beautiful Mrs Jopling-Rowe, Kate Perugini. The Princess Louise visited him, and by command of the Queen bulletins of his health were sent to Her Majesty. One of his last requests, duly honoured, was that Her Majesty would receive his wife.

He grew thinner and his beard grew; and on 13 August 1896 he died in the presence of his wife, his sons Everett and John Guille, and two of his daughters. He was beautiful in death as in life – Lord Rosebery remarked on this perfection of the physical shell.

By request of the Royal Academy he was buried in St Paul's Cathedral. The pall was borne by Holman Hunt, Philip Calderon, R.A., Sir Henry

Irving, Sir George Reid, Viscount Wolseley, the Earl of Rosebery, the Earl of Carlisle and the Marquis of Granby. Fulsome panegyrics were uttered. As Millais once said: nobody knew anything about art; there was therefore no voice lifted, especially at this moment, to point out that his art had belied his early promise. But everybody knew what success was: nothing succeeded like it. Millais' success commanded homage. His kindliness, his manliness, his heartiness were duly praised; and if any reference were made to his Pre-Raphaelite other self it was an indulgent glance at an early indiscretion that had quickly passed. His favourite publication, *Punch*, now busy poking fun at Beardsley, published a poetical eulogy. It rightly declared that Millais was 'no thrall of dream'; that his brush was 'too masterful to take abiding harm, From mere mimetic craze.' From Pre-Raphaelitism he might have taken the abiding harm of independence. He might have been poor, struggling and embittered like Brown. Instead of which he had given the world what it wanted and the world had fulfilled its part of the bargain. What could be fairer?

7 A Question of Values

There was a heavenly placidity about Kensington in these later Victorian days. The hansom cabs jingled merrily round. From Kensington Square to Hammersmith was a zone dotted by Pre-Raphaelites. There were the Burne-Jones' at the Grange, North End, and the Holman Hunts at Draycott Lodge, Fulham, and the Morris' at Kelmscott House, Hammersmith, the Richmonds (close Pre-Raphaelite allies) at Beavor Lodge, Hammersmith. In the square itself there were friendly houses where they met. Judge Lushington and his daughters lived at No. 36. Sir John and Lady Simon at No. 34. Sir John Simon, famous authority on sanitation, was also a warm patron and admirer of the arts, and all these artists were to be numbered in the circle that gathered round him and his wife.

Burne-Jones was well content with his pleasant and not very distant neighbours.

If you did not think of St Giles' and Whitechapel, this clean, comfortable, rural London was blissful, and Burne-Jones did not think of them. Happily he worked on, in the old house where Samuel Richardson had once written his interminable stories of love. There were not many signs of the march of Progress there – though the steady thrust of the expanding metropolis was turning the land on which the house stood into potential gold. Burne-Jones was pleased to think that he could, by holding on to it,

defy the march of Progress. His garden, he told Morris, was a delight, because his neighbours were calculating on its value per foot as a building site.

On the breezy edge of the downs a few miles from Brighton the Jones' had their country retreat. Not yet did the loud-speakers blare from modernistic hotels, a roaring wave of charabancs and cars hustle along the cliffs and through the sleepy villages, a measle rash of bungalows scarify the horizon, north, east and west. Rottingdean was old Sussex still.

There the Kiplings were near neighbours. Pre-Raphaelitism whispered its enchantment into the ear of the Imperial Muse. Perhaps some of those little golden fables spun by the painter influenced his 'beloved Ruddy', turning him back from his sharply realist contemporary vision to those overlapping vistas of a past which was also the present in which palaeolithic man, Roman legionaries, mediaeval burgesses still lived.

Vividly little Angela Mackail, Burne-Jones' grand-daughter, saw these two houses. The impression left on her mind was one of intense discomfort. There was not a chair in the sitting-room, with its Pomegranate wallpaper on a dark blue ground, that you could sit on with ease. It was impossible to lie, or to do anything save remain rigidly erect, on the massive black sofa, whose yellow upholstery stuck to one's clothes. The cushions were unyielding, the bolsters rigid. The aesthetic towel-horses in the bedrooms were lacking in stability and apt to fall heavily forward. The Pre-Raphaelite beds, with their wooden slats running lengthways, banished sleep. The room above the summer house at Rottingdean was a triumph of discomfort, cold in winter, hot in summer, with windows sliding in grooves which would not properly open or close. The chairs it contained were the furniture of legend. They had been designed by her grandfather for the seats of the knights at the Round Table in the tapestry Morris made from his cartoons. A skilled carpenter had made these fantastic objects of utility, but the seats were too high for even a knight to keep his feet on the ground and the arms were too close to allow any freedom in the use of knife and fork.

On the landing at the top flight of blue stairs a zinc-lined recess had been built against the wall with a tap in it for the use of the housemaid. Above it was a singularly brilliant stained-glass window, containing four scenes from the story of the Holy Grail. The material and the spiritual were jumbled together with a splendid carelessness.

This discomfort, this strange disregard for the actual utility of things made for a useful purpose, the mixture of values, is an important Pre-Raphaelite fact. It was closely connected with the principle that everyone

should in his or (presumably) her degree (it is true that women played a passive, a mediaeval part in their ideal scheme of things) be an artist. The emphasis was laid on *making*, the idea of contemplating or using a thing when made was to this simple, creative enthusiasm a matter of minor importance. Other people were making things. Everybody was supposed to be making things. So many would be occupied in making chairs that the mere chair-users scarcely counted. They, it must be assumed, would have *their* hands full of some other creative interest – much too full to bother about a merely idle pleasure.

It is characteristic that Morris' definition of art concerned what the artist should get from it; not what an audience or 'a public' of any kind would get from it. Hunt, for example, in a lecture at Oxford, explained that the work of an artist was a comfort, a solace, to the world at large. He took it for granted that the process of appreciating, when the work was done, was a serious and separate occupation. This, Morris did not comprehend. All the fun was in doing the job, for the chap who did it. To obtain more fun you started another job. This involved the disappearance of 'Art' altogether, as a conscious activity. Very well. That too was what he wanted. The abolition of class privilege entailed also the abolition of geniuses as a class. A 'genius' was as bad an anachronism as a lord.

Yet with the discomfort went the theory that the artistic object should be 'fit for purpose'. It was a curious combination, though one that can be explained. 'Fitness to purpose' from a Pre-Raphaelite point of view was a political statement. It meant the avoidance of waste because waste implied riches as opposed to wealth, and riches implied capitalism. Therefore 'Fitness to purpose' was Socialism.

It did not imply that it was, as it has since been interpreted, in a mysterious way ethical, to exclude all ornament or decoration that could be described as 'unnecessary'. If the emancipated socialist workman felt like covering every inch of a surface with a pattern, well and good: provided it was done of his own free will and he found pleasure in doing it. Morris himself revelled in ornament; but it was ornament of his own spontaneous and pleasurable devising. The alternative was slave labour.

The illustrations to Moxon's Tennyson represented, to Morris and Burne-Jones, slavery. It was not their idea of an illustrated book at all, in spite of their undying love for the pictures in it by Millais and Rossetti. Here was a convincing case of the worker in chains – the Victorian wood-engraver. The 'artist', in a lordly impatient way, would scribble his drawing on the prepared surface of a block of wood. It was then the mechanical,

the unintelligent task of the engraver to carve out the spaces round and between these scribbles until they remained standing in relief. Sometimes he would not even have the whole of a block to cut. A section would be given to him: the remaining sections to other skilled slaves. So devoid of personality was their labour that the sections, when fitted together, would show no signs of different handiwork.

The master made the slave feel the lash. Rossetti flew into a rage when a block a sixteenth of an inch too short was sent him for his *St Cecilia*. When asked could such a little space matter, 'Good God,' he said, 'what do you mean by that? I could get a whole city in there.' It was a magnificent phrase: yet ten, twenty times the labour devoted by Rossetti would go into the realisation of that tiny microcosm by the man with the graving tool. 'Look at most things in *Once a Week*,' said Burne-Jones, 'the wasted time of poor engravers in rendering all that scrawl, if rightly used, might fill England with beautiful work.' By perfect engraving he meant restraint in leaving out every idea that was not wanted, simplicity and of course the spirit found in the earliest engravings before a slave civilisation had laid its hand on the craft.

It is useful to understand this process of thought, this technical problem, to understand the last important enterprise of Morris' life (in which Burne-Jones took so considerable a part) – the Kelmscott Press Books and in particular the Kelmscott Chaucer. Unable to reform politics he could, at least, he thought, make some reforms in book production.

8 The End of a Dream

The Kelmscott books were the main evidence of Morris' retirement from active socialism. The Socialist League paled before the Independent Labour Party and the newly formed London County Council. It became a small and bitter sect. In 1889 it was taken over by professed anarchists and Morris was deposed from leadership in favour of the extremist Frank Kitz. He did not seem to care much. His money and personality had thrust leadership upon him; but as to any personal status he was good-humouredly indifferent. He continued for a time to help the paper, the *Commonweal*. This also sank by degrees into a subversive squalor. It was published from a grocer's shop in Lamb's Conduit Street, was indicted in 1892 for an article in support of bomb-throwers at Walsall. The proprietor, J. D. Nicoll, got eighteen months in jail. Morris thought it was stupid of Nicoll to put in the article.

He reasoned that the failure to overturn the system was due to the

fact that there were not enough true socialists. That being so, the first essential was to make socialists; that is, to raise the mental level of as many people as possible until in due course there were so many that the system changed, without violence, of its own accord. It was a longer process, but it was, he thought, surer.

His propaganda writings became less urgent and topical. Their tone mellowed again with the mellowness of distance. Under the impulse of action he had hammered at Balfour and Salisbury. He even wrote a contemporary propaganda play – *The Tables Turned, or Mr Nupkins Awakened* – an anticipation of the Shavian drama. But he was more at home with revolution – archaic as in *The Dream of John Ball*, or with a revolution that by-passed the present, as in *News from Nowhere* – and he was still a propagandist when in the *Roots of the Mountains* he wrote of the Germanic tribes of some not very precise but early century and the Great Roof, their communal hall, where was merry talk and music when the hunting-carles came back.

Here to him, strangely though reasonably, was the heart of the problem – the problem with which we had been left ever since the breakdown of the Roman Empire. On the one hand, a self-sufficient community, hunting, spinning, shaping what it required, living close to nature; working for the sake of living. On the other, an artificial urban community, like Rome itself, like London, shutting Nature out, depriving men of their freedom by the very fact that the means of supporting themselves were out of their control. The problem at least was not archaic. Indeed as the twentieth century progresses, it has a new, an acute meaning, when the artificial famine of which he and his prophetic teachers wrote, accompanied by the war he perceived to have started, has taken a fresh lease, a new form and the most consummate intricacy of mechanical development that the world has ever seen has ironically made necessary a return to the primitive conditions he preferred.

The self-sufficiency that he looked forward to made him in 1890 start printing his own books. This craft process also had to be under his personal control. It had to be made afresh and revolutionised on the most ancient model available. What asses people were, he said, ever to have changed from Gothic type to Roman. In fact he regretted the existence of a printed book. The antecedent model of the beautifully lettered, ornamented manuscript was better still, being more completely yet the direct product of the craftsman's hand. He lamented the simplicity of the scribe at his desk.

However, as type and a press had to be used it was essential to undo all that had been done by the slave printer. The energy released from politics went into this task.

He accumulated specimens and spent a very great deal of money on early books of all sorts. He designed his own type, aiming at 'a letter pure in form; severe without needless excrescences, solid without the thickening and thinning of the line which is the essential fault of the ordinary modern type and which makes it difficult to read'. He arrived at the correct sequence of margins on severely utilitarian grounds. He used for paper the purest linen rag, the moulds being made to reproduce the slight irregularity in texture of those employed by the earliest printers.

The result was a series of books like no book that ever was. If they had a flaw it was that they were not books to read any more than the chairs were chairs to sit in. The weight of the type on the admirable paper, the proportion of the printed surface to the rest, made a direct appeal to the eye; but the distraction of mind caused by these details he had not taken into account. Characteristically the last person Morris thought of was the author: the book was not the self-effacing vehicle of a writer's intellect so much as a piece of craftsmanship. And though he professed to think of the reader he would rather the reader were improved by the design than the contents of the volume.

There was something childlike about this phase of which the Kelmscott Chaucer was the outstanding example. All during the last six years of his life it kept him busy and diverted his mind from failure in the larger issue and worry about his personal affairs.

They were all delighted when he gave up his active interest in politics and returned to his writing and designing. Jane Morris had been worried and grieved at that alarming excursion into real life; and there had been family griefs which affected them both, for of the two daughters Jenny had been often ill, suffered from epileptic fits; while May had contracted an engagement of which, while it was theoretically in accord with his principles, he could not approve.

The Jones', needless to say, were overjoyed when he 'came back to them'; for though Georgiana read aloud to the servants and the workmen elevating passages from Ruskin and Morris, it was to improve their minds in an ideal sort of way rather than to make them socialists. Edward Burne-Jones rejoiced when they could once more have breakfast together, and Top, just as when he first knew him, would walk up and down the room while he was talking, putting out his fist to explain a thing, and full

of ideal projects. The designs for the Kelmscott Chaucer which he under-
took to contribute were a paean of thanksgiving. There were eighty-seven
of them when it was finished.

The Press hummed with activity. Reprints of the Caxton books, the
Golden Legend, the histories of Troy, and *Reynard the Fox*, followed one
another in quick succession. In 1893 he designed the first ornamented page
of the Chaucer. 'My eyes! How good it is,' he exclaimed. But the Chaucer
took a long time. Burne-Jones' pencil drawings which were to be trans-
lated into woodcuts were subjected by both of them to the most fastidious
scrutiny. They were both inexorable judges. 'We shall be twenty years
getting it out at this rate,' Morris reflected with some anxiety.

The growing ranks of volumes pleased him. He gave them with princely
generosity to friends; though his love for those in his possession was like
that for a child – he stretched out anxiously to take back the treasured
object into his own fondling hands.

But, wonder of wonders, the Press was a profit. They were books for
rich men; as his interior decoration had been for rich men's houses; and
rich men bought them.

The Chaucer dragged on. There was a check when some of the pages
yellowed through a flaw in the preparation of the ink. He grew anxious.
'Every day beyond to-morrow that it isn't done is one too many.' Some-
one remarked on the beauty of the later sheets where the picture pages
face one another. He was insistent that Burne-Jones should not hear of
this praise, otherwise he would want to do the first lot over again 'and
then we should never be done but always going round and round in a
circle'.

It was finished in 1896, in the last year of his life. One day he was sitting
in his study at Hammersmith. His priceless books lined the shelves, huge
leather-covered volumes interspersed with the honey-colour of aged
vellum. There was the Huntingfield Psalter of the twelfth, the Tiptoft
Missal of the thirteenth century. There were folio Bibles and little Books
of Hours. There was the *Speculum Humanae Salvationis* of 1483 with all
the original woodcuts and a precious East Anglian manuscript of about
1300, in which two missing leaves, found in the Fitzwilliam Museum, had,
by arrangement, been reinserted. Books and valuable pages of decorated
parchment littered his table. The patient and loving brush-drawing of
the monk in his calm cell, the conscientious craft of the German printer,
the life work of men whose names were lost, who had lost all thought of
self, but left on some square inches of paper or vellum, in rich cinnabar,

burnished gold and outline of black the expression of their gratitude for living, surrounded him.

There came a great parcel from the binders. With eager eyes he saw the contents. A mighty folio with a white pigskin binding clasped in silver. Turning the crisp leaves he saw again, more beautiful than ever, the full-page woodcut title, the fourteen large borders, the pictures set in their decorative frames, the twenty-six large initial words, the ornamented initial letters, large and small, the noble dignity of the characters. It was the moment of pure satisfaction when a man looks on his labour and sees that it is good. The work of five years was finished at last. The final Pre-Raphaelite masterpiece, the Kelmscott Chaucer, was complete. William Butler Yeats has called it 'the most beautiful book in the world'. It is the tribute of a poet to a poetic creation. It might not be a useful edition of Chaucer. It might not be convenient to handle. It might set at naught the, in many respects admirable, tradition of English typography; but it was a noble conception – the conception of another, an alternative world to that of the factory and the frock-coat. Morris had not produced a book for the age in which he lived. He had produced a book for an age in which he did not live. Its luminous pages existed in a void which remained to be filled by the ideal society of which he had dreamed, towards which he yearned with a longing never to be fulfilled.

There was much in the later years of William Morris that made for satisfaction. The books of the Kelmscott Press were a new, a visible and tangible achievement. The firm of Morris & Co. was a smoothly running vehicle for the distribution of his designs. The demand for these was so steady that the firm practically ran itself. His trade partners, the brothers R. and F. Smith, took the business off his shoulders. It was to continue, on the strength of the original impetus, for more than forty years after his death. He had the devoted support of disciples of his own, fellow-workers who were also friends. There was not only Burne-Jones, but Philip Webb, Emery Walker and Sydney Cockerell, the two last working whole-heartedly with him on the books. His work was not a cul-de-sac as that of the painters seemed to be. It was bearing fruit. The Arts and Crafts movement had arisen from it. There was W. R. Lethaby, as enlightened a champion as any of the Middle Ages, Walter Crane, the socialist designer, Cobden-Sanderson, expert in the craft of the book. Edward

Johnston, exquisite in the craft of writing and lettering; and many more who strove with as pure an enthusiasm as his own.

Morris did not found the Arts and Crafts movement, though it is sometimes taken for granted that he did and that he contributed help to its efforts. Was it not what he had intended? It was – and yet it was not. That others should, as he did, take a pride in the individual work of the hand, that was what he could have wished. But – as long as the craftsman remained a member of a separate class or type – unfused with society as a whole – a rival organisation side by side with the industrial system – so long was his work undone and even a failure inasmuch as he had simply helped to add another caste to the existing castes without merging all into one. The Arts and Crafts movement perpetuated some of the contradictions he had encountered himself. Its products were expensive necessarily in relation to the machine economy. Therefore they were sold to the rich and thus became a novel luxury instead of the normal employment of the country in whose production and enjoyment all would share.

Nor did an association of craftsmen make the System, as he had defined it, less strong or seriously threaten its strength. On the contrary the factory, the machine loomed larger, more menacing in some respects, but in others with an appearance of internal reform. Buildings and conditions were improved. The machine put forward its own standard of design, in which the fitness for purpose of which Morris had made a point was subtly converted into a matter of efficiency in production and ease of reproduction. But the dilemma for one of Morris' ideas remained. If the system was wrong as he maintained, it was no less wrong because of certain improvements which left it unchanged or positively strengthened.

Some of these things were the developments of a later day than his. But the main fact was evident to him, tempering his satisfaction, that 'arts and crafts' did not solve the main social problem, and that he had tried and failed to solve it, though he persisted to the end in his avoidance of what savoured of the hated century into which he was born. Old things, mediaeval things, were his diversion. A thirteenth-century manuscript would tempt him; but nothing modern unless like Mark Twain's *Huckleberry Finn* or Doughty's *Arabia Deserta* it were also primaeval. When Mr Arnold Dolmetsch brought down the virginals to Kelmscott House, and played him a pavane and a galliard by William Byrd, he recognised the antiquity of the music and the instrument with a cry of joy.

He could never habituate himself to the contemplation of art merely, however much he approved, and yet by 1896 he could do no more work.

He suffered from increasingly severe attacks of gout. He was diabetic and he had worn himself out with labour enough for half a dozen men. At the beginning of 1896 he alarmed Burne-Jones by leaning his forehead on his hand, in the middle of breakfast, 'as he does so often now. It is a thing I have never seen him do before in all the years I have known him.' The mournful feeling grew on him that activity being over so was life itself. He went to Folkestone, but without advantage of his health. He went to Norway on an Orient liner, but the melancholy of the fjords oppressed him. He returned to Hammersmith not to leave again. It was too late now for the projected edition of the *Morte d'Arthur*, too late save to prepare for that final voyage as to whose nature he had always abstained from speculation. Surrounded by disciples and friends he died in October 1896 at the age of sixty-two.

The funeral befitted one whose nature partook of the saint, the pagan and the craftsman. It took place at Kelmscott where there had been much rain. The noise of waters filled the air, the streams were full, the meadows flooded. There was something pagan in the farm waggon with yellow body and bright red wheels, wreathed with vine and boughs of willow, which received the coffin from London; craftsmanly in the well-designed box with wrought-iron handles; reverential beyond ordinary reverence in the mourners who included comrades of the Socialist League, workmen from Merton Abbey and the Oxford Street shop, pupils of the Art Workers' Guild and lifelong friends. 'Alone, quite quite alone' was the thought of Burne-Jones as he came away from Kelmscott Church. He died two years later.

Jane Morris, whose beauty had inspired so much of their art, lived until 1914. Her daughter May carried on the tradition of Pre-Raphaelite crafts-manship until 1938.

Conclusion

The Pre-Raphaelite history comprises a case of drug-addiction and psychopathology, a shadowy conflict with the devil, a soap advertisement and an abortive attempt at political revolution. In various individual ways a tragic element appears in these circumstances, bound up with a closely connected series of events; but in general terms the tragedy involved was that of the Pre-Raphaelites' place in their time. They were out of accord with an age obsessed by industrial progress and the machine. They lived a life of the imagination and nourished it from sources remote from the

materialism around them. Long ago, when George Bernard Shaw was writing art criticism, he gave an account of a picture of the ramparts of Heaven by the follower of Burne-Jones, John Melhuish Strudwick. 'One wonders,' he said, 'how this sordid nineteenth century of ours could have such dreams and realise them in art.' The 'sordid century' was the reason for the dream. A special Victorian creation was anti-Victorianism.

The most brilliant misfits of Victorian England, the Pre-Raphaelites invented time and place of their own in which to live and work. In doing so they might be regarded as having little effect on the development of all that is usually nominated 'progress' in modern thought and purpose. Yet in the lengthening perspective of the twentieth century they gain fresh admiration. There are paintings that have stood the test of time. Pre-Raphaelite art in its several phases has had its influence abroad. Rossetti and Burne-Jones were inspiring to the Symbolists of France and Belgium, just as at a later date the Surrealists have had something to learn from the tense detail of Holman Hunt and the early Millais. If William Morris failed to revolutionise the social order he gave a new impulse to the arts of design and an inspiring example to Europe.

Sources and Acknowledgments

The biographies, memoirs, diaries and published letters of the Pre-Raphaelites and their associates are many and copious and since this book was first published there has been a fresh wave of interest and study signalised by both books and exhibitions. *Pre-Raphaelitism and the Pre-Raphaelite Brotherhood* by W. Holman Hunt, O.M., D.C.L. (2 vols), 1905, in spite of a certain bias remains a main source. Other works up to the 1930s include *The Life and Letters of Sir John Everett Millais, P.R.A.* by his son, John Guille Millais, 1899; *Dante Gabriel Rossetti – His Family Letters with a Memoir*, by William Michael Rossetti, 1895; *Ruskin: Rossetti: Pre-Raphaelitism*, Diaries and Letters, 1854–1862, arranged by W. M. Rossetti, 1899; *Thomas Woolner, R.A., Sculptor and Poet*, by Amy Woolner, 1917; *Ford Madox Brown* by Ford Madox Hueffer, 1896; *William Morris* by J. W. Mackail, 1899; *Memorials of Edward Burne-Jones* by Lady Burne-Jones, 1904. Rossetti figures prominently in the published recollections of William Bell Scott, Treffry Dunn and Hall Caine; and in fictional guise in Theodore Watts-Dunton's novel *Aylwin*. The life of Rossetti by Evelyn Waugh, 1927, and of his wife by Violet Hunt, 1932, were biographical additions of a critically candid kind.

The many works published after the Second World War include *Dante Gabriel Rossetti, A Victorian Romantic* by Oswald Doughty (second ed.), 1960; the comprehensive *Letters of Dante Gabriel Rossetti* edited by O. Doughty and J. R. Wahl (4 vols), 1965–7; *Pre-Raphaelite Twilight*, an account of Charles Augustus Howell by the daughter of William Michael Rossetti, Mrs Helen Rossetti Angeli, 1954. Outstanding works on Pre-Raphaelite art have been *Pre-Raphaelite Painters* by R. Ironside and J. Gere, 1948; *The Paintings and Drawings of Dante Gabriel Rossetti*, A *Catalogue Raisonne* by Virginia Surtees (2 vols), 1971, and *The Stained Glass of William Morris and His Circle* by Charles Sewter (2 vols), 1974–5. Mention is due to the illustrated guide to Kelmscott by A. R. Dufty, F.S.A., 1969, for the Society of Antiquaries, the Society being instrumental in the rehabilitation of Morris' house and its contents, 1964–7. An

excellent prototype of numerous subsequent exhibitions was 'The Pre-Raphaelite Brotherhood', City Museum and Art Gallery, Birmingham, 1947.

A comprehensive modern source of inquiry is *Pre-Raphaelitism. A Biblio-Critical Study* by Dr W. E. Fredeman, 1965.

The author would like to renew his thanks to those who generously provided him with information, suggestions and material used in this book. The thanks of the author and publisher are due also to the galleries that have kindly allowed reproduction of works in their possession.

INDEX

Aberdeen, Lord, 55

Acland, Henry Wentworth (1815–1900), famous medical man, friend of Ruskin, 33, 40, 43, 66

Allingham, William (1824–89), Irish poet, friend of Rossetti, 27, 68, 71, 153, 192

Arnold, Matthew (1822–88), poet, sympathetic to Pre-Raphaelitism, 87, 141, 144

Baldwin, Stanley, 77

Balfour, Arthur, 179, 216

Bancroft, Samuel, Jr, American Rossetti enthusiast, 189–90

Baudelaire, Charles, 118, 120

Bazin, carpet-weaver from Lyons, 171

Beardsley, Aubrey, 212

Beatrice, ideal love of Dante Alighieri, 40–41, 94–5

Beckett, Sir Edmund, lawyer, controversialist, 172

Behnes, William (d. 1864), sculptor, 20

Bergheim, Samuel, mesmerist, 106, 160

Bessel, Mr, Millais' art master, 15

Bischoffsheim, Mrs, 143

Blagden, Isabella, 119

Blake, William (1757–1827), poet and painter, forerunner of Pre-Raphaelite revolt against materialism, 18, 94

Blind, Mathilde (1841–96), writer, educationalist, friend of Madox Brown, 138

Blunt, Wilfrid, 92, 204

Boyce, G. P. (1826–97), water-colourist, friend of Rossetti, 95

Boyd, Alice, friend of Bell Scott, 109, 110, 112, 165

Boyd, Spencer, brother of Alice, 109

Brett, John (1830–1902), minor Pre-Raphaelite, 64–5

Bright, H. A., merchant and author, 195

Brown, Emma Madox, the painter's wife, 40, 49, 72, 91, 99, 125

Brown, Ford Madox (1821–93), painter, 'unofficial' Pre-Raphaelite, 12, 18–19, 21, 22, 26, 32, 35, 36, 37–8, 40, 42, 49, 61, 62, 64, 67, 72, 73, 76, 77, 79, 81, 82, 87, 91, 92, 98, 99, 100, 107, 121, 122, 125, 136, 138, 139, 143, 156, 163, 168, 169, 190, 196, 205, 206–7, 210, 212

Brown, Lucy Madox, the painter's daughter, 187

Browning, Robert (1812–89), admired by Pre-Raphaelites, 17, 70, 72, 86, 104, 119, 121, 141, 144, 148

Bruce, Henry A., M.P., 112

Buchanan, Robert William (1841–1901; pseudonym: Thomas Maitland), poet and novelist, author of attack on Rossetti, 117–20, 121, 201

Burden, Jane see Morris, Jane

Burne-Jones, (Sir) Edward Coley (1833–98), 12, 31, 66–8, 70, 71–6, 77, 81, 83, 98, 99, 100, 123, 125, 127, 128, 132, 133, 138, 139, 176–80, 187, 190, 194, 202, 212–13, 214, 215, 217, 218, 219, 221, 222

Burne-Jones, Georgiana (wife of Edward), 40, 77, 91, 98, 99, 123, 125, 127, 129, 163–4, 173, 177, 179, 180, 194, 212, 217

Burton, Sir Richard, 159

Burton, W. S. (1824–1916), minor Pre-Raphaelite, 64

Byrd, William, 220

Caine, Lily, 201

Caine, (Sir) Thomas Henry Hall (1853–1931), novelist, friend of Rossetti, 93, 96, 98, 100, 106, 107, 194–204

Burne-Jones, 117, 121, 179, 187, 202, 203

Grant, Sir Francis (1803–78), R.A., 85

Gray, David, 117–18

Grosvenor, Countess, 143

Hake, George, amanuensis to Rossetti, 122, 135, 144, 188–9, 202, 203

Hake, Thomas Gordon (1809–95), doctor, poet, friend of Rossetti, 102, 106, 114, 116, 119, 120, 121, 122, 131, 134, 136, 144

Haldane, R. B., 179

Hallé, pianist and conductor, 86

Hals, Franz, 148

Harcourt, Sir William, 144, 211

Hasboon, Jarius, Hunt's model, 160

Heeley, Wilfrid L., Oxford friend of Burne-Jones and Morris, 68

Herbert, Miss, actress, 97

Herkomer, Professor Hubert, 210

Hogarth, William, 15

Horner, Lady, 179

Houghton, Lord, patron of letters, 86, 195

Howell, Charles Augustus, 99–101, 102, 103, 104–5, 106, 107, 108, 112, 114, 115, 136, 158, 187–8, 191, 192, 202

Howitt, William and Mary, authors, friends of Rossetti, 39, 105–6

Hueffer, Dr, 119, 138

Hueffer, Ford Madox, 207, 208

Hughes, Arthur (1832–1915), painter and illustrator, devoted Pre-Raphaelite, 12, 25, 26, 46, 64, 71, 73, 74, 75, 77, 81, 98, 208

Hughes, Mrs see Cox, Sarah

Hunt, William Holman (1827–1910), 11, 12, 14–17, 18–19, 20, 21, 22, 23, 25, 29–30, 32, 35, 36, 39, 45, 47–8, 50–53, 54–7, 59, 60, 65, 66, 67, 68, 71, 72, 74, 79, 80, 81, 82, 83, 84, 86–9, 102, 131, 132, 139, 141, 148–9, 152, 156–66, 167, 169, 179, 187, 200, 204–9, 210, 211, 212, 214, 222

Hyndman, Henry Mayers, socialist leader, 181

Ingram, Sir William, 150

Irving, Sir Henry, 144, 211–12

James, Henry, 144

Jenner, Dr, 87

Joachim, violinist, 86, 144

Johnston, Edward, 219–20

Jones, George (1786–1869), R.A., 14

Jowett, Mr, Master of Balliol, 123

Keats, John (1795–1821), main inspiration of Pre-Raphaelite art, 16, 17, 18, 24, 25, 68, 73, 86

Keble, John (1792–1866), with Newman, indirect religious influence on Pre-Raphaelites, 19

Kipling, Rudyard, 67, 77, 127, 213

Kingsley, Charles (1819–75), 62

Kitz, Frank, revolutionary, 215

Knewstub, W. J., assistant of Rossetti, 98

Landseer, Charles (1799–1879), R.A., brother of the animal painter, 46

Landseer, Sir Edwin (1802–73), animal painter, early object of Pre-Raphaelite dislike, 23, 84, 147, 153

Langtry, Lily, 144

Lansdowne, Lord, 84

Lasinio, 23

Lauro, Agostino, 47

Lear, Edward (1812–88), friend of the Pre-Raphaelites, 18, 52–3, 156

Leathart, James, Pre-Raphaelite patron, 65

Leech, John (1817–64), friend of Millais, 57–8, 82, 86, 141

Legros, Alphonse (1837–1911), 99

Leigh-Smith, Barbara (Mme Bodichon; 1827–91), friend of Pre-Raphaelites, 115

Leighton, Frederic (Lord) (1830–96), 82, 83, 86, 100, 142, 150, 159, 209, 211

Leslie, Charles Robert (1794–1859), R.A., genre painter of school despised by Pre-Raphaelites, 14

Leslie, Lady Constance, 152

Lethaby, W. R., 219

Lewis, Arthur, 86

Lewis, J. F., painter admired by Ruskin, 32

Leyland, F. R., Pre-Raphaelite patron, 65, 106

Lindsay, Sir Coutts, art patron, 84, 152, 162

Linnell, Alfred, 185

Losh, Miss, admirer of Rossetti, 110–11, 113, 114, 116, 127–8, 130, 134

Lushington, Vernon, friend and patron of